T0377732

DUMBARTON OAKS STUDIES 50

FACING CRISIS

DUMBARTON
OAKS STUDIES
50

DUMBARTON OAKS
RESEARCH LIBRARY
AND COLLECTION
WASHINGTON, DC

FACING CRISIS

Art as Politics in Fourteenth-Century Venice

Stefania Gerevini

ISBN 978-0-88402-503-0

LIBRARY OF CONGRESS CATALOGING-IN-PUBLICATION DATA

NAMES: Gerevini, Stefania, author.

TITLE: Facing crisis : art as politics in fourteenth-century Venice / Stefania Gerevini.

OTHER TITLES: Dumbarton Oaks studies ; 50.

DESCRIPTION: Washington, D.C. : Dumbarton Oaks Research Library and Collection, [2024]. | Series: Dumbarton Oaks studies ; 50 | Includes bibliographical references and index. | Summary: "Though Venice emerged as a leading Mediterranean power in the Trecento, the city faced a series of crises during a brief but cataclysmic period coinciding with Andrea Dandolo's dogeship (1343–1354): earthquakes, disease, fierce military conflicts, and dramatic political and institutional tensions had the republic on edge. It was nevertheless precisely at this time that the government sponsored the ambitious and sumptuous artistic campaigns in San Marco that are at the heart of this book: a reliquary-chapel, a new baptistery, and a folding altarpiece, all masterpieces crafted with unparalleled technical skill, blending Byzantine and Italianate visual forms. Far from being mere artistic commissions, these works were affirmative political interventions that interrogated the meaning of community, authority, and (shared) political leadership at a time when those notions were unsettled. Looking beyond established concepts of triumph and imperialism, this book situates the artistic interactions between Byzantium and Venice into ongoing processes of state formation and attests to the power of images to inform (and transform) political imaginations in troubled times. This study thus offers new insights into how medieval communities across the Mediterranean understood and responded to uncertainty through the visual, and in doing so, probes the value of 'crisis' as a methodological framework"—Provided by publisher.

IDENTIFIERS: LCCN 2023049894 | ISBN 9780884025030 (hardcover)

SUBJECTS: LCSH: Dandolo, Andrea, approximately 1307–1354. | Basilica di San Marco (Venice, Italy) | Art—Political aspects—Italy—Venice. | Art, Byzantine—Italy—Venice. | Art, Medieval—Byzantine influences. | Art, Byzantine—Influence. | Venice (Italy)—Politics and Government—History—14th century.

CLASSIFICATION: LCC NA5621.V5 G47 2024 | DDC 726.60945/311—dc23/eng/20240223

LC record available at https://lccn.loc.gov/2023049894

FRONTISPIECE: Pala feriale, Paolo Veneziano and sons, completed in 1345. Venice, Museo di San Marco (formerly high altar). Photo courtesy of the Procuratoria di San Marco.

To Maria Casula Gerevini,
in loving memory

I like the word *krisis* which Sokrates taught me.
It means Decision.

Ruling (of a court). Middle (of the spinal column).
. . .
 Krisis means
the crack that runs

between Sokrates sitting on the edge of his bunk telling us Death Is
No Misfortune

and his soul making little twitchy moves against the flesh,
which show up

on the film as bright dots or phosphorescence before
storms.

 —Anne Carson, "TV Men: Sokrates," in *Glass, Irony and God* (New York, 1995), 67–68.

CONTENTS

FIGURES

ACKNOWLEDGMENTS

Writing takes time, and over time I have accrued debts of gratitude toward several individuals and institutions. Without their support, advice, and understanding, the manuscript that has become this book would not have been completed.

My greatest debt is to Antony Eastmond at the Courtauld Institute of Art. Tony ignited my interest in the arts of medieval Venice and the wider Byzantine world during a memorable (and memorably cold) MA trip in 2006, and I have continued to benefit from his guidance, support, and critical eye to this day. It was Tony who originally suggested that I should write a book about Andrea Dandolo's Venice, and because no good deed goes unpunished, he was later repaid with multiple drafts of the manuscript. The incisive comments and poignant questions with which he annotated those drafts are the signature style of his exceptional scholarship and mentoring and have saved me from many mistakes.

I also owe very special thanks to Joanna Cannon, who has been an unsurpassed model of scholarly rigor and personal generosity over the years. Joanna welcomed me to Giotto's Circle and provided essential guidance at crucial moments during the proposal and submission of this book, often sacrificing the precious little research time that was available to her. For this, as well as for instructing me in the art of small celebrations, I am immensely grateful.

My interest in the nexus between the visual arts and the political realm goes back a long time. My deepest thanks go to Stefano Baia Curioni for starting me on this course exactly two decades ago, and for providing unflagging support and an inspiring model of cultural entrepreneurship since.

I am also infinitely indebted to Christopher J. Smith. This manuscript significantly benefited from his vast knowledge and poetic intuition, and our conversations about culture and crisis were potent stimuli for clarifying my arguments on this subject. My gratitude for those intellectual exchanges is only surpassed by my gratefulness for the gift of Christopher and Susan's unfaltering friendship.

Very special thanks also go to Michaela Zöschg. Our experimental "agraphia sessions"—peppered with her razor-sharp comments—ensured that my writing continued to flow during lockdown. Meanwhile, Michaela's talent for calling things by their names provided laughter and honest support as I grieved important losses.

Many other mentors, colleagues, and friends generously offered advice and suggestions that broadened my intellectual horizons and improved my work. Elena Boeck asked penetrating questions about Venice and Byzantium and offered wise counsel and scintillating company along the entire journey. Anne Derbes shared her expertise on baptismal rituals and generously read an early draft of the manuscript, providing feedback. Serena Romano energetically prodded me into completing the manuscript, combining sound advice with sidesplitting anecdotes in Milan, Paris, Venice, and Brno. Quentin Skinner was exceptionally giving of his time, sharing his immense knowledge of European political history and theory with the utmost kindness on the occasion of an academic visit to Milan.

Sophia Akrivopoulou, Maria Bergamo, Anthony Michael Bertelli, Paul Binski, Brian Boeck, Leslie Brubaker, Tim Byrne, Donal Cooper, Philippe Cordez, Thomas E. A. Dale, Ivan Drpić, Finbarr Barry Flood, Patricia Fortini Brown, Benjamin Fourlas, Beate Fricke, the members of Giotto's Circle, Giunia Gatta, John Haldon, Maria Harvey, Emanuele Lugli, Isabelle Marchesin, Zuleika Murat, Scott Nethersole, Tom

Nickson, Alessandro Nova, Debra Pincus, Ioanna Rapti, Guido Rebecchini, Stefano Riccioni, Gervase Rosser, Maria Alessia Rossi, Paolo Tedesco, Marka Tomić, Vasiliki Tsamakda, Tamás Vonyó, and Alicia Walker contributed to my research with valuable advice, insights, and practical help; my heartfelt thanks to each of them.

I also owe special mention to Teresa Maria Callaioli for her excellent editorial and research assistance; and to Giovanna Di Martino, whose patience and impeccable organization skills ensured that my research trips were successful, and that image rights were acquired in a timely fashion.

This book could not have been written without the support of the Procuratoria di San Marco: Proto Mario Piana and Proto Ettore Vio generously granted me access to the church, treasury, and archives over the years. Antonella Fumo and Chiara Vian solicitously responded to my frequent requests for assistance, greeting me with cheerfulness on my numerous visits to the basilica.

My research has also benefited from the generous support of several other institutions. I am especially thankful to Bocconi University, the Department of Social and Political Sciences, and the Research Center ASK for providing me with the time and resources that were necessary for my fieldwork in Venice and for the acquisition of color images for the book. I am also grateful to the British School at Rome, the Courtauld Institute of Art, Dumbarton Oaks Research Library and Collection, the Fondazione Giorgio Cini, the Kunsthistorisches Institut in Florenz, the Scuola IMT Alti Studi Lucca, the Institut national d'histoire de l'art (INHA), and the Leibniz-WissenschaftsCampus–Byzanz zwischen Orient und Okzident–Mainz/Frankfurt, all of which provided financial support and access to their excellent research infrastructures and welcomed me into their vibrant intellectual communities. I am indebted to all my colleagues at those institutions for their encouragement, insights, and stimulating conversations, as well as for being such delightful companions on innumerable medieval and Byzantine adventures.

Life sometimes gets in the way of writing. I am blessed that so many friends and dear ones helped me not only to survive but to thrive at both. Simone Autera, Giulia Avanza, Laura Forti, and Marta Equi Pierazzini rallied round me on countless occasions with tact, wisdom—and a collection of brushes. Rodolfo Maffeis offered selfless support while I recovered from a severe injury incurred during the editing of this book. Nicoletta Balbo, Francesca Beccacece, Elena Boccalandro, Benedetta Chiesi, Carlo Devillanova, Eleni Dimitriadou, Luca Fantacci, Simone Ghislandi, Giulia Giupponi, Anne-Marie Jeannet, Elena Mondo, Michele Mozzarelli, Pierluigi Mulas, Natalia Oprea, Massimiliano Radi, Micaela Rossi, Veronica Toffolutti, and Roland Williams were sources of laughter, wisdom, practical help, and patient listening more often than I can account for.

I feel very privileged to publish with Dumbarton Oaks, and I am grateful to the editorial board for including my book in the Byzantine Studies series. I owe very special thanks to Colin Whiting, who has been a model editor. Colin supported this project from its early days, providing encouragement and helpful critique throughout the process, dispensing both with the greatest professionalism, kindness, and irony. I am also grateful to David Weeks, who meticulously copyedited the manuscript, welcoming my fastidious questions with equal amounts of indulgence and amusement, and Abigail Anderson, who proofread the manuscript with a sharp eye.

This book is dedicated to my mother Maria, my wisest confidante and most intrepid travel companion on journeys by air, land, armchair, and heart. She passed away before this book was completed. That it was written at all is a tribute to her unrivaled gift for turning crises into krises.

INTRODUCTION

Dᴜʀɪɴɢ ᴛʜᴇ ᴍᴏɴᴛʜ ᴏғ ғᴇʙʀᴜᴀʀʏ 1341 (1340 *more veneto*), a terrible storm struck the city of Venice. Seeking shelter, an old fisherman had just docked his boat near the church of San Marco when three strangers approached him and ordered him to sail them across the Grand Canal, toward Venice's harbor entrance. After some initial protests, the sailor reluctantly accommodated their request. Once they had reached their destination, a galley full of demons appeared. Evidently, the demons had unleashed the tempest to destroy Venice. Unperturbed, the three strangers sailed toward the enemies, made the sign of the cross, and shattered their vessel, thus calming the storm and saving Venice from devastation (Fig. 1).

Having accomplished their task, they then asked the fisherman to deliver each of them to his respective abode: San Nicolò al Lido, San Giorgio Maggiore, and San Marco. Disembarking at San Marco, the last stranger revealed what the reader already suspects: he was St. Mark the Evangelist, protector of Venice, and his companions were St. George and St. Nicholas. Before disappearing, St. Mark ordered the fisherman to report what he had witnessed to the doge, so that he could be suitably rewarded. The saint also gave the fisherman a ring as incontrovertible proof of the miraculous event. The man was instructed to hand the ring over to the procurators and the doge, who would restore it to the treasury from

where the evangelist had taken it. The man dutifully did so, and the precious ring still survives in San Marco as a memorial of the wondrous event (Fig. 2 and Fig. 3).[1]

Casting the mid-trecento as a period of extraordinary, deadly danger, this legend provides an ideal point of departure for this book, which examines the artistic renewal of the basilica of San Marco undertaken by the

1 I follow here the earliest printed version of the legend, Marcantonio Coccio Sabellico, *Istorie veneziane* (Venice, 1487), 289–91. The legend was then included in the Mariegola of the Scuola Grande di San Marco in 1498. See G. Matino, "Il ciclo dell'albergo della Scuola Grande di San Marco: Una nuova prospettiva," in *La Scuola Grande di San Marco a Venezia*, ed. A. Vincenzi (Modena, 2017), 1:117–33, with further references. A more detailed version of the legend was also included in Marino Sanudo, *Vitae ducorum Venetorum italice scriptae ab origine urbis, sive ab anno CCCCXXI usque ad annum MCCCXCIII*, RIS 22 (Milan, 1733), cols. 599–1252, at 608–9. This was largely written between 1493 and 1495. See M. Melchiorre, "Sanudo, Marino il Giovane," *DBI* 90 (2017), https://www.treccani.it/enciclopedia /marino-marin-il-giovane-sanudo_(Dizionario-Biografico)/. The earliest known manuscript version of the legend appears in the so-called *Cronaca pseudo-Zancaruola*, Venice, Biblioteca Nazionale Marciana, It. VII, 49–50 (=9274–75), which dates from the second half of the fifteenth century; from the same period, see also Paris, Bibliothèque Nationale de France, It. 318. On the *Cronaca Zancaruola* and the family of manuscripts related to it, see G. Zorzanello, "La cronaca veneziana trascritta da Gasparo Zancaruolo (Codice Marciano It. VII, 2570, Già Phillipps 5215)," *AVen* 114 (1980): 37–66. Early sources are also briefly discussed in A. Manno, ed., *San Marco Evangelista: Opere d'arte dalle chiese di Venezia* (Venice, 1995), 236–37. See also I. Fenlon, *The Ceremonial City: History, Memory and Myth in Renaissance Venice* (New Haven, CT, 2007), 32–33.

Venetian government under the leadership of Doge Andrea Dandolo (r. 1343–1354) through the interpretive lens of crisis. Uncharacteristically for San Marco, where artistic campaigns are usually difficult to date or assign to specific patrons, the artistic enterprises commissioned during Andrea Dandolo's dogate constitute a well-defined corpus. Shortly after Dandolo's election, the high altar of the basilica was thoroughly refurbished between 1343 and 1345, with the makeover of the Byzantine golden altarpiece, known as the *pala d'oro*, and the commissioning of a new painted altarpiece from Paolo Veneziano (the so-called *pala feriale*). In the

following years, work in San Marco extended to two new shrines. The southwest arm of the vestibule of the basilica, used as a baptistery, was decorated with a lavish cycle of mosaics and marble incrustations that presumably reached completion before Dandolo's death in 1354. In addition, a new chapel was built in the basilica's northeast transept. This chapel was dedicated to the eastern martyr Isidore of Chios: the martyr's body, which had allegedly been translated to Venice in 1125, was rediscovered by Doge Andrea Dandolo, who gave it a solemn burial in the basilica of San Marco. The decoration of the chapel of Sant'Isidoro, which also comprised an extensive

FIGURE 2. *The Presentation of the Ring to the Doge of Venice*, Paris Bordon. Venice, Gallerie dell'Accademia, 1534. Photo courtesy of Cameraphoto arte.

FIGURE 3. Ring relic of St. Mark, late thirteenth or early fourteenth century; reliquary, ca. 1336. Venice, Treasury of San Marco. Photo courtesy of the Procuratoria di San Marco.

mosaic cycle, was completed in 1355, shortly after Dandolo's death (see Fig. 4 for a ground plan of the basilica, showing Dandolo's projects).

Scholarship has routinely discussed these projects as visual hybrids, emphasizing their indebtedness to late Byzantine visual culture. Such engagement with Byzantine artistic heritage has been seen as the visual manifestation of an "ideology of triumph" over Byzantium that originated in the aftermath of the Latin takeover of Constantinople in 1204, and which manifested itself in a sophisticated rhetoric of *spolia* on the façades of San Marco and developed further

in the fourteenth century, mirroring Venice's rise as an early global power. These notions—that Venice remained an artistic subsidiary of Byzantium long after the Fourth Crusade, and that artistic borrowing was primarily intended to convey Venice's triumph—have become established scholarly positions. But the image of impending catastrophe and narrowly averted destruction delivered by the legend of the fisherman complicates this scholarly dichotomy and invites us to reconsider the historical milieu within which the artistic renewal of San Marco took place, as well as the approaches that we call

FIGURE 4.

San Marco, Venice, ground plan and areas renewed during Andrea Dandolo's reign. Image adapted from Courtauld Institute of Art, Conway Library, neg. no. B.F. 698.

Ancient work prior to 1063.
Domenico Contarini, 1063—1071.
Decoration (Marble Mosaics), 1100—1350.
Work done about 1300.
Renaissance.

A. Chapel of St. Isidore.
B. Baptistery.
C. Treasury.
D. Chapel of St. Zeno.

upon to understand the function and meaning of those artistic commissions.

While work progressed in the basilica between 1343 and 1355, Venice faced famine, a violent earthquake, the plague, growing tensions with the city-states of northern Italy, and a fierce war against Genoa, its chief international rival. In

these same years, Venice backed and later briefly led an international military league of Christian polities against the Ottoman advance in the eastern Mediterranean. Simultaneously, Venice faced significant domestic turmoil. In 1297, the constitutional act known as the *Serrata* restricted eligibility to the Great Council to old aristocratic

families, inaugurating a period of intense strife. The foundations and structures of the Venetian government—including the position and the functions of the doge—were comprehensively revised in the mid-fourteenth century, at the same time as the boundaries of the Venetian state and the nature and extent of its citizenship were redefined in response to the city's territorial expansion into mainland Italy, the Adriatic, and the eastern Mediterranean.

My working hypothesis is that that these events informed the ways in which art was made and viewed in San Marco—including, crucially, questions of patronage. The artistic renewal of the basilica in the fourteenth century has generally been approached as the product of Andrea Dandolo's intellect and as the direct expression of his personal political agenda. Andrea Dandolo's activity as a statesman was indeed remarkable: he supervised a thorough reorganization of Venice's statutes, oversaw the collation of the city's international treatises, and directed the writing of a history of Venice *ab urbe condita*. These works, and the specific concerns and institutional vision they express, will play an important role in shaping my interpretation of "Dandolo's projects" in San Marco. But Venice's legal and institutional frameworks—particularly the increasing limits imposed on ducal authority in the fourteenth century—invite a more nuanced interpretation of the doge's role as artistic patron and fuller consideration of the wider institutional forces at play in the basilica's artistic renovation. The present study embraces this more expansive approach, exploring how the visual and textual programs of the high altar, baptistery, and chapel of Sant'Isidoro manifested the complex fabric of Venetian public patronage and the dynamic social and political realities that undergirded it.

Throughout this study, "crisis" is not understood as a synonym of "adversity." Rather, our approach to the concept is informed by Hannah Arendt's particular designation of "crisis" as a boundary situation, when a community's taken-for-granted integrity is disrupted. This definition is both more general and more specific than "adversity," for it makes crisis central to politics. At times of crisis, communities (and their governors) are called upon not just to react, but to

decidedly reaffirm or deny previously established mutual bonds and rules of interaction.[2] This formulation derives from the ancient meaning of the word κρίσις, which originally designated not upheaval, but the ability to discern and understand, and by extension any act of judgment and informed decision-making. Looking at historical change through the lens of crisis, so defined, brings into specific focus the fact that how individuals and communities evaluate, and represent to themselves, the particular circumstances in which they operate is central to all processes of historical transformation. To perceive change through the prism of crisis is to see change as productive of and resulting from choices within, for, and about the very nature of community. To what extent is this interpretive framework applicable to a medieval context? Crisis, meaning both an actual event and the faculty to discern and adjudicate, is central to medieval Christian worldviews. In the Greek New Testament, the term κρίσις occurs multiple times, but most frequently appears with reference to the Day of Judgment, ἡ ἡμέρα τῆς κρίσεως. Conceptually inseparable from Christian ideas about the end of time and the trajectory of human salvation and damnation, "crisis" is thus a defining component of medieval understandings of history, eschatology, ethics, and politics.

Based on this layered understanding of crisis, our core thesis runs as follows: at one level, this study submits that the artistic campaigns undertaken during Dandolo's reign made visually manifest the range of topical concerns that engulfed the Venetian government and broader community in the mid-fourteenth century. For example, Paolo Veneziano's altarpiece displays an emphasis on supernatural intervention that is unparalleled in San Marco, and that may be related to an increased need for reassurance in unsettled times. The conflict against Genoa most likely influenced the dedication of a chapel to St. Isidore, for his body was brought to Venice from Chios,

2 H. Arendt, "The Crisis in Education," in *Between Past and Future: Six Exercises in Political Thought* (1961; repr., New York, 2006), 170–93; and H. Arendt, "The Crisis in Culture: Its Social and Its Political Significance," in *Between Past and Future*, 194–222. For an analysis of Arendt's approach to crisis, see J. Norberg, "Arendt in Crisis: Political Thought in between Past and Future," *College Literature* 38.1 (2011): 131–49.

a vital Genoese stronghold in the East. Finally, uncertainty about the nature and the boundaries of citizenship and political authority—which the expansion of Venice's overseas territories transformed into an ever more urgent problem—offers a valuable approach to interpreting the imagery of the baptistery, with its emphasis on legitimacy, hierarchy, and unity in diversity. At another level, Venice's radical instability rendered habitual patterns of institutional and political decision-making, communication, and control inadequate for facing the current challenges, creating both the need and the opportunity to develop alternative means of intervention in the public arena. The Venetian government, under Dandolo's leadership, responded to crisis with a wide-ranging strategy of legal, institutional, and historical revision aimed at clarifying the nature, functions, and mechanisms of the Venetian state, and the specific place of Venice and its government within a divinely ordained cosmos. This study contends that the fourteenth-century artistic projects in San Marco were an integral component of such a program of state building. That is, they represented affirmative political interventions that interrogated the meaning of community, authority, and legitimate rule at a time when these notions were called into question, and which subjected Venice's governors and their activity to divine justice and to God's judgment at the end of time.

❧

By examining the renovation of San Marco in the fourteenth century through the prism of crisis, this study provides novel scholarly approaches to Venice and Byzantium and will contribute to methodological debates in the broader field of Byzantine and medieval studies. As an overview of the historiography of crisis will reveal, scholarly expectations that fourteenth-century Venetian art should be defined in terms of its relative proximity to Byzantine (or Western) visual languages originate in the taxonomies of modern art history and related ideas about boundaries, centers, and peripheries that do not accurately reflect visual or sociopolitical attitudes in the trecento. Similarly, the vocabulary of visual "dualism" and "hybridity" that is routinely employed to describe the arts of San Marco implicitly casts

Venice as a derivative culture and advances conceptual oppositions between East and West, and ideals of artistic purity and separateness, that do not do justice to Venice's complex social and cultural fabric in the fourteenth century, or to the density, ambivalence, and temporal depth of the interactions among late medieval communities.

By contrast, using the lens of crisis steers the conversation away from formalist concerns about the genealogies of artistic formulae and encourages us instead to approach the artistic renovation of San Marco from a Venetian standpoint and explore how Venetian patrons and viewers assigned meaning to visual objects based on their specific social and cultural experiences. Dandolo's campaigns were eminently public visual statements. Each project entailed significant public expenditure; it was the result of a collective, institutional decision and made a specific intervention in the religious and political space of San Marco. In this context, visual diversity—including the selective and nuanced recourse to Byzantine artifacts, iconographies, and visual forms—cannot be explained as a generic "symptom" of Venice's triumphalist ethos or conservative culture. Instead, the visual qualities of each program demand to be understood as purposeful aesthetic choices, whose meanings were inseparable from and specific to the needs and functions that each project was designed to address.

This approach requires that we clarify the scope of the term "Byzantine" in the context of trecento Venice. In the mid-fourteenth century, Byzantium—narrowly defined as the Eastern Roman Empire—represented only one of Venice's several interlocutors. On this account, our study avoids focusing exclusively on the relation of "Venice and Byzantium." Instead, it seeks to situate the art of San Marco within its local social and institutional context, as well as against a wider and more granular web of interactions that included the Eastern Roman Empire, but also the Italian city-states of northern Italy, Venice's colonies, the Adriatic and the Balkans, Genoa, and the Latin polities of the eastern Mediterranean. Accordingly, our study addresses "Venice and Byzantium" from a broader perspective, defining "Byzantium" less restrictively as a scholarly rubric that (in spite of its many ideological biases) both captures and interrogates

the layered and entangled histories of interaction between the Eastern Roman Empire and its neighbors, as well as the specificity and autonomy of the cultures that surrounded it. Alongside its long history of engagement with the Eastern Roman Empire, Venice maintained close relations with the empire's neighbors and successors, and it had continuous exchanges with the Greek-speaking communities and Orthodox Christian enclaves across the Mediterranean, both within and outside Venice's own empire. Those interactions transformed the social and political fabric of the city and played a significant part in defining its public image. From this perspective, the high altar, the chapel of Sant'Isidoro, and the baptistery will each provide a different insight into the meanings of "Byzantine art" in fourteenth-century Venice, as well as a powerful witness to Venice's central role in defining what we call today the "Byzantine world."

FACING CRISIS

The Legend of the Storm: Sanctity, Politics, and Material History in Trecento Venice

THIS STUDY OPENED WITH A WELL-known Venetian legend that identifies the year 1340 as a critical juncture in the history of Venice. The earliest written versions of this legend date from the fifteenth century, and fourteenth-century chronicles do not mention any extraordinary storms in the 1340s. This cautions us against simplistic understandings of this story as a popular reinterpretation of an actual environmental phenomenon, or as the direct literary expression of fourteenth-century anxiety. In spite of the legend's being recorded in writing decades after the alleged "diabolic storm" of 1340, scholarship has generally suggested that oral accounts may have circulated since the trecento.[1] Although we lack more precise information about its origins, the legend may at least be regarded as one narrative device through which the Venetian community retrospectively metabolized and metaphorized a phase of relatively recent adversity and as a literary space within which the same community reasserted the mechanisms associated with normalcy and its breach. Seen from this perspective, the legend raises a set of questions that are relevant to the material and the time span covered in this book.

First, the legend outlines a scenario of deadly danger, where the very survival of the city of Venice is under threat. Also, it casts the subsequent fight for its rescue as a contest between evil and holy powers. Venetian sources routinely portray the history of their city as a sequence of supernatural interventions and manifestations of divine benevolence. Nevertheless, the legend invites us to reflect on how contemporaries imagined and transfigured danger and adversity (both visually and textually), what solutions they envisioned, and how they turned to narrative and metaphor to make sense of their lived experience of upheaval, and to endure it. These questions are central to this book, which explores the ways in which medieval communities metabolized and responded to change through the visual.

Furthermore, the legend attributes the city's surviving the violent, diabolic storm to the intervention of a group of saintly patrons. Scholarship has long recognized the key significance of civic religion in late medieval Italian city-states, and the part that the cult of saints played in making and redefining Venice's self-image in medieval and Renaissance times. But the legend also gestures to a new orientation of Venice's public religion: the multiplication of official civic patrons and their symbolic reorganization around the key figure of Mark, chief protector of the Venetian state.

1 Fenlon, *Ceremonial City*, 32–33 (see above, p. 1, n. 1).

This development originated in the fourteenth century, at a time when significant efforts were made to record the presence of holy bodies and relics in the lagoon and to centralize the management of their cult. More specifically, while St. George and St. Nicholas had long been venerated in Venice, there exists historical and visual evidence that their cult was more vigorously promoted in the early and mid-trecento, and that the two saints were directly associated with the Venetian state, and with the church of San Marco, at this time. A precious Byzantine reliquary of the arm of St. George in the treasury of San Marco—allegedly part of Venice's booty in 1204—was restored in 1325, and the refurbishment carefully annotated in the inventory of the basilica (Fig. 5). In addition, the doge's private chapel in the ducal palace, dedicated to St. Nicholas, was refurbished in 1346, during Andrea Dandolo's reign. The same doge reputedly inspected the body of the saint, preserved at San Nicolò al Lido. Finally, St. Nicholas is conspicuously represented on the pala feriale (the painted altarpiece executed by Paolo Veneziano for the high altar), as well as in the baptistery and the chapel of Sant'Isidoro, confirming Nicholas's prominence at this time.

Another relevant component of the legend of the storm is that the holy patrons' intercessory mission unfolds across the Venetian archipelago and culminates at Bocca di Porto, one of the straits joining the Venetian lagoon with the wider Adriatic Sea. The legend's topographic emphasis, and the fact that the supernatural battle is fought at the physical threshold between Venice and the outer maritime space, prompts us to think carefully about the changing relationship between state and space in Venice in the late Middle Ages. As the next section will explore in more detail, the mid-fourteenth century was a turning point in the development of Venice's territorial policies. In 1339 Venice acquired its first territorial outpost on the Italian *terraferma*, breaking away from a time-honored tradition of noninvolvement with the mainland. Meanwhile, the city also consolidated its colonial possessions in the Adriatic and the Aegean. In addition to frequent political unrest, Venice's territorial expansion generated significant and enduring administrative challenges. The Venetian government was now required to administer and control an area that

was territorially vast, geographically fragmented, and culturally highly diverse. It was confronted with a new need to define the relationship between the capital and its different administrative divisions, and to articulate the requisites for citizenship as well as the rights and responsibilities of the various constituencies that made up the Venetian state. Questions of state building, hierarchy, and boundary demarcation are central to all the artistic campaigns sponsored by the government in San Marco in the mid-trecento. As the relevant chapter explains, however, they were eminently evident in the baptistery, which gave visual form to new ideas about community and citizenship, political authority, and the mechanisms for delegating and distributing it.

As we have already noted, divine intervention is facilitated in the legend by the active participation of a member of the Venetian popular class: the fisherman, who both enabled and witnessed the miraculous event. After careful verification, the miracle was then ratified by the doge and the senators of Venice, becoming part of the official public memory of the city. Scholarship has often emphasized the extent to which the myth of Venice rested on literary and pictorial images of harmonious interaction between different constituencies of the Venetian *civitas*, and the degree to which such narratives of order and peaceful cohabitation concealed acute social strife and political tensions throughout the Renaissance. The legend of the storm is unusual in this respect. In his dialogue with St. Mark, the fisherman claims that Venice's public authorities will be incredulous and deny him a reward. In other words, he anticipates that his interaction with the state will consist of a formal hearing—a legal procedure that will require an argument and sufficient evidence to support it. Aside from the literary trope, this prompts important questions about Venetian social interactions and conceptions of the state and about the significance of oral, textual, and visual evidence in Venice's late medieval public culture. What was the relationship between citizens and state in fourteenth-century Venice? What was the function of the doge, and what were the limits of his authority? These questions are central to my book. The structures and organs of the Venetian state—including the prerogatives of the doge—were

redefined in the aftermath of the Serrata of the Great Council (1297). This revision, which lasted for most of the trecento, culminated in the mid-fourteenth century, during the dogate of Andrea Dandolo and of his infamous successor Marino Falier—beheaded for treason in 1355.[2] As we shall see, the imagery of San Marco gave visual form to emerging ideas about the state. It conveyed a new image of the doge as public servant and as guarantor of the law and the continuity of tradition in the exercise of power. It also promoted a vision of the Venetian state as a collegial, corporate enterprise.

Finally, and crucially for this study, the official validation of the miracle in the legend of the storm rests on material evidence: St. Mark's ring proves the veracity of both the miraculous encounter between the saint and the fisherman and the latter's account of Venice's rescue from destruction. The ring—which is mentioned in the fourteenth-century inventory of the treasury of San Marco and has survived—enjoys a particular status in the narrative. It is a mundane (if precious) manufactured object, which nevertheless participates in the supernatural by virtue of its connection with the evangelist (see above, Fig. 3).[3]

At one level, the ring is a historical object. It authenticates the fisherman's account to the doge and magistrates, and it does so particularly as it is said already to have been preserved in the treasury, whence St. Mark took it. Once the ring is deposited again in the treasury of San Marco, it becomes a repository of public memory, providing visible evidence of the reliability and accuracy of the legend of the storm and justifying its official memorialization. The imbrications between art, history writing, and public memory at San Marco are key concerns of this book, which argues that the fourteenth-century renovation of the basilica was part of a vast program of institutional and historical construction meant to give more solid ground and a clearer sense of trajectory to the Venetian community and government during difficult times.

The primary narrative function of St. Mark's ring is to prove the historical reality of a miraculous event. Thus the object operates both *at* and *as* the threshold between extraordinary and normal, supernatural and natural, and—crucially—as the point of contact between historical and atemporal. The ring is not, in other words, a mere historical source. Instead, it is a piece of historical evidence that testifies to the irruption of the divine within history, thus conjoining the temporal with the eternal and posing questions about how these two realms relate to each other. The conceptual tension between history and eternity, and the ambivalent status of religious artworks and images as objects suspended between these two temporal realms, is central to our understanding of the art of San Marco in the mid-fourteenth century, when the ongoing crisis sparked a novel interest in history, eternity, and the trajectory of human salvation.

A Perfect Storm?
Contextualizing the Fourteenth-Century Renewal of San Marco

Between its early medieval foundation and the loss of its independence in 1797, Venice lived through several challenging historical conjunctures. Nonetheless, the metaphor of a "perfect storm" is a particularly appropriate descriptor of Andrea Dandolo's reign (r. 1343–1354), which the Venetian historian Marino Sanudo, writing at the turn of the sixteenth century, tersely summarized as follows: "During his time [as doge], war, plague and famine were almost incessant."[4] Subscribing to Sanudo's view,

2 V. Lazzarini, "Marino Faliero: La congiura," *NAVen* 13 (1897): 5–108, 277–374; V. Lazzarini, *Marino Faliero: Avanti il dogado, la congiura, appendici* (Florence, 1963); G. Ravegnani, *Il traditore di Venezia: Vita di Marino Falier doge* (Bari, 2017).

3 The ring is mentioned in the 1325 inventory of the treasury, in a rubric added in 1336: "1336. We ordered that a balas ring that belonged to St. Mark the Evangelist be placed inside a crystal corporal, mounted with gold and silver" (*1336. Habemus anulum unum balaxii qui fuit beati Marci Evangelistae positum in uno corporale cristali fulcito auro et argento*). See R. Gallo, *Il tesoro di S. Marco e la sua storia* (Venice, 1967), 279, and 101–3 for a discussion of the object. The ring has survived, within a crystal reliquary. Both may be attributed to the late thirteenth or early fourteenth century. See H. R. Hahnloser, ed., *Il tesoro di San Marco*, vol. 2, *Il tesoro e il museo* (Florence, 1971), 161–62, no. 158. As mentioned above, the legend indicates that the ring had been in the treasury before 1340 and that St. Mark himself had lifted the jewel from the basilica to hand to the fisherman.

4 Sanudo, *Vitae ducorum* 628: *In questo suo tempo, sempre quasi fu guerra, peste e carestia.* The sentence concludes Andrea Dandolo's biography. Sanudo began writing the *Vitae ducorum* in 1493 and reworked this vast opus until 1530; see M. Melchiorre, "Sanudo, Marino il Giovane," *DBI* 90 (2017), with

modern scholarship has frequently remarked that the central decades of the fourteenth century were a period of acute environmental, geopolitical, and institutional transition for the city. In the next pages, I engage with this literature, considering the international challenges that Venice faced during Dandolo's dogate, the severe environmental events (an earthquake and the plague) that struck the city in the same years, and the longer-term social and political transformations that took place in Venice during the century's central decades. This survey will more accurately situate the artistic renewal of San Marco within its sociopolitical, institutional, and cultural context, thus laying the groundwork for the methodological section that will follow. The complex circumstances under which the San Marco projects were created and viewed invite us to revisit conventional readings of those artistic commissions as (exclusively) the visual expression of Venetian triumphant ideology and stimulate us to enrich the set of questions and approaches that we call upon to study San Marco and to investigate artistic interaction and cultural identity in Venice, Byzantium, and the broader Mediterranean.

VENICE, BYZANTIUM, AND THE MEDITERRANEAN IN THE FOURTEENTH CENTURY

During the summer of 1343, shortly after Dandolo's election to the ducal seat, the Venetian government conceded a substantial loan to Anna of Savoy, regent to the Byzantine emperor John V Palaiologos. The loan was in all likelihood intended to sustain the heavy cost of the war of succession that was ongoing in Byzantium. The conflict lasted from 1341 to 1347, with dire financial consequences for the Eastern Roman Empire. The competitors for the throne were Anna's young son John V, on one side, and on the other John VI Kantakouzenos, chief advisor of Anna's late husband Andronikos III Palaiologos. The empress, who sided with her son, had requested from Venice the hefty sum of 30,000 gold ducats, which she had pledged to pay back with interest within three years. As security against the loan, Anna of Savoy offered no less than the

Byzantine crown jewels. The latter were sent to Venice, and once there dutifully deposited in the treasury of San Marco. The empire failed to pay the loan back by the agreed term, and this initiated a long chain of political negotiations that lasted until the fall of Constantinople in 1453 (at which time the valuables were still in Venetian hands), and which generated protracted controversy over possession of the island of Tenedos.[5] Aside from its specific outcome, this episode eloquently expresses the complexity and fluidity of Mediterranean power networks and the interconnectedness between diplomacy and public economies in the late medieval Mediterranean. It bears witness to Venice's ingenious maneuvering of financial and diplomatic leverage to pursue its colonial ambitions, but also evinces the risks and heavy losses that the republic faced in the process. Finally, it exposes the severity of political turmoil in Byzantium, the extent to which foreign powers could encroach on the empire's internal affairs, and the degree to which Latin polities were affected by Byzantine politics and policies in their turn. Collectively, these observations stimulate us to reexamine the meanings of Byzantine art and visual language in fourteenth-century Venice beyond simplistic ideas of triumph and emulation. At this time, the Byzantine Empire was greatly diminished and could no longer provide the paradigm of political and territorial might that it had offered its Latin conquerors in 1204. In addition, relations between Venice and Byzantium were highly volatile in the trecento, as both polities continuously renegotiated their positions on the international scene.

5 The most detailed discussion of this episode is in T. Bertelè, "I gioielli della corona bizantina dati in pegno alla Repubblica Veneta nel sec. XIV e Mastino II della Scala," in *Studi in onore di Amintore Fanfani* (Milan, 1962), 2:89–177. On the Byzantine civil war and on John VI Kantakouzenos's reign, which overlapped with Andrea Dandolo's dogate, see D. M. Nicol, *The Last Centuries of Byzantium: 1261–1453*, 2nd ed. (Cambridge, 1993), 185–250; D. M. Nicol, *The Reluctant Emperor: A Biography of John Cantacuzene, Byzantine Emperor and Monk, c. 1295–1383* (Cambridge, 1996); and D. M. Nicol, *Byzantium and Venice: A Study in Diplomatic and Cultural Relations* (Cambridge, 1988), esp. 246–63. Attractively though conjecturally, Henry Maguire has suggested that the acquisition of the Byzantine crown jewels may have prompted the redecoration of the south wall of the treasury of San Marco: H. Maguire, "The South Façade of the Treasury of San Marco," in *San Marco: La basilica di Venezia; Arte, storia, conservazione*, ed. E. Vio (Venice, 2019), 1:123–29.

extensive bibliography, https://www.treccani.it/enciclopedia /marino-marin-il-giovane-sanudo_(Dizionario-Biografico)/.

In this context, binary understandings of artistic borrowing as the manifestation of one-to-one power relations between Byzantium and Venice appear unconvincing. Instead, the selective and nuanced recourse to Byzantine artifacts, iconographies, and visual forms in the projects of renewal of San Marco in the trecento demands to be situated more precisely against the complex political and religious matrix of the period, and considered in relation to the different religious and political needs that each of Dandolo's campaigns was designed to address.

The Venetian loan (and the Byzantine civil war that underpinned it) intersected another key geopolitical development: the Ottoman expansion in the eastern Mediterranean and the renewed efforts on the part of Christian polities to counter it. The papacy had long promoted the reestablishment of an international Christian League against the infidels, and a Christian coalition had already operated in the previous decade, for a time under direct Venetian leadership. While the military consortium had gained support from several polities (including the Byzantine Empire) in its earlier incarnation, Venice, Cyprus, and the Knights of Rhodes, whose territorial and commercial interests were most directly threatened, were the only states to participate in its second instantiation. The anti-Ottoman league was rather ineffectual—its chief achievement being the capture of the port city of Smyrna (İzmir) in 1344—and was dissolved in 1351, when Venice was compelled to turn all its military might against its chief rival, Genoa.[6] Even so, the advance of Ottoman forces in the eastern Mediterranean remained a key concern for Venice, ushering in a new phase of cooperation between Latin powers and the "schismatic" Byzantine crown and reinvigorating (wishful) ideas of Christian solidarity and unity-in-difference that lingered in Europe long after the formal dissolution of the military coalition. Although the impact of unionist

agendas on fifteenth-century art has long been the object of scholarly focus,[7] the ways in which ideas about a Christian ecumene may have informed the visual arts of the fourteenth century remain understudied.[8] This invites us to consider the ambivalent attitudes of reciprocal hostility and brotherhood among fellow Christians across the Mediterranean in our analysis of the trecento visual cycles of San Marco.

Despite the importance of Ottoman progress in the East, Venice's principal concern lay elsewhere. Between 1256 and 1380, the republic was enmeshed in intermittent wars against Genoa, as both cities strove to expand and consolidate their commercial and territorial claims in the eastern Mediterranean. The struggle between the two sea powers alternately took the form of open military confrontation, commercial war, and diplomatic scheming, drawing numerous other principalities, including Byzantium, to join the fray and causing ceaseless geopolitical realignments throughout the fourteenth century.[9] From 1350 to 1355, just as

6 For an introduction to the activities of the Christian League in the mid-fourteenth century, see P. Edbury, "Christians and Muslims in the Eastern Mediterranean," in *NCMH* 6:864–84. For more details, see K. M. Setton, *The Papacy and the Levant (1204–1571)*, vol. 1, *The Thirteenth and Fourteenth Centuries* (Philadelphia, 1976), esp. 177–223. See also M. Carr, *Merchant Crusaders in the Aegean, 1291–1352* (Martlesham, 2015), esp. 63–78.

7 M. Vassilaki, "Painting Icons in Venetian Crete at the Time of the Council of Ferrara/Florence (1438/1439)," *IKON* 9 (2016): 41–52. On the earlier history of the iconography of the embrace between Peter and Paul, see H. L. Kessler, "The Meeting of Peter and Paul in Rome: An Emblematic Narrative of Spiritual Brotherhood," *DOP* 41 (1987): 265–75. On the Council, see J. Gill, *The Council of Florence* (Cambridge, 1959); J. Gill, *Personalities of the Council of Florence: And Other Essays* (New York, 1965). The response of Italian Renaissance artists to the arrival of the Byzantine delegations has drawn much scholarly attention. For an introduction, see R. S. Nelson, "Byzantium and the Rebirth of Art and Learning in Italy and France," in *Byzantium: Faith and Power (1261–1557)*, ed. H. C. Evans (New York, 2004), 515–23, and the catalogue entries that follow Nelson's essay.

8 For an introduction, see A. E. Laiou, "Marino Sanudo Torsello, Byzantium and the Turks: The Background of the Anti-Turkish League of 1332–1334," *Speculum* 45.3 (1970): 374–92; W. Caferro and D. G. Fisher, eds., *The Unbounded Community: Papers in Christian Ecumenism in Honor of Jaroslav Pelikan* (New York, 1996); and G. Christ et al., *Union in Separation: Diasporic Groups and Identities in the Eastern Mediterranean (1100–1800)* (Rome, 2015). See also C. J. Hilsdale, *Byzantine Art and Diplomacy in an Age of Decline* (Cambridge, 2014), who includes unionism and its repudiations in her analysis of Byzantine diplomacy between the thirteenth and fifteenth centuries.

9 An informative introduction to the conflict is M. Balard, "La lotta contro Genova," in *Storia di Venezia: Dalle origini alla caduta della Serenissima*, vol. 3, *La formazione dello stato patrizio*, ed. G. Arnaldi, G. Cracco, and A. Tenenti (Rome, 1997), 87–126. The standard reference works on the involvement of the two sea powers in the East are M. Balard, *La Romanie génoise, XIIᵉ–début du XVᵉ siècle* (Rome, 1978); and

work on the baptistery and chapel of Sant'Isidoro in San Marco was under way, Venice and Genoa resumed open war, fighting a series of ferocious naval battles in the Aegean Sea and off the coast of Sardinia. In 1354, the year of Dandolo's death and of the completion of the baptistery, the Venetian commander Niccolò Pisani attempted to provoke Genoa into a battle off the island of Chios and was subsequently defeated at Porto Longo, off the southern coast of the Peloponnese, before the two maritime powers, exhausted by their prolonged military efforts, signed a truce in 1355.[10]

The war between Genoa and Venice was a matter of pressing concern for all Mediterranean principalities. The papacy attempted to persuade the two powers to cease fire.[11] And Petrarch, Andrea Dandolo's close acquaintance, sent several pleas for peace to the doge, first as a private citizen and then, more formally, as diplomatic envoy.[12] The doge's response to one of Petrarch's missives, written shortly after the resumption of war, is revealing of Venetian sentiments toward the enemy:

> We have waged war so that it will be clear that we seek nothing but an honorable peace for our homeland, which is dearer to us than our own life; and while we would act arrogantly and violently if we rejected (peace with) an enemy that was placated and submissive, we have no reluctance in endorsing a war against those who could not hold peace in lesser regard.[13] (Venice, 22 May 1351)

Dandolo's letter is a masterpiece of official rhetoric, simultaneously voicing the distress that accompanied the government's decision to wage war, the indignation against the rival city, cast as an enemy of peace, and the patriotic stance of the doge, who specifically invokes the "homeland" (*patria*) in his text.[14] As a literary rendition of the conflict between Genoa and Venice, the epistle invites us to reflect on how the war with Genoa was brokered by the Venetian government to the civic community. In addition, it prompts us to consider how the same conflict may have structured contemporary Venetian understandings of patria—that is, what Venice was, and what it meant to be Venetian. This is a productive perspective from which to look at the artistic renewal of San Marco. To what extent do Dandolo's projects bear the trace of Venice's antagonism against Genoa? And to what degree do they illuminate Venice's claims as a Mediterranean power, and the transformation of its public image as it established and consolidated its presence abroad?

The war with Genoa was not the only military effort that Venice engaged in during the trecento. Traditionally inclined toward military neutrality and intense diplomatic activity, Venice became involved in a growing number of military confrontations in the fourteenth century as it endeavored to stabilize and expand its presence both internationally and locally. At the regional level, the relations between Venice and the Italian mainland were gradually but significantly transformed at this time. The protection of Venice's commercial interests, including its monopoly over the trade of salt, and its access to important fluvial and land routes generated increasing tensions with the urban centers of northern Italy, leading to clashes with Padua (1304–1305), Ferrara (1308–1313), and Verona (1336–1339). The latter conflict concluded with Venice's annexation of the city of Treviso (1339), the first noteworthy territorial conquest on the Italian mainland, and with the establishment of an informal protectorate over Padua

F. Thiriet, *La Romanie vénitienne au Moyen Age: Le développement et l'exploitation du domaine colonial vénitien, XIIᵉ–XVᵉ siècles* (Paris, 1959).

10 V. Lazzarini, "La battaglia di Porto Longo nell'isola di Sapienza," *NAVen* 8.1 (1894): 5–45.

11 E. Deprez and G. Mollat, eds., *Clément VI (1342–1352): Lettres closes, patentes et cuiales, intéressant les pays autres que la France* (Paris, 1960), 2:291, no. 2107, dated 24 November 1349.

12 On the relationship between Dandolo and Petrarch, see L. Lazzarini, "'Dux ille danduleus': Andrea Dandolo e la cultura veneziana a metà del Trecento," in *Petrarca, Venezia e il Veneto*, ed. G. Padoan (Florence, 1976), 123–56.

13 *Bellum ita suscepimus ut nihil aliud quam pacem honorabilem patrie, que vita nostra nobis est carior, querere videamur, et quemadmodum superbe ac violenter nos agere si aspernemur placatum cedentemque hostem, sic nunc, cum prope confractum resistentem ac tergiversantem traxerimus, nulla verecundia sumus obstricti si bella hos contra permittimus qui pacem pati minime potuerunt.* G. Arnaldi, "Andrea Dandolo doge-cronista," in *Cronache e cronisti dell'Italia comunale* (Spoleto,

2016), 165–298, at 285. Unless otherwise stated, translations into English are mine.

14 On the notion of patria in the Middle Ages, see G. Post, *Studies in Medieval Legal Thought: Public Law and the State 1100–1322* (Princeton, NJ, 2015), 435–52. See also E. H. Kantorowicz, "*Pro patria mori* in Medieval Political Thought," *AHR* 56.3 (1951): 472–92.

(1337–1356), which Venice exercised through the appointment of the city's *podestà*. Combined with the increasing landed interests of Venice's patrician class, these events inaugurated a new, expansionist phase in Venice's policy toward the terraferma. Paused in the central decades of the trecento, when the war against Genoa, multiple rebellions in the colonies, and the need to confront the Ottomans were of more pressing concern, the enlargement of Venice's possessions on the mainland resumed in earnest in the early fifteenth century, when Venice came to control much of the northeastern portion of the Italian peninsula.[15]

Similar questions emerge from consideration of Venice's efforts to expand and consolidate its possessions overseas. Safe navigability of the Adriatic Sea was crucial to the survival of the republic and its maritime trade. Thus, beginning in the tenth century, Venice had endeavored to control the coastal cities of Dalmatia and Croatia, which it subdued in the eleventh and twelfth centuries, respectively, and which provided Venetian merchant vessels with safe harbors and arsenals along the route to the Levant. In the mid-fourteenth century, Venice's grip on the eastern Adriatic coast was challenged by local aristocracies, whose interests often clashed with those of the capital, and by neighboring states, particularly Angevin Hungary, that also aimed to extend their control over the wealthy merchant ports of the region. During Andrea Dandolo's dogate, the government was confronted with two violent uprisings in Dalmatia. In 1345, the city of Zadar revolted with the support of Angevin Hungary, opening a conflict that would last until the following year. A few years later, in 1348, Koper also briefly rebelled, taking advantage of Venice's state of emergency during the plague. In both cases, Venice responded with hard-hitting military actions and brought the two cities under submission again until 1358. That year, Venice lost most of its Dalmatian colonies and protectorates to the Hungarian kingdom, from which the republic would nevertheless definitively regain them in the early fifteenth century.[16]

Venice's efforts to consolidate its commercial presence and territorial control overseas were not confined to Dalmatia. In 1351, during Andrea Dandolo's dogate, Venice purchased from the Byzantine Empire the islands of Kerkyra and Kefalonia, and the city of Butrint on the coast. The acquisition of these territories was highly strategic, as it reduced the distance between Venice's southernmost possessions in Dalmatia and the city's strongholds in the Peloponnese, Methone and Korone. The actual takeover of the new Ionian territories was significantly delayed, however, by the conflict with Genoa, and only came into effect in 1386. Meanwhile, Venice also continued to be intensely engaged in the Aegean, whose geopolitical instability matched its strategic importance.[17] There, Venice negotiated its presence amid piratical raids, growing Catalan, Genoese, and Ottoman military ambitions and frequent political and social unrest in the colonies. In response to these challenges, Venice gradually developed a more integrated approach to defending and administering its possessions, combining intense diplomatic activity with armed interventions to further extend its hegemony in the area. The fourteenth-century history of the city of Negroponte and the island of Euboea provides an eloquent example of Venice's Aegean policies at this time.[18] Venice had acquired a quarter

15 For a detailed introduction and extensive references, see G. M. Varanini, "Venezia e l'entroterra (1300 circa–1420)," in Arnaldi, Cracco, and Tenenti, *Storia di Venezia*, 3:159–236.

16 This account is largely based on B. Krekic, "Venezia e l'Adriatico," in Arnaldi, Cracco, and Tenenti, *Storia di Venezia*, 3:51–85.

For a coeval account of the rebellion of Zadar in 1345, seen from the Venetian perspective, see G. Ortalli and O. Pittarello, eds., *Cronica Jadretina: Venezia-Zara, 1345–1346* (Venice, 2014). The chronicle is likely to have been composed by Dandolo's chancellor Benintendi Ravegnani. On the uprising of Koper, see G. Cesca, *La sollevazione di Capodistria nel 1348: 100 documenti inediti* (Verona, 1882). For a recent reappraisal of the relations between Venice and the eastern Adriatic coast, see U. Israel and O. J. Schmitt, eds., *Venezia e Dalmazia* (Rome, 2013).

17 Literature on the late medieval history of the Aegean is ever growing. Reference works include P. Lock, *The Franks in the Aegean, 1204–1500* (London, 1995); M. Balard, "Latins in the Aegean and the Balkans in the Fourteenth Century," in *NCMH* 6:825–38; Carr, *Merchant Crusaders*. David Jacoby has written several studies on the subject: see, for example, D. Jacoby, "The Eastern Mediterranean in the Later Middle Ages: An Island World?," in *Byzantines, Latins, and Turks in the Eastern Mediterranean World after 1150*, ed. J. Harris, C. Holmes, and E. Russell (Oxford, 2012), 93–118.

18 For a detailed discussion of the history of the island under Venetian rule, see S. Borsari, *L'Eubea veneziana* (Venice, 2007). See also D. Jacoby, "La consolidation de la domination de Venise dans la ville de Négrepont (1205–1390): Un aspect de sa politique coloniale," in *Bisanzio, Venezia e il mondo franco-greco (XIII–XV secolo): Atti del colloquio internazionale organizzato*

within the urban precincts of Negroponte, on the eastern coast of Greece, as early as 1211. The city—which overlooked Euboea and was separated from it by a narrow isthmus and bridge—functioned as a vibrant commercial and banking entrepôt and as a key transit station between Venice, Constantinople, and the Black Sea. Venice did not seek to further extend its possessions in the area until the 1340s, but it closely scrutinized local political developments and intervened twice (in 1317 and 1327) to foil Catalan attempts to capture Euboea. In 1342, the year before Andrea Dandolo's election, Venice finally seized an opportunity to acquire the castle of Larmena (Armena), in the southern part of the island. This was followed by Karystos, which the Venetian government obtained from its Aragonese ruler in 1359. By 1390, Venice had brought the remaining portions of the island under its rule and would control Euboea until it was eventually conquered by the Ottomans in 1470.[19]

If the city's colony of Negroponte significantly facilitated Venetian navigation toward Constantinople and the Black Sea, the republic's commercial interests in the eastern Aegean and the maintenance of its trade networks with Cyprus, Syria, and the Turkish coast relied heavily on the island of Crete, Venice's oldest and longest-lived colony. Venice had formally annexed Crete in 1207, taking actual possession of the island a few years later. By the late thirteenth century about four thousand Venetian citizens, both patricians and commoners, had relocated to Crete. The republic gave Venetian patricians generous landed privileges, in exchange for their military and financial support as well as for manpower for the defense of Venice's overseas possessions in the Aegean. So long as the capital's

requests remained proportionate to the privileges conceded to settlers, Venice could rely on its feudatories' loyalty. Venetian settlers also offered the capital active support against any attempts on the part of the local Greek aristocracy—intolerant of the new regime, which had largely deprived them of property and political rights—to destabilize the government. This fragile balance was threatened in the central decades of the fourteenth century, resulting in a violent rebellion against the capital led jointly by Venetian settlers and Greek forces in 1363.[20] While a discussion of St. Titus's revolt (as Crete's rebellion came to be known) falls outside of the scope of this study, the tensions that led to it developed in the period covered in our analysis, adding to the institutional instability and complexity that dominated Andrea Dandolo's dogate and may have informed the visual programs of his artistic campaigns in San Marco. In 1345, the central government required Crete to contribute two vessels for the defense of the Christian stronghold of Smyrna, which the Anti-Ottoman League had recently reconquered. The following year, Crete was compelled to underwrite a significant financial subsidy to assist with the repression of the revolt of Zadar. Finally, the conflict between Venice and Genoa entailed burdensome requests for money, vessels, and men just as Crete tried to recover from the losses and strain that had ensued from the 1348 plague.[21]

As Venice's territorial conquests grew in number and complexity, so inevitably did the variety of its visual landscape. Venice's increasing diplomatic and political engagement with the neighboring cities of the Italian mainland translated into intense artistic exchanges between the lagoon and the coasts of the Adriatic. In turn, many of Venice's eastern colonies had formerly belonged to the Byzantine Empire, or to areas under Byzantine influence, and Byzantine art, in its many local variants, represented the prevailing local visual idiom. How did the social, religious,

nel centenario della nascita di Raymond-Joseph Loenertz O.P., Venezia, 1–2 dicembre 2000, ed. C. A. Maltézou and P. Schreiner (Venice, 2002), 151–87. On Venetian-built heritage in the Aegean, see now N. D. Kontogiannis and S. S. Skartsis, *Venetian and Ottoman Heritage in the Aegean: The Bailo House in Chalcis, Greece* (Turnhout, 2020).

19 D. Jacoby, "The Demographic Evolution of Euboea under Latin Rule," in *The Greek Islands and the Sea: Proceedings of the First International Colloquium Held at the Hellenic Institute, Royal Holloway, University of London, 21–22 September 2001*, ed. J. Chrystomides, C. Dendrinos, and J. Harris (Camberley, 2004), 131–80, at 132–34. See also Jacoby, "The Eastern Mediterranean," 98–99.

20 S. Mckee, "The Revolt of St. Tito in Fourteenth-Century Venetian Crete: A Reassessment," *Mediterranean Historical Review* 9.2 (1994): 173–204.

21 Literature on Venetian Crete is vast and ever growing. This paragraph is largely based on F. Thiriet, "Sui dissidi sorti tra il comune di Venezia e i suoi feudatari di Creta nel Trecento," *AStIt* 114.4 (1956): 699–712.

and political stratification of Venice's colonies inform the ways in which art was made and viewed in the capital? And how does it affect our understanding of artistic borrowing and visual diversity in San Marco? These issues will be at the heart of the next chapters. Before turning to them, however, it is useful to survey other events that may have informed how art was made and viewed in Venice in the mid-trecento.

AN EARTHQUAKE AND
THE PLAGUE IN VENICE, 1348

Opening with a severe earthquake, and continuing with a plague epidemic, 1348 was a challenging year. The earth tremor occurred on 25 January: centered in the town of Villach (now in Austria), it affected both Venice and the mainland. Contemporary sources report significant damage to several churches, including San Silvestro, San Giacomo all'Orio and San Vitale, Sant'Angelo, and San Basilio.[22] Evidently, this seismic event left a mark on Venetian public memory, for an inscription, written in the vernacular, was set up above the portal of the Scuola Grande della Carità to memorialize it. Alongside other information, the text states that the earthquake "caused such fright that almost everybody thought they would die, and the earth kept trembling for about forty days," and that a terrible epidemic (the plague) started immediately after.[23]

The significance of the Black Death in shaping late medieval economic, political, and cultural realities and imagination has generated steady scholarly debate. As a consequence, our knowledge of Venetian experience of the plague is reasonably detailed. The plague struck the city with extraordinary violence during the first quarter of 1348. The first official record mentioning the epidemic dates from 30 March, when the

Great Council appointed an advisory committee to organize and coordinate the city's public health response.[24] The Council reconvened on 3 April, when it heard and ratified the containment measures recommended by the three advisors. The need to dispose quickly and hygienically of infected corpses was of the utmost concern. Physical exposure of the deceased to public piety and prayers was forbidden. In addition, it was ordered that the bodies of those who died in hospices, or could not afford to pay for their own burial, should be removed from the city at public expense and buried in the remote localities of San Leonardo Fossamala and San Marco Boccalama (present-day Motte di Volpego), where a team of undertakers and priests ensured that mass graves were sufficiently deep to ensure public safety and that corpses were blessed before burial. When these areas reached full capacity, Sant'Erasmo and San Martino di Strada were also repurposed as cemeteries.[25] These provisions exclusively concerned the less affluent components of the Venetian social body. Everyone else continued to be buried within the precincts of the city. Anxious about disease transmission, the authorities ordered that all urban graves should be at least five feet deep, and that additional sand be excavated from nearby canals and brought to the cemeteries.[26] The Venetian government also acted quickly to prevent disease transmission. With the exception of ambassadors, no Venetian or foreign travelers infected with the plague were allowed entry into the city. Private and public carriers who contravened the ban were severely punished: the former were imprisoned for a month and had their vessels burned; the latter were also imprisoned and lost their jobs with the public transport authority. Every vessel that reached Venice from affected areas was to be carefully examined, and anyone who had contracted the illness was denied entry.[27] Taverns were largely closed throughout

22 F. Manzano, ed., *Annali del Friuli, ossia Raccolta delle cose storiche appartenenti a questa regione* (Udine, 1858–79), 5:55.

23 "E fo sì gran spave(n)to che quaxi tuta la çe(n)te pensava d(e) morir e no st(e)te / la tera de tremar cerca dì XL. ..." The long epigraph, which is still in situ, is transcribed in full and discussed in A. Stussi, "La Lingua," in Arnaldi, Cracco, and Tenenti, *Storia di Venezia*, 3:911–32. The earthquake and its effects in modern Veneto, Friuli, and Austria are discussed, with maps and extensive further references, in C. Hammerl, "The Earthquake of January 25th, 1348: Discussion of Sources," EC Project RHISE (1989–1993), https://emidius.mi.ingv.it/RHISE/ii_20ham/ii_20ham.html.

24 The following account is primarily based on M. Brunetti, "Venezia durante la peste del 1348," *Ateneo Veneto* 32.1 (1909): 289–311; and M. Brunetti, "Venezia durante la peste del 1348," *Ateneo Veneto* 32.2 (1909): 5–42. Both include extensive archival references. See also A. Tenenti, "Le 'temporali calamità,'" in Arnaldi, Cracco, and Tenenti, *Storia di Venezia*, 3:27–49.

25 Brunetti, "Venezia durante la peste," 291–94.

26 Brunetti, "Venezia durante la peste," 293.

27 Brunetti, "Venezia durante la peste," 294–95.

the city, and the sale and consumption of wine on the street was also forbidden.[28]

In addition to representing a serious threat to the survival of its citizens and the exercise of its trading activities, the 1348 epidemic had dire consequences for Venice's public finances, as the state faced shrinking revenues and incurred additional expenses to manage the plague. The government responded with a series of austerity measures to reduce the deficit. It merged a number of administrative bureaus, rationalizing their functions. It reduced the salaries of ambassadors and select categories of civil servants. It undertook an aggressive policy of migration replacement. And it discontinued the renovation of the ducal palace—which had been under way since 1340—dismissing workers, architects, and managers employed on the project.[29] The Black Death, and the social and cultural trauma it caused, represented recent and vivid memories for the Venetian community and government at the time when the baptistery and chapel of Sant'Isidoro were decorated. In turn, this prompts us to consider whether and how memories of the Plague informed the design of the new mosaic programs, and their reception on the part of Venetian viewers.

REFORMING THE STATE IN THE AFTERMATH OF THE SERRATA

In addition to being confronted with increasing geopolitical volatility overseas, Venice tackled significant domestic social and political changes in the trecento, in the wake of the Serrata of the Great Council. These changes, which led to a gradual separation of the Venetian elite from the city's citizen class, affected Venetian patterns of patronage, particularly in the public sphere. In addition, as the structures of Venice's government changed, so did the ways in which political rule and the exercise of government were represented, both conceptually and visually. The complex interactions between aesthetics and politics in San Marco are an overarching concern of this book. In order to situate them more accurately, it is paramount to consider Venice's institutional

transformations throughout the fourteenth century in some detail.

The Serrata—one of the most debated events in Venice's political history—began in 1297 and comprised a series of legislative acts that during the following decades permanently changed the criteria of eligibility and procedures of admission to Venice's Great Council, (re)defining and stabilizing the contours of the Venetian ruling class and its patriciate.[30] Simultaneously, the Great Council was also transformed into the chief organ of government: gradually, the appointment of all public officers came to be voted by the Council, and individual candidates for public office were generally chosen from within the ranks of the Great Council itself.[31]

This process of social and political reform only reached completion in the fifteenth century. By then, eligibility to the Great Council had been transformed into a hereditary right, and governing had become the appanage of a well-defined and stable cluster of families, which coincided with Venice's nobility. Eligibility to the Council had also become a standard criterion for discriminating between patricians—the ruling elite—and members of Venice's other social groups, citizens, and lower commoners, who did not directly

28 Brunetti, "Venezia durante la peste," 295–97.

29 Brunetti, "Venezia durante la peste," 299–311, with archival references.

30 Reference works on the Serrata include M. Merores, "Der Große Rat von Venedig und die sogenannte Serrata vom Jahre 1297," *Vierteljahrschrift für Sozial- und Wirtschaftsgeschichte* 21.1/2 (1928): 33–113; G. Cracco, *Società e stato nel medioevo veneziano: Secoli XII–XIV* (Florence, 1967), esp. 331–50; F. C. Lane, "The Enlargement of the Great Council of Venice," in *Florilegium Historiale: Essays Presented to W. K. Ferguson*, ed. J. G. Rowe (Toronto, 1971), 237–74; S. Chojnacki, "In Search of the Venetian Patriciate: Families and Factions in the Fourteenth Century," in *Renaissance Venice*, ed. J. R. Hale (London, 1973), 47–90; G. Ruggiero, "Modernization and the Mythic State in Early Renaissance Venice: The Serrata Revisited," *Viator* 10 (1979): 245–56, which also usefully summarizes the main terms of scholarly debates; G. Rösch, *Der venezianische Adel bis zur Schließung des Großen Rats: Zur Genese einer Führungsschicht* (Stuttgart, 1989); S. Chojnacki, "La formazione della nobiltà dopo la Serrata," in Arnaldi, Cracco, and Tenenti, *Storia di Venezia*, 3:641–725; G. Rösch, "The Serrata of the Great Council and Venetian Society, 1286–1323," in *Venice Reconsidered: The History and Civilization of an Italian City-State, 1297–1797*, ed. J. Martin and D. Romano (Baltimore, 2000), 67–88. A collection of highly useful primary sources has now been published in B. G. Kohl and R. C. Mueller, "The Serrata of the Greater Council of Venice, 1282–1323: The Documents," in *Venice and the Veneto during the Renaissance: The Legacy of Benjamin Kohl*, ed. M. Knapton, J. E. Law, and A. A. Smith (Florence, 2015), 3–34.

31 Ruggiero, "Modernization and the Mythic State," 246.

participate in the government of the republic.[32] The *cittadini* were in turn divided into two subsets: citizens by right of birth (*cittadini originari*) and naturalized citizens (*cittadini per privilegio*). Only the former group enjoyed special rights, including eligibility for employment in the state chancery, and for membership in Venice's *Scuole*.

This social and political structure was the result of a lengthy and contentious process of redefinition that unfolded in the fourteenth century. In 1297, it was established by law that everyone who had been a member of Venice's Great Council during the previous four years could reapply for membership. In addition, those who had not served on the Great Council during the previous four years but had nevertheless been members before then could also be reappointed. Candidates from this group were to be chosen by three electors, when the latter were asked to do so by the doge and his council. Nominees would then be voted on one by one by the *Quarantia* and considered approved if they received twelve votes.[33] This reform considerably enlarged the Great Council, both expanding and "locking" the Venetian political census. The overall direction of the reform was further clarified in 1298, when membership on the Council was transformed into a permanent appointment.[34] Initially, these guidelines were not primarily intended to discriminate between nobles and commoners, but, as has been argued, to co-opt individuals with proven experience of government and to ensure continuity in the composition of the ruling elite.[35]

Over the next decades, however, the criteria for access to public office became more restrictive. Simultaneously, efforts to distinguish between nobles (who were entitled to a seat on the Council) and commoners (who were not)

became more intense. In 1315, the minimum age for admission to the Council was set at eighteen, and eligible candidates were required to be registered with the *Quarantia*.[36] In 1317, the *Avogadori del Comun* (state attorneys) were given authority to investigate doubtful claims to noble status.[37] A few years later, in 1321, all members of Venice's aristocracy aged twenty-five and over were given a seat on and the right to vote in the Great Council.[38] By 1323, it was further established that only those men whose fathers and ancestors had been members of the Council were eligible for admission, effectively transforming the right to govern into a hereditary privilege.[39]

The standards for inclusion in Venice's ruling class also appear to have become more stringent after 1310, at the same time as the criteria for admission of new families and individuals to the Council grew stricter.[40] Nevertheless, public registers of patricians were not systematically produced until the following century—an indication that the procedures for assessing individual affiliation with different social groups were still in flux in the fourteenth century.[41] The dimensional and functional transformation of the Great Council also triggered a revision of the specific responsibilities and duties of different governing and administrative bodies. As Guido Ruggiero emphasizes, the Serrata inaugurated a comprehensive process of bureaucratic and institutional

32 On the legal category of "citizenship" and its gradually more precise formulation in the fourteenth and fifteenth centuries, see J. S. Grubb, "Elite Citizens," in Martin and Romano, *Venice Reconsidered*, 339–64; K. Petkov, *The Anxieties of a Citizen Class: The Miracles of the True Cross of San Giovanni Evangelista, Venice 1370–1480* (Leiden, 2014); and S. Chojnacki, "Political Adulthood in Fifteenth-Century Venice," *AHR* 91.4 (1986): 791–810.

33 Merores, "Der Große Rat von Venedig," 75–76, with archival references. See also Lane, "Enlargement," 254.

34 Lane, "Enlargement," 254–55.

35 Chojnacki, "La formazione della nobiltà."

36 Venice, Archivio di Stato di Venezia, Maggior Consiglio, *Deliberazioni*, Clericus-Civicus (1315–1318), fol. 58r. Cited in Rösch, "The Serrata," 86, n. 37. The same author suggests that this roster—which has not survived—may have represented an early predecessor of Venice's later registry of noble births, which was formalized in the sixteenth century into the so-called *Libro d'Oro*. A similar argument is advanced by Lane, "Enlargement," 258. However, this list registered applicants to the Council, rather than those admitted to it. S. Chojnacki, "Social Identity in Renaissance Venice: The Second *Serrata*," *Renaissance Studies* 8.4 (1994): 341–58, at 345.

37 ASV, Maggior Consiglio, *Deliberazioni*, Clericus-Civicus (1315–1318), fol. 121v. Cited in Rösch, "The Serrata," 75, n. 39.

38 Rösch, "The Serrata," 75.

39 Lane, "Enlargement," 258; and Rösch, "The Serrata," 75, with archival references. See also Merores, "Der Große Rat von Venedig," 79–81; and Kohl and Mueller, "Serrata of the Greater Council," 31–32, no. 28, for an edited version of the document of 1323.

40 Ruggiero, "Modernization and the Mythic State," 248; and Lane, "Enlargement," 260.

41 Chojnacki, "Social Identity," esp. 345–48; and Chojnacki, "La formazione della nobiltà."

reorganization that lasted for the better part of the century, and that was considerably accelerated during Andrea Dandolo's dogate.[42] In turn, this prompts us to examine whether these sociopolitical transformations affected public patronage in San Marco, and to investigate the ways in which the imagery of the basilica reflected ongoing political and institutional change.

(RE)DEFINING THE RULER

As the question "who should rule, and how?" became more pressing, the status and functions of the doge, Venice's head of state, also came under close scrutiny. This has crucial implications for our understanding of the fourteenth-century visual programs of San Marco, each of which included prominent visual and textual representations of the doges in their different capacities: as military leaders, patrons of the church of San Marco, and members of the Venetian government.

Initially appointed by popular acclamation, from the twelfth century on doges came to be designated by a group of electors, selected from among the members of the Great Council by means of an increasingly complex and lengthy procedure.[43] Once elected, the new doge was ritually presented to the Venetian community in the church of San Marco, where he was invested with the symbols of ducal power.[44] The history of ducal insignia is both complex and fraught with ambiguities.[45] However, it is often assumed that by 1130 the original attribute of ducal authority, the *baculus*—a pastoral or scepter evocative of sacramental power—had been replaced by the *vexillum Sancti Marci*. This banner, which the doge subsequently handed over to Venice's military chief, conjured the authority of the Venetian state rather than the personal power of the doge. It appears on the earliest known ducal lead seals, belonging to Pietro Polani and Domenico Morosini, as well as on most later seals and coinage.[46]

By norm, doges held office for life. However, they were civil servants. They were accountable to the Venetian state (from which they received a salary) and could be removed from office.[47] Starting from the late twelfth century, newly elected doges were also required to swear a formal oath of allegiance to the Venetian community, further indexing the submission of ducal authority to that of the rising communal government.[48] Known as the ducal *promissio*, this written oath clarified the doge's political, administrative, and judicial duties. The trajectory charted by these texts from the twelfth to the fifteenth century is one of progressively stricter limitations on ducal power. Such restrictions multiplied in the decades that followed the Serrata, when a team of *correttori* (reviewers) modified and augmented the text of the oath before the election of every new doge.[49] Upon his election in 1343, Andrea

42 Ruggiero, "Modernization and the Mythic State," 250–53.

43 On popular acclamation, see A. Pertusi, "Quaedam regalia insegne: Ricerche sulle insegne del potere ducale a Venezia durante il Medioevo," *StVen* 7 (1965): 3–124, esp. 65–66. The Great Council was formally established in 1172, and Sebastiano Ziani was the first doge to be elected by a group of magistrates from this Council. See E. Musatti, *Storia della promissione ducale* (Padua, 1888), 48. The number of ducal electors and the criteria for their selection changed over time. By the mid-thirteenth century, the electoral council comprised forty-one members. See Martino da Canale, *Les estoires de Venise: Cronaca veneziana in lingua francese dalle origini al 1275*, ed. A. Limentani (Florence, 1972), 356–57.

44 On the origins and early chronology of this ceremony, see Pertusi, "Quaedam regalia insignia," 68–69.

45 The reference works on this topic remain Pertusi, "Quaedam regalia insignia"; G. Fasoli, "Liturgia e cerimoniale ducale," in *Scritti di storia medievale*, ed. A. I. Pini, F. Bocchi, and A. Carile (Bologna, 1974), 529–61; and G. Fasoli, "Nascita di un mito," in Pini, Bocchi, and Carile, *Scritti*, 445–72.

46 Pertusi, "Quaedam regalia insignia," at 22–23, and at 26 for Domenico Morosini's (r. 1148–1156) lead seal, where the vexillum is more clearly visible. The same article claims (79–81) that the baculus did not disappear altogether but was subsequently carried in procession by the *iudex* (magistrate) to signify that judicial power had been transferred from the person of the doge to the judiciary. On ducal seals, see also G. C. Bascapè, "Sigilli delle repubbliche marinare," in *Sigillografia: Il sigillo nella diplomatica, nel diritto, nella storia, nell'arte* (Milano, 1969), 1:245–62.

47 Andrea Dandolo received 5,200 Venetian lire per year. Andrea Dandolo, *Promissione*, in *Andreae Danduli ducis Venetiarum chronica per extensum descripta: aa 46–1280 d.C.*, ed. E. Pastorello, *RIS*, n.s. 12.1 (Bologna, 1942), lxxix–cii, xci, n. 49. On the right to remove the doge from office, see below, n. 52.

48 The earliest surviving *promissio* is Enrico Dandolo's and dates from 1192. See G. Graziato, ed., *Le promissioni del doge di Venezia: Dalle origini alla fine del Duecento* (Venice, 1986). It is generally assumed that doges may have sworn oaths earlier during the twelfth century. For a full discussion and further references, see Pertusi, "Quaedam regalia insignia," 23–25, n. 60.

49 On the Serrata as a turning point in ducal history, see Graziato, *Le promissioni*, esp. xx; and Musatti, *Storia della promissione*, 68–69, who indicates that the earliest written record he could identify that specifically mentioned the "correttori" dated from 1311. However, on the same page, the author concedes that "five noblemen" entrusted with the preparation of the doge's

Dandolo undersigned a lengthy document that reveals the efforts of the ruling elite to scrutinize and control all aspects of ducal activity (see Fig. 6 for the frontispiece of the document). To mention but a few significant clauses, Dandolo pledged never to send legations or letters to the pope, to foreign sovereigns, or to any other parties on behalf of the Venetian commune unless he had obtained prior approval from the majority of his councilors.[50] He also swore that he would step down from office, and leave the ducal palace within three days, should he be required to do so by six members of the Minor Council and by the majority of the Great Council.[51] Significantly, he vowed never to summon the *arengo* (popular assembly) or any other public gatherings without the prior consent of both councils—not even when the assembly's agenda concerned solely the basilica of San Marco, of which the doge retained full patronage.[52]

Scholars have repeatedly emphasized how the growing restrictions imposed on ducal power in the later Middle Ages were paralleled by an amplification and specification of the ceremonial apparatus surrounding the ducal persona. Beginning with Francesco Dandolo's oath (1329), ducal *promissiones* came to include prescriptions about the *berretta*, the official headgear worn by the doge. At about the same time, the inventories of the treasury of San Marco—where the berretta was preserved together with other insignia of ducal power—provide some details about changes made to the headdress, including the addition of gemstones for increased dignity or the removal of decorations to make it more comfortable to wear.[53] At the same time as the doge's ceremonial uniform

was being regulated more explicitly, ducal appellations also stabilized. Simply referred to as *dux* in early medieval official documents, Venice's doges acquired over the centuries longer formal titles that reflected the city's territorial expansion. The ducal title reached its final articulation in 1206. In the aftermath of the Fourth Crusade, and until the loss of Dalmatia in 1358, the name of the ruler was accompanied in all diplomatic tracts by the following: "By the grace of God, doge of Venice, Dalmatia, and Croatia, [and] lord of one quarter and a half of the entire empire of Rome" (*Dei Gratia dux Venecie, Dalmatie atque Chroatie, dominus quarte partis et dimidie tocius imperii Romanie*). In contrast to the growing limitations imposed on the ducal office, this title suggests divine approval of the doge's authority. This contradiction expresses the doge's unique position, oscillating between the secular and charismatic realms. Thirteenth- and fourteenth-century protocols of ducal investiture and enthronement throw this dual nature of ducal authority into even sharper relief, offering a valuable framework of interpretation for our study of the portraits of doges on the high altar, in the mosaics of the chapel of Sant'Isidoro, and in the baptistery of San Marco. In addition, those textual accounts illuminate the specific significance of San Marco as the stage of ducal investiture, adding further meaning and complexity to the artistic renewal of the basilica—and particularly of the high altar—at this time.

Andrea Dandolo's promissio provides details about the ceremony to be followed for his investiture. After being elected, the new doge would be expected at the church of San Marco. The investiture would take place at the high altar, once the doge had solemnly vowed on the four Gospels to preserve the state and the honor of the church of San Marco, in good faith and without any fraud. Following the oath, the *primicerius* (high priest) of the basilica would invest the doge with the vexillum. Having received the banner, the doge would proceed to the ducal palace.[54]

This text accords well with Martino da Canale's account of Lorenzo Tiepolo and Jacopo Contarini's investiture ceremonies, respectively

oath were already referred to in a series of provisions of the Great Council, beginning in the mid-thirteenth century.

50 Dandolo, *Promissione*, lxxxvii, no. 29.

51 Dandolo, *Promissione*, xcii, no. 51.

52 Dandolo, *Promissione*, xciii, no. 53. This clause had already been included in ducal oaths in the mid-thirteenth century, but the doge had so far retained the right to summon the arengo for matters that pertained to the church of San Marco. Andrea Dandolo's oath no longer mentions this ducal prerogative. See Fasoli, "Liturgia e cerimoniale ducale," 552.

53 Pertusi, "Quaedam regalia insignia," 85–86; and Gallo, *Il tesoro di S. Marco* 193–98 (see above, p. 12, n. 3); changes to the ducal berretta are mentioned in several notes added to the 1325 inventory, published in the same volume.

54 Dandolo, *Promissione*, c–ci, no. 98.

FIGURE 6. Venice, Biblioteca del Museo Correr, cl. 3, 327, fol. 1r. Photo courtesy of the Fondazione Musei Civici di Venezia.

held in 1268 and 1275. His accounts provide us with other precious details. In his report of Contarini's accession, Canale informs us that while the ducal electors (appointed in the number of forty-one) assembled in the ducal palace to elect the new doge, the great chancellor addressed the Venetian community gathered in the church of San Marco. The chancellor elucidated the electoral procedures that would be followed and explained the oath of allegiance that the doge would be required to take, specifying that the ruler would have to comply with the Council's determinations and act on the basis of their advice. Once his speech was completed, a man was called upon to declare—on behalf of the entire community—that the Venetians would welcome the elected candidate as their doge.[55] During the following days, as the election was still in progress, the Venetian bishop summoned all members of Venice's religious communities, including the regular clergy and mendicant orders. Together with the primicerius and chaplains of the basilica, the members of the interim government, and the people of Venice, they processed to San Marco, where they prayed to Christ, the Virgin, and St. Mark that the Lord might give the community a doge who pleased him, and who could guarantee the well-being of the Venetian state.[56]

When the new doge was finally elected, preparations for the rituals of investiture began. The bells of San Marco rang, once again summoning the Venetian community to San Marco.[57] There the doge's electors congregated on the ducal pulpit, whence their spokesperson conveyed the group's gratitude to God, the Virgin, and St. Mark, in reason of their election of a wise, brave, and noble doge. Once the name of the new doge was announced, the congregation rejoined: "So be it! So be it!" (*Sia! Sia!*).[58] Immediately after, the doge was divested and

led to the altar, where the investiture proper unfolded in a manner similar to that described in Dandolo's promissio.[59]

Together, Andrea Dandolo's *promissio* and Martino da Canale's detailed description of the electoral procedures, both administrative and ceremonial, bear witness to the ambivalent nature of the ducal office and the room it left for new stipulations and reinterpretations of the status and function of the ruler. On the one hand, the doge became a magistrate with nearly no independent legislative or executive powers; on the other, the doge was the living image of the Venetian state, the guarantor of its authority and of the divine sanction upon which rested the legitimacy of the Venetian dominion. Canale's account sheds light on another relevant point. In addition to bringing into coherence the administrative and transcendental components of government—as scholars have routinely argued—the doge also represented the one Venetian institution that conciliated the ruling elite and the popular class, whose political rights and social status and responsibilities progressively diverged at this time. He was elected by the nobility, but his installation in office culminated in popular approval. He was a member of the aristocracy, and his authority was effectively subordinate to that of his (noble) councilors. Yet the ceremonies of ducal enthronement included key exchanges between the doge and the wider community—the doge's acclamation being foremost among them. Before the Serrata, representatives of all Venetian guilds appear to have paid

55 Canale, *Les estoires de Venise*, 357.

56 Canale, *Les estoires de Venise*, 361.

57 Canale, *Les estoires de Venise*, 280–81, with reference to the election of Lorenzo Tiepolo in 1268.

58 Canale, *Les estoires de Venise*, 363–65, with reference to the election of Jacopo Contarini. In his earlier description of Lorenzo Tiepolo's election (1268), Canale simply indicates that the doge was "acclaimed" (*loés*). Canale, *Les estoires de Venise*, 280–81.

59 Dandolo's promissio and Canale's text differ on one detail: the individual responsible for investing the doge with the vexillum of authority. Dandolo's promissio indicates that the primicerius of San Marco (the head of the basilica's clergy) was given this responsibility. If he were absent, then the chief chaplain was to take charge. Dandolo, *Promissione*, c, no. 98. In Canale's account of Lorenzo Tiepolo's installation (1268), the chaplain and vicar (*sic*) are both mentioned. In the same passage, the author also indicates that the doge would swear his oath before the Venetian community and that as he proceeded to the ducal palace he would pause on the palace's staircase to listen to the sung *laudes* that accompanied his election (Canale, *Les estoires de Venise*, 280–81). In his account of Jacopo Contarini's election, Canale indicates—rather intriguingly—that the doge "took" the vexillum (*il prist li confanon*); Canale, *Les estoires de Venise*, 364–65. On the history of the ducal *laudes*, see Pertusi, "Quaedam regalia insignia," 92–93. More broadly, on acclamations and the ducal persona, see the excellent essay by J. Reuland, "Voicing the Doge's Sacred Image," *The Journal of Musicology* 32.2 (2015): 198–245.

homage to the newly appointed ruler in the ducal palace, where they were invited to participate in a banquet that demonstrated the reciprocal bond between non-noble citizens and the doge.[60]

Aside from these subsidiary events, Canale's chronicle and Dandolo's promissio unanimously emphasize the significance of San Marco as the chief stage of these ceremonies, and the one site where all components of the Venetian community came together during the enthronement rituals. The administrative procedure for the doge's election is described as occurring inside the ducal palace, presumably behind closed doors, and we are given no specific information about it. Instead, the identity of the new doge was announced publicly in San Marco, before the entire Venetian community. In other words, it is inside the basilica that the new doge—until then just one magistrate among many—was invested with his extra-administrative functions. Immediately after his appointment as doge, Andrea Dandolo instigated the makeover of the high altar of the basilica, the focus of all ducal investitures. This project, as we will see in the relevant chapter, expresses coeval concerns about the nature of ducal authority and its specific role within the Venetian state. Similar concerns also emerge from the visual cycles of the baptistery and chapel of Sant'Isidoro. Whereas the chapel of Sant'Isidoro—which offered a detailed visual account of the translation of St. Isidore's body from Chios to Venice in 1125, under the direction of Doge Domenico Michiel—addressed the specific role of the doge as "image" of the state in matters of foreign policy and vis-à-vis the Venetian dominion, the baptistery mosaics integrated political iconography and sacred imagery to reflect on the sources and proceedings of authority. In this context, they advocated a vision of the Venetian government as a shared enterprise, within which the doge acted as a civil servant and guarantor of the lawfulness, justice, and piety of Venice's state.

In sum, the Serrata inaugurated a period of intense political and administrative revision that also entailed the figure and the role of the doge. Just as the definition of the new elite and the criteria of access to public office were redefined slowly, over decades, so was the office of the doge, the precise contours of which were never defined conclusively or unequivocally. The complexity of these political matters was further amplified by the economic downturn of the early trecento, which prompted the government to restrict the right to exercise certain merchant activities to Venetian citizens, and by the factionalism of the Venetian elite, which led to one attempted coup d'état in 1310 and another in 1355, shortly after Dandolo's death. The systemic shocks of the mid-trecento contributed, too, to destabilizing the established political equilibrium: the plague, which allegedly killed fifty patrician families and at least a third of the overall population of Venice, required policies of repopulation, presumably intensifying ongoing reflections about the nature and extent of citizenship and nobility and the functions of the head of state in times of crisis. In addition, the expansion of Venice's dominion and the development of a colonial elite generated an acute need to better define the relations between Venetian and overseas ruling groups, the legal and political rights of colonists and their descendants, and the rules of their inclusion in the republic's organs of government.[61] These questions were being heavily debated at the time when Andrea Dandolo became doge and when the government sponsored the renovation of San Marco in 1343–1355. It is the core thesis of this book that the projects of artistic renewal instigated by Andrea Dandolo in San Marco manifested the political tensions of the time, as well as the institutional and cultural responses that they generated. The next section considers the latter in detail.

60 Canale, *Les estoires de Venise*, 284–305. In her study of the role of Venice's *dogaressa,* Holly S. Hurlburt suggests that by the fourteenth century the guilds had become associated with the doge's wife and that they attended a banquet at the ducal palace after her inauguration rather than her husband's: H. S. Hurlburt, *The Dogaressa of Venice, 1200–1500: Wife and Icon* (New York, 2006), 55–56.

61 On the elite of Crete, see M. O'Connell, "The Venetian Patriciate in the Mediterranean: Legal Identity and Lineage in Fifteenth-Century Venetian Crete," *Renaissance Quarterly* 57.2 (2004): 466–93.

Law and Order: Andrea Dandolo's Legal Initiatives and Historical Writings

Andrea Dandolo's activity as a statesman was relentless throughout his term of office and was driven by an enduring concern for legitimacy, institutional continuity, and legal order. This is revealed by the vast administrative, legal, and historical programs he spearheaded, first in his capacity as procurator of San Marco (1328–1343) and then as doge (1343–1354). Dandolo's work in these areas aimed to give more solid ground to Venice's territorial and commercial claims overseas, to clarify the functioning of the city's government, and to better define the internal structures, mechanisms, and procedures of the Venetian state, increasing the efficiency of the bureaucratic and political machine and reducing the potential for confusion. His initiatives are worthy of detailed consideration. They were undertaken at the same time as the artistic renewal of San Marco, providing the institutional and legal framework within which to examine public patronage in the basilica. Furthermore, the visual programs commissioned for the basilica at this time manifest a preoccupation with notions of authority, legitimacy, community, and order that resonates meaningfully with Dandolo's reforms in the legal and administrative arena. This correspondence, in turn, provides the basis for one of the overarching arguments of this study: that the makeover of the high altar, the baptistery, and the chapel of Sant'Isidoro belong together with Dandolo's program of reforms, and that—much like his legal, administrative, and historical work—they aimed to interrogate and consolidate the foundations of Venice's political rule at times of increased instability, both internal and international.

Before his election as doge, Andrea Dandolo's *cursus honorum* involved roles with significant legal and judicial responsibilities.[62] In 1328, he was appointed as procurator of San Marco. This office—which entailed project-management responsibilities in San Marco, but also required him to develop specific expertise in the fields of property management, family, juvenile, and testamentary law, and finance and contract law—made him particularly attuned to the importance of clear and efficient legal and administrative procedure.[63] While serving as procurator, Andrea Dandolo undertook the composition of a legal compilation known as *Summula statutorum floridorum Veneciarum*. The *Summula* was specifically intended as a compendium for law practitioners (notaries and magistrates) and aimed to dispel any (excuses of) ignorance of the law. It covered three main areas: judicial law, contract law, and testamentary law, the legal fields that Dandolo would have engaged with daily and thus came to know intimately. The *Summula* collected a group of deliberations by the Great Council that had not been formally included in the civic statutes but had nevertheless gained the force of law through habit and practice.[64] By identifying these decrees as necessary additions to and specifications of the city statutes, the *Summula* performed two key functions. First, it prevented the multiplication of *consuetudines* (legal customs derived from court precedents) and their potentially arbitrary application on the part of notaries and judges. Second, it acknowledged the Great Council as a privileged source of the law (over jurisprudence), initiating a transformation of Venice's legal system that would be accelerated by Dandolo's next legal initiative: the revision of the civic statutes that he undertook following his election to the ducal seat in 1343.[65]

62 In addition, there is scholarly consensus that Andrea Dandolo received formal legal training, either in Venice or Padua. See G. Arnaldi, "La cancelleria ducale fra culto della 'legalitas' e nuova cultura umanistica," in *Cronache e cronisti*, 507–43, at 517, with further references.

63 On Dandolo's specific assignments as procurator, see Dandolo, *Chronica per extensum descripta*, vi–vii. On the *Procuratori di San Marco*, see R. C. Mueller, "The Procurators of San Marco in Thirteenth and Fourteenth Centuries: A Study of the Office as a Financial and Trust Institution," *StVen* 13 (1971): 105–220. See also D. S. Chambers, "Merit and Money: The Procurators of St. Mark and Their Commissioni, 1443–1605," *JWarb* 60 (1997): 23–88; and R. C. Mueller, "The Procuratori di San Marco and the Venetian Credit Market: A Study of the Development of Credit and Banking in the Trecento" (PhD diss., Johns Hopkins University, 1969).

64 V. Crescenzi, "La *Summula statutorum* di Andrea Dandolo secondo il manoscritto Montecassino, 459," *Initium* 12 (2007): 623–97; and L. Genuardi, "La 'Summula statutorum floridorum Veneciarum' di Andrea Dandolo," *NAVen* 21.2 (1911): 436–67.

65 As per its prologue, the articles of the *Summula* were gathered "in order for them to add to and specify the [contents of the] statutes, and to interrupt [the legal effect of] accepted custom" (*ut statutis eciam addictions et declarationes faciant et omnem approbatam consuetudinem interrumpant*). Crescenzi, "La *Summula*," 635. On Dandolo's efforts to weaken the authority of *consuetudines* and concentrate all legislative power in the Great Council, see Crescenzi, "La *Summula*," 626–27.

Shortly after his designation as doge, Dandolo oversaw the appointment of a committee specifically tasked with the collation and revision of Venice's thirteenth-century constitutions. This ambitious project was completed in 1346, when the so-called *Liber Sextus* (sixth book) was approved by the Council and appended to the five existing volumes of Venice's statutes.[66] Much like the *Summula*, the new statutes manifested Dandolo's acute awareness of the importance of an orderly and efficient legal system for the smooth running of government. In addition, the *Liber Sextus*—which, as a constitutional reform approved by the Council, was infinitely more influential than the *Summula*—represented a pivotal change for the legal system of the city. Venice oscillated during the Middle Ages between a system based on jurisprudence and driven by legal practice (what we would now call common law) and one based on codified legislation, which considered only legislative enactments to be legally binding (civil law). Dandolo reinforced and expanded the corpus of codified laws, accelerating the conversion of the city's legal system from the former to the latter model. In doing so, the reform contributed to redefining the foundations and structures of Venetian political power. Identifying the Great Council as the primary source of law in the aftermath of the Serrata, Dandolo's reform effectively subordinated the judicial organs of the city to its political authorities, thus clarifying how power was distributed among different organs of the state and consolidating the newly established aristocratic oligarchy.[67]

In addition to manifesting Dandolo's efforts to rationalize the state, clarify its functioning, and ensure greater stability, the *Liber Sextus* offers valuable insights into the doge's broader understanding of the law as a tool of governance, and into his approach to questions of continuity and change in public regulation and policy. In the introduction to the *Liber Sextus*, the doge writes:

No articulation of the law—no matter how carefully digested through considerate thought—is sufficient to [predict/regulate] the variety of human nature and its unpredictable machinations, nor does it achieve a clear resolution of its knotty ambiguity, particularly since no sooner has anything [i.e., a legal principle] been stated clearly and with particular certainty than it is called into doubt by emerging cases (*emergentibus causis*) which extant laws cannot resolve [lit. remedy]. And it is not to be considered reprehensible that human statutes are occasionally changed, following the variability of mores and times, [and] above all if urgent necessity or patent usefulness demand so—given that even God modified in the New Testament some of the things he had established in the Old.[68]

The implicit assumption behind Dandolo's statement is that stability of the law is key to the functioning of a society, but that specific circumstances demand constitutional reforms. First, legal adaptations are warranted by human nature, which is both changeable and unpredictable. Aside from these (presumably incremental) revisions, urgent necessity and patent usefulness may require substantive legal reform. One can easily discern between the lines Dandolo's concerns as a ruler. During his dogeship, the government faced institutional and political turmoil, international tensions, and geopolitical realignments as well as the need to both manage and organize colonial rule. This critical juncture generated new administrative, legal, and technical scenarios that required the adaptation or clarification of existing laws. By systematizing Venice's constitutional norms and procedures, the reform made the legal foundations of the Venetian state more intelligible and serviceable. It illuminated the

66 The statutes were published in Rizzardi Griffo, ed., *Volumen statutorum legum, ac iurium dd. Venetorum* (Venice, 1619). The *Liber Sextus* can be found on pages 86–128. The book is discussed by Ester Pastorello in her introduction to Dandolo, *Chronica per extensum descripta*, viii, xiii.

67 G. Cracco, "La cultura giuridico-politica nella Venezia della 'Serrata,'" in *Storia della cultura veneta*, ed. G. Arnaldi (Vicenza, 1976), 2:238–71.

68 *Quia nulla iuris editio (quantumcumque perpenso digesta consilio) ad humanae naturae varietatem, & eius machinationes inopinabiles sufficit, nec ad decisionem lucidam sue nodose ambiguitatis attingit, praesertim etiam quod vix aliquid adeo certum, vel clarum statuitur, quin ex causis emergentibus, quibus iura posita mederi non possunt, in dubium revocetur. Et quia non est reprehensibile iudicandum, si secundum varietatem morum, & temporum statuta quandocumque varientur humana, maxime cum urgens necessitas, vel evidens utilitas, id exposcit, quoniam et ipse Deus, ex hiis, quae in vetero Testamento statuerat, nonnulla mutavit in Novo* (Griffo, *Volumen statutorum legum*, 86r).

functioning of the judicial system and clarified the mechanisms of accountability of the different organs of the republic, ultimately cultivating the city's governability and stability at times of uncertainty.

This hypothesis is further sustained by Dandolo's subsequent legal initiatives. In 1346, immediately after the completion of the *Liber Sextus*, which attended to Venice's domestic regulations, the doge turned to the city's foreign relations. Over the centuries, Venice had signed several international treaties, pacts, and privileges, which were nevertheless scattered among different branches of Venice's public archives. Dandolo ordered that all international deeds be gathered together and reorganized into two books. Pacts signed with other Italian states were to be collected in the so-called *Liber Blancus*, while the *Liber Albus* comprised all treatises signed with overseas polities.[69] Within each book the documents were classified according to subject matter, place, and date. In essence, the *Liber Blancus* and *Liber Albus* represented searchable diplomatic archives and were intended to simplify access to and consultation of individual treatises, elucidating the extent of Venice's rights and responsibilities abroad and illuminating the city's diplomatic history.[70] Nevertheless, compiling these codices was not merely a matter of bureaucratic efficiency. It should also be read as a qualified response to the widespread geopolitical volatility of the central decades of the fourteenth century, and in relation to Venice's efforts to stabilize its unruly dominions and reinforce its international status vis-à-vis an ever-increasing range of competitors. Giorgio Cracco poignantly notes that the *Liber Albus* and *Liber Blancus* together represented a powerful legal and political device. Providing written certification of Venice's privileges and rights abroad, they enabled the city to buttress its territorial and commercial ambitions

with an increasingly systematized and codified corpus of notarial and diplomatic acts.[71]

Dandolo prefaced the *Liber Albus* and *Liber Blancus* with a prologue that exudes the doge's confidence in the value of documentary activity and his appreciation for legal and procedural clarity and order. Commenting on the indecorous dispersion of Venice's foreign treaties, Dandolo writes:

> What advantage is there in having found a noble matter, if it is not adorned [lit. clad] in a noble form? How can the solemnity of what is found be delectable, if it is obscured by the ugliness of perturbed order? With good reason, we see how nothing has intensified [the fame of] Cicero and others—whom the highest virtues, forever valid, make memorable— more than [their] most accurate observance of order in what is to be done, and [their] proper articulation of what is to be said.[72]

This passage confirms Dandolo's ability as an administrator and his pragmatic attitude toward bureaucracy and the res publica: what is the advantage of preserving treatises that record Venice's privileges, if those same documents cannot be consulted and deployed to uphold the city's legal rights? This question is likely to have been particularly pressing during Dandolo's dogate, when Venice faced rebellions in several of its colonies and was forced to negotiate its international preeminence and rights with a growing number of competitors.

In addition to illuminating Dandolo's talent as a statesman, the passage above suggests the doge's familiarity with the world of rhetoric. By extension, the excerpt also bears witness to the close interconnections between Venetian political, legal, and administrative culture, on the one hand, and training in the liberal arts on the other. There is, to be sure, nothing exceptional about the doge's

69 The two collections of documents have not been published in their entirety. They are preserved in ASV, *Pacta*, Liber Albus; and ASV, *Pacta*, Liber Blancus.

70 See Dandolo's own prologue to the volumes, in G. L. F. Tafel and G. M. Thomas, *Der Doge Andreas Dandolo und die von demselben angelegten Urkundensammlungen zur Staats- und Handelsgeschichte Venedigs: Mit den Original-Registern des Liber Albus, des Liber Blancus und der Libri Pactorum aus dem Wiener Archiv* (Munich, 1855), 25–26.

71 Cracco, "La cultura giuridico-politica," 2:238–71.

72 *Quid enim prodesset nobilem invenisse materiam nisi nobilem vestiretur in formam? Quid inventorum solempnitas oblectaret, si turbati ordinis deformitate nigresceret? Sane Ciceronem et ceteros, quos summe virtutes in eternum valiture commemorant, nil magis adauxisse conspicimus, quam accuratissima observantia ordinis in agendis et recta distributio dicendorum* (Tafel and Thomas, *Der Doge Andreas Dandolo*, 24–25).

references to Cicero and ancient rhetorical virtues in the prologue of a legal collection—after all, rhetorical discourse was a staple of late medieval Italian political and legal culture. Nevertheless, Dandolo's explicit praise of form, his celebration of order as a "divine oracle" and the "brightest of lights," and his admiration for the accurate articulation of speech carry significance beyond the boundaries of his legal activity.[73]

Order was a central tenet of medieval political and social thought, which conceived of well-functioning societies in terms of balanced and stable hierarchical structures.[74] In keeping with this tradition, order and its safeguarding played a pivotal role in Andrea Dandolo's legal works, explaining his seemingly hyperbolic praise of order as a "divine oracle." As will emerge in the following chapters, a similar concern can also be discerned in the artistic projects commissioned in San Marco under Dandolo's rule, most conspicuously in the iconographies chosen for the decoration of the baptistery domes. There, each religious subject—the Ancient of Days, the Mission of the Apostles, and the Angelic Hierarchies—provided a semantically rich visual gloss to the rituals of baptism, but also offered a visual metaphor of harmonious group interaction, orderly transmission of authority, and hierarchical distribution of power and responsibility that lent itself to a political reading. Contemporary viewers, especially members of the governing elite, would be inclined to read those scenes through a political and civic lens that expanded the primary religious implications of each mosaic and found its justification in the wide-ranging civic functions of baptismal buildings and their imagery in the late Middle Ages.

Finally, the excerpt translated above firmly situates the doge within the traditions of medieval rhetoric and the art of memory. These considerations provide us with a rich road map for examining Dandolo's documentary productions, historical writings, and artistic projects, and for interpreting the interactions among those different areas of the doge's activity. In medieval rhetorical and mnemonic cultures, words and images were not regarded as mere conveyors of information or meaning. Rather, they were understood to create experiences for the subjects who formed their audience.[75] In other words, the medieval rhetorical tradition acknowledged the ability of textual and visual forms to act upon their viewers and direct their response. What range of responses did Dandolo's visual programs elicit from their beholders, and more generally what did the high altar, baptistery, and chapel of Sant'Isidoro *do* for their viewers? In what ways did their material properties and formal qualities enable those artworks to perform their intended function? The iconography, style, and medium of Dandolo's visual programs were carefully orchestrated. Each of his projects in San Marco artfully combined images and text to channel elaborate messages that were simultaneously religious and political. As will become increasingly clear throughout the following chapters, ritual performance, the semantics of materials, and the power of locational memory were skillfully mobilized to engage viewers, awaken their historical consciousness, and impress on them a political and social program that rested on ideas of order, legitimacy, and "community in difference" in times of change.

Once the affirmation of order is identified as one of the many possible political responses to crisis (a topic to which we will return at length in our discussion of the baptistery of San Marco) and rhetoric and memory are brought into the picture, it seems hardly surprising that Andrea

73 In his prologue, Dandolo refers to order as *divinum oraculum* and *luminare perfulgidum*. See Tafel and Thomas, *Der Doge Andreas Dandolo*, 24.

74 Reference works on medieval approaches to social hierarchies include G. Duby, *The Three Orders: Feudal Society Imagined* (Chicago, 1980); S. Reynolds, *Kingdoms and Communities in Western Europe, 900–1300* (Oxford, 1984); J. Denton, ed., *Orders and Hierarchies in Late Medieval and Renaissance Europe* (Manchester, 1999). On Byzantine *taxis*, see among others L. A. Neville, *Authority in Byzantine Provincial Society, 950–1100* (Cambridge, 2004); D. M. Angelov and M. Saxby, eds., *Power and Subversion in Byzantium: Papers from the 43rd Spring Symposium of Byzantine Studies, Birmingham, March 2010* (Farnham, 2013); and P. Armstrong, *Authority in Byzantium* (Farnham, 2013).

75 Literature on the topic of medieval rhetoric (both textual and visual) is vast. Standard authors and works include M. Carruthers, *The Craft of Thought: Meditation, Rhetoric, and the Making of Images, 400–1200* (Cambridge, 1998); M. Carruthers, *The Experience of Beauty in the Middle Ages* (Oxford, 2013); P. Binski, *Gothic Sculpture* (New Haven, CT, 2019). On the significance of a rhetorical approach to both text and imagery in the political arena, see especially Q. Skinner, *Visions of Politics*, vol. 1, *Regarding Method* (Cambridge, 2002).

Dandolo's other chief concern was the history of Venice. The preservation of collective memory and the creation of a Venetian public history played a pivotal role in Andrea Dandolo's comprehensive program of state building. He first tried his pen at history when he served as procurator of San Marco. The result of this writing effort, known as the *Chronica Brevis*, was most likely intended to provide the Venetian chancery and the procurators of San Marco with a convenient summary of Venetian history and with a catalogue of names, dates, and facts that might be useful to retrieve and verify in their daily activities as administrators.[76] Upon his appointment as doge, Dandolo supervised the production of a longer and more detailed historical oeuvre. This chronicle was most likely begun in 1344—just as the refurbishment of the high altar of San Marco was under way—and was completed in 1352. It was largely modeled on Paolino da Venezia's *Historia satyrica*, but also complemented the transcription of hundreds of archival documents that Dandolo and his assistants presumably unearthed while updating the civic statutes and compiling the *Liber Albus* and *Liber Blancus*.[77] The *Chronica per extensum descripta*, as this work has come to be known, was a quintessentially public oeuvre. First, the text is believed to have been compiled by the scribes of the ducal chancery, under Dandolo's supervision. Second, the chronicle was compiled at the same time as the *Liber Albus* and *Liber Blancus* and incorporates the text of several documents that were gathered in those codices, demonstrating the complementarity between historical and archival collation.[78] Third, when it reached completion in 1352, the master copy of the chronicle was officially presented to the Great Council with a preface by the Great Chancellor Benintendi Ravegnani, and it was thenceforth preserved in the ducal chancery. Fourth, a copy of the text was preserved in the archives of the Council of the Ten.[79] This magistracy was established in 1310 following Bajamonte Tiepolo's plot, and originally functioned as a political court. Made permanent in 1335, it grew into one of the most powerful organs of the Venetian government and was specifically tasked with ensuring the safety of the republic—which included supervising matters of foreign policy and internal security.[80] Evidently, Andrea Dandolo's chronicle was understood as instrumental to the same goals and therefore entrusted to the protection of this Council.

The *Chronica per extensum descripta* enunciated the origins of Venice and its history. It recapitulated the names, responsibilities, and honors of its leaders and enumerated and expounded Venice's interactions and diplomatic relations with a range of ecclesiastical and secular powers across the Mediterranean. Finally, it offered a comprehensive assessment of Venice's religious history, with specific focus on the holy treasures (relics and saints' bodies) accumulated by the city's government over time. Much like the legal compilations discussed above, Dandolo's chronicle served as a powerful means of political certification and stabilization and as a tool of public governance that reminded its readers—the Venetian governing elite and chancery officials—of the origins and constitutional values of their state when taking public decisions and actions in the face of changing problems and environments.

The significance of Dandolo's legal, historical, and administrative reforms in "making" the Venetian state, and in navigating Venice through crisis, can hardly be overestimated. It is the contention of this book that his artistic projects participated in the same process—that is, the art of San Marco did not merely reflect or illustrate the political and institutional realities within which it was created; it contributed to the formation of those realities in the first place.[81] But what exactly do we mean by "crisis"? And what does art have to do with it?

76 Arnaldi, "La cancelleria ducale," 519 (see above, p. 26, n. 62).

77 On Dandolo's use of Paolo da Venezia's chronicle, see Ester Pastorello's insights in Dandolo, *Chronica per extensum descripta*, esp. xxxii–xxxvii, lix–lxi.

78 Dandolo, *Chronica per extensum descripta*, lxii.

79 Dandolo, *Chronica per extensum descripta*, xxx, lxiii–lxiv, on known manuscript copies of the chronicle, their original function, and the office where the presentation copy was preserved.

80 On the Council of the Ten, see G. Maranini, *La costituzione di Venezia* (Venice, 1931), 2:385–472.

81 For a similar interpretation applied to English royal imagery in the later Middle Ages, see the compelling essay by P. Binski, "Hierarchies and Orders in English Royal Images of Power," in *Orders and Hierarchies in Late Medieval and Renaissance Europe*, ed. J. Denton (London, 1999), 74–93.

Thinking through Crisis:
A Vocabulary for Uncertainty

Terms use those who use them uncritically.[82]

The mid-trecento represented a time of exceptionally severe challenges for Venice, and the Venetian government responded to ongoing strife with a vast program of administrative, legal, and historical reforms that both clarified the premises of Venice's res publica and stabilized its own rule. How valuable is the notion of "crisis" as a descriptor of this conjuncture, and what interpretative possibilities does this concept enable, or foreclose? Answering this question will elucidate the historiographic and methodological framework of this study and will be threefold. First, I will introduce the vast and unsystematic scholarly debate on crisis that has developed exponentially among historians since the late nineteenth century. Second, I will review the main implications of this discussion for our understanding of the fourteenth century in general, and of trecento Venetian art in particular. Third, I will explain how the category of crisis operates conceptually in the book, and why it is compatible with the cultural and historical matrix of the Middle Ages.

HISTORIOGRAPHIES OF CRISIS

The notion of crisis has met with persistent popularity among modern historians. In the late eighteenth and the nineteenth centuries, scholars began to understand crisis as a historical reality coincident with dramatic societal upheavals—and, most frequently, conducive to revolution.[83] Scholarly approaches to crisis have multiplied since. Crisis has been evoked as the defining trait of modernity and as the shape of modern history itself.[84] Alternatively, scholars have deployed crisis as a conceptual framework within which to understand epochal or structural change that is traceable at the local, international, or global

level, and that affects a particular aspect of civilization (its economy, politics, culture, religion, society, or psyche) or several of those realms simultaneously.[85] Crisis has also been thought of as the paradigm of scientific innovation[86] or as a heuristic category that enables analysis of complex historical conjunctures.[87] Because it is also used in medical contexts to indicate the turning point of an illness, "crisis" has been assailed by some as an interpretative perspective that frames historical discontinuities in pathological terms, as disruptions of a normalcy that is (uncritically) assumed to be desirable.[88]

To put it simply, at one end of the interpretative spectrum crisis has been taken as a historical fact: a situation of great disagreement, difficulty, or confusion that materializes when certain conditions are verified. At this level, the main objects of scholarly contention have been the nature, number, and intensity of the "symptoms" that lead to or express a crisis; its expected course and outcomes; and the applicability of the category of "crisis" to specific periods or contexts.[89] At the

82 R. Starn, "Historians and 'Crisis,'" *Past & Present* 52.1 (1971): 3–22, at 20.

83 An early and notorious example is Jean-Jacques Rousseau's statement (1762): "We are approaching a state of crisis and the age of revolutions"; J.-J. Rousseau, *Emile: Or On Education*, ed. A. Bloom (New York, 1979), 194.

84 Literature on modernity and crisis is vast and diverse. The standard reference on this topic remains R. Koselleck, *Critique and Crisis: Enlightenment and the Pathogenesis of Modern Society* (Cambridge, MA, 1988).

85 The rich literature on the "general crisis" of the seventeenth century provides an ideal example of the range of meanings attributed to "crisis." The debate was catalyzed by E. J. Hobsbawm, "The General Crisis of the European Economy in the 17th Century," *Past & Present* 5.1 (1954): 33–53. A selection of important responses to and expansions of his formulation are gathered in T. Aston, ed., *Crisis in Europe 1560–1660: Essays from Past and Present* (London, 1965). The debate was significantly reframed by T. K. Rabb, *The Struggle for Stability in Early Modern Europe* (Oxford, 1975). A more recent take that marks a return to the "realist" approach to crisis and emphasizes its global dimension is G. Parker, *Global Crisis: War, Climate Change and Catastrophe in the Seventeenth Century* (New Haven, CT, 2013).

86 The most influential articulation of this idea is T. S. Kuhn, *The Structure of Scientific Revolutions*, 3rd ed. (Chicago, 1996), esp. chaps. 7, 8.

87 See Starn, "Historians and 'Crisis'"; and J. B. Shank, "Crisis: A Useful Category of Post–Social Scientific Historical Analysis?," *AHR* 113.4 (2008): 1090–99.

88 See the critique by J. Roitman, *Anti-Crisis* (Durham, NC, 2013). For a briefer articulation of the argument, see also J. Roitman, "Crisis," *Political Concepts: A Critical Lexicon* 1 (2012), http://www.politicalconcepts.org/issue1/crisis/. For a seminal and balanced appraisal of the potential and limits of crisis, see Starn, "Historians and 'Crisis.'"

89 A recent articulation of the "realist" perspective, with an enriching discussion of its potential and limits, is J. F. Haldon, *The Empire That Would Not Die: The Paradox of Eastern Roman Survival, 640–740* (Cambridge, MA, 2016). For a recent application of Marxist perspectives to medieval history, see C. Wickham, *Medieval Rome: Stability and Crisis of a City, 900–1150* (Oxford, 2015).

opposite end of the spectrum, crisis is understood not as a thing in itself but as a mode of inquiry into history: an interpretive standpoint from which to interrogate and explain discontinuities and transformations. From this perspective, the issue at stake is not so much whether crises *actually* exist, but how the interpretive lens of crisis *works*: what aspects of a given historical conjuncture it enables us to see, and what phenomena it bars from our view.

Cutting across this divide, scholars have also polarized around two different views of crises. In one sense, crises have been conceptualized as "breakdowns," that is, phases of adversity that cause existing equilibria or systems to collapse, or explanatory devices that can be deployed instrumentally to preempt critical thought and action. In another sense, crises have been understood as "breakthroughs"—moments of struggle leading to renewal and innovation—and as interpretative categories that encourage critical thinking and action by emphasizing disjunctures and indeterminacies.[90]

The category of "crisis," then, resists straightforward definition. Instead, the term oscillates in scholarly usage between the substantive and semantic realms: crisis as a reality versus crisis as a way of organizing and understanding reality. Compounding the ambiguity, literature has also deployed "crisis" as a loose synonym for a number of starkly different concepts. On one level, crisis appears in association with ideas of decline, failure, confusion, and adversity. On another, it portends (re)generation and innovation. Such oscillations apply to discussions of crisis in almost every historical period, but they have generated strikingly divergent narratives of the trecento, and of the Venetian trecento in particular.[91]

VENICE AS THRESHOLD: THE "FOURTEENTH-CENTURY CRISIS," RENAISSANCE PARADIGMS, AND BYZANTINE DECLINE

Notions of crisis, decline, and renewal have dominated scholarly discourses about the trecento throughout the twentieth century. Marxist historians and economists, as well as those struggling against Marxist paradigms, have long argued over the causes, magnitude, and short- and long-term effects of the demographic and economic stagnation of this period in Europe. They have debated the role played by major environmental disasters (earthquakes, floods, and the plague) in precipitating or reflecting those phenomena, and they have battled over the significance of the fourteenth century as a turning point in the transformation of European economies from the "crisis of feudalism" to the establishment of modern capitalism.[92]

Alternatively, and within a tradition more or less explicitly indebted to Jacob Burckhardt's theorization of historical crises and his conceptualization of the Italian Renaissance, scholarship traditionally resorted to the "fourteenth-century crisis" as a means to explain and consolidate the alleged divide between medieval and Renaissance

End of Civilization (Oxford, 2005). On "crisis" and the origins of the Renaissance, see the classic (and much debated) study by H. Baron, *The Crisis of the Early Italian Renaissance: Civic Humanism and Republican Liberty in an Age of Classicism and Tyranny* (Princeton, NJ, 1955). On the seventeenth century, and in addition to the works cited above (see above, p. 31, n. 85), see A. Wunder, *Baroque Seville: Sacred Art in a Century of Crisis* (University Park, PA, 2017).

92 On the historiography of the "late medieval crisis," see, for example, P. Schuster, "Die Krise des Spätmittelalters: Zur Evidenz eines sozial- und wirtschaftsgeschichtlichen Paradigmas in der Geschichtsschreibung des 20. Jahrhunderts," *HZ* 269.1 (1999): 19–56. Scholarly debates on these issues were particularly intense among the contributors to the French *Annales* and the British *Past & Present* in the 1960s and 1970s. For a recapitulation of the notorious "Brenner debate," see T. H. Aston and C. H. E. Philpin, eds., *The Brenner Debate: Agrarian Class Structure and Economic Development in Pre-Industrial Europe* (Cambridge, 1985). For the French perspective, with reference to a wider literature, see G. Bois, *Crise du féodalisme: Économie rurale et démographie en Normandie orientale du début du XIV^e siècle au milieu du XVI^e siécle* (Paris, 1976); and more recently, G. Bois, "On the Crisis of the Late Middle Ages," *The Medieval History Journal* 1.2 (1998): 311–21. For a useful summary of literature—particularly German—on these topics, and for bibliography on the more recent "environmental turn," see also W. Rösener, "Die Krise des Spätmittelalters in Neuer Perspektive," *Vierteljahrschrift Für Sozial- und Wirtschaftsgeschichte* 99.2 (2012): 189–208.

90 I borrow the concise formulation of crisis as breakdown or breakthrough from R. Starn, "Crisis," in *New Dictionary of the History of Ideas*, ed. M. C. Horowitz (New York, 2005), 2:500–501. For a provocative view of crisis as a shock strategy that can be deliberately used to prevent or paralyze critical thought and action, see N. Klein, *The Shock Doctrine: The Rise of Disaster Capitalism* (New York, 2007).

91 Scholarly debates about "crisis" are particularly vibrant in relation to late antiquity. See, for example, J. D. Howard-Johnston, *Witnesses to a World Crisis: Historians and Histories of the Middle East in the Seventh Century* (Oxford, 2010); S. A. Harvey, *Asceticism and Society in Crisis: John of Ephesus and the Lives of the Eastern Saints* (Berkeley, 1990). For a rather extreme view, see B. Ward-Perkins, *The Fall of Rome: And the*

cultures and to explicate the rise of humanism.[93] According to an influential version of this narrative, the challenges that Europe faced in the trecento—particularly the experience of the Black Death—"inflicted deep injury on the personality of the age."[94] Yet they also triggered a set of creative responses and innovations in the arena of politics, social organization, and culture that ultimately led to a regeneration: the Renaissance, and ultimately the rise of modernity. In a variant of the same argument that nonetheless aims to give greater emphasis to continuities, the "trecento crisis" is not only thought to have triggered innovation, but itself to have been caused by novel economic, social, and cultural practices that would take firmer hold of Italy and continental Europe in the following century.[95]

Many aspects of this narrative and its premises have been the object of sharp and well-justified criticism over the past decades. The short- and long-term effects of the plague on Mediterranean societies have been carefully scrutinized.[96] More broadly, ideas of a neat divide between the "Middle Ages" and the "Renaissance" have been challenged, as has the validity of the very notion of "Renaissance" as a label for the arts and culture of the fifteenth and sixteenth centuries outside of Italy. Also, scholarship has objected to the West-centrism of this periodization and pointed to its limits within an increasingly global understanding of (art) history.[97] The effects of such critical reassessments on scholarly attitudes toward crisis have been ambivalent. On the one hand, the contours of the fourteenth-century crisis in Europe have been smoothened and specified. On the other, global history has appropriated crisis as a (deceptively) neutral category that allows comparisons between the life conditions and the political or social infrastructures of different civilizations across space and time.[98]

The gradual convergence of Byzantine and Western medieval art history has further complicated scholarly attitudes toward crisis. An established historiographic tradition identifies the last centuries of Byzantium, from the thirteenth century to the fall of Constantinople in 1453, with a drawn-out period of decline. Much like ideas of crisis and rebirth in the West, the idea of a prolonged Byzantine decline that prefigured its final demise in 1453 is rooted in the early phases of Byzantine historiography. More precisely, it is thought to have originated in Edward Gibbon's influential reading of Byzantine history as a process of teleological degeneration, which was then absorbed into the scholarship of early twentieth-century Byzantinists. The main contours of "Byzantine decline"—famine, plague, political instability—echo those of the Western fourteenth-century crisis, and the two terms are often used as near-synonyms in scholarly literature. Nonetheless, as Cecily Hilsdale has aptly remarked, there is a significant semantic difference between "crisis" and "decline." While

93 Jacob Burckhardt articulates his ideas about historical crises in J. Burckhardt, *Reflections on History* (London, 1944), originally published in German as *Weltgeschichtliche Betrachtungen* (Berlin, 1905). See also L. Gossman, "Cultural History and Crisis: Burckhardt's Civilization of the Renaissance in Italy," in *Rediscovering History: Culture, Politics, and the Psyche*, ed. M. S. Roth (Stanford, 1994), 404–27; J. R. Hinde, *Jacob Burckhardt and the Crisis of Modernity* (Montreal, 2000); and J. R. Martin, "The Theory of Storms: Jacob Burckhardt and the Concept of 'Historical Crisis,'" *Journal of European Studies* 40.4 (2010): 307–27.

94 R. E. Lerner, *The Age of Adversity: The Fourteenth Century* (Ithaca, NY, 1968), 34.

95 This idea is common currency. It is expressed with particular clarity in the concluding paragraphs of Millard Meiss's classic study on the effects of the plague on Tuscan art: "In these respects, then, this was a period of crisis, the first crisis of what we may call, in its larger sense, humanism." M. Meiss, *Painting in Florence and Siena after the Black Death* (Princeton, NJ, 1951), 165.

96 For a reappraisal of Meiss's study, see H. W. van Os, "The Black Death and Sienese Painting: A Problem of Interpretation," *AH* 4 (1981): 237–49. For a different take on the effects of the plague on Tuscan art, see J. B. Steinhoff, *Sienese Painting after the Black Death: Artistic Pluralism, Politics, and the New Art Market* (Cambridge, 2007). On the interactions between the plague and image-making in medieval art, see also Louise Marshall's publications, including L. Marshall, "God's Executioners: Angels, Devils and the Plague in Giovanni Sercambi's Illustrated *Chronicle* (1400)," in *Disaster, Death and the Emotions in the Shadow of the Apocalypse, 1400–1700*, ed. J. Spinks and C. Zika (London, 2016), 177–99.

97 For a useful review of approaches and further references, see, for example, J. Summit and D. Wallace, "Rethinking Periodization," *Journal of Medieval and Early Modern Studies* 37.3 (2007): 447–51, and the other essays included in the same volume. See also T. DaCosta Kaufmann, "Periodization and Its Discontents," *Journal of Art Historiography* 2 (2010), https://arthistoriography.files.wordpress.com/2011/02/media_152489_en.pdf. And in relation to globalization, see K. Davis and M. Puett, "Periodization and 'The Medieval Globe': A Conversation," *The Medieval Globe* 2.1 (2016): 1–14.

98 For an example of this approach, see, among others, Parker, *Global Crisis*.

the outcomes of crisis are uncertain, decline refers to a process of inevitable and irreversible deterioration. Thus, describing the last centuries of the Byzantine Empire in terms of decline is tantamount to reinterpreting its history teleologically, in light of its final fall in 1453.[99]

Much like the idea of a fourteenth-century European crisis, the narrative of Byzantine decline has been variously challenged and reconfigured over the past decades. Hilsdale has unmasked the modern and largely unjustified teleological assumptions that lie at the core of that interpretative matrix. Scholars have remarked the innovativeness of the arts of the period and have recently begun to approach them as an active response to uncertainty and instability.[100] Finally, scholarship has been vocal about the continuities between Byzantine and post-Byzantine societies, revisiting the significance of the fall of Constantinople as a "point of no return" in Byzantine history.[101]

Criticisms of established periodizations and master narratives about Byzantium, the medieval West, and the Renaissance have generated a certain reluctance among medieval art and cultural historians to engage critically with the category of crisis. Current literature generally avoids the term altogether. Alternatively, it equates crisis with societal stress, or uses it as a self-evident concept, falling back onto general notions of crisis as adversity. Yet the discussion above demonstrates that "crisis" is not just another recurrent catchword in fourteenth-century literature. Rather, it is central to modern scholarly constructions of the fourteenth century as a transitional period, both in the eastern and western Mediterranean. In addition, Western "crisis" and Byzantine "decline" have common (if underexplored) historiographic roots.[102] Ultimately, the two terms may be seen to participate in the same teleological narrative about the origins of modernity whose limits have been variously exposed in postcolonial studies.[103] Within this framework, the fourteenth century was a time of all-encompassing upheaval. But Europe reemerged from crisis into modernity, while the Byzantine East, stifled by an irreversible decline, did not. Long conceptualized as a threshold between East and West, Venice participates in the histories and historiographies of both Europe and Byzantium and represents the (problematic) point of convergence between the two conflicting accounts of artistic development that emerge from them. Perhaps unsurprisingly, then, crisis has played a highly ambivalent role in structuring modern understandings of Venice and its art.

Venetian historiography has long revolved around the so-called myth of Venice, which cast the city as a stable, harmonious republic. Over the past decades, scholarship has gradually replaced this idealized view—and similarly stereotyped counterviews of the city as a repressive and secretive oligarchy—with a more nuanced

99 This paragraph is based on Cecily Hilsdale's poignant critique of the historiography of Byzantine "decline" in Hilsdale, *Byzantine Art and Diplomacy*, esp. 20–22, with extensive references (see above, p. 14, n. 8); and C. J. Hilsdale, "The Timeliness of Timelessness: Reconsidering Decline in the Palaiologan Period," in *Late Byzantium Reconsidered: The Arts of the Palaiologan Era in the Mediterranean*, ed. A. Mattiello and M. A. Rossi (London, 2019), 53–70. On 1453 as a historical watershed, see also D. Lawton, "1453 and the Stream of Time," *Journal of Medieval and Early Modern Studies* 37.3 (2007): 469–91. See also the essays gathered in E. N. Boeck, ed., *Afterlives of Byzantine Monuments in Post-Byzantine Times: Proceedings of the Session Held at the 12th International Congress of South-East European Studies (Bucharest, 2–6 September 2019), Études byzantines et post-byzantines*, n.s. 3 (Bucharest, 2021).

100 See among others the essays gathered in Mattiello and Rossi, *Late Byzantium Reconsidered*.

101 For different takes on the term, and critical appraisals of it, see O. Gratziou, "Μεταβυζαντινή Τέχνη: Χρονολογικός Προσδιορισμός ή Εννοιολογική Κατηγορία," in *1453: Η Άλωση Της Κωνσταντινούπολης Και η Μετάβαση Από Τους Μεσαιωνικούς Στους Νεώτερους Χρόνους*, ed. T. Kiousopoulou (Heraklion, 2005), 183–96; L. Safran, "'Byzantine' Art in Post-Byzantine South Italy? Notes on a Fuzzy Concept," *Common Knowledge* 18.3 (2012): 487–504; E. L. Spratt, "Toward a Definition of 'Post-Byzantine' Art: The Angleton Collection at the Princeton University Art Museum," *Record of the Art Museum, Princeton University* 71/72 (2012): 2–19; and E. Moutafov and I. Toth, "Byzantine and Post-Byzantine Art: Crossing Borders, Exploring Boundaries," in "Byzantine and Post-Byzantine Art: Crossing Borders, Exploring Boundaries," ed. E. Moutafov and I. Toth, special issue, *Art Studies Readings* 1 (2017): 11–36.

102 For a concise overview of the origins and modern developments of Byzantine studies, see E. Jeffreys, J. F. Haldon, and R. Cormack, "Byzantine Studies as an Academic Discipline," in *OHBS* (Oxford, 2008), 3–20.

103 Postcolonial studies is an ever-growing field. The classic reference, of course, remains E. W. Said, *Orientalism* (New York, 1978), to be accompanied by the critical reading in D. M. Varisco, *Reading Orientalism: Said and the Unsaid* (Seattle, 2007). For a discussion of postcolonialism and Byzantine studies, see J. J. Gleeson and A. Vukovich "Orientalism and the Postcolonial Turn," TORCH: The Oxford Research Centre in the Humanities, video talks, 17 May 2019, https://www.torch.ox.ac.uk/orientalism-2020.

understanding of the Venetian state as an adaptive set of institutions that changed over time, in response to external challenges and internal tensions among the city's political and social formations.[104] The significance and specific function of the visual arts in this context has also been reformulated. Previously seen as a faithful mirror of Venice's serene splendor, or alternatively as a primary means to disseminate the (manufactured) image of Venice as a peaceful and harmonious republic, the visual arts of the lagoon are now increasingly understood as key sites of articulation of Venice's stratified social and cultural identities, and as the locus of their revision over time.[105] In her masterly study *Venetian Narrative Painting in the Age of Carpaccio*, which represents a valuable methodological antecedent for our study, Patricia Fortini Brown specifically relates the development of Venice's singular style of narrative painting in the mid-fifteenth century to widespread disquiet among its citizens. In a context

of enhanced uncertainty, she argues, the near-photographic quality of Venetian visual *istorie* served to reassure contemporaries of the reliability of their grip on reality. It made the unsettling ambiguity of their lived experience tolerable and mitigated the anxiety that derived from rapid political and societal transformations.[106] In a similar vein, Kiril Petkov recently looked at ten miracle accounts produced by the Scuola di San Giovanni Evangelista, explaining textual and visual storytelling as the direct manifestation of the concerns, expectations, and anxieties of Venice's citizen class—the *cittadini originari*—at a crucial time in the process of their identity formation in the fifteenth century.[107] These studies, which identify social uncertainty as a key driver of artistic and cultural change, have however had a limited impact on scholarly approaches to medieval Venice in general, and to the arts of San Marco in particular.

Driven by different intellectual concerns, Byzantine and medieval studies have long conceptualized the lagoon as a cultural and artistic threshold between East and West and as the most enduring center of reception and appropriation of Byzantine art in Western Europe. In his seminal study of the history of the basilica of San Marco, Otto Demus tersely captures this idea. As he writes, when Venice came into existence it did so as a part of the Byzantine Empire.[108] Therefore, in his view, the history of medieval Venice could be retold as the story of the relationship between the city and Byzantium—a relationship that "ran the whole gamut from subordination to domination."[109] The power balance tipped in favor of Venice in 1204, when participants in the Fourth Crusade conquered Constantinople and Venice obtained large shares of the imperial city's treasures, as well as formal ownership of "one fourth and a half" of the empire's territories. Venice's victory over Byzantium gave rise to a thriving and long-lived ideology of triumph. In the short term, such triumphal

104 For an excellent survey of extant literature on the myth of Venice, and a critical review of scholarly positions, see J. J. Martin and D. Romano, "Reconsidering Venice," in Martin and Romano, *Venice Reconsidered* (see above, p. 19, n. 30), 1–35, as well as the other essays in the same volume.

105 The classic work on art and the myth of Venice is D. Rosand, *Myths of Venice: The Figuration of a State* (Chapel Hill, NC, 2001). Much work has been done in recent years to widen scholarly understandings of the nexus between art and the multiple social and political identities of Venetian citizens. For an introduction to the range of foreign communities in the city and their architectural and artistic patronage, see D. Calabi, "Gli stranieri e la città," in *Storia di Venezia: Dalle origini alla caduta della Serenissima*, vol. 5, *Il Rinascimento: Politica e cultura*, ed. A. Tenenti and U. Tucci (Rome, 1996), 913–46. On art as a means of social and political integration of privileged immigrants, see B. De Maria, *Becoming Venetian: Immigrants and the Arts in Early Modern Venice* (New Haven, CT, 2010). On one of the largest immigrant communities, see E. C. Burke, *The Greeks of Venice, 1498–1600: Immigration, Settlement and Integration* (Turnhout, 2016). On the uses of public spaces, see E. Crouzet-Pavan, "Cultures et contre-cultures: À propos des logiques spatiales de l'espace public vénitien," in *Shaping Urban Identity in Late Medieval Europe*, ed. M. Boone and P. Stabel (Leuven, 2000), 89–117. On trading communities and their lodges, see, for example, E. Concina, *Fondaci: Architettura, arte e mercatura tra Levante, Venezia e Alemagna* (Venice, 1997). On material culture and social distinction, see P. Fortini Brown, *Private Lives in Renaissance Venice: Art, Architecture, and the Family* (New Haven, CT, 2004). Scholarship on confraternities is ever growing: see G. Koster, *Kunstler und ihre Bruder: Maler, Bildhauer und Architekten in den venezianischen Scuole Grandi (bis ca. 1600)* (Berlin, 2008); and R. Mackenney, *Venice as the Polity of Mercy: Guilds, Confraternities, and the Social Order, c. 1250–c. 1650* (Toronto, 2019).

106 P. Fortini Brown, *Venetian Narrative Painting in the Age of Carpaccio* (New Haven, CT, 1988), esp. 1–6, for a brief introduction to her argument.

107 Petkov, *Anxieties of a Citizen Class* (see above, p. 20, n. 32).

108 O. Demus, *The Church of San Marco in Venice: History, Architecture, Sculpture* (Washington, DC, 1960), 3.

109 Demus, *Church of San Marco*, 3.

rhetoric manifested itself in the aesthetic over-haul of San Marco, the state church of the city. By the third quarter of the thirteenth century, the exterior of the basilica had been encrusted with an overabundance of marbles and sculptural spoils from Constantinople. Its treasury had been enriched with a wide array of Byzantine relics, reliquaries, and precious artworks that nurtured Venice's image as a "holy city." And the area before the western entrance of San Marco had been turned into a monumental ceremonial space, reminiscent of imperial fora.[110]

Modern understandings of Venice as a cultural and artistic intermediary between East and West, and of San Marco as the visual manifestation of Venice's triumphal ideology in the aftermath of 1204, owe much to Otto Demus's scholarship. In a series of seminal publications, Demus compellingly interprets the architecture, the mosaic program, and the external sculptures of the basilica in the light of Venice's changing relations with Byzantium, and of the city's victory over the empire in 1204.[111] However—and

crucially for this study—Demus never extends this interpretation to the fourteenth century. Instead, he cautions that Dandolo's projects in San Marco represented "an entirely new and separate chapter in the decoration of the church." Having originally intended to publish them, Demus eventually omitted the baptistery and chapel of Sant'Isidoro from his monumental study of the mosaics of the basilica, leaving the question open as to how he would have situated them within his broad narrative of Venetian ascent vis-à-vis Byzantium.[112]

Despite Demus's caveat, the field of Byzantine studies has largely looked at Dandolo's projects in San Marco as evidence of Venice's enduring triumphalist stance. While the Latin rule of Constantinople ended in 1260, Venice's victorious ideology is generally understood to have inflected the arts of Venice long after the thirteenth century. In this context, the renovated high altar, baptistery, and chapel of Sant'Isidoro have largely been understood as (late) appropriations and adaptations of Byzantine models and explained as the visual means by which Venice

110 For a concise but rich review of both materials and historiography on the Fourth Crusade and San Marco, see R. S. Nelson, "High Justice: Venice, San Marco, and the Spoils of 1204," in *Η Βυζαντινή τέχνη μετά την τέταρτη Σταυροφορία: Η τέταρτη σταυροφορία και οι επιπτώσεις της*, ed. P. L. Vokotopoulos (Athens, 2007), 143–58. A standard reference on 1204 and its implications for Venice is G. Ortalli, G. Ravegnani, and P. Schreiner, eds., *Quarta crociata: Venezia, Bisanzio, Impero Latino*, 2 vols. (Venice, 2006). On the treasury, see, for example, Gallo, *Il tesoro di S. Marco*, 9–13; D. Buckton, ed., *The Treasury of San Marco, Venice* (Milan, 1984); and Hahnloser, *Il tesoro e il museo*. In his contribution to this last study, on page 3, W. F. Volbach directly connects the creation of the treasury with 1204. On the exterior redecoration of San Marco, see Demus, *Church of San Marco*, esp. 113–23. On the bronze horses set up on the terrace above the west façade, see M. Jacoff, *The Horses of San Marco and the Quadriga of the Lord* (Princeton, NJ, 1993). On Piazza San Marco as an emulation of the imperial fora, see J. Schulz, "Urbanism in Medieval Venice," in *City States in Classical Antiquity and Medieval Italy: Athens and Rome, Florence and Venice*, ed. A. Molho, K. Raaflaub, and J. Emlen (Stuttgart, 1991), 419–45. For a critical reappraisal of earlier scholarship and a range of new approaches to the art of San Marco in the thirteenth century, see the essays gathered in H. Maguire and R. S. Nelson, eds., *San Marco, Byzantium, and the Myths of Venice* (Washington, DC, 2010). The idea of a rhetoric of spoils and victory on the façades of San Marco has recently been opposed by A. F. Bergmeier, "The Production of Ex Novo Spolia and the Creation of History in Thirteenth-Century Venice," *FlorMitt* 62.2/3 (2020): 127–57.

111 Demus wrote a staggering number of publications on Venice. From these, Venice emerges as the intermediary between the Byzantine East and the medieval West, but also as an early

recipient of "proto-Renaissance" artistic trends, particularly in sculpture. 1204 is constantly identified as the main watershed in the history of Venice and its relations with Byzantium. These ideas emerge with different degrees of intensity in his articles, as well as in his major monographs: Demus, *Church of San Marco*; O. Demus, *The Mosaics of San Marco in Venice*, 2 vols. (Chicago, 1984); O. Demus and G. Tigler, *Le sculture esterne di San Marco* (Milan, 1995).

112 Demus, *Mosaics of San Marco*, 1:xi–xii, also cited in D. Pincus, "Venice and Its Doge in the Grand Design: Andrea Dandolo and the Fourteenth-Century Mosaics of the Baptistery," in Maguire and Nelson, *San Marco, Byzantium, and the Myths of Venice*, 245–71, at 248. Demus's archives at Dumbarton Oaks indicate that the scholar had originally intended to survey and research the two fourteenth-century chapels as part of the multiyear San Marco Project, hosted by Dumbarton Oaks. The idea was eventually abandoned in the early months of 1979, as fieldwork in Venice approached its final season: "I hope . . . to complete the work [the photographic survey of the mosaics of San Marco]—leaving aside the fourteenth-century mosaics of the baptistery and Isidore Chapel . . . so as to be able to arrive in Dumbarton Oaks in time to profit from the Symposium"; Otto Demus to Giles Constable, then director of Dumbarton Oaks, on 25 March 1979 (stamped as received on 9 April 1979). Washington, DC, Dumbarton Oaks Research Library and Collection, *Otto Demus Papers and the San Marco Mosaics Project and Corpus of North Adriatic Mosaics Papers*, Series 8 (1979), The previous year, a symposium was held at Dumbarton Oaks as a way to conclude the project and present its preliminary results. See O. Demus, "Venetian Mosaics and Their Byzantine Sources: Report on the Dumbarton Oaks Symposium of 1978," *DOP* 33 (1979): 337–43.

asserted its abiding pride as victor and successor of Byzantium and its claims as a rising colonial power. This interpretive tradition has alternately either disregarded the politically fraught circumstances under which the government sponsored those campaigns or reinterpreted them as a stimulus for the production of propagandistic art. For example, Debra Pincus—whose research has substantially furthered our knowledge of Dandolo's projects, and to whom this book is enormously indebted—has remarked that Dandolo's reign coincided with a phase of conflicts and instability. But she ultimately concurs with triumphalist interpretations of the fourteenth-century renewal of San Marco and approaches it as the inaugural phase of the long process of gestation of the myth of Venice.[113] Hans Belting, in turn, in two brief but important interpretive essays, alludes to a number of concerns that are crucial to the present study. He advises that the war against Genoa likely informed artistic patronage in San Marco and notes that the geopolitical realignments in the eastern Mediterranean transformed the ways in which style (particularly Byzantine style) would be understood and used in Venice. And he points out that style had key political implications in Dandolo's commissions in San Marco. Yet Belting too reaches the conclusion that Byzantine forms conveyed Venice's unique history and its claims to inherit Byzantium, and that they were instrumental to Dandolo's attempt to promote a quasi-royal ducal persona.[114]

The triumphal narrative outlined above effectively (if implicitly) turns Venice and its enduring predilection for Byzantine art forms into intellectual and artistic bastions against notions of Byzantine decline. This narrative coexists uncomfortably with another, competing account. It too positions Venetian art at the boundary between East and West and sees the city as a stronghold of Byzantine aesthetic values in Italy. This alternate narrative, though, hinges more directly on historiographic models of European crisis and renewal, and on Vasarian art-historical oppositions between Greek and Latin visual idioms, respectively identified with the "old" and "new" vocabularies of fourteenth-century Italian art. The trecento emerges from this account as a period of artistic transition, during which Venetian artists increasingly moved away from the (conservative) Byzantinizing visual idiom that they had previously interiorized and adopted a new (and more modern) pictorial language that was better aligned with the latest artistic developments in Italy and Europe. The contours of this narrative have been significantly softened and revised over the past decades. Its original derogatory stance toward Byzantine art has been largely disavowed, and the shortcomings of a teleological reading of artistic change have been repeatedly exposed. More generally, scholars have uncovered significant evidence of the enduring fascination of Venice's fifteenth- and sixteenth-century artists with Byzantine pictorial traditions, and of the new meanings that the arts of Byzantium acquired in the lagoon before and after the fall of Constantinople to the Ottomans in 1453.[115] They have brought attention to the singularity and long-lasting popularity of Cretan and Cretan-Venetian icons.[116] And they have investigated the

113 D. Pincus, "Hard Times and Ducal Radiance: Andrea Dandolo and the Construction of the Ruler in Fourteenth-Century Venice," in Martin and Romano, *Venice Reconsidered*, 89–136; and D. Pincus, "The Turn Westward: New Stylistic Directions in Fourteenth-Century Venetian Sculpture," in *Medieval Renaissance Baroque: A Cat's Cradle for Marilyn Aronberg Lavin*, ed. D. A. Levine and J. Freiberg (New York, 2010), 25–44.

114 H. Belting, "Bisanzio a Venezia non è Bisanzio a Bisanzio," in *Il Trecento adriatico: Paolo Veneziano e la pittura tra Oriente e Occidente*, ed. F. Flores d'Arcais and G. Gentili (Milan, 2002), 71–79; and H. Belting, "Dandolo's Dreams: Venetian State Art and Byzantium," in *Byzantium: Faith and Power (1261–1557); Perspectives on Late Byzantine Art and Culture*, ed. D. T. Brooks (New Haven, CT, 2006), 138–53.

115 Scholarship on Giovanni Bellini provides an outstanding example of this trend. See, among others, R. Goffen, "Icon and Vision: Giovanni Bellini's Half-Length Madonnas," *ArtB* 57.4 (1975): 487–518; C. Campbell and A. Chong, eds., *Bellini and the East* (London, 2005); and P. Hills, "Vesting the Body of Christ," in *Examining Giovanni Bellini: An Art "More Human and More Divine,"* ed. C. C. Wilson (Turnhout, 2015), 61–76. Architectural historians have also placed increasing emphasis on the enduring import of Byzantine architecture on Venetian Renaissance buildings, especially those designed by Mauro Codussi (ca. 1440–1504). For a brief introduction, see R. Lieberman, "Venetian Church Architecture around 1500," *Bollettino del Centro Internazionale di Studi di Architettura "Andrea Palladio"* 19 (1977): 35–48; and D. Howard, *The Architectural History of Venice*, rev. ed. (New Haven, CT, 2002), 132–49.

116 See, among others, N. M. Chatzēdakē, *Da Candia a Venezia: Icone greche in Italia, XV–XVI secolo* (Athens, 1993); M. Vassilaki, *The Hand of Angelos: An Icon Painter in Venetian Crete* (Farnham, 2010); and M. Vassilaki, "Looking at Icons

significance of specific social groupings and the role of colonial subjects and other social and cultural minorities in shaping Venice's artistic language from the fourteenth century onward.[117]

Furthermore, from a methodological standpoint, Michele Bacci reminds us that our understanding of late medieval icon painting in Venice and its overseas territories is poorly served by established art-historical terminologies and categories, and by the very language of "hybridity."[118] In a similar vein, Michalis Olympios criticizes the conventional terminology employed in the study of the arts and architecture of Crete in the fifteenth and sixteenth centuries.[119] Finally, in a wide-ranging critical review of Venetian art historiography that builds on a vast (but dispersed) body of recent research, Herbert Kessler and Serena Romano have proposed new chronological partitions and interpretative approaches to the arts of the lagoon. Revisiting ideas of Venice as "another Byzantium," the authors challenge simplistic understandings of Byzantine art as a unified (and stable) visual language, invoking instead the manifold Byzantine artistic traditions that Venice had access to from its foundation, the temporal depth of Venice's engagement with

Byzantium and its neighbors, and the broad range of meanings that artistic appropriation acquired in Venice as a consequence. Furthermore, Kessler and Romano forcefully reaffirm the active nature of Venice's artistic appropriation: in their words, Venice "targeted" a range of foreign artistic traditions—Byzantine, Islamic, Gothic, and Italian—in view of needs that were specific and locally determined, and that ultimately resulted in "assertively local" artworks. Conversely, Venetian art was also cherished and imitated abroad. Venice featured prominently in the trade and pilgrimage routes of the Mediterranean. These functioned as highways of artistic interaction, not only contributing to the city's own aesthetic diversity but also disseminating Venetian aesthetics (and Venetian artifacts) among the elite groups across the Mediterranean. Venice's importance as a commercial, religious, and political hub in turn invites reconsideration of the role that the city's art may have played in nurturing and transforming Italian trecento painting, including Giotto's visual horizons between his two major campaigns in Assisi and Padua. Finally, and crucially for the argument of this study, Kessler and Romano remind us that the arts of San Marco consistently integrated contemporary life and politics into sacred history.[120]

The constructive critical efforts made by several interpreters will assist future scholarship in reconciling the two divergent narratives outlined above, and in obviating some of their flaws. Meanwhile, a certain degree of dualism and determinism still colors the conceptual categories and the vocabulary that are available to art historians to engage with Venetian art of this period, both in the capital and in its colonies. Within this paradigm, Dandolo's artistic projects in San Marco are routinely discussed as the outcome of an enigmatic commixture of Byzantine and Western visual elements, and thus described in terms of visual dualism and hybridity.[121]

and Contracts for Their Commission in Fifteenth-Century Venetian Crete," in *Paths to Europe: From Byzantium to the Low Countries*, ed. B. Coulie and P. Dujardin (Cinisello Balsamo, 2017), 101–15. Michele Bacci has also published extensively on Veneto-Cretan interactions: M. Bacci, "Some Thoughts of Greco-Venetian Artistic Interactions in the Fourteenth and Early-Fifteenth Centuries," in *Wonderful Things: Byzantium through Its Art; Papers from the Forty-Second Spring Symposium of Byzantine Studies, London, 20–22 March 2009*, ed. A. Eastmond and L. James (Farnham, 2013), 203–28; M. Bacci, "Veneto-Byzantine 'Hybrids': Towards a Reassessment," *Studies in Iconography* 35 (2014): 73–106; and M. Bacci, "Greek Madonnas and Venetian Fashion," *Convivium* 7.1 (2020): 152–77.

117 See especially M. Georgopoulou, *Venice's Mediterranean Colonies: Architecture and Urbanism* (Cambridge, 2001); E. R. Dursteler, *Venetians in Constantinople: Nation, Identity, and Coexistence in the Early Modern Mediterranean* (Baltimore, 2006); and E. N. Rothman, *Brokering Empire: Trans-Imperial Subjects between Venice and Istanbul* (Ithaca, NY, 2012).

118 M. Bacci, "L'arte delle società miste del Levante medievale: Tradizioni storiografiche a confronto," in *Medioevo: Arte e storia; Atti del convegno internazionale di studi Parma, 18–22 settembre 2007*, ed. A. C. Quintavalle (Milan, 2008), 339–54. See also Bacci, "Some Thoughts"; and Bacci, "Veneto-Byzantine 'Hybrids,'" esp. 73–77.

119 M. Olympios, "Treacherous Taxonomy: Art in Venetian Crete around 1500 and the 'Cretan Renaissance,'" *ArtB* 98.4 (2016): 417–37.

120 H. L. Kessler and S. Romano, "A Hub of Art: In, Out, and Around Venice, 1177–1499," *Convivium* 7.1 (2020): 17–51. See also the brief but compelling essay by H. L. Kessler, "Conclusion: La Genèse Cotton est morte," in *Les stratégies de la narration dans la peinture médiévale: La représentation de l'Ancien Testament aux IVᵉ–XIIᵉ siècles*, ed. M. Angheben (Turnhout, 2020), 373–402.

121 On hybridity, see, for example, see Belting, "Bisanzio a Venezia," 73; and Belting, "Dandolo's Dreams," 144. On the artistic "chiasm" of Dandolo's projects, iconographically and

The two accounts of Venetian art summarized above are widely divergent. Yet they share one key feature: they approach Byzantine and Italian art as monolithic entities, and they cast Venetian medieval art as essentially derivative. In one view, Venice's public image and cultural identity rely on the emulation (however creative and appropriative) of Byzantine forms—implicitly testifying to the enduring vitality of Byzantine art against notions of Byzantine decline. In another view, Venice only truly becomes a "generative" artistic center when the artists of the lagoon disenfranchise themselves from the legacy of Byzantine art, embracing and metabolizing instead the visual innovations of their colleagues on the Italian mainland, the new humanist fascination with antiquity, and by extension the march of the West toward modernity. Andrea Dandolo's projects in San Marco represent the point of convergence *and* the breaking point of these conflicting narratives, and thus offer an ideal ground for their reappraisal. Each of these campaigns entailed significant public expenditure and was the result of a collective, institutional decision. And it made a specific intervention in the religious and political space of San Marco, and by extension of the city of Venice. In this context, style and iconography were not generic "symptoms" of Venetian conservatism or triumphalism. Instead, as I will suggest in the final section of this study, they represented a specific aesthetic response to uncertainty and instability and embedded the particular concerns and questions confronted by the Venetian

governing elite and the broader community at times of accelerated change. The notion of "crisis," once emancipated from any deterministic connotations, may significantly contribute to redressing these views.

MAKING CRISIS WORK: ART, HISTORY, AND POLITICS

In reinstating "crisis" at the center of my analysis of the art of San Marco in the fourteenth century, I do not wish to revive cyclical or teleological views of art history or reiterate simplistic ideas of decline and rebirth. Instead, I aim to revisit the polarized narratives about fourteenth-century Venetian art introduced above and to provide a new matrix within which to understand artistic choice and visual change. To this end, and in view of the manifold uses of the term "crisis" in modern scholarship, this section elucidates the specific meanings associated with the concept over the next chapters.

This study embraces the dual connotation of crisis as a historical reality and as an interpretive perspective. In the first sense, my use of the term "crisis" follows Hannah Arendt's formulation.[122] Arendt does not treat "crisis" as a mere synonym of "acute adversity." In her writings, the term applies more specifically to those disruptive circumstances that force communities to reappraise their core cultural, social, and political institutions and to reaffirm or transform those institutions as well as the values that underpin them. The domestic and international challenges that Venice faced in the mid-fourteenth century produced a protracted unsettlement that threatened the integrity and solidarity of the Venetian state, its ruling class, and its civic community. This breach of normalcy did not merely trigger social anxiety (as it would do, in Fortini Brown's reading, among the citizen class excluded from power in the fifteenth century).[123] Rather, in line with Arendt's characterization of crisis, ongoing disruptions fissured Venice's institutional tissue and political fabric, provoking its government to enact a vast program of legal, political, and social reorganization.

stylistically divided between Byzantine and Western traditions, see E. De Franceschi, "Lo spazio figurativo del battistero marciano a Venezia: Una introduzione," *Ateneo Veneto*, ser. 3, 12.1 (2013): 253–65, at 264. On Dandolo's projects as manifesting "Byzantine residues reinterpreted with new vitality," see F. Flores d'Arcais, "Il Trecento in San Marco: La recente letteratura critica e gli ultimi restauri," in Vio, *San Marco: La basilica*, 1:297–307, at 306 (see above, p. 13, n. 5). For a critically nuanced use of the concept of hybridity, see T. E. A. Dale, "Cultural Hybridity in Medieval Venice: Reinventing the East at San Marco after the Fourth Crusade," in Maguire and Nelson, *San Marco, Byzantium, and the Myths of Venice*, 151–91. For a critical discussion of the terms "hybridity" and "visual dualism" as applied to these projects, see S. Gerevini, "Art as Politics in the Baptistery and Chapel of Sant'Isidoro at San Marco, Venice," *DOP* 74 (2020): 243–68. I will return to the question of Venetian visual diversity in the conclusion of this study. For a range of different approaches, see E. Beaucamp and P. Cordez, eds., *Typical Venice? The Art of Commodities: 13th–16th Centuries* (Turnhout, 2020).

122 Arendt, "The Crisis in Education" (see above, p. 5, n. 2); and Arendt, "The Crisis in Culture" (see above, p. 5, n. 2). For an analysis of Arendt's approach to crisis, see Norberg, "Arendt in Crisis" (see above, p. 5, n. 2).

123 Fortini Brown, *Venetian Narrative Painting*.

Throughout this study, crisis will also function as a heuristic tool. Here, my approach will be governed by the original meaning of the Greek term κρίσις and by its complex medieval legacy. As we shall see, κρίσις did not originally describe an unsettled condition. Rather, it referred chiefly to the ability to *separate* (mentally or physically)—that is, to the process or act by which complexity and uncertainty were understood, adjudicated, and resolved. From this standpoint, crisis does not so much indicate disruption as it relates how disruption is apprehended and addressed by those who experience it.

From a methodological perspective, this dual approach proves capacious enough to capture both Venice's instability in the mid-fourteenth century (crisis), and the political, institutional, and cultural processes by which contemporaries (particularly those in government) endeavored to comprehend and remedy the situation (*krisis*). This twofold understanding of crisis (as an actual event that upsets the regular flow of time and as a criterion that enables subjects to understand and decide upon reality) is fully compatible with medieval conceptual frameworks. In the Greek New Testament, κρίσις referred to divine justice, and most commonly to the Day of Judgment, η ημέρα της κρίσεως.[124] The latter marked the end of the world and of earthly time and signaled the end point of the Christian path toward salvation, turning crisis into the linchpin of medieval understandings of history. In addition, the Day of Judgment represented the ultimate instantiation of God's discernment, and thus the paradigm on which to model earthly codes of behavior and judicial systems—making the category of κρίσις (and its Latin counterpart *iudicium*) conceptually inseparable from medieval ideas about justice and order.

This broader notion of crisis offers a rich roadmap for us to examine Andrea Dandolo's artistic projects in San Marco and to situate them against trecento attitudes toward history, politics,

and eschatology. Art, we will argue, participated in all aspects of crisis. At one level, it expressed the concerns of contemporaries, giving visual form to their anxieties and the questions that confronted them at times of accelerated change. At another level, art *was* itself crisis—that is, it contributed to the processes of appraisal and adjudication by which the Venetian government metabolized and responded to unrest. Finally, the imagery of San Marco *presaged* crisis, by engaging with universal history and with Christian ideas about judgment and salvation.

CRISIS, DISRUPTION, AND COMMON SENSE

In Arendt's view, crises differ from other disruptive circumstances in their ability to reveal the inadequacy of prejudices and eradicate them. Etymologically, the term "prejudice," which derives from Latin *prae-iudicium* ("prior judgment"), relates to any preestablished criteria and protocols of action. It is with this connotation that Arendt employs the word. As she explains, "The disappearance of prejudices simply means that we have lost the answers on which we ordinarily rely without even realizing they were originally answers to questions. A crisis forces us back to the questions themselves and requires from us either new or old answers, but in any case, direct judgments."[125] A crisis, then, is a situation of upheaval that causes the suspension of ordinary response mechanisms—which prove insufficient or inefficient as means of addressing the issues at hand—in favor of a new critical appraisal of problems and their solutions. As Arendt explains, however, crises also represent real threats to the stability of communities, for at times of crisis common sense also disintegrates, together with prejudice. To be sure, by "common sense" Arendt refers to something more indispensable than practical knowledge. Common sense, she clarifies, is a particular kind of human reason, by which "we and our five individual senses are fitted into a single world common to us all and by the aid of which we move about in it. . . . In every crisis a piece of the world, something common to us all, is destroyed."[126] In Arendt's view, the failure of common sense that looms during crises coincides

124 Variations of this phrase recur in several passages of the Greek New Testament, and most frequently in the Gospel of Matthew (Matt. 10:15, 11:22, 11:24, 12:36, and 23:33). For all recurrences of the term κρίσις in the Greek New Testament, and the range of its meanings, see W. Bauer and F. W. Danker, eds., *Greek-English Lexicon of the New Testament and Other Early Christian Literature*, 3rd ed. (Chicago, 2000), s.v. κρίσις.

125 Arendt, "The Crisis in Education," 171.
126 Arendt, "The Crisis in Education," 175.

with the danger of losing a shared way of looking at and understanding reality, and therefore with the disappearance of a sense of collective direction and purpose. Such disorientation weakens the bonds that cement a community and enable it to function. By challenging the society's fundamental rules of coexistence and its values, it increases the potential for conflict and operates as a divisive and potentially destructive force. Thankfully, crisis's destructive potential can be countered. In fact, "A crisis becomes a disaster only when we respond to it with preformed judgments, that is, with prejudices."[127]

Arendt's determination of crisis as chasm— that is, a breach of normalcy that simultaneously threatens the survival of a community *and* provokes its members to rethink and reassert the foundations of their living together in order to avert disaster—provides a useful matrix within which to examine fourteenth-century Venice and to investigate the function and meaning of the artistic renewal of San Marco. The plague, the rivalry against Genoa, Ottoman advances in the East, internal strife, and the tensions that ensued from colonial expansion did not simply trouble the Venetian government and community. Instead, it jolted them out of their default mechanisms of decision-making and response. As already discussed, internal and external conflict soared, and Venice's established social, institutional, and political formations were destabilized in the process. In turn, the need to address these ongoing challenges also compelled Venice's governors to reckon with fundamental questions about the nature and the sources of political authority, the distribution and exercise of power, and the meaning and boundaries of citizenship.

The imagery in the altar area, baptistery, and chapel of Sant'Isidoro bears the trace of both phenomena. On the one hand, the depictions of communal intercession and popular piety on the pala feriale may have reflected the growing preoccupation of Venice's governors with their city's safety, stability, and well-being. Similarly, the baptistery includes the representation of a doge and two public officers kneeling at the foot of the cross, which is tempting to interpret as evidence of contemporary presentiments of fragmentation and

potential dissolution. Yet the mosaics in the baptistery also present the viewer with a catalogue of "difficult decisions" from biblical history, visual examples of just and unjust sovereigns, and scenes of (divine) bestowal of authority that would incite the beholder to reflect on the foundations of political power and the responsibilities and dilemmas it entailed. Along similar lines, the chapel of Sant'Isidoro depicts Doge Domenico Michiel's military mission on the island of Chios. As the earliest (and only) images in San Marco showing a doge as a military chief in the act of exercising his authority outside of Venice, these mosaics resonate with quandaries over how to assert, legitimize, and organize Venice's rule overseas.

Arendt's formulation provides a valuable criterion for distinguishing "crisis" from other disruptive circumstances, identifying and explaining the intellectual and political processes that crises set in motion, and understanding the significance of the visual arts within these processes. It also offers a useful and well-balanced paradigm within which to understand the dynamic interactions between uncertainty, the recovery of tradition, and the implementation of change—a question to which we shall return. The limitation of this approach, however, as of other conceptualizations of crisis as a "situation," is that it implicitly confines the role of the visual to that of a mirror— however faithful, distorting, or idealizing—of reality and the sentiment of contemporaries toward the events of the real world. That this is only one way of looking at the relation between aesthetics and politics, and that image making has a greater part to play at times of uncertainty, emerges from consideration of the ancient Greek word κρίσις and its medieval survivals.

THE ANCIENT ROOTS OF CRISIS

In antiquity, the verb κρίνω and the noun κρίσις indicated, in essence, the act of separating, or the ability to separate.[128] A wide array of meanings radiated from this semantic core. For example, in the language of anatomy, κρίσις named the spinal cord: the axis that both divides and unites the body. And medical jargon referred to κρίσις as the

127 Arendt, "The Crisis in Education," 171.

128 The following discussion is based on LSJ, s.v. κρίσις. See also P. Chantraine, ed., "Κρίνω," in *Dictionnaire etymologique de la langue grecque: Histoire des mots* (Paris, 1999), 584–85.

turning point in the progress of a disease: a transition that could indicate either recovery or death. However, the notion of κρίσις unfolded its fullest semantic potential in the intellectual realm. The ability to separate mentally is equivalent with the capacity to discern, which makes κρίσις coterminous with the activity of thought itself: any act of thinking, however complex, rests on the ability to distinguish something for itself, and to discriminate it from other things.[129] As such, κρίσις did not in origin describe a situation of uncertainty or adversity. Instead, it referred to the faculty of the mind by which reality was understood and uncertainty dissipated. This explains why the term κρίσις is most commonly translated as "decision" and "judgment": forming a judgment, or reaching a decision about something, requires that we exercise discernment, in order to identify the terms of the problem at hand and distinguish among the choices presented to us. This is true of all decisions, and ancient Greek sources use κρίσις flexibly to identify the selection of winners of sports and theatrical events, the rulings of a court, and even the verdict over the victors of a war or battle. But the ability to discern clearly was nowhere more vital than in the political realm, where κρίσις denoted both a civic right and the exercise of legal justice. As Aristotle stated in a much-quoted passage from his *Politics*—a treatise that was first translated into Latin around 1260 and that revolutionized fourteenth-century political theory and practice—"a citizen pure and simple is defined by nothing else so much as by his participating in judicial activity [*krisis*] and office" (πολίτης δ' ἁπλῶς οὐδενὶ τῶν ἄλλων ὁρίζεται μᾶλλον ἢ τῷ μετέχειν κρίσεως καὶ ἀρχῆς).[130]

From a methodological standpoint, the ancient semantics of crisis enriches our understanding of the word to include the processes that enable an individual or community to adjudicate reality and act upon it. In turn, this affords a new perspective on both the artistic renewal of San Marco in the mid-fourteenth century and the relation between art and politics more broadly. As mentioned above, the challenges that Venice faced at this time prompted the doge and the government to ask fundamental questions about authority, leadership, and community. These questions were translated into the vast program of institutional, historical, and legal reform that we surveyed in the previous section. In his capacity as doge, Andrea Dandolo supervised the revision of the city statutes and commissioned an additional book of constitutions—the so-called *Liber Sextus*—to be appended to them. He ordered the collation of Venice's diplomatic agreements with foreign polities and committed the chancery to compiling the first official written history of Venice. Those projects, implemented over the course of a decade, at the same time as the artistic renewal of San Marco, *were* krisis, in the original sense of the Greek word. They expressed the government's attempt to "see more clearly" and decide more efficiently by dispelling documentary disorder and factual confusion. In Dandolo's intention, the Venetian state would emerge from this process of historical and legal verification as a more orderly political organism, based on clearer norms and procedures that would increase its resilience and its ability to confront and manage change.

As an exercise in political and historical visualization, the imagery in San Marco contributed crucially to Dandolo's enterprise of state building: it, too, was *krisis*. This statement requires clarification, for Venetian studies have long recognized the significance of images in "figuring" the Venetian state. Within this framework, images produced between the fourteenth century and the end of the Republic are widely understood to have incarnated and publicly disseminated

129 This idea is central to A. Schmitt, *Modernity and Plato: Two Paradigms of Rationality* (Rochester, 2012). For a brief but compelling analysis of Arbogast Schmitt's argument about κρίσις, see also A. Stavru, "'Aisthesis' e 'Krisis': Rappresentazione e differenza in Platone e Aristotele," *Quaderni urbinati di cultura classica* 81.3 (2005): 151–54. I am grateful to Alessandro Stavru for introducing me to Schmitt's work.

130 Aristotle, *Politics* 3.1275a. For an introduction to scholarship on citizenship in antiquity, see J. K. Davies, "Citizenship, Greek," in *The Oxford Companion to Classical Civilization* ed. S. Hornblower and A. Spawforth, 2nd ed. (Oxford, 2014), 173–74, at 174. See also M. Crawford, "Citizenship, Roman," in *The Oxford Companion to Classical Civilization*, ed. S. Hornblower and A. Spawforth, 2nd ed. (Oxford, 2014), 174–75, at 174. For a more detailed analysis, see L. Cecchet and A. Busetto, *Citizens in the Graeco-Roman World: Aspects of Citizenship from the Archaic*

Period to AD 212 (Leiden, 2017); on the intersections between citizenship and religion, see J. Blok, *Citizenship in Classical Athens* (Cambridge, 2017); and for a broader historical overview, see P. Riesenberg, *Citizenship in the Western Tradition: Plato to Rousseau* (Chapel Hill, NC, 1992).

Venice's political ideals, functioning as potent ideological tools in the service of the state.[131] This formulation captures the crucial significance of the visual arts as a means of political communication throughout Venetian history. But it implicitly postulates the existence of a body of political theory—or at least a fully formed "political ideal" or conceptual model of the state—that it would then be the task of images to visually reflect and disseminate. As we will see in detail in relation to the chapel of Sant'Isidoro and the baptistery, however, this neatly contoured political model was unavailable in fourteenth-century Venice. The social bases of the Venetian state were being redefined, as were the structures of its government and the relations between its different organs. On a wider level, both political practice and political theory were in flux across Italy. The need to give legal justification to the independence of local communal governments from imperial and papal temporal authorities prompted fourteenth-century jurists to better define the foundations of civic liberty and autonomy. And the seemingly inevitable collapse of republican regimes under the pressure of civic discord in the mid-century stimulated political theorists to reflect on the machinery of government and to suggest practical solutions to avoid divisions and maintain republican regimes.[132] Contemporary reasoning about the state, though, had not yet congealed into a stable theoretical framework; or, more accurately, the (modern) idea of the state as a separate legal and constitutional order that rulers have a duty to maintain was beginning to take shape at this time.[133] In this context, the imagery of San Marco, which includes textual and figural representations of the doge, public officials, and

commoners, should not be regarded as subservient to a political ideal that it directly translated or reflected. Rather more fundamentally, image making *participated* in the process of (trans)formation of the Venetian state by giving visual form (and thus legibility and substance) to emerging ideas of leadership, authority, and community, just as they began to coalesce into the government's administrative and legal reforms in the mid-fourteenth century. This interpretive framework also inflects the meanings of style and the selective use of Byzantine visual language more specifically. The latter did not translate an existing (and stable) imperial ideology that Venice strove to appropriate through artistic emulation. Instead, it represented one significant component within a broader range of politically inflected visual traditions, which Dandolo's commissions creatively drew upon and which—together—embodied a search for suitable aesthetic means to express emerging concerns and new political ideals in the face of uncertainty.

In addition, each of the artistic commissions sponsored by the government in San Marco engaged history at multiple levels. They comprised carefully chosen "tokens of the past," in the form of relics, holy bodies, or revered artworks. They restaged those objects architecturally and artistically, enhancing their visibility within the church. The authenticity and venerable history of those "vestiges," too, were emphasized in the new layout by means of detailed visual storying and extensive textual inscriptions that documented and invented the past in equal degrees. The mobilization of history at times of transition, and the active use of the past and its tangible vestiges to both understand and justify change, represents much-studied aspects of medieval civilizations in general, and of Venice's culture in particular.[134] Scholarship has specifically acknowledged Andrea Dandolo's sensitivity to the power of history to both document and reinvent the past, and to the centrality of historical narrative (both visual and textual) within his program of political and

131 Rosand, *Myths of Venice*, esp. 1–4.

132 Q. Skinner, *The Foundations of Modern Political Thought: The Renaissance* (Cambridge, 1978), esp. 1–21 and 42–65.

133 Scholarship concurs that the thirteenth and fourteenth centuries were formative stages in the history of modern political thought in Europe. On medieval notions of the state as emerging from legal codifications, see A. Harding, *Medieval Law and the Foundations of the State* (Oxford, 2002); on the origins of the modern idea of the state in the works of fourteenth-century Italian jurists and political theorists, see Skinner, *Foundations*. On medieval notions of state and political ideas, see also J. Canning, *A History of Medieval Political Thought: 300–1450* (London, 1996); and Post, *Medieval Legal Thought* (see above, p. 15, n. 14).

134 For a range of different approaches to this subject, and further references, see the essays gathered in Maguire and Nelson, *San Marco, Byzantium, and the Myths of Venic*; and M. Büchsel, H. L. Kessler, and R. Müller, eds., *The Atrium of San Marco in Venice: The Genesis and Medieval Reality of the Genesis Mosaics* (Berlin, 2014).

institutional development. The category of crisis rarely figures in these discussions. Yet crisis is—literally—the pivot on which medieval temporal, historical, and political structures revolve, and so it requires more careful consideration.

RECOVERING MEDIEVAL CRISIS

Whether it is regarded as a situation of radical disruption or as the ability and the act of discernment, crisis has an intrinsic temporal dimension. From the former perspective, crisis represents a historical disjuncture; as such, it presupposes and demarcates a before and an after that can be compared one against the other. In the second formulation, crisis engages time and history more ambivalently. Every act of discernment occurs at a specific point in time. It is the threshold that separates the past (when a certain problem was unclear, unseen, or unresolved) from the present of clarification and deliberation. But κρίσις also indicates the general faculty of discerning. In this sense, it allows us to distinguish one moment or event for itself, and to separate it from what comes before or after. Thus, crisis is what makes possible both the perception of time and the organization of history.

These two notions—crisis as a disruption in the course of history versus crisis as the discernment that "makes" time and history—converged in the medieval episteme. The term κρίσις appears frequently in the Greek Bible, particularly in the New Testament. Consistent with classical usage, the word is broadly used there to refer to the activity of God or the Messiah as judge. However, it is commonly used in relation to the "Hour" or "Day of Judgment," when all men and women will be sorted out and rewarded with eternal beatitude or damnation according to their deeds.[135] This imbues κρίσις (and its Latin counterpart in the Vulgate, iudicium) with apocalyptic connotations and places it at the heart of medieval reflections about time and history, as well as about justice and order.

Based on a range of (largely allusive) prophetic texts and parables, the most detailed of which are Daniel 10–12, Matthew 25:31–46, and John's Book of Revelation, the Last Judgment is understood to coincide with the Second Coming of Christ, and thus with the fullness of divine revelation, with the end of the created world and of human time, and with the irruption of eternity into history. Within the medieval Christian worldview, then, divine judgment represented an actual historical event and a principle of universal order and justice that structured and presided over the world.[136]

In spite of several medieval attempts to predict the end of the world and link it to specific warning signs (typically natural disasters or political upheaval), the time of the Second Coming was by definition unknowable.[137] Yet the fact that

135 The "Hour of Judgment" (ἡ ὥρα τῆς κρίσεως αὐτοῦ) is referred to in Rev. 14:7. Mentions of the "Day of Judgment" (ἡ ἡμέρα τῆς κρίσεως) abound in the Bible. For a comprehensive list of occurrences and their translations, see Bauer and Danker, *A Greek-English Lexicon*, s.v. κρίσις.

136 This and the following paragraphs condense a vast body of scholarship on medieval apocalypticism and eschatology, inevitably intersecting lively debates on these controversial topics and on the terminology used to study them. For concise but compelling reviews of research in these fields, and for informed analyses of the main scholarly positions and controversies in these areas, see the editors' introductions to the following collective volumes, whose lead I have followed in my own account: C. W. Bynum and P. H. Freedman, "Introduction," in *Last Things: Death and the Apocalypse in the Middle Ages*, ed. C. W. Bynum and P. H. Freedman (Philadelphia, 2000) 1–17; M. A. Ryan, "Introduction: A Companion to the Premodern Apocalpyse," in *A Companion to the Premodern Apocalypse*, ed. M. A. Ryan (Leiden, 2016), 1–17; and V. Wieser and V. Eltschinger, "Introduction: Approaches to Medieval Cultures of Eschatology," in *Cultures of Eschatology*, vol. 1, *Empires and Scriptural Authorities in Medieval Christian, Islamic and Buddhist Communities*, ed. V. Wieser, V. Eltschinger, and J. Heiss (Berlin, 2020), 1–22. See also M. Angheben, *Alfa e Omega: Il giudizio universale tra oriente e occidente*, ed. V. Pace (Castel Bolognese, 2006), 9–17. On the distinction between the Last Judgment and the broader semantic and temporal implications of the Apocalypse in medieval thought, see Y. Christe, *Jugements derniers* (Saint-Léger-Vauban, 1999).

137 Classic works on medieval millenarism, prophecy, and end-of-time calculations include: N. Cohn, *The Pursuit of the Millennium: Revolutionary Millenarians and Mystical Anarchists of the Middle Ages* (Fairlawn, NJ, 1957); R. E. Lerner, *The Powers of Prophecy: The Cedar of Lebanon Vision from the Mongol Onslaught to the Dawn of the Enlightenment* (Berkeley, 1983); and P. J. Alexander, *The Byzantine Apocalyptic Tradition* (Berkeley, 1985). On calculations and the ultimately unknowable nature of the end of times, see R. Landes, "Lest the Millennium Be Fulfilled: Apocalyptic Expectations and the Pattern of Western Chronography 100–800 CE," in *The Use and Abuse of Eschatology in the Middle Ages*, ed. W. Verbeke, D. Verhelst, and A. Welkenhuysen (Leuven, 1988), 137–211. For different takes on the significance of natural disasters within medieval apocalypticism, and further bibliography, see among others L. A. Smoller, "Of Earthquakes, Hail, Frogs and Geography: Plague and the Investigation of the Apocalypse in the Later Middle Ages," in Bynum and Freedman, *Last Things*, 156–87; and A. F.

it would definitely happen turned earthly time into a finite entity (uncertain only in its duration), and rendered divine judgment and the end of the world forever imminent. Hence the Middle Ages lived in an attitude of continuous expectation of crisis. On the one hand, the prospect of the end fueled fears of punishment and disaster—particularly as the Second Coming was described in the book of Daniel and in John's Revelation as preceded by violent signs and a fierce battle between good and evil. On the other hand, apocalyptic expectations generated (more optimistic) prospects of redemption and reward. Because history—which implied transience and death—was the direct manifestation of the fallen state of humankind, the ultimate reunion of man with God was coterminous with the Last Judgment and the end of earthly time. In this context, apocalyptic sentiment nourished the hope of passing "from the shifting sands of history to the eternal realm of beatitude."[138]

If redemption required the end of human time, the economy of Christian salvation was nonetheless intimately entangled with history.[139] By the fullness of his grace, God had willingly entered time and become human. The incarnation of Christ had redeemed historical time, transforming it into another form of revelation and the only available pathway to salvation. In turn, crisis—that is, divine judgment—did not merely terminate human history, nor did it simply represent the ultimate catastrophe. Instead, it gave history meaning and structure. From an apocalyptic perspective, history manifested the trajectory of divine providence. And it operated as the arena within which individual salvation and cosmic justice were worked out.[140]

For the medieval episteme, then, crisis, history, and justice are fundamentally intertwined. Medieval understandings of history as—simultaneously—an obfuscation of God's revelation and the locus of its gestation inevitably inflected medieval interpretations of present events and oriented contemporary political frameworks. Millennialist takes on the Apocalypse, and related concerns with the Antichrist and the ultimate conflict between Good and Evil, nurtured medieval reform movements, both pacific and militant. In this context, adverse events (natural disasters, health emergencies, war losses, etc.) lent themselves to being interpreted as signs of divine wrath. As such, they sustained criticism against established authorities, either secular or ecclesiastic. And they were used by reformist leaders to endorse change, and less frequently to instigate collective action against consolidated political or religious powers, which were presented as transgressing God's justice and serving "unholy" causes. Apocalypticism, however, was not necessarily subversive. On the contrary, seeing history in providential terms (i.e., as oriented toward salvation) encouraged integrating current events into a universal scheme of meaning. Apocalyptic perspectives on time could then be marshaled to make the present more legible, normalizing exceptional events and imparting a sense of order, justice, and direction to a reality in disarray. Or they could be used by those in power as tools of political control, to mitigate social anxieties, defuse dissent, stabilize authority, explain change, or even justify the status quo.[141]

Both these attitudes are attested in the mid-trecento. On the one hand, there was an upsurge

Bergmeier, "Natural Disasters and Time: Non-Eschatological Perceptions of Earthquakes in Late Antique and Medieval Historiography," *Millennium* 18.1 (2021): 155–74.

138 M. Reeves, "The Development of Apocalyptic Thought: Medieval Attitudes," in *The Apocalypse in English Renaissance Thought and Literature: Patterns, Antecedents, and Repercussions*, ed. C. A. Patrides and J. A. Wittreich (Ithaca, NY, 1984), 40–72, at 41.

139 For an introduction to this topic, with specific reference to the arts of medieval and Renaissance Europe, see S. Cohen, *Transformations of Time and Temporality in Medieval and Renaissance Art* (Leiden, 2014), esp. 144.

140 C. C. Flanigan, "The Apocalypse and the Medieval Liturgy," in *The Apocalypse in the Middle Ages*, ed. R. K. Emmerson and B. McGinn (Ithaca, NY, 1992), 333–51, at 341.

See also Bynum and Freedman, "Introduction," 5; and Wieser and Eltschinger, "Introduction," 1:2–3.

141 For a concise but illuminating discussion of heterodox millennialism and orthodox apocalypticism, see R. K. Emmerson, *Apocalypse Illuminated: The Visual Exegesis of Revelation in Medieval Illustrated Manuscripts* (University Park, PA, 2018), esp. 9–10. See also B. McGinn, "Apocalypticism and Church Reform: 1100–1500," in *The Encyclopedia of Apocalypticism*, ed. B. McGinn, J. J. Collins, and S. J. Stein (New York, 1998), 2:74–109. On the significance of the Apocalypse in providing a transcendental structure within which to situate current events, see B. McGinn, "John's Apocalypse and the Apocalyptic Mentality," in Emmerson and McGinn, *Apocalypse*, 3–19. For an illuminating discussion of apocalypticism as reinforcing social and political structures, see B. McGinn, *Visions of the End: Apocalyptic Traditions in the Middle Ages* (New York, 1998), esp. 30–32.

of apocalyptically inflected polemics and political reform movements across Europe, and particularly in Italy. Cola di Rienzo's attempt to overturn the government of papal Rome is an ideal case in point, especially as it took place during Dandolo's dogeship. Cola made recursive and direct use of apocalyptic rhetoric in his attempt to gain the consensus of the people of Rome and used the visual arts widely in support of his political program. A series of large-scale apocalyptic paintings were commissioned by the Roman tribune in the public spaces of the capital. Protesting the decay of the city of Rome and setting up visual and textual parallels with the Apocalypse, these artworks were explicitly meant to arouse the fear of contemporaries and to stir their contempt toward the current state of affairs.[142] At the same time as Cola exploited apocalyptic rhetoric and imagery in the service of political reform, several European monarchs—including the Angevins in Naples and Charles IV of Bohemia—used them to stabilize their governments and to promote their self-images as righteous rulers and guarantors of divine justice on earth.[143] These examples illustrate both the pervasiveness of apocalyptic rhetoric and eschatological discourse in trecento political and historical culture and the significance of public imagery in pressing agendas of reform, or—on the contrary—in condemning transgression and promoting order and compliance with established authority.

Although less explicitly expressed, apocalyptic concerns formed a discernible undercurrent in the artistic campaigns sponsored by the Venetian government during Dandolo's dogate. To begin with, while the fourteenth-century interventions in San Marco did not include a new representation of the Last Judgment, they did entail the restoration of the basilica's central portal, which featured a monumental mosaic of this subject. The mosaic, which was later replaced, had been set up in the thirteenth century above the main entrance on the west façade of the basilica (Fig. 7).[144] It was still visible in the fourteenth century, as were the refined sculptural programs that filled the arches and intradoses surrounding the mosaic. Proceeding outward from the innermost arch, the latter included allegorical representations of sin and confrontations between good and evil; the labors of the months accompanied by the relevant zodiacal symbols and personifications of Christian virtues and beatitudes; a group of biblical prophets; and immediately adjacent to the Last Judgment, Venice's trades and occupations, which Mark Rosen interprets as an idealized rendition of the "Venetian republic, productively at work."[145] Together, the sculptures and the mosaic visually expressed the interactions between Venice's ordinary (and orderly) civic life, the unfolding of human activities throughout historical time, and the economy of salvation that culminated in the Last Judgment.[146] The stabilizing aims of this visual program were evidently not lost on fourteenth-century patrons and viewers: as noted by Debra Pincus, the central doorway was restored in 1344, during Dandolo's reign and at the same time as the high altar. Regrettably, the extent of this refurbishment is unknown, but the event was recorded in a commemorative inscription that was still in situ in the second half of the eighteenth century, when Giovanni Grevembroch

142 R. G. Musto, *Apocalypse in Rome: Cola di Rienzo and the Politics of the New Age* (Berkeley, 2003), esp. 105–6 and 123–27. See also A. Schwarz, "Images and Illusions of Power in Trecento Art: Cola di Rienzo and the Ancient Roman Republic" (PhD diss., State University of New York at Binghamton, 1994).

143 For an introduction to Charles IV's *Last Judgment*, see F. Piqué and D. C. Stulik, *Conservation of the Last Judgment Mosaic, St. Vitus Cathedral, Prague* (Los Angeles, 2004). For an excellent discussion of apocalyptic cycles across Italy, with extensive bibliography, see A. Derbes, "Washed in the Blood of the Lamb: Apocalyptic Visions in the Baptistery of Padua," *Speculum* 91.4 (2016): 945–97, esp. 946, n. 6, for a comprehensive review of literature on Angevin commissions of apocalyptic cycles, in both monumental and portable form.

144 M. Andaloro et al., eds., *San Marco: La Basilica patriarcale in Venezia*, vol. 2, *I mosaici, le iscriozioni, la pala d'oro* (Milan, 1991), 207. The mosaic was first remade in 1681 by the mosaicist Pietro Spagna. The seventeenth-century mosaic was replaced with the current version in 1836–1838.

145 M. Rosen, "The Republic at Work: S. Marco's Reliefs of the Venetian Trades," *ArtB* 90.1 (2008): 54–75.

146 For a provocative interpretation of the sculpted program as expressing the "upward progression from bestiality, temptation and unlawfulness to order, harmony and productive labor" against Venice's sociopolitical tensions in the thirteenth century, see Rosen, "Republic at Work," 56. On the overall artistic program of the central portal as a condensed and specifically Venetian iteration of medieval *Specula mundi*, see Demus, *Church of San Marco*, 150. For a detailed analysis of the sculptural decoration, see G. Tigler, *Il portale maggiore di San Marco a Venezia: Aspetti iconografici e stilistici dei rilievi duecenteschi* (Venice, 1995); and Demus and Tigler, *Le sculture esterne di San Marco* (see above, p. 36, n. 111), 16–22, 107–205, with further bibliography.

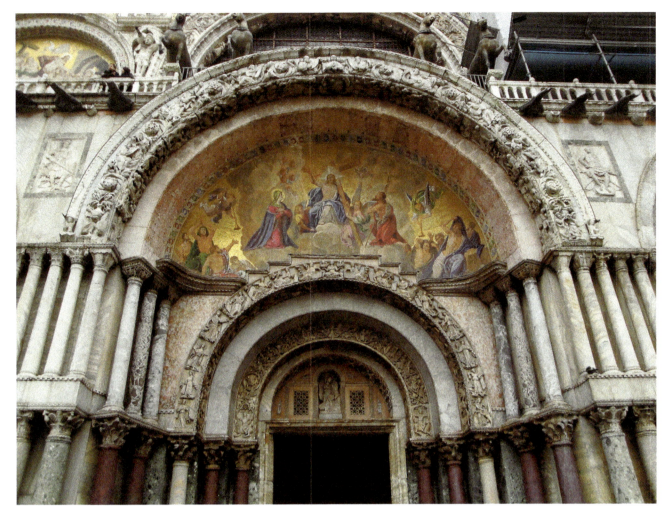

FIGURE 7. San Marco, Venice, west façade, central portal. Photo by author.

transcribed it in his *Monumenta Veneta*.[147] Aligned with the central axis of the portal, the text was prominently placed below the mosaic niche: thus it symbolically appropriated the earlier artistic program to the fourteenth century and associated Dandolo's dogate with the iconography of the Last Judgment and the vision of orderly civic life conveyed by the sculpted arches (Fig. 8).

Dandolo's other projects in San Marco also offered reflections on the interactions between temporality and eternity and were variously infused with apocalyptic and eschatological implications. As Anne Derbes definitively demonstrates, the association between the Apocalypse and baptism was clear to the medieval imagination.[148] The Venetian baptistery—located in close proximity to the west narthex's Genesis cycle with its detailed depiction of the Fall—concisely recapitulates the history and trajectory of human salvation in postlapsarian times, from Old Testament prophecies to the Passion of Christ and the apostles' evangelizing mission. The visual program culminates in the eastern dome, which bears explicit reference to the Second Coming: at the center of the dome Christ sits in glory surrounded by angels, raising both hands in a gesture of victory or double blessing that was

147 Pincus, "Venice and Its Doge," 250–51 (see above, p. 36, n. 112). The inscription was transcribed in G. Grevembroch, *Monumenta Veneta*, Venice, Biblioteca del Museo Civico Correr, ms. Gradenigo Dolfin 228, vol. 1 (1754), I. The inscription reads: *Ducante Andrea Dandolo / Per Duce Restaurata fuit / Anno mcccxxxxiiii* (During Andrea Dandolo's dogate, it was restored, thanks to the doge, in 1344).

148 Derbes, "Washed in the Blood of the Lamb." On page 988, the author makes a brief reference to the baptistery of San Marco and its overt apocalyptic implications.

FIGURE 8. Venice, Biblioteca Nazionale del Museo Civico Correr, Gradenigo-Dolfin 228, vol.1, 1, drawing by Giovanni Grevembroch, 1754. Photo courtesy of Fondazione Musei Civici di Venezia.

widely employed in representations of the Last Judgment (and of Divine Wisdom) in the monumental arts of Serbia and the Balkans. The high altar of San Marco also creatively dramatized the enigmatic relationship between human history and divine revelation at the end of times. As will be discussed in more detail in the relevant chapter, this was done with the alternating display of Paolo Veneziano's pala feriale and the Byzantine pala d'oro. The former, which concealed the golden altarpiece on nonfestive days, focused on Christ's human nature and sufferings and St. Mark's martyrdom and miraculous interventions throughout Venetian history. By contrast, the pala d'oro, which was only revealed on major feast days, paraded a refulgent vision of the heavenly hierarchies arranged around a central representation of Christ enthroned. Meaningfully, the latter was located immediately below the throne

of the *hetoimasia*, the image that signaled Christ's Second Coming in Byzantine imagery, particularly in representations of the Last Judgment.[149]

As scholars have long acknowledged, the juxtaposition of narrative images and extratemporal, sacred iconographies in Dandolo's projects situated Venice and the Venetian state outside of human time, within the "larger, meta-historical chronology of God's time."[150] Dandolo's concerns

149 For a brief discussion of the *hetoimasia* in Byzantine art, see the entry by A. W. Carr, "Hetoimasia," in *ODB* 2:926. See also S. E. J. Gerstel, *Beholding the Sacred Mysteries: Programs of the Byzantine Sanctuary* (Seattle, 1999), esp. 38–40; and R. Betancourt, "Prolepsis and Anticipation: The Apocalyptic Futurity of the Now, East and West," in Ryan, *Premodern Apocalypse*, 177–205, with brief references to Venice.

150 These ideas cut across scholarship on San Marco. They are most eloquently articulated in P. Fortini Brown, *Venice and Antiquity: The Venetian Sense of the Past* (New Haven, CT, 1996), 39–43 (from which I have borrowed the passage quoted

with soteriology have been interpreted primarily within the framework of Venice's *praedestinatio*—a belief in the city's special place in the history of salvation, which originated in the aftermath of 1204 and was subsequently developed throughout the duecento and trecento, expressing Venice's enduring ideology of triumph.[151] This interpretive tradition is valuable because it draws attention to the distinctive apocalyptic undercurrents of Dandolo's projects. Still, explaining Dandolo's concerns with "last things" as simply another iteration of Venice's pride and triumphal rhetoric fails to capture the central role that crisis played in structuring medieval attitudes toward time, history, and justice, and the profound ways in which it informed contemporary cultural and political responses to uncertainty and strife.

If it is in the nature of crises to threaten to dissolve a community's integrity, and if the survival of that community depends on exercising krisis—that is, clarifying and reaffirming the foundations on which that community is construed and operates—then it follows that Venice's capacity to navigate crisis as a medieval Christian polity significantly relied on its ability to accommodate disruption and change within ideas of a (stable) Christian cosmos and within the trajectory of Christian salvation. Visual (and textual) history making in San Marco played a pivotal role in this process. At times of strife, the alignment between divine will and the activities and structures of government ceased to be self-evident—if only because things "going wrong" may be indicative of God's discontent and punishment. Acute and protracted turmoil threatened the very foundations of the state and instigated governors to reflect on the relation between divine and earthly order and justice, and on how they interacted in history. Venice was no exception. This study submits that domestic and international strife, and growing awareness of ongoing changes to the world order, prompted the doge and his councilors to clarify how temporal power related to divine krisis, and how the workings of the Venetian state conformed to God's justice *in time*, delivering his plans for the salvation of humankind. The art of San Marco dramatized their reflections and the new image of government, history, and cosmos that emerged from their questioning.

here); Pincus, "Venice and Its Doge"; Pincus, "Hard Times and Ducal Radiance" (see above, p. 37, n. 113); and D. Pincus, "Geografia e politica nel battistero di San Marco: La cupola degli apostoli," in *San Marco: Aspetti storici ed agiografici; Atti del convegno internazionale di studi, Venezia, 26–29 aprile 1994*, ed. A. Niero (Venice, 1996), 459–73.

151 For an excellent overview of the genesis and development of the idea of *praedestinatio* in Venice, see T. E. A. Dale, "Inventing a Sacred Past: Pictorial Narratives of St. Mark the Evangelist in Aquileia and Venice, ca. 1000–1300," *DOP* 48 (1994): 53–104, esp. 93–101.

THE HIGH ALTAR

Byzantine Art Made "History"

AT THE END OF MAY 1343, THE VENETIAN government allocated the sum of 400 ducats to the renovation of the Byzantine golden altarpiece of San Marco, with the intended aim of honoring the evangelist and contributing to "the magnificence of the city" (*pro magnificentia civitatis*) (Fig. 9).[1] This eminently public project was completed in 1345 and was memorialized on the pala d'oro itself by means of two lengthy inscriptions, engraved in Gothic characters on a pair of gilded plaques at the lower center of the altarpiece (Fig. 10). The two plaques, which also represent the earliest extant sources for the history of the pala d'oro, read, respectively:

> In the year 1105, when Ordelaffo Falier was the doge of the city, this pala, so rich in precious stones, was first made; it was [then] renovated when you, Pietro Ziani, were doge, and at the time Angelo Falier was the procurator of deeds, in 1209.

and:

Subsequently, in 1345, the most highly esteemed Andrea Dandolo was doge, and when the noble men Marco Loredan and Francesco Querini were procurators of the venerable mother church of San Marco, rightly blessed, then this ancient altarpiece was made new, precious with gemstones.[2]

The same date of completion was also inscribed on the pala feriale, a painted altarpiece that the government commissioned from the eminent Venetian artist Paolo Veneziano (and his sons) to adorn the altar and to protect and conceal the golden retable on non-feast days, when the latter was not on display (Fig. 11). Two inscriptions in Gothic majuscule, placed along the lower register

1 Venice, Archivio di Stato di Venezia, Maggior Consiglio, *Deliberazioni*, Spiritus (1325–1349), 129v, document dated to 20 May 1343. The document is published in B. Cecchetti, ed., *Documenti per la storia dell'augusta ducale Basilica di San Marco in Venezia dal nono secolo sino alla fine del decimo ottavo dall'Archivio di Stato e dalla Biblioteca Marciana in Venezia* (Venice, 1886), 212, n. 830.

2 The first inscription reads: "anno milleno cen | teno iungito qui[n] | to tu[n]c ordelafv[s] | faledru[s] in urbe du | cabat h[ec] nova f[a]c[t]a | fuit gemis ditis | sima pala q[ue] reno | vata fuit te pet | re ducante ziani | et procurabat | tunc angel[us] acta | faledr[us] anno mill | eno bis centeno | q[ue] noveno." The second reads: "post quadragen | o quinto post mi | lle trecentos da[n] | dul[us] andreas pr[e]cla | r[us] honore ducaba | t nob[i]lib[us]q[ue] viris | tunc p[ro]cura[n]tib[us] al | ma[m] eccl[esi]am marci v | enera[n]da[m] iure be | ati d[e] lauredanis | marco frescoq[ue] q[u]i | rino tunc vetus | hec pala gemis | p[re]ciosa novatur." For different approaches to the inscription's formal qualities, see D. Marangon, "Il fascino delle forme greche a Venezia: Andrea Dandolo, l'arte e l'epigrafia," *Hortus Artium Medievalium* 22 (2016): 157–64; and D. Pincus, "The Beginning of Gothic Lettering at the Basilica of San Marco: The Contribution of Doge Andrea Dandolo," in Vio, *San Marco: La basilica*, 1:319–29 (see above, p. 13, n. 5).

of the pala feriale, provide the names of the artists involved in the project and indicate that the altarpiece was completed on 22 April 1345, only three days before the Feast of St. Mark, celebrated annually on 25 April.[3]

3 The two (poorly visible) texts, arranged at the bottom of the first and fourth narrative panels in the lower register of the altarpiece, read, respectively: "M.C.C.CXLV. MS. APLIS. DIE XXII" and "MAG[ISTE]R PAULUS CU[M] LUCA ET IOH[ANN]E FILIIS SUIS PINXERU[N]T HOC OPUS." Together, they translate as: "[On] 22 April 1345 | Master Paolo with his sons Luca and Giovanni painted this work." As one of only a few signed and dated works by Paolo Veneziano, and as a prominent public commission in the state church of Venice, the pala feriale has played a central part in scholarly discussions about Paolo's artistic career and his development as a painter. See

FIGURE 9.
Pala d'oro, twelfth, thirteenth, and
fourteenth centuries, Byzantine with
Venetian additions. Venice, San Marco.
Photo courtesy of the Procuratoria di
San Marco.

This chapter situates the redesign of the high altar—and the new ensemble formed by the pala d'oro and the pala feriale more specifically—against the multiple environmental, political, and societal challenges that the Venetian community faced in those years. To what degree did growing perceptions of instability and danger affect the ways in which the pala d'oro and the pala feriale would be viewed by contemporaries? Is it at all possible that contemporaries may have related the reframing of the pala d'oro to Venice's new alliance with the Byzantine crown? To what extent did the makeover of the Byzantine golden altarpiece contribute to crystallizing new ideas about rulership as they emerged in Venice in the trecento, in the aftermath of the Serrata? More broadly, and crucially, in what measure can the refashioning of the high altar be understood as participating in, and furthering, the government's strategies of crisis management and state building?

The argument here is threefold. First, the ensemble formed by the pala feriale and pala d'oro mirrored the rising anxieties of the Venetian community. Confronted with rapid change and mounting threats, the Venetian government articulated a complex visual reflection on the nature of Christian suffering and its place within the trajectory of human salvation. As a way to neutralize the fear generated by current predicaments, the imagery on the high altar also reasserted Venice's long-standing bond with its chief patron, both invoking and memorializing the saint's miraculous intervention, with the help of Venice's other holy defenders, at times of dire need.

Second, the visual program of the high altar also offered a more radical message that dovetailed with the program of historical and legal reform discussed above. The fourteenth-century makeover transformed the altar, and the Byzantine pala d'oro more specifically, into a site of historical remembrance and political

R. Goffen, "Paolo Veneziano e Andrea Dandolo: Una nuova lettura della pala feriale," in *La pala d'oro*, ed. H. R. Hahnloser and R. Polacco (Venice, 1994), 173–84; R. Goffen, "Il paliotto della pala d'oro di Paolo Veneziano e la committenza del doge Andrea Dandolo," in Niero, *San Marco: Aspetti storici*, 313–33; F. Flores d'Arcais, "Paolo Veneziano e la pittura del Trecento in Adriatico," in Flores d'Arcais and Gentili, *Il Trecento adriatico*, 19–31. For a detailed description of the artwork and comprehensive bibliography, see F. Pedrocco, *Paolo Veneziano* (Milan, 2003), esp. 170–73.

FIGURE 10.
Pala d'oro, inscriptions, 1345. Photo courtesy of the Procuratoria di San Marco.

FIGURE 11.
Pala feriale, Paolo Veneziano and sons, completed in 1345. Venice, Museo di San Marco (formerly high altar). Photo courtesy of the Procuratoria di San Marco.

fig. 10

fig. 11

legitimation. Commemorating selected moments and actors from the Venetian past and providing material proof that those events had actually happened, the high altar of San Marco articulated ideas of institutional stability and political continuity at times of heightened uncertainty. In addition, by making explicit reference to the city's chief magistracies, the altar also promoted a radically novel image of the Venetian state as based on corporate rather than individual action, a political ideal that would be pivotal to Dandolo's later campaigns in San Marco.

Third, within a medieval Christian world-view, issues of political and institutional reform and ideas about "how to govern" were inevitably entangled with notions of divine order and justice, and with preoccupations about the end of times. Such worries intensified at times of instability, triggering an increased interest in "things eternal" that left clear marks on the visual arts.[4] The fourteenth-century artistic makeover of the altar area of San Marco manifests similar leanings. Dandolo's renewal turned the high altar into a multimedia recapitulation of the economy of Christian salvation that was at once religious and political. The rich imagery of the high altar, its material *varietas*, and its decorative program's adaptability to different liturgical performances encouraged rereading current predicaments against the broader canvas of divine judgment and eternal redemption. They also provided a powerful meditation on the relation between the unfolding of human history, the fullness of divine revelation at the end of times, and the functions and responsibilities of political authority—which would also emerge as a dominant concern in Dandolo's later projects. The Byzantine pala d'oro represented the kernel of this complex program, functioning simultaneously as the "stuff of history" and a locus of transcendence.

Two Altarpieces for San Marco: The Pala d'Oro and the Pala Feriale

As we currently see it, the pala d'oro measures 3.34 × 2.12 meters and is organized in two horizontal sections.[5] The upper tier features an incomplete

Christological cycle. This set of enamels is customarily identified as part of a precious, mid-twelfth-century Byzantine epistyle that once decorated a church in Constantinople—possibly one of the ecclesiastical spaces of the Pantokrator monastery.[6] Presumed to have been looted during or after the Fourth Crusade, this group of enamels is generally considered a later addition to the pala d'oro, which was already in place (on or in front of the high altar of San Marco) in the early twelfth century. On the basis of the fourteenth-century inscriptions transcribed above, it is generally held that the large-scale enamels were mounted on the golden altarpiece under Doge Pietro Ziani, in 1209.

The enamels that form the lower tier of the pala d'oro are chronologically compatible with Doge Falier's commission in 1105. They are arranged hierarchically around the central figure of Christ in Majesty surrounded by the four evangelists (Fig. 12). Above Christ is the empty throne of the *hetoimasia* flanked by two angels. Around the central composition, from top to bottom, are three choirs of angels, saints, and prophets—an iconography that imbues the overall program with an epiphanic nature and an apocalyptic flavor. Two narrative cycles, respectively focused on the life of Christ and the life of St. Mark, unfold along the upper and side margins.[7] Below the figure of Christ are the best

4 Hilsdale, "The Timeliness of Timelessness," (see above, p. 34, n. 99). See also Hilsdale, *Byzantine Art and Diplomacy* (see above, p. 14, n. 8).

5 The earlier history of the pala d'oro and its multiple reconfigurations over time have been intensely debated in scholarship. The standard reference on the topic is Hahnloser and Polacco, *La pala d'oro*. See especially page 3 on measurements and 136–37 for a tentative visual reconstruction of the different layouts of the altarpiece between the eleventh and fourteenth centuries. See also Gallo, *Il tesoro di S. Marco*, 157–92 (see above, p. 12, n. 3); M. English Frazer, "The Pala d'Oro and the Cult of St. Mark in Venice," *JÖB* 32.5 (1982): 273–80; Dale, "Inventing a Sacred Past," esp. 61–67 (see above, p. 49, n. 151); and D. Buckton and J. Osborne, "The Enamel of Doge Ordelaffo Falier on the Pala d'Oro in Venice," *Gesta* 39.1 (2000): 43–49. The fourteenth-century makeover of the Byzantine altarpiece has more recently been discussed by H. A. Klein, "Refashioning Byzantium in Venice, ca. 1200–1400," in Maguire and Nelson,

San Marco, Byzantium, and the Myths of Venice, 193–225 (see above, p. 36, n. 110).

6 Hahnloser and Polacco, *La pala d'oro*, 4. This provenance is based on the (later) testimony of Sylvester Syropoulos, who reputedly identified the enamels during a visit to San Marco in 1438, as he traveled to Italy with Emperor John VIII Palaiologos on the occasion of the Council of Florence. See Sylvester Syropoulos, *Les "Mémoires" du Grand Ecclésiarique de l'Eglise de Constantinople Sylvestre Syropoulos sur le concile de Florence: 1438–1439*, ed. V. Laurent (Paris, 1971), 222–25. The passage has been translated into English in Klein, "Refashioning Byzantium," 194, with further references. For a broader contextualization of Syropoulos's witness, see J. P. Harris, "'A Blow Sent by God': Changing Byzantine Memories of the Crusades," in *Remembering the Crusades and Crusading*, ed. M. Cassidy-Welch (London, 2017), 189–201; and F. Kondyli et al., eds., *Sylvester Syropoulos on Politics and Culture in the Fifteenth-Century Mediterranean: Themes and Problems in the Memoirs, Section 4* (Farnham, 2014).

7 Scholarship has long debated the original position of the narrative enamels on the pala. They are alternately believed to have occupied their current position since 1105, or to have initially been arranged in two rows at the bottom of the altarpiece and moved in 1209, when the larger Christological plaques were added to the golden retable. Either way, those enamels were most likely in their current positions by the fourteenth century,

FIGURE 12.
Pala d'oro,
Christ in Majesty
surrounded by the
four evangelists,
Virgin orant flanked
by Doge Ordelaffo
Falier and Empress
Irene Doukaina,
inscriptions. Photo
courtesy of the
Procuratoria di
San Marco.

making debates about their original placement (and parallel discussions about the original function of the pala d'oro as an antependium or retable in the twelfth century) less relevant to the present discussion. For differing interpretations of the origins of the enamels in Byzantium or Venice, and of their original position on the pala d'oro, see W. F. Volbach, "Gli smalti della pala d'oro," in Hahnloser and Polacco, *La pala d'oro*, 1–72; and R. Polacco, "Una nuova lettura della pala d'oro," in Hahnloser and Polacco, *La pala d'oro*, 113–48.

known, and most vehemently discussed, enamels of the altarpiece: Doge Ordelaffo Falier, identified by a Latin inscription; the effigy of the Virgin, in orant position; and a Byzantine empress, inscribed in Greek as Irene and generally identified as Irene Doukaina.[8] The ducal

8 Hahnloser and Polacco, *La pala d'oro*, 7–9.

56 FACING CRISIS

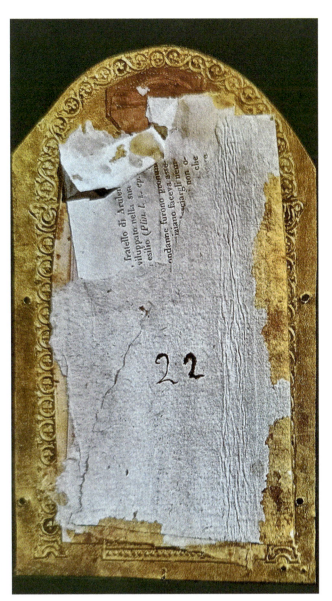

FIGURE 13. Pala d'oro, Doge Ordelaffo
Falier, obverse, 1105, probably altered in
1209. Photo courtesy of the Procuratoria
di San Marco.

FIGURE 14. Pala d'oro, Doge Ordelaffo
Falier, reverse, probably altered in 1209.
Photo courtesy of the Procuratoria
di San Marco.

portrait, in which the doge's head looks dis-
proportionately small in relation to his body,
was evidently tampered with (Figs. 13 and 14).
While earlier scholarship tended to assign this
intervention to the fourteenth-century make-
over of the pala d'oro, David Buckton and John
Osborne have convincingly argued that the ren-
ovation of the ducal enamel most likely occurred
in 1209, when Venice's imperial aspirations in
the aftermath of the Fourth Crusade would have
justified the addition of a nimbus (a widespread

symbol of imperial authority in Byzantium) to
the doge's image.[9]

Some of the details of the fourteenth-century
interventions on the pala d'oro, and their rela-
tion to earlier modifications of the altar area,

9 Buckton and Osborne, "The Enamel of Doge Ordelaffo
Falier," with extensive discussion of earlier literature. A less
credible attribution to Andrea Dandolo is suggested by Renato
Polacco in Polacco, "Una nuova lettura," 113–17. On page 7 of
the same volume, Fritz Volbach more cautiously abstains from
providing a date.

remain elusive. Nevertheless, its most relevant components are known.[10] First, the pala d'oro was provided with a new, silver-gilt outer frame.[11] Second, as part of the same campaign, each enamel in the lower and upper sections of the pala was also encased in a highly three-dimensional, gabled microarchitectural frame which enhanced the material and visual opulence of the artwork, imparted to it a clear optical rhythm, and emphasized its horizontal partitions (Figs. 9 and 15). Third, as already mentioned, the golden altarpiece was equipped at this time with two lengthy dedicatory inscriptions in Latin that recapitulate the history of the pala d'oro and commemorate the names of the doges and procurators who oversaw its making in 1105 and its subsequent refurbishments in 1209, after the Fourth Crusade, and in 1343–1345. The insertion of these inscriptions presumably required the removal of one or a pair of figurative enamels. Plausibly, these represented Emperor Alexios I Komnenos (r. 1081–1118), who reigned when the pala d'oro was originally commissioned, and—possibly—his son John II Komnenos.[12]

Finally, and crucially, the pala d'oro was transformed in the fourteenth century into a folding altarpiece, through the addition of Paolo Veneziano's pala feriale. This painted panel adorned the altar on non-feast days, simultaneously protecting and concealing the golden retable when the latter was not on display. The pala feriale—whose dimensions and unusual layout were carefully designed to match those of the pala d'oro—is divided into two horizontal registers and survives without its frame. The upper section comprises an emotionally charged image of the Man of Sorrows at the top center, flanked by the Virgin and St. John the Evangelist. Unusually, St. John is not represented as a youth, as was customary in representations of the Passion. Instead, he is rendered as an elderly, bearded figure. This visual type, which evoked St. John's old-age

prophetic visions on the island of Patmos and his role as the author of the Book of Revelation, manifests a concern with the afterlife, and with the complex relationship between the Incarnation, human salvation, and divine revelation at the end of time that permeates the entire altar program as well as Dandolo's other commissions in San Marco. The upper tier of the pala feriale also includes a row of icon-like bust portraits of saints, arranged on either side of the central triptych. On the (viewer's) left stand a warrior saint, who has alternately been identified as St. Theodore or St. George, and St. Mark. On the opposite side are St. Peter and St. Nicholas. The lower section of the retable is entirely dedicated to the life and miracles of St. Mark, represented in seven narrative panels that simultaneously add to and condense the visual hagiography represented on the pala d'oro. The martyrdom of the Evangelist, which was believed to have happened on Easter day, is suitably placed on a vertical axis with the Man of Sorrows, establishing a link between the sacrifice of the Lord and that of the saint.[13]

The fourteenth-century project of renewal of the high altar was not confined to the altarpieces, but also extended to their immediate surroundings. Immediately behind the pala d'oro and the altar stood two tall columns made of green marble, decorated with two statues of the archangel Gabriel and the Virgin Mary and forming an Annunciation (Figs. 16 and 17).[14] This

10 On the fourteenth-century additions, see H. R. Hahnloser, "Le oreficerie della pala d'oro," in Hahnloser and Polacco, *La pala d'oro*, 79–111; and E. Taburet-Delahaye, "I gioielli della pala d'oro," in Hahnloser and Polacco, *La pala d'oro*, 149–59.

11 On the secular enamels adorning this frame, see M. Bergamo, *Alessandro, il cavaliere, il doge: Le placchette profane della pala d'oro di San Marco* (Rome, 2022).

12 Hahnloser and Polacco, *La pala d'oro*, 5–7.

13 On the association of Mark's martyrdom with Easter day, see Dandolo, *Chronica per extensum descripta*, 11 (see above, p. 21, n. 47). See also Goffen, "Paolo Veneziano," 178.

14 This sculptural ensemble has generated significant scholarly debate. The columns, which came to support the opening mechanism of the pala d'oro, are commonly associated with Andrea Dandolo's dogate: M. Da Villa Urbani, "L'Annunciazione' dietro il ciborio e la 'Madonna di Marzo," in *Quaderni della Procuratoria: Arte, storia, restauri della basilica di San Marco a Venezia*, vol. 10, *Le colonne del ciborio*, ed. I. Favaretto (Venice, 2015), 33–38. However, the statues of the Virgin and of the archangel Gabriel are considered the work of Marco Romano or a close follower, suggesting an earlier date (ca. 1318 or ca. 1335–1340). See, for example, G. Valenzano, "'Celavit Marcus opus hoc insigne Romanus. Laudibus non parvis est sua digna manus': L'attività di Marco Romano a Venezia," in *Marco Romano e il contesto artistico senese fra la fine del Duecento e gli inizi del Trecento*, ed. A. Bagnoli (Cinisello Balsamo, 2010), 132–39; C. Di Fabio, "Giotto, Giovanni Pisano e Marco Romano: Rapporti fra pittura e scultura nella Cappella degli Scrovegni," *Bollettino del Museo Civico di Padova* 100 (2011): 143–84, esp. 148–9; and C. Di Fabio, "Memoria e modernità: Della propria figura di Enrico Scrovegni e di altre sculture nella Cappella dell'Arena di Padova, con aggiunte

FIGURE 16

Archangel Gabriel, Marco Romano (?), ca. 1318–1340. Venice, Treasury of San Marco (formerly presbytery of San Marco). Photo courtesy of the Procuratoria di San Marco.

FIGURE 17.

Virgin Mary, Marco Romano (?), ca. 1318–1340. Venice, Treasury of San Marco (formerly presbytery of San Marco). Photo courtesy of the Procuratoria di San Marco.

fig. 16

sculptural ensemble was located just behind the pala d'oro and supported the complex mechanism

that allowed the pala to be opened on major feast days. The exact functioning of this contraption, which was dismantled in the nineteenth century, is difficult to reconstruct. Nevertheless, Antonio Pellanda, who supervised the works in the basilica, recorded in a series of drawings both the appearance of the altar ensemble and the mechanism by which the pala feriale and pala d'oro were moved (Figs. 18–20). These drawings indicate that both

al catalogo di Marco Romano," in *Medioevo: Immagine e memoria; Atti del convegno internazionale di studi: Parma, 23–28 settembre 2008*, ed. A. Quintavalle (Milan, 2009), 532–46, with extensive bibliographical references. Whether the Annunciation already occupied its position behind the altar or was placed there during Dandolo's dogate, the sculptural group was fully integrated in the renewed artistic program of the high altar.

fig. 17

the upper half of the painted altarpiece adhered to the rear of the upper section of the golden retable. On regular days, the upper section of the pala d'oro would be folded down, making the pala feriale visible. On feast days, a pulley system, located behind the altar and supported by the two columns, made it possible to fold up the pala feriale, first onto itself and then further up and backward, opening the pala d'oro to reveal its upper section.[16]

The fourteenth-century *consuetudines* of San Marco usefully list the feast days on which the golden altarpiece was on view: Christmas Day (25 December), the Circumcision of Christ (1 January), and the Epiphany (6 January); the movable feast days of Easter, Pentecost, and the Ascension; the Feast of All Angels (Michaelmas, 29 September); all main Marian feast days; All Saints' Day (1 November); the feasts of all the apostles and the evangelists; the Feast of the Holy Cross (presumably the Exaltation of the cross, 14 September); the Feast of the Dedication of San Marco, and the Feasts of St. Lawrence and St. Martin; the day of Corpus Christi; and the feast days of saints to whom the altars of San Marco are dedicated. Finally, the pala was opened on the Feast of St. Donatus (on Sundays?) during Lent (?), on Rogation Days (three days before the Ascension), and on those (unspecified) days when pilgrims visited the church of San Marco. On all those occasions the church remained open all day, presumably to allow lay visitors to visit the basilica and attend services, and wardens guarded it until the night.[17]

The lavish visual spectacle offered by the alternating display of the painted and golden retables was both amplified and framed by a sumptuous ciborium with historiated columns, whose

the pala d'oro and the pala feriale were divided into two horizontal sections joined in the middle through hinges, allowing vertical rotation (Fig. 21). Based on Pellanda's testimony and on Jacopo Sansovino's sixteenth-century account, we know that the pala d'oro and the pala feriale were attached to each other.[15] Most likely, the reverse of

15 "La qual coperta insieme con la palla, s'apre in due parti da mezzo in su con un molinello a mano posto dietro l'altare,"

Francesco Sansovino, *Venetia, citta nobilissima et singolare* (Venice, 1581), 36r–v, cited in A. De Marchi, "Polyptiques vénitiens: Anamnèse d'une identité méconnue," in *Autour de Lorenzo Veneziano: Fragments de polyptyques vénitiens du XIVᵉ siècle*, ed. A. De Marchi and C. Guarnieri (Cinisello Balsamo, 2005), 13–44, at 34

16 A full discussion of the opening mechanism is in A. De Marchi, "La postérité du devant-d'autel à Venise: Retables orfévrés et retables peints," in *The Altar and Its Environment: 1150–1400*, ed. J. E. A. Kroesen and V. M. Schmidt (Turnhout, 2009), 57–86.

17 B. Betto, *Il capitolo della Basilica di S. Marco in Venezia: Statuti e consuetudini dei primi decenni del sec. 14* (Padua, 1984), 159.

FIGURE 18.

Reconstruction of the opening mechanism
of the pala d'oro and pala feriale before the
restoration campaign of 1835–1838: closed, with
pala feriale on view. San Marco, Venice, drawing
and watercolor by Antonio Pellanda, 1860. Photo
courtesy of the Procuratoria di San Marco.

FIGURE 19.

Reconstruction of the opening mechanism
of the pala d'oro and pala feriale before the
restoration campaign of 1835–1838: pala feriale
half folded up. San Marco, Venice, drawing and
watercolor by Antonio Pellanda, 1860. Photo
courtesy of the Procuratoria di San Marco.

FIGURE 20.

Reconstruction of the opening mechanism
of the pala d'oro and pala feriale before the
restoration campaign of 1835–1838: pala d'oro
fully on view. San Marco, Venice, drawing and
watercolor by Antonio Pellanda, 1860. Photo
courtesy of the Procuratoria di San Marco.

fig. 18

chronology has generated lively scholarly debate
but which was most likely erected in the early thir-
teenth century (Fig. 22).[18] Beyond the ciborium,
the eastern apse of the basilica had already been

decorated in the twelfth century with a monu-
mental mosaic of Christ enthroned—remade in
1506—and full-figure portraits of St. Nicholas,
St. Peter, St. Mark, and St. Hermagoras. The
saintly figures occupied the space between the
windows below the apse conch and were accom-
panied by a long inscription that clarified the
saints' role as Venice's holy intercessors (Fig. 23).[19]

18 The date of construction of the ciborium and the date of
manufacture of the columns that support it are still debated.
Scholars have alternately identified the columns as early
Christian artworks reused in medieval Venice, as archaizing
artifacts made in Venice in the thirteenth century in imitation
of early Christian exemplars, or as a composite group compris-
ing both early Christian and thirteenth-century specimens.
For a concise summary and extensive bibliographic informa-
tion, see Demus, *Church of San Marco*, 165–68 (see above, p. 35,
n. 108). More recently, see the detailed study by T. Weigel, *Die
Reliefsäulen des Hauptaltarciboriums von San Marco in Venedig:
Studien zu einer spätantiken Werkgruppe* (Münster, 1997). On
page 256 of this study, the author dates the ciborium to ca.
1230. He is followed by A. M. Kosegarten, "Zur liturgischen
Ausstattung von San Marco in Venedig im 13. Jahrhundert:
Kanzeln und Altarziborien," *MarbJb* 29 (2002): 7–77, esp.
48–54. See also T. Weigel, "Le colonne istoriate del ciborio
dell'altare maggiore," in Favaretto, *Le colonne del ciborio*, 11–19;

and L. Lazzarini, "Indagini di laboratorio sui materiali delle
colonne del ciborio," in Favaretto, *Le colonne del ciborio*, 57–63.

19 Demus, *Mosaics of San Marco*, 1:32–33 (see above, p. 36,
n. 111); Dale, "Inventing a Sacred Past," 62–63 (see above, p. 49,
n. 151), complete with an English translation of the apse inscrip-
tion; L. Jessop, "Art and the Gregorian Reform: Saints Peter and
Clement in the Church of San Marco at Venice," *RACAR* 32.1/2
(2007): 24–34; and M. Mason, "I primi mosaici della basilica
e l'elaborazione della leggenda marciana: Considerazioni sullo
stile e l'iconografia," in Vio, *San Marco: La basilica*, 1:226–47
(see above, p. 13, n. 5). See also L. Caselli, ed., *San Pietro e San
Marco: Arte e iconografia in area adriatica* (Rome, 2009). On the
remaking of the mosaic of Christ enthroned, and for a complete

Finally, it has attractively been proposed that a group of thirteenth-century sculptures—which represent the nativity of Christ and a selection of episodes from his infancy and are currently scattered among different collections in and outside of Venice—once formed a unified cycle, installed atop the medieval choir screen of the basilica of San Marco.[20] If this proves to be correct, the high

altar would be visually enfolded in a longer narrative account of the early stages of the Incarnation, which opened with the Annunciation behind the altar and continued nearer the viewers on the chancel screen.[21]

Returning to the altar area, the front of the *mensa* was embellished with a silver *paliotto*, made in Venice around 1300, which is still extant

transcription of the epigraph, see Andaloro et al., *San Marco*, 2:30 (see above, p. 46, n. 144).

20 The sculptures under discussion have generated lively debate and diverging interpretations. The hypothesis considered above was advanced by L. V. Geymonat and L. Lazzarini, "A Nativity Cycle for the Choir Screen of San Marco, Venice," *Convivium* 7.1 (2020): 80–113. By contrast, Thomas Dale (who does not consider the infancy sculptures to have formed a cohesive ensemble) has argued for the group of the Epiphany to have been placed above the Porta da Mar, and to have conveyed ideas of Venetian triumph and divine predestination: T. E. A. Dale, "Epiphany at San Marco: The Sculptural Program of the Porta

da Mar in the Dugento," in Vio, *San Marco: La basilica*, 2:38–55 (see above, p. 13, n. 5).

21 Geymonat and Lazzarini, "Nativity Cycle," tentatively suggest that the choir screen and statues were set up during Ranieri Zen's dogate (1253–1268). The appearance of this enclosure is not known, but it is likely to have comprised a low chancel barrier surmounted by columns and an architrave, rather than a solid architectural screen that would block the altar view. The open arcade format is found at Santa Maria Assunta in Torcello and was also chosen in 1394 by Pierpaolo and Jacobello dalle Masegne when they executed the chancel screen that is still in situ in San Marco.

FIGURE 21.
Folding mechanism
of the pala d'oro
and pala feriale.
San Marco,
Venice, drawing
and watercolor by
Antonio Pellanda,
1860. Photo courtesy
of the Procuratoria
di San Marco.

(Fig. 24).[22] While the circumstances of this commission are unknown, there is evidence that this antependium became a stable visual complement to both the pala feriale and the pala d'oro during Andrea Dandolo's term as procurator of San Marco (1328–1343): the treasury inventories indicate that the object was put on permanent display in front of the altar from 1336 onward.[23]

22 This artwork was heavily restored in the nineteenth century, with evident replacements and misplacements of both inscriptions and figurative plaques. It has been published in Hahnloser, *Il tesoro e il museo*, 152–56, no. 2:152 (see above, p. 12, n. 3), with careful indication of modern replacements; I. Furlan, ed., *Venezia e Bisanzio: Venezia, Palazzo Ducale, 8 giugno–30 settembre 1974* (Milan, 1974), no. 77 (lacks page number); Buckton, *Treasury of San Marco*, 278–81, no. 40 (see above, p. 36, n. 110); H. Fillitz and G. Morello, eds., *Omaggio a San Marco: Tesori dall'Europa* (Milan, 1994), 138–39, no. 41.

23 The note was added in 1336 to the inventory of the treasury drafted in 1325. Published in Gallo, *Il tesoro di S. Marco*, 277 (see above, p. 12, n. 3).

We shall return to the rich visual interactions between the silver antependium and the two retables of San Marco later. For now, it will be sufficient to remark that the paliotto, like the pala feriale, is also divided into two registers, each decorated with figures in relief. The upper section features a central image of Christ enthroned flanked by the Virgin and St. John the Evangelist. On either side of the central Deesis are standing figures of saints that are visually reminiscent of their enameled counterparts on the pala d'oro. The lower section of the paliotto hosts a representation of St. Mark in ecclesiastical garb, directly below Christ, and (another) narrative cycle of the life of the evangelist (see Fig. 25 for a detail of the central figures).

In addition to its more permanent fixtures, the altar of San Marco was also embellished with movable adornments and liturgical accoutrements that rotated throughout the year, further enhancing its splendor. Several such objects have survived in the basilica's treasury and were

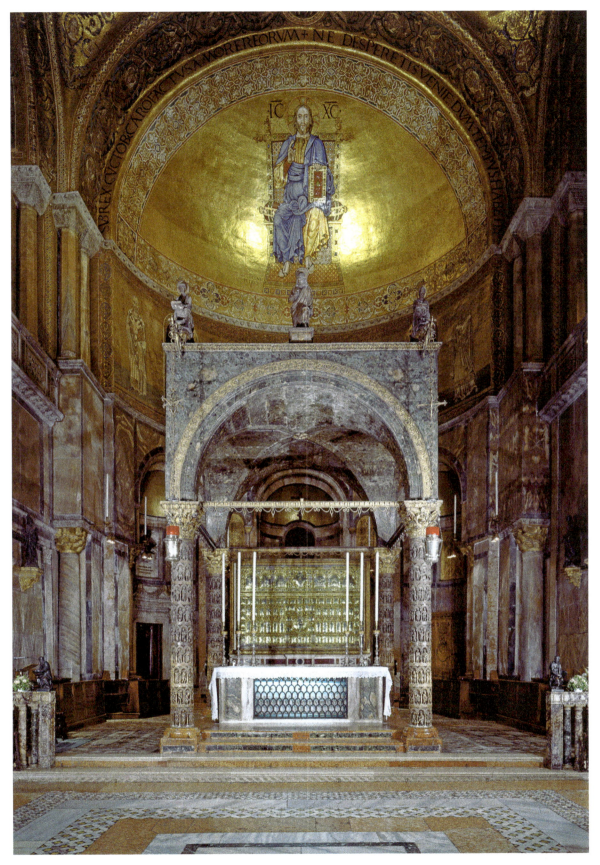

San Marco, Venice, high altar and presbytery. Photo courtesy of the Procuratoria di San Marco.

FIGURE 23.
San Marco, Venice,
lower section of the
central apse, early
twelfth century.
Photo courtesy of
the Procuratoria
di San Marco.

likely exhibited on or in the proximity of the
high altar on major feast days.[24] The specific
ritual usage of most of the individual objects
and their circumstances and modes of display
in Venice remain unknown.[25] A partial excep-
tion is three lavish liturgical books and book
bindings, currently preserved at the Biblioteca
Nazionale Marciana and originally owned by
the basilica.[26] The manuscripts—a missal, an
epistolary, and a Gospel lectionary—were written

in Latin. They were all produced in Venice in the
mid-fourteenth century, most likely in Andrea
Dandolo's years. They were commissioned for
liturgical use in San Marco and have been attrib-
uted to the same circle of artists, possibly a
workshop in the ducal chancery.[27] These newly
commissioned manuscripts were then inserted,
for protection and decoration, in three existing
book bindings. The latter were probably already
preserved in the basilica's treasury, where the pres-
ence of six book covers decorated with enamels
and pearls was recorded in the inventory of
1325.[28] The three covers were produced at differ-
ent times between the early tenth and thirteenth
centuries (Figs. 26–28). Scholars have identified
two of them unanimously as Byzantine, while
the third binding, which enclosed the missal
and is of less outstanding manufacture, is alter-
nately described as a genuine Byzantine piece or
as a thirteenth-century Venetian imitation of an
earlier Byzantine exemplar.[29] By the fourteenth

24 On the treasury of San Marco, see at least Gallo, *Il tesoro
di S. Marco*; Hahnloser, *Il tesoro e il museo*; Buckton, *Treasury
of San Marco*.

25 On this aspect, see S. Gerevini, "The Grotto of the Virgin
in San Marco: Artistic Reuse and Cultural Identity in Medieval
Venice," *Gesta* 53.2 (2014): 197–220.

26 The manuscripts under discussion are an epistolary
(BNM, Lat. I 101 [=2260]), a Gospel lectionary (BNM, Lat. I
100 [=2089]), and a missal (BNM, Lat. III 111 [=2116]). The
most comprehensive study of these manuscripts and their bind-
ings is R. Katzenstein, "Three Liturgical Manuscripts from San
Marco: Art and Patronage in Mid-Trecento Venice" (PhD diss.,
Harvard University, 1987). The bindings are also published
in A. Pasini, *Il tesoro di San Marco in Venezia* (Venice, 1886),
115–17; Hahnloser, *Il tesoro e il museo*, 2:47–50, nos. 35–37;
Buckton, *Treasury of San Marco*, 124–28, no. 9, 152–55, no. 14;
H. C. Evans and W. D. Wixom, eds., *The Glory of Byzantium:
Art and Culture of the Middle Byzantine Era, A.D. 843–1261*
(New York, 1997), 88, no. 41. See also T. Papamastorakis,
"Βυζαντιναί Παρενδύσεις Ένετίας: Luxurious Book-Covers in
the Biblioteca Marciana," Δελτ. Χριστ. Άρχ. Ετ. 27 (2006): 391–
409; S. Marcon, "Il tesoro di San Marco: Le legature preziose,
e gli studi di Iacopo Morelli su numerosi oggetti," in *Oreficeria
sacra a Venezia e nel Veneto: Un dialogo tra le arti figurative*, ed.
L. Caselli and E. Merkel (Treviso, 2007), 131–65; and S. Marcon,
"Oreficeria bizantina per i volumi preziosi di San Marco," in
Caselli and Merkel, *Oreficeria sacra*, 57–70. The Latin manu-
scripts have been examined in detail in G. Cattin, ed., *Musica e
liturgia a San Marco: Testi e melodie per la liturgia delle ore dal*

*12 al 17 secolo; Dal graduale tropato del Duecento ai graduali cin-
quecenteschi* (Venice, 1990), esp. 1:248–57, nos. 12–14.

27 Cattin, *Musica e liturgia*, 1:249–51, with further bibliography.

28 Gallo, *Il tesoro di S. Marco*, 279.

29 In his catalogue entry for Hahnloser, *Il tesoro e il museo*,
2:39–50, no. 37, André Grabar argues for a thirteenth-century
Venetian provenance, based on judgments about technical
quality and epigraphic details. More recently, Papamastorakis,
"Βυζαντιναί Παρενδύσεις," has held the same view. While the
inscriptions do present a number of peculiarities that point
to the artist's lack of familiarity with Greek, the unexcep-
tional quality of execution of the binding—particularly of the
gemstones' mounts, which Grabar criticizes—does not per se
prove a Venetian provenance. Venice was a renowned center of
production of metalwork artifacts in the thirteenth century,

fig. 24

FIGURE 24.

Silver antependium, ca. 1300, with later frame, 1336. Venice, Treasury of San Marco (formerly antependium of the high altar of the basilica). Photo courtesy of the Procuratoria di San Marco.

FIGURE 25.

Silver antependium, central plaques. Venice, Treasury of San Marco. Photo courtesy of the Procuratoria di San Marco.

fig. 25

fig. 26

fig. 27

FIGURE 26. Book binding, Byzantine, late ninth or early tenth century. Venice, Biblioteca Nazionale Marciana. Photo courtesy of the Biblioteca Nazionale Marciana.

fig. 28

FIGURE 27. Book binding, Byzantine, late tenth or early eleventh century. Venice, Biblioteca Nazionale Marciana. Photo courtesy of the Biblioteca Nazionale Marciana.

FIGURE 28. Book binding, Byzantine or Venetian, twelfth or thirteenth century (?), with fourteenth-century Venetian additions. Venice, Biblioteca Nazionale Marciana. Photo courtesy of the Biblioteca Nazionale Marciana.

century, the object had probably suffered some losses: new portraits of the four evangelists, executed in translucent enamel on silver, were added to its rear board—presumably when the binding was attached to the Latin missal (Fig. 28).

The book set would be processed in the basilica and displayed in the sanctuary on solemn liturgical occasions. The three covers agree beautifully with the overall redesign of the altar, lending strength to the hypothesis that the renewal of the pala d'oro was conceived as the centerpiece of a comprehensive redesign of the sanctuary area. The bindings—made of gold and gilded silver and encrusted with enamels, gemstones, and glass pastes—were almost miniature versions of the pala d'oro itself and visually complemented it.[30] Moreover, much like the folding altarpiece of San Marco, the ensemble formed by the Latin manuscripts and their Byzantine

and goldsmiths (as well as crystal carvers, gem cutters, and glassmakers) had already organized themselves into guilds in the second half of the century, manufacturing sophisticated artworks for local consumption and export. In this context it seems unlikely that the government would commission a new binding for use in the basilica from underskilled artisans.

30 Also noted by Katzenstein, "Three Liturgical Manuscripts," 241.

THE HIGH ALTAR 69

(or Byzantinizing) covers combined new artistic commissions with earlier (and foreign) artworks. This created artistic palimpsests that spoke to the antiquity of San Marco and its sacredness, and that reframed artistic change in terms of enhancement of and continuity with the past.[31] Finally, the Latin manuscripts and their Byzantine covers engaged their viewers—those at least who could look at the objects at close quarters—in a layered visual experience that combined religious narrative with icon-like sacred imagery, and that was not unlike that created on a grander scale by the pala feriale and pala d'oro.

Thus redesigned, the high altar of San Marco provided visitors to the basilica with an awe-inspiring visual spectacle that morphed continuously during the year to adapt to different liturgical requirements. Just how impressive the new altar area must have looked to contemporaries is evidenced by the immediate and enduring impact that the pala d'oro and pala feriale ensemble had on the visual landscape of Venice and neighboring regions. As Andrea De Marchi reminds us, the production of metalwork retables, and of cheaper specimens made of gilded wood, surged in Venice and its areas of influence after Dandolo's campaign.[32] More generally, Venetian medieval and early Renaissance altarpieces are distinctively three-dimensional, comprising elaborate raised frames that find no direct comparisons elsewhere in Italy and that are usefully understood as a long-term response to and adaptation of the model provided by the raised Gothic frame of the pala d'oro.[33] Finally, and crucially, a number of folding altarpieces (*pale ribaltabili*) and altar reliquaries painted by Venetian artists have survived from the fourteenth and fifteenth

centuries that are best explained as (more elementary) emulations of the striking opening mechanism of the pala feriale in San Marco.[34]

The widespread aesthetic impact of the high altar of San Marco proves that visitors to the church looked at it very carefully indeed. What purposes did the new design serve, though—and by what visual means did it achieve them?

Facing Crisis:
Liturgy, History, and Miracle Making

To begin with the obvious, the primary purpose of the layered altarpiece of San Marco was to provide a backdrop and a visual commentary to the mystery of the Eucharist that was celebrated at the altar, and to the liturgical reenactment of Christ's death on the cross and resurrection.[35] In addition, the altarpiece of San Marco was specifically intended to manifest and certify the physical presence of the body of St. Mark in the church, and explicitly depicted Venice's wider team of holy helpers. Finally, the altar played an important role in Venice's political ceremonial. Upon their election, newly minted doges processed to

31 Papamastorakis, "Βυζαντιναί Παρενδύσεις," esp. 392, pushes this argument further, suggesting that the three book covers may have been selected from the larger set of six bindings preserved in the treasury of San Marco and preferred to new, Palaiologan covers that could be easily acquired on the market precisely because of their antique look, which would better support Dandolo's efforts to express ideas about antiquity and continuity.

32 De Marchi, "La postérité," 72–78 (see above, p. 61, n. 16). For an impressive example from Kotor, see N. Jakšić, "Srbrna oltarna pala u Kotoru," *Ars Adriatica* 3 (2013): 53–66.

33 De Marchi, "La postérité," 64. See also N. Silver, "'Magna ars de talibus tabulis et figuris': Reframing Panel Painting as Venetian Commodity (14th–15th Centuries)," in Beaucamp and Cordez, *Typical Venice?*, 69–86.

34 C. Guarnieri, "Una pala ribaltabile per l'esposizione delle reliquie: Le 'Storie di Santa Lucia' di Jacobello del Fiore a Fermo," *ArtV* 73 (2016): 9–35; and C. Guarnieri, "Lo svelamento rituale delle reliquie e le pale ribaltabili di Paolo Veneziano sulla costa istriano-dalmata," in *La Serenissima via mare: Arte e cultura tra Venezia e il Quarnaro*, ed. V. Baradel and C. Guarnieri (Padua, 2019), 39–53. On page 40, Guarnieri notes that the pala feriale/pala d'oro ensemble is the earliest dated folding altarpiece in the city, as well as the most sophisticated; she also advances the tentative hypothesis that earlier (if simpler) examples of pale ribaltabili may have existed in Venice. See also De Marchi's important study "La postérité," particularly his discussion of the (lost) retable for the church of San Zaccaria. On the significance of the pala d'oro for the history of Venetian altarpieces, see also P. Humfrey, *The Altarpiece in Renaissance Venice* (New Haven, CT, 1993), esp. 21–29. On metalwork antependia and retables in the Venetian area, including some folding examples, see A. Niero, "Notizie di archivio sulle pale di argento delle lagune venete," *StVen* n.s. 2 (1978): 257–91; A. Niero, "Censimento delle pale nell'area lagunare," in Hahnloser and Polacco, *La pala d'oro*, 187–89 (see above, pp. 52–53, n. 3); and S. Gerevini, "Dynamic Splendor: The Metalwork Altarpieces of Medieval Venetia," *Convivium* 9.2 (2022): 102–23.

35 The standard reference on the history of the altar and its connections with the liturgy is J. Braun, *Der christliche Altar in seiner geschichtlichen Entwicklung* (Munich, 1924). A more recent, and excellent, collection of essays on different aspects of altar decoration and the development of altarpieces across medieval Europe is Kroesen and Schmidt, *The Altar and Its Environment* (see above, p. 61, n. 16).

the basilica. Once there they disrobed and subsequently accessed the sanctuary area, where they ritually lifted the *vexillum Sancti Marci*—the emblem of ducal authority—from the altar table. These functions were not new to the trecento. But concerns with the Eucharist and the Passion of Christ, preoccupations with divine intervention and saintly presence, and interest in the staging of ducal power and its limitations may have been particularly pressing at this time.

The later Middle Ages were a time of flourishing Eucharistic piety in Western Europe. This eucharistic focus, which culminated in the establishment of the Feast of Corpus Christi and in new rituals of exposition and adoration of the host, originated in new theological articulations of the real presence of Christ in the Eucharist. Eucharistic piety was also significantly furthered by the mendicant orders, whose theologies, devotional practices, and ideas of religious and spiritual reform centered on Christ's Passion. The liturgical arts of Europe also became more explicitly eucharistic at this time. And images of the sufferings of Christ—which were ideally suited to convey his presence in the host and explicate the doctrine of transubstantiation, while also engaging the viewers emotionally and triggering their compunction—became favored subjects for the decoration of altars.[36]

The trecento layout of the high altar of San Marco actively engaged with these religious developments. In 1336, the fourteenth-century silver antependium, discussed above, acquired its uppermost border. This included a representation of the Man of Sorrows in relief, flanked by the Virgin and St. John the Evangelist, and by a row of half-length figures of saints on each side (see above, Fig. 24). This was the first but not the last occurrence of this iconography in the basilica. As Catherine Puglisi and William Barcham have also noted, when Paolo Veneziano was commissioned

to paint the cover for the pala d'oro in 1343, he—or his patrons—picked up on this iconographic detail and translated it into a monumental painted ensemble.[37] Just like the silver altar frontal, the pala feriale comprises an emotionally charged image of the Man of Sorrows at the top center. Rather than being confined to a small and poorly visible plaque on the frame, however, the image of the suffering Christ was now magnified and given center stage, providing a more direct visual reference to the mystery of the Eucharist and offering a clear devotional focus to the faithful.[38]

The choice of the Man of Sorrows for the high altar of San Marco is one outstanding example of the sophisticated and multilayered interplay between Byzantine and local Italian artistic and religious traditions in Dandolo's projects.[39]

36 For a comprehensive introduction and further bibliographies, see the essays gathered in I. C. Levy, G. Macy, and K. Van Ausdall, eds., *A Companion to the Eucharist in the Middle Ages* (Leiden, 2012), especially G. Macy, "Theology of the Eucharist in the High Middle Ages," 365–98, and K. Van Ausdall, "Art and Eucharist in the Late Middle Ages," 541–617. On the shifting iconographic focus of altarpieces to reflect growing Eucharistic piety during the thirteenth century, see also S. Kemperdick, "Altar Panels in Northern Germany, 1180–1350," in Kroesen and Schmidt, *The Altar and Its Environment*, 125–46.

37 The fourteenth-century missal cited above (BNM, Lat. III 111, fol. 7r) also includes a diminutive representation of the Man of Sorrows, confirming the relevance of the subject matter for the basilica's mid-century patrons. The folio is illustrated in Cattin, *Musica e liturgia*, 1:135. See also C. R. Puglisi and W. L. Barcham, *Art and Faith in the Venetian World: Venerating Christ as the Man of Sorrows* (Turnhout, 2019), 52.

38 The Man of Sorrows on the pala feriale has been the object of a number of studies by Catherine Puglisi and William Barcham: C. R. Puglisi and W. L. Barcham, "Gli esordi del 'Cristo passo' nell'arte veneziana e la pala feriale di Paolo Veneziano," in *"Cose nuove e cose antiche": Scritti per monsignor Antonio Niero e Don Bruno Bertoli*, ed. F. Cavazzana Romanelli, M. Leonardi, and S. Rossi Minutelli (Venice, 2006), 403–29; C. R. Puglisi and W. L. Barcham, "'The Man of Sorrows' and Royal Imaging: The Body Politic and Sovereign Authority in Mid-Fourteenth-Century Prague and Paris," *Artibus et Historiae* 35.70 (2014): 31–59, esp. 32–33; and Puglisi and Barcham, *Art and Faith*, esp. 51–55.

39 The complexity of such interactions should be measured against the lively debate about the origins of the Man of Sorrows in Byzantium, and about the trajectories of its visual and functional translation to Western Europe. The standard reference is still H. Belting, *The Image and Its Public in the Middle Ages: Form and Function of Early Paintings of the Passion* (New Rochelle, NY, 1990). See also H. Belting, "An Image and Its Function in the Liturgy: The Man of Sorrows in Byzantium," *DOP* 34/35 (1980): 1–16. For an introduction to Western adaptations of the image, see A. Derbes and A. Neff, "Italy, the Mendicant Orders, and the Byzantine Sphere," in Evans, *Byzantium: Faith and Power* (see above, p. 14, n. 7), 449–61, esp. 456–58. Amy Neff has done extensive work on the Man of Sorrows: A. Neff, "Byzantium Westernized, Byzantium Marginalized: Two Icons in the *Supplicationes variae*," *Gesta* 38.1 (1999): 81–102; see also her more recent *A Soul's Journey: Franciscan Art, Theology, and Devotion in the* Supplicationes variae (Toronto, 2019). On Byzantine uses, see also T. V. Barnand, "The Complexity of the Iconography of the Bilateral Icon of the Virgin Hodegetria and the Man of Sorrows, Kastoria," in Eastmond and James, *Wonderful Things*, 129–38 (see above, p. 38, n. 116), with further bibliography.

On the one hand, Paolo Veneziano's *imago pietatis* agrees with the devotional significance and functional adaptability of this image in late medieval Italy. On the other hand, the Man of Sorrows was often chosen in Palaiologan churches for the decoration of the *prothesis* chamber, the side apse where the eucharistic elements were prepared. The placement of the imago pietatis in the sanctuary of San Marco similarly emphasizes its eucharistic connotations, in accordance with late Byzantine uses of the same image.

The semantic charge of the pala feriale would be further enhanced during Holy Week, when Christ's real presence in the Eucharist at San Marco would also be powerfully manifested through the display and veneration of his Passion relics. Venice had allegedly acquired the holy *pignora* in Constantinople in 1204 but promoted them ever more assertively in the late duecento and the trecento.[40] The relic of the Holy Blood—

with its direct eucharistic associations—and the relics of the true cross were publicly displayed in San Marco on Holy Friday and on the Feast of the Ascension.[41] Although coeval sources are silent on the specific modes of their ostension, it seems likely that they would be presented to the congregation on or in the proximity of the high altar of the basilica—possibly, from the hexagonal pulpit known as the *bigonzo*—thus engaging in fruitful conversations with the imagery of both the pala d'oro, opened on the day of the Ascension, and the pala feriale, on view on Holy Friday.

The interactions between the pala feriale, the Passion relics, and the liturgy of Holy Week were both religiously profound and aesthetically powerful. On the one hand, the visual and ritual ensemble conformed to contemporary interest in the suffering of Christ and capitalized on the devotional charge of the Man of Sorrows, which—as a summary of the entire Passion cycle—made Christ's humanity instantly accessible and reminded viewers of the necessity of the Redeemer's sacrifice within the economy of salvation.[42] On the other hand, the high altar of the basilica revitalized the original liturgical association of the Man of Sorrows, which likely originated in Byzantium in the twelfth century and was widely depicted on icons in use during the Passion service on Holy Friday.[43] Intriguingly, San Marco also possesses a Byzantine *aër-epitaphios*, a (much-restored) embroidered textile

40 The Passion relics of San Marco have a complex history and historiography. They are attested for the first time in a letter written in 1265 by Doge Ranieri Zen, published by Ester Pastorello as an appendix to Dandolo, *Chronica per extensum descripta*, 393–94 (see above, p. 21, n. 47). Andrea Dandolo himself was the first historical author to associate them explicitly with the Fourth Crusade: Dandolo, *Chronica per extensum descripta*, 280. These relics and their reliquaries are included in all major studies on the treasury of San Marco: Pasini, *Il tesoro di San Marco* (see above, p. 66, n. 26); Gallo, *Il tesoro di S. Marco* (see above, p. 12, n. 3) ; and Buckton, *Treasury of San Marco* (see above, p. 36, n. 110). Furthermore, they are discussed in A. Frolow, "Notes sur les reliques et les reliquaires byzantins de Saint-Marc de Venise," Δελτ. Χριστ. Ἀρχ. Ἑτ 4.4 (1964–1965): 205–26; D. Pincus, "Christian Relics and the Body Politic: A Thirteenth-Century Relief Plaque in the Church of San Marco," in *Interpretazioni veneziane: Studi di storia dell'arte in onore di Michelangelo Muraro*, ed. D. Rosand (Venice, 1984), 39–57; M. Donega, "I reliquiari del sangue di Cristo del tesoro di San Marco," *Arte documento* 11 (1997): 64–71; H. A. Klein, "Die Heiltümer von Venedig—die 'byzantinischen' Reliquien der Stadt," in Ortalli, Ravegnani, and Schreiner, *Quarta crociata*, 2:699–736 (see above, p. 36, n. 110); K. Krause, "The 'Staurotheke of the Empress Maria' in Venice: A Renaissance Replica of a Lost Byzantine Cross Reliquary in the Treasury of St Mark's," in *Die kulturhistorische Bedeutung byzantinischer Epigramme: Akten des internationalen Workshop (Wien, 1–2. Dezember 2006)*, ed. W. Hörander and A. Rhoby (Vienna, 2008), 37–53; K. Krause, "Feuerprobe, Portraits in Stein: Mittelalterliche Propaganda für Venedigs Reliquien aus Konstantinopel und die Frage nach ihrem Erfolg," in *Lateinisch-griechisch-arabische Begegnungen: Kulturelle Diversität im Mittelmeerraum des Spätmittelalters*, ed. M. Mersch and U. Ritzerfeld (Berlin, 2009), 111–62; and Klein, "Refashioning Byzantium" (see above, p. 55, n. 5). In addition, C. J. Hahn and H. A. Klein, eds., *Saints and Sacred Matter: The Cult of Relics in Byzantium and Beyond* (Washington, DC, 2015); and C. J.

Hahn, *Strange Beauty: Issues in the Making and Meaning of Reliquaries, 400–circa 1204* (University Park, PA, 2012), provide assistance in situating the Passion relics of San Marco in their broader religious and artistic context.

41 Canale, *Les estoires de Venise* (see above, p. 21, n. 43), 262–63: "Li vendredi fait Monsignor li dus monstrer en l'iglise de Monsignor Saint Marc les precioues reliques, et li sanc de Notre Signor, et la Sainte Cruis: et sachés que tot li peuple, dames et damoiseles, les vont veoir" (On Friday, the doge had the precious relics [and] the blood of Our Savior, and the Holy Cross exhibited in the church of Saint Mark: and be aware that all people, women and young ladies come to see them). On the display on Ascension Day, see Ziani's letter in 1265 published in Dandolo, *Chronica per extensum descripta*, appendix 1, 393 (see above, p. 21, n. 47).

42 Further research may highlight the connections between Paolo Veneziano's altarpiece and the early fourteenth-century Man of Sorrows at the Museo Diocesano di Torcello, which is remarkably understudied. On this panel, see Flores d'Arcais and Gentili, *Il Trecento adriatico*, 130–31, no. 14 (see above, p. 37, n. 114).

43 Belting, "Image and Its Function."

bearing a representation of the dead Christ on the Stone of Unction (Fig. 29).[44] In Byzantium, similar textiles had a specific liturgical function: the *aër* was employed to cover the eucharistic elements after they had been prepared, and the *epitaphios* was more specifically employed during the liturgy of Holy Friday and Saturday.[45] Unfortunately, whether and on what occasions the Byzantine embroidery was used in the basilica in the fourteenth century is unknown. Early modern sources, however, indicate that the textile was displayed on Holy Friday. In the sixteenth century, a textile with the *Cristo passo* (the dead Christ) is mentioned as a cover for the *sepulchrum*, the temporary structure that functioned as the tomb of Christ during the Holy Friday and Easter celebrations, and specifically for the Deposition and *Quem quaeritis* rituals.[46] By the sixteenth century the sepulchrum was positioned in the north transept, adjacent to the door of the chapel of Sant'Isidoro. However, the same source indicates that "in the past" the structure was placed by the choir—that is, nearer the high altar. Later, eighteenth-century sources postulate a different use for the aër-epitaphios. On Holy Friday, the Passion relics were exhibited from the bigonzo—the hexagonal pulpit located to the right of the main altar (looking east)—and the aër-epitaphios served to decorate the pulpit.[47]

Neither of the uses documented in later times is explicitly attested in the fourteenth century. But it seems reasonable to assume that the eucharistic and paschal connotations of the textile (the likes of which were widely employed throughout the Byzantine world) were known in Venice. In addition, the eighteenth-century inventory describes the Byzantine aër-epitaphios as badly damaged, which might indicate wear due to repeated use.[48] Finally, the earliest inventory of the treasury of San Marco, drafted in 1283, includes a list of standards and textiles that were "placed in the church of San Marco on major feast days."[49] The list mentions a crimson cloth "embroidered with needle, with Christ in the middle."[50] Whether or not the entry refers specifically to the Byzantine item under discussion, the inventory provides direct evidence that precious textiles were displayed in the basilica on important occasions. In this context, it is not inconceivable that the aër-epitaphios may have been displayed on the sepulchre by the choir entrance, or alternatively on or near the altar, or on the bigonzo on Holy Friday and Saturday. In any of these positions, the textile would have amplified the visual and emotional charge of the pala feriale.

The second obvious intent of the high altar of San Marco's artistic apparatus was to signal St. Mark's physical presence in the basilica. The church had been the repository of St. Mark's body since the ninth century, when it was translated to Venice in 828, and the decorative program of the presbytery was clearly intended to advertise and amplify the presence and immediate proximity of the saint. In its fourteenth-century incarnation, the altar program fulfilled this purpose

44 This is one of two Byzantine textiles to have survived in San Marco. Both are discussed by M. Theocharis, "Ricami bizantini," in Hahnloser, *Il tesoro e il museo*, 2:91–93, no. 115 (textile with archangels), and 94–97, no. 116 (aër-epitaphios) (see above, p. 12, n. 3). On the modern restoration of the textiles, see M. G. Vaccari and S. Conti, "I 'veli' bizantini del Museo Marciano di Venezia: La pulitura; Problemi, sperimentazioni, risultati," *OPD Restauro* 8 (1996): 48–65, 88–91.

45 On the different liturgical use of *aëres* (used to cover the eucharistic elements once they were placed on the altar) and *epitaphioi* (used during the liturgy of Holy Saturday), see the succinct entries by A. Gonosová in *ODB* 1:27, 720–21.

46 On the ceremonies and the sepulchrum, see S. Rankin, "From Liturgical Ceremony to Public Ritual: 'Quem Queritis' at St. Mark's, Venice," in *Da Bisanzio a San Marco: Musica e liturgia*, ed. G. Cattin (Bologna, 1997), 137–91, esp. 188, where a passage from the sixteenth-century manuscript BNM, Lat. III 172 (=2276), indicates the position of the sepulchre then, and previously, and the use of a textile with a dead Christ to cover it. On the use of the epitaphios as cover for the sepulchre, see also Hills, "Vesting the Body of Christ."

47 Gallo, *Il tesoro di S. Marco*, 242–43, with reference to primary sources.

48 Gallo, *Il tesoro di S. Marco*, 242: "a standard embroidered with gold and silk, representing Christ in the sepulchre, serves the bigonzo for the display of the Holy Blood (and is) nearly lost (*prossimo a perdersi*)."

49 Gallo, *Il tesoro di S. Marco*, 275: *ponuntur in ecclesia B[eatissi]mi Marci in magnis festivitatibus*.

50 Gallo, *Il tesoro di S. Marco*, 275. For a summary of the arguments for and against identifying the textile in the inventory entry with the Byzantine aër-epitaphios, see H. Schilb, "Byzantine Identity and Its Patrons: Embroidered Aeres and Epitaphioi of the Palaiologan and Post-Byzantine Periods" (PhD diss., Indiana University, 2009), 291–94, no. 12. The author considers the possible uses of the textile in Byzantium, but unfortunately not in Venice.

FIGURE 29.
Aër-epitaphios,
Byzantine, twelfth
century (?). Venice,
Museo di San Marco.
Photo courtesy of
the Procuratoria di
San Marco.

through a strategy of visual accumulation.[51] Each of the three *tabulae* that adorned the altar (the pala d'oro, the silver antependium, and the pala feriale) featured a narrative cycle of the life of St. Mark, so that at all times of the year, and whatever the ritual inflection of the celebrations, the faithful would be reminded of the saint's presence and preeminence in the basilica. However, each tabula handled the evangelist's hagiography differently. The diminutive size of the enamel plaques on the pala d'oro, and their peripheral location along the sides of the retable, suggest that St. Mark's narrative—though crucial to

Venice's religious identity and self-image—was ancillary to the refulgent vision of divine glory and cosmic order conveyed by the golden altarpiece in its fourteenth-century layout. Instead, St. Mark's bust portrait occupies a privileged position, next to the Virgin in the upper tier of Paolo Veneziano's painting, and his life occupies half of the pictorial space on both the antependium and the pala feriale, where individual episodes are also larger and better visible.

On both panels, particular emphasis is given to Mark's capture and martyrdom in Alexandria. Admittedly, the foregrounding of a holy patron's pious death was a standard practice in medieval and Byzantine art. Nevertheless, St. Mark's capture and martyrdom, which allegedly occurred on Easter day as the saint was celebrating Mass at the altar, invited especially rich conjectures. These were not lost on the designers of the basilica's altar

51 On artistic redundancy in the decorative program of the altar of San Marco, see also S. de Blaauw, "Altar Imagery in Italy Before the Altarpiece," in Kroesen and Schmidt, *The Altar and Its Environment*, 47–56 (see above, p. 61, n. 16). On page 55, this program is described as "an attempt to create an up-to-date presbytery with strong early Christian connotations."

program. On the pala feriale, St. Mark's martyr-
dom is placed on a vertical axis with the Man of
Sorrows, establishing a direct link between the
sacrifice of the Lord and that of the evangelist.
A similar strategy of typological juxtaposition is
also pursued on the altar frontal. There the Man
of Sorrows, Christ in Majesty, and St. Mark in
glory are all vertically aligned, further insisting
on the correspondence between the Passion and
resurrection of the Redeemer on the one side and
the evangelist's martyrdom and glorification on
the other.[52]

Besides Venice's ever recurring partisan ide-
ology, another element may have justified the
increased emphasis on Mark's hagiography, and
the insistence on its semantic conflation with
Christ's Passion. Eucharistic images were tasked
with explicating an unfathomable mystery—the
conversion of the consecrated bread into the
actual body of Christ, which occurred without
any visible transformation of matter. Making
Christ literally visible at the altar, these images
remedied his otherwise obstinate invisibility in
the host. Ostensibly, the presence of St. Mark in
the Venetian basilica had nothing metaphorical
about it, for the church of San Marco had been
built to house his body after it was translated
from Alexandria in 828. Nevertheless, the exact
location of St. Mark's body in the basilica was a
state secret, which was only revealed to the doge,
procurators, and leading cleric (primicerius).[53]
The evangelist's relics were therefore inaccessible
to the faithful in the fourteenth century—leaving
it to the mosaic cycles in the basilica and the pic-
torial hagiographies on the high altar to certify
that St. Mark was actually present in the church.[54]

Indirectly corroborating the evidentiary role
of images on the high altar, Andrea Dandolo's
Chronica per extensum descripta addressed pos-
sible reservations about the presence of the holy
body in the basilica. At the end of his account of

St. Mark's secret reburial following the *Apparitio*
(1094), the doge warned his readers that their
faith in the existence of the saint's body should
not waver simply because they did not know its
precise location. By virtue of his subsequent roles
as procurator and doge, he—the author—could in
fact employ the following words from the Gospel
of John: "The man who saw it has given testi-
mony, and his testimony is true. He knows that
he tells the truth, and he testifies so that you also
may believe" (John 19:35), and "by believing you
may have life in His name" (John 20:31).[55] Both
these Gospel passages issue from the mouth of St.
John, an eyewitness to the death and resurrection
of Christ. Also, the second quotation immediately
follows the account of the Apparition of Christ
to St. Thomas, the doubting apostle. Together,
these excerpts designate the doge as the authorita-
tive witness and guarantor of the presence of St.
Mark's body in the basilica and exhort the chron-
icle's readers to trust his testimony and hold on to
their faith. Yet they also insinuate that the inacces-
sibility of Mark's tomb generated some diffidence
among contemporaries.

The pala feriale appears to have been spe-
cifically designed to address this problem,
powerfully asserting St. Mark's *praesentia* in
Venice, and in the church of San Marco more
specifically. All other pictorial representations of
the life of St. Mark—the twelfth-century mosa-
ics in the chapel of San Clemente, the thirteenth-
century cycle in the Zen chapel and on the west
façade, as well as the enameled hagiography
on the pala d'oro and the embossed plaques on
the fourteenth-century paliotto—end with the
saint's burial in Alexandria, or with the arrival
of his body in Venice in 828. The pala feriale
construes an altogether different narrative,
which focuses specifically on the saint's physical

52 Also noted by Goffen, "Paolo Veneziano," 178 (see above,
pp. 52–53, n. 3).

53 On the confidentiality of the evangelist's placement in
the basilica in the fourteenth century, see Dandolo, *Chronica
per extensum descripta* (see above, p. 21, n. 47), 219 (transcribed
below, n. 55).

54 Fourteenth-century pilgrims to Venice make explicit refer-
ence to the inaccessibility of St. Mark's body: see, for example,
Niccolò da Poggibonsi, *Libro d'oltramare*, ed. Alberto Bacchi
della Lega (Bologna, 1881), 1:5.

55 Dandolo, *Chronica per extensum descripta*, 219: *Consciis
duce, primicerio et procuratore, reverendum corpus in ea [ecclesia]
secrete colocatur; locus igitur omnibus usque in hodiernum, preter
eorum sucessoribus, exstat incognitus. Nec propterea nesciencium
fide vacilet, cum ego, qui loquor, primo procuratoris gerens offi-
cium, nunc Christi gratia dux efectus, possim dicere verba Iohanis,
capitulo XVIIII: et qui vidit testimonium perhibuit; et verum
est testimonium eius; et ille scit quia vera dicit, ut et vos credatis;
et Iohanis penultimo capitulo: Ut credentes, eius meritis, vitam
habeatis.* The passage may support Marino Sanudo's later asser-
tion that Dandolo personally inspected the evangelist's body:
Sanudo, *Vitae ducorum*, 627 (see above, p. 1, n. 1).

presence in the basilica and on the miracles he performed to the benefit of Venice. Mark's actual life is summarized on the pala feriale in only four scenes: his *Consecration by St. Peter, Anianus's Healing, Christ's Apparition to St. Mark in Prison,* and his *Martyrdom.* The three remaining panels—which amount to almost half the length of the cycle—are dedicated to posthumous episodes. Mark's arrival in Venice in 828, which appears on the pala d'oro, is conspicuously absent from the painted altarpiece. Instead, the evangelist's *translatio* is conveyed through a scene of miraculous intercession that had been represented for the first time in the twelfth century, inside the chapel of San Clemente. When Mark's body was being transported from Alexandria to Venice by sea, the Venetian vessel was caught up in a nocturnal storm. Appearing to the monk who supervised his body, and instructing him that they were near the coast and that the crew should lower the sails and prepare to dock, St. Mark averted a disastrous shipwreck, saving the vessel with its precious cargo.[56] With a leap forward in time, the next panel renders another well-known miraculous performance, believed to have happened in 1084 or 1094 and known as the *Apparitio.* Reputedly, memory of the evangelist's secret burial place had been lost, causing great anxiety among Venetian religious and political authorities, who summoned the entire congregation for three days of collective prayer and fasting. Granting the prayers of his devotees, at the end of the third day St. Mark miraculously revealed to the doge and bishop the location of his body, which had been hidden inside a pillar near the east end of the building.[57] This episode was memorialized in mosaic in the south transept in the thirteenth century, and for the second time on the pala feriale in the mid-fourteenth.[58] As

Ana Munk has already noted, the two representations diverge in one significant detail: the evangelist's uncorrupted body is invisible in the mosaic, where the viewer is confronted with an open yet empty-looking pillar. Instead, St. Mark is fully visible on the pala feriale, where he emerges from a column before the doge, the bishop, and their retinues—to renew and reinforce his bond with the Venetian state (Figs. 30 and 31).[59]

Paolo Veneziano's source for the pala feriale is commonly identified with Jacobus de Voragine's account of the life of St. Mark in the *Golden Legend.*[60] However, another manuscript might represent a more likely companion text for this painting.[61] This text, exemplars of which have survived since the mid-fourteenth century, provides a detailed account of the *Apparitio* that also includes a short, retrospective narrative of the averted shipwreck represented in the preceding panel. Intriguingly, this version of the *Apparitio* positively compares the miraculous appearance of the evangelist in 1084 with Christ's own resurrection from the sepulchre—going so far as to argue that Mark's apparition was even more wondrous than Christ's resurrection, for the latter only occurred a few days after Christ's death, while the evangelist performed the same act centuries after his martyrdom.[62]

This flattering description provides an attractive textual parallel to the pala feriale. The altarpiece aligns the Man of Sorrows with Mark's martyrdom, implicitly presenting them as events of comparable magnitude. In addition—and unlike the earlier representation of the same scene in the mosaics of the south transept—the evangelist's head is actually visible in the *Apparitio,* as it emerges from the column in what looks like a quasi-resurrection. Finally, just as the apostles witnessed Christ's posthumous apparitions and lived on to testify to their veracity, the doge and

56 Jacobus de Voragine, *The Golden Legend: Readings on the Saints,* trans. W. G. Ryan (Princeton, NJ, 2012), 245.

57 The miracle is reported by Canale, *Les estoires de Venise,* 218–19, no. 60 (see above, p. 21, n. 43); and Jacobus de Voragine, *Golden Legend,* 245. For a discussion of the textual tradition of the miracle, see G. Monticolo, "L'*Apparitio Sancti Marci* ed i suoi manoscritti," *NAVen* 9 (1895): 111–78.

58 The mosaics in the south transept are generally dated to the mid-thirteenth century and have been associated with Doge Ranieri Zen by Demus, *Mosaics of San Marco,* 2:27 (see above, p. 36, n. 111). See also Dale, "Inventing a Sacred Past," esp. 85–88 (see above, p. 49, n. 151).

59 A. Munk, "The Art of Relic Cults in Trecento Venice: 'Corpi Sancti' as a Pictorial Motif and Artistic Motivation," *Radovi Instituta za Povijest Umjetnosti* 30 (2006): 81–92; and A. Munk, "Somatic Treasures: Function and Reception of Effigies on Holy Tombs in Fourteenth Century Venice," *IKON* 4 (2011): 193–210.

60 Jacobus de Voragine, *Golden Legend,* 242–48.

61 For a discussion of the text and its relation to Dandolo's *Chronica per extensum descripta,* see Monticolo, "L'*Apparitio Sancti Marci.*"

62 Monticolo, "L'*Apparitio Sancti Marci,*" 144.

the community are represented in Paolo's painting in very close proximity to the *Apparitio* column, as they gaze intently at the evangelist's miraculous apparition.

The last scene of the pala feriale, which introduces a new episode in the evangelist's visual hagiography, also places specific emphasis on St. Mark's real presence in the basilica and his miraculous interventions. Notably, this panel does not represent historical events of an official public nature. Instead, it brings the hagiographical account into the present and adds a new color to the evangelist's cult in San Marco by showing a diverse group of faithful gathered near his shrine (Fig. 32).

This scene, too, may find a useful textual accompaniment in the Apparitio manuscript mentioned above. The text provides a detailed account of the many miracles that St. Mark performed after his re-*collocatio* in San Marco in 1094. Intriguingly, these narratives place great emphasis on the high altar of the basilica. In the manuscript, most of Mark's miracles occur at the altar of the basilica itself, to reward pilgrims who traveled to the shrine of the evangelist in Venice. Alternately, St. Mark is said to have appeared to his imperiled devotees in dreams or visions, and to have occasionally intervened to save them in remote places. But the beneficiaries of such long-distance miracles then habitually undertook thanksgiving pilgrimages to San Marco, which in turn culminated in their arrival at the altar.

The last panel of the pala feriale—which depicts men and women of different walks of life, some in chains, others physically impaired—may be understood in relation to this catalogue of saintly interventions as a way to record and certify them, and by extension as the means to advertise the presence and active agency of Mark's body in his church, and at the high altar more specifically. In fulfilling this aim, the pala feriale ran into a problem. Mark's tomb was placed underneath the high altar, in the crypt of the basilica.[63]

As already discussed, however, the tomb was inaccessible and unknown to the faithful, leaving them without a physical target for their devotion and prayers.[64] The last panel of the pala feriale offered a clever visual solution to this problem, by conflating the evangelist's shrine with the high altar of the basilica. The tomb is depicted as a sealed, elevated sarcophagus, supported by columns and placed under a canopy. But the mottled, deep green color of the ciborium and the shape and partitions of its four columns neatly match those surrounding the high altar of the basilica: the pala feriale visually promoted the altar of the church as the chief focus for the cult of St. Mark, and as a substitute for his tomb, located underneath it.[65]

───────────

63 The body of the evangelist was removed from the crypt and placed inside the high altar, where the sarcophagus is still visible behind a (modern) metal grid, in 1834–1835. See E. Vio, "La tomba e l'altare di San Marco: Le colonne in cripta a sostegno di quelle istoriate del ciborio," in Favaretto, *Le colonne del ciborio*, 39–47 (see above, p. 59, n. 14); and A. Fumo, "La ricognizione

del corpo di San Marco: Cronache e documenti," in *Quaderni della Procuratoria: Arte, storia, restauri della basilica di San Marco a Venezia*, vol. 15, *Sedici anni di studi sulla basilica: Il punto della situazione*, ed. I. Favaretto (Venice, 2021), 48–56, for a detailed report of the nineteenth-century survey and building work. On the crypt, see also Vio, *San Marco: La basilica* (see above, p. 13, n. 5); M. Agazzi, "San Marco: Da cappella palatina a cripta contariniana," in *Le cripte di Venezia: Gli ambienti di culto sommersi della cristianità medievale*, ed. M. Zorzi (Treviso, 2018), 25–51; and M. Agazzi, "Questioni marciane: Architettura e scultura," in Vio, *San Marco: La basilica*, 1:91–109. I am grateful to the author for sharing her work with me.

64 Agazzi, "San Marco," 49, and "Questioni marciane," 91, indicates that although the crypt was inaccessible to the public, two confraternities—the Scuola dei Mascoli (founded in 1211) and the Scuola degli Orbi (the confraternity of the blind, founded in 1315)—may have gathered in the crypt before they moved into dedicated spaces elsewhere. Unfortunately the reference here is an embargoed MA thesis: G. Campagnari, "Gli altari della Basilica di San Marco: Ricerche e ipotesi per la comprensione della fase medievale" (MA thesis, Università Ca' Foscari Venezia, 2015). The Orbi are also mentioned by G. Tassini, *Curiosità veneziane, ovvero Origini delle denominazioni stradali di Venezia*, 2nd ed. (Venice, 1872), 512 (with no further references). The tomb was located in the main apse of the crypt and was secluded: thus access to the lower church by the members of those confraternities does not contradict Dandolo's statement about the secrecy of St. Mark's burial or pilgrims' accounts to the same effect. Nonetheless, it seems intriguing that access to the crypt may have been granted to those who were not able to see, and who could therefore not reveal the tomb's location to others.

65 The fourteenth-century *consuetudines* of the basilica indicate that after the end of the Mass the custodians of the basilica remained near the high altar, supervising pilgrims and devotees who came to make offerings and pray: Betto, *Il capitolo*, 148 (see above, p. 61, n. 17). This entry offers further evidence that the high altar functioned as a primary religious focus, in lieu of the saint's tomb. On the high altar as devotional substitute for the tomb, see also M. Tomasi, *Le arche dei santi: Scultura, religione e politica nel Trecento Veneto* (Rome, 2012), 47–49.

FIGURE 30. *Apparitio*, mid-thirteenth century. San Marco, Venice, south transept. Photo courtesy of the Procuratoria di San Marco.

FIGURE 31. Pala feriale, Paolo Veneziano, *Apparitio*, 1345. Venice, Museo di San Marco (formerly high altar). Photo courtesy of the Procuratoria di San Marco.

fig. 31

THE HIGH ALTAR 79

FIGURE 32. Pala feriale, Paolo Veneziano, the faithful visit St. Mark's shrine, 1345. Venice, Museo di San Marco (formerly high altar). Photo courtesy of the Procuratoria di San Marco.

The specific solutions adopted in San Marco to remedy the inaccessibility of the evangelist's tomb were tailored to Venice's visual and devotional needs. A useful comparative example, however, is afforded by the church of Hagios Demetrios in Thessalonike. As at San Marco, the exact location of the body of St. Demetrios in the basilica was unknown to the faithful, generating over the centuries the need periodically to confirm the saint's presence and renovate his cult. Robin Cormack and others have noted that in the absence of an actual body to venerate, the architectural and visual programs of the church functioned as the effective proof of the existence and historicity of the saint, as well as of his active role as intercessor for his devotees and for the city.[66] Several mosaic portraits of St. Demetrios were set up in the church that depicted the saint in the proximity of his devotees and of Thessalonike's officers, promoting ideas of vicinity and active protection. Also, analogous to San Marco, a monumental ciborium (that did not contain the saint's tomb) was promoted in Hagios Demetrios as a chief devotional site, and as the locus of the encounter between the faithful and St. Demetrios—at least until the eleventh century, when the miraculous appearance of *myron* from the (still concealed) body of the saint further complicated the holy topography of the basilica.

The comparison with Hagios Demetrios offers a useful framework within which to examine the function and the semantics of the pala feriale in San Marco. On one level, the painting works as a means of certification and verification: it records historical events that have already been inscribed elsewhere, in the textual accounts of St. Mark's life and miracles. But for the first time in Venetian history, the altarpiece also depicts the location—whether real or fictive—of Mark's burial site within the basilica, explicitly identifying it with the altar area. Also for the first time, the pala represents pilgrims at the shrine of the evangelist, both portraying and promoting acts of collective devotion and individual prayer before the altar. These are radical innovations for San Marco.[67] Previously, the government had advertised the cult of St. Mark and the basilica as the exclusive foci of Venice's public religion, and as the agents of legitimation of the city's apostolic origins and right to rule. Instead, the pala feriale also casts St. Mark as an active intercessor for those in need, incidentally directing them toward the high altar as a privileged site of encounter with their patron. By combining the representation of popular devotions and miraculous individual healing in the last panel with established episodes from St. Mark's hagiography and Venetian official history, the pala feriale integrates ordinary people and the victims of malaise into Venice's public image, thereby arguably advertising and strengthening communal solidarity.

Concerns with group solidarity, cohesiveness, and the need for increased holy protection at difficult times also color the meaning of the upper tier of the pala feriale. Unlike the pala d'oro, which conjured a universal vision of heavenly glory within which hierarchy and the collective presence of apostles, prophets, and angels mattered more than their individual personalities, the holy figures on the pala feriale were evidently selected on the basis of their specific association with Venice. Doubtless, the inclusion of civic patrons and locally relevant saints in the decorative program of altarpieces was a standard practice across Europe. Analogously, Byzantine churches and templon screens included permanent and rotating icons of patron saints. Yet the depiction of a team of local holy protectors was a novelty for the high altar of San Marco, and one that both modified and expanded the group of saintly intercessors chosen for representation in the lower section of the eastern apse two centuries earlier: St. Nicholas, St. Peter, St. Mark,

66 Literature on Hagios Demetrios and how the cult of St. Demetrios was visually promoted on site and through portable objects is extensive. This paragraph draws on the following important studies: R. Cormack, *Writing in Gold: Byzantine Society and Its Icons* (London, 1985), 50–94; R. Cormack, "The Making of a Patron Saint: The Power of Art and Ritual in Byzantine Thessaloniki," in *World Art: Themes of Unity in Diversity; Acts of the XXVIth International Congress of the History of Art*, ed. I. Lavin (University Park, PA, 1989), 3:547–56; C. Bakirtzis, "Pilgrimage to Thessalonike: The Tomb of St. Demetrios," *DOP* 56 (2002): 175–92; F. A. Bauer, *Eine Stadt und ihr Patron: Thessaloniki und der Heilige Demetrios* (Regensburg, 2013); and L. Veneskey, "Truth and Mimesis in Byzantium: A Speaking Reliquary of Saint Demetrios of Thessaloniki," *AH* 42.1 (2019): 16–39.

67 The innovativeness of this representation has also been noted by Munk, "Relic Cults."

and St. Hermagoras. It has long been acknowledged that this particular selection—particularly the inclusion of the first patriarch of Aquileia, St. Hermagoras—advertised Venice's claims to religious primacy over the patriarchal seat of Aquileia.[68] By the fourteenth century those controversies had long subsided, permitting a partial reconfiguration of the team of holy patrons on the pala feriale.

As briefly mentioned above, the altarpiece sequence opened with the effigy of an uninscribed warrior saint. Scholars have identified this image alternately with St. Theodore or St. George. The former was the early protector of the city before the translation of St. Mark in 828. While St. Theodore's cult was largely replaced in later centuries by that of the evangelist, there exists some positive (if ambivalent) evidence of increased interest in the saint on the part of Venice's public authorities in the fourteenth century. St. Theodore is represented (together with St. George) in the baptistery of San Marco: there, the two holy warriors are rendered as knights on horseback in two stone reliefs on the east wall, where they flank the sculpted image of the baptism of Christ. In addition, the sixteenth-century writer Francesco Sansovino claimed in his learned description of the city of Venice that the so-called *San Todaro*, a sculpture standing atop one of the two columns in the Piazzetta San Marco and long identified with St. Theodore, was placed there in 1329. Sansovino claimed to have drawn this information from a trecento source, the (otherwise unidentified) Piero Guilonzardo (or Guilombardo). Confusingly for us, Sansovino also noted (but promptly dismissed) that the fourteenth-century chronicler, who had witnessed the events of 1329, had identified the sculpture as St. George, rather than as St. Theodore.[69]

St. George was also actively venerated in Venice, and abundant evidence exists of an increase in his cult's popularity in the fourteenth century. St. George was the dedicatee of the monastery of San Giorgio Maggiore, which was founded in the eleventh century and soon developed into one of the chief loci of Venetian public religion. He was also one of the three holy protagonists of the legend of the storm that functioned as the narrative metaphor for Venice's crisis (and survival), and which most likely developed in the second half of the trecento. Furthermore, St. George was a crusader saint, whose protection would presumably be sought with enhanced fervor when Venice entered the Christian League in the mid-fourteenth century. Finally, St. George was the civic protector of the city of Genoa, Venice's chief rival: his effigy conspicuously appeared on Genoa's military banner and was used to bless the Genoese fleet before it departed.[70] The conflict between the two cities dominated Venetian consciousness in the mid-century, and as we shall see in the next chapter, was a chief trigger for the building of the chapel of Sant'Isidoro. The chapel's mosaics included a full-figure portrait of St. George, and the saint

conspicuous occasions offered (philologically inaccurate) reinterpretations of existing artifacts. On this subject, see the important essay by R. Nelson, "The History of Legends and the Legends of History: The Pilastri Acritani in Venice," in Maguire and Nelson, *San Marco, Byzantium, and the Myths of Venice*, 63–90 (see above, p. 36, n. 110); and his earlier study, "High Justice" (see above, p. 36, n. 110). See also M. Perry, "Saint Mark's Trophies: Legend, Superstition, and Archaeology in Renaissance Venice," *JWarb* 40.1 (1977): 27–49. The *San Todaro* itself is a composite object and has generated lively scholarly debate centered on its physical history as well as the plausibility of the date of 1329 for its installation on the column. For a recent overview, see L. Sperti, "La testa del Todaro: Un palinsesto in marmo tra età costantiniana e tardo Medioevo," in *Pietre di Venezia: Spolia in se, spolia in re; Atti del convegno internazionale (Venezia, 17–18 ottobre 2013)*, ed. M. Centanni and L. Sperti (Rome, 2015), 173–93, with extensive bibliography. See also the seminal contribution by G. Tigler, "Intorno alle colonne di Piazza San Marco," *AttiVen* 158.1 (2000): 1–46. For two early studies that have informed all subsequent debate, see L. Sartorio, "San Teodoro, statua composita," *ArtV* 1.2 (1947): 132–34; and G. Mariacher, "Postilla al 'San Teodoro, statua composita,'" *ArtV* 1.3 (1947): 230–32.

70 C. E. Benes, "Civic Identity," in *A Companion to Medieval Genoa*, ed. C. E. Benes (Leiden, 2018), 193–217, esp. 204–5. On the blessing of the Genoese fleet with the standard of St. George, see G. Gorse, "Architecture and Urban Topography," in Benes, *Companion to Medieval Genoa*, 218–42, esp. 235.

68 Demus, *Mosaics of San Marco*, 1:33; Dale, "Inventing a Sacred Past," 62–63; T. E. A. Dale, *Relics, Prayer, and Politics in Medieval Venetia: Romanesque Painting in the Crypt of Aquileia Cathedral* (Princeton, NJ, 1997), esp. 48–56; and Jessop, "Art and the Gregorian Reform," 29 (see above, p. 62, n. 19).

69 Francesco Sansovino, *Venetia, citta nobilissima et singolare* (Venice, 1663), 316–17. The writings of Piero Guilonzardo (or Guilombardo) have never been retrieved, rendering any further arguments about the original identity of the statue as St. Theodore or St. George highly conjectural. By Francesco Sansovino's time, its identification as St. Theodore was undisputed. Venetian Renaissance sources, however, have on other

also appeared in a sculpted relief on the east wall of the baptistery. In addition, the 1325 inventory of the treasury of San Marco, drafted only a few years before Dandolo's accession to the office of procurator, records that St. George's arm relic and its Byzantine mount were then re-encased in a sumptuous Gothic silver and enamel reliquary.[71] Taken together, these observations provide strong evidence that St. George's public cult was promoted with increased emphasis in Venice and San Marco in the central decades of the fourteenth century. Whether this makes him a more likely candidate than St. Theodore for representation on the pala feriale must nonetheless remain an open question.

Following the warrior saint, the most privileged place on the altarpiece, closest to the Virgin, is occupied by St. Mark, whose presence on the high altar of San Marco needs no further explanation. On the (viewer's) right, St. Peter appears next to St. John, while St. Nicholas closes the series of holy protectors. The inclusion of St. Peter is consistent with the earlier mosaic program of the presbytery; it is easily explained by his responsibility for appointing St. Mark to his mission to Alexandria, also represented in the first narrative panel in the lower register of the pala feriale, and by the dedication of Venice's cathedral of San Pietro in Castello to the apostle. In turn, St. Nicholas—whose image also appears in the chapel of Sant'Isidoro and in the baptistery,

testifying to the renewed relevance of his cult in Venice during Dandolo's times—was the dedicatee of the doge's private chapel in the ducal palace and of the church of San Nicolò al Lido, where the saint's body was believed to have been translated from Myra in 1100, in open competition with the city of Bari.[72] The cult of St. Nicholas (which is already attested in the twelfth-century mosaics in the apse of the basilica) had acquired dense political and civic implications over the centuries: the public rituals held yearly on the Feast of the Assumption culminated near the Lido with a symbolic marriage between the doge of Venice and the Adriatic Sea. As we shall see in chapter 3, this ceremony was pivotal to the articulation of the doge's status and of Venice's international ambitions. Followed by religious services held at San Nicolò al Lido, where the ducal procession stopped before returning to San Marco, the rituals of the Assumption politically inflected St. Nicholas's cult and connected it with Venice's engagement overseas. Finally, St. Nicholas completed the trinity of patrons who rescued Venice from destruction in the legend of the storm. While no direct relationship may be posited between the making of the pala feriale and the genesis of the legend, the panel painting and the legendary narrative similarly point to an ongoing process of expansion and reorganization of the Venetian holy pantheon. The latter remained centered on St. Mark, and on Venice's other long-standing civic patrons, but it progressively updated the team of holy protectors by integrating other saints, reviving the cult of ancient protectors, and placing saintly cults (and holy shrines) more explicitly under the supervision of the government. In so doing, the

71 The renovation of the reliquary is recorded in the 1325 inventory of the treasury of San Marco: Gallo, *Il tesoro di S. Marco*, 276, no. 4 (see above, p. 12, n. 3). On the artifact, see Pasini, *Il tesoro di San Marco*, 43–44 (see above, p. 66, n. 26); Hahnloser, *Il tesoro e il museo*, 2:162–63, no. 159 (see above, p. 12, n. 3); Buckton, *Treasury of San Marco*, 282–85, no. 41 (see above, p. 36, n. 110); M. Bagnoli et al., eds., *Treasures of Heaven: Saints, Relics, and Devotion in Medieval Europe* (London, 2011), 92, no. 51. For a broader discussion of the object in the context of Venice's cult of St. George in the later Middle Ages, see D. M. Perry, "St. George and Venice: The Rise of Imperial Culture," in *Matter of Faith: An Interdisciplinary Study of Relics and Relic Veneration in the Medieval Period*, ed. J. Robinson, L. De Beer, and A. Harnden (London, 2014), 15–22; and K. R. Mathews, "Reanimating the Power of Holy Protectors: Merchants and Their Saints in the Visual Culture of Medieval and Early Modern Venice," in *Saints as Intercessors between the Wealthy and the Divine: Art and Hagiography among the Medieval Merchant Classes*, ed. E. Kelley and C. Turner Camp (London, 2019), 238–70. The object is more briefly discussed in Krause, "Feuerprobe" (see above, p. 72, n. 40); Pincus, "Christian Relics" (see above, p. 72, n. 40); and Klein, "Refashioning Byzantium" (see above, p 55, n. 5).

72 A. Pertusi, "Ai confini tra religione e politica: La contesa per le reliquie di S. Nicola tra Bari, Venezia e Genova," *Quaderni medievali* 5 (1978): 6–56. The chapel of San Nicola—which is now lost—would deserve a separate study. For a concise but compelling introduction to its history and decorations, see Fortini Brown, *Venetian Narrative Painting*, 259–60 (see above, p. 35, n. 106). It is worth noting that Paolo Veneziano was commissioned to paint a new altarpiece for the chapel in 1346. The polyptych is now lost, but two panels in the collection of the Uffizi in Florence (Inv. Contini Bonacossi, nos. 6, 7) are routinely associated with it. For the document recording the commission, see M. Muraro, *Paolo da Venezia* (Milan, 1969), 88. For an overview of scholarly debates and further references, see Pedrocco, *Paolo Veneziano*, 174–75, nos. 17.1, 17.2 (see above, p. 53, n. 3).

pala feriale marshaled the collective power and intercession of the city's patrons in support of Venice's religious and civic community at challenging times.

Scholars have devoted increasing attention to the proliferation of saintly cults, miracle accounts, and miracle cycles in the visual cultures of the eastern and western Mediterranean in the later Middle Ages.[73] More specifically, Michael Goodich has persuasively demonstrated how, in the fourteenth century, hagiographies and miraculous narratives acted as a means to exercise hope in times of adversity, and how the immanence of divine justice that was manifested in miraculous events served to counter the anomie, conflict, and violence of the world when human mechanisms such as the state proved unreliable or flawed.[74] This may well have been the case in Venice. When the pala d'oro and pala feriale were set up on the high altar, political strife was already intense. Venice's colonial policy was met with resistance in the Balkans and the eastern Mediterranean, and the rapid advance of the Ottomans in the East caused mounting concerns among Christian polities. These events may have inflected the meaning of the imagery of the pala feriale and colored the ways in which contemporaries saw it. Paolo

Veneziano's pala feriale displays an emphasis on intense devotion, human suffering, and supernatural intervention that is unprecedented in San Marco, and that may be understood as a response to the increased need for reassurance at times of instability. In this light, as Rona Goffen has also suggested, the averted shipwreck on the pala feriale operated as a metaphor for a wider range of forfended perils—much as Giotto's *Navicella* in San Pietro, Rome, indexed the current predicaments of the Church.[75] In a similar vein, the Man of Sorrows (known in Greek as Ἄκρα ταπείνωσις, "utmost humiliation") may have offered Venetian viewers and governors a visual example of endurance and patience that was particularly opportune at difficult times, and that possessed specific political significance as a model for the "humble ruler"—a visual type whose pivotal role in Venetian political ideology will emerge in our discussion of the baptistery cycle.[76] In addition, as a reminder of the intimate connection between sacrifice and eternal salvation in the life of Christians, the imago pietatis offered hope in the possibility that earthly misfortunes may precede an enduring divine reward. The miracle of the *Apparitio* struck a similarly consoling chord, reiterating the special bond between St. Mark, the Venetian state, and the doge who knelt as a supplicant before his effigy. In turn, the visual catalogue of *miracula* intimated that no one was excluded from the evangelist's protection, which extended to the sick, the poor, and those unjustly punished. Emphasis on the physical presence of St. Mark's body in the basilica offered comfort and the promise of relief to an endangered community. Finally, the presence of Venice's other chief patrons simultaneously offered the congregation a wider focus for devotion at difficult times, a reminder of the

73 Alice-Mary Talbot has written extensively about miracles and miraculous healing in Byzantium. See, for example, A.-M. Talbot, "Pilgrimage to Healing Shrines: The Evidence of Miracle Accounts," *DOP* 56 (2002): 153–73; and A.-M. Talbot and S. F. Johnson, *Miracle Tales from Byzantium* (Cambridge, MA, 2012). Stephanos Efthymiadis has also done important work in this area. For an overview, see the essays gathered in S. Efthymiadis, *Hagiography in Byzantium: Literature, Social History and Cult* (Farnham, 2011). For a range of different perspectives, see J. T. Chirban, *Holistic Healing in Byzantium* (Brookline, MA, 2010). On the difference between miracles and sorcery, see A. P. Kazhdan, "Holy and Unholy Miracle Workers," in *Byzantine Magic*, ed. H. Maguire (Washington, DC, 1995), 73–82. On visual miracles, see M. A. Rossi, "Christ's Miracles in Monumental Art in Byzantium and Serbia (1280–1330)" (PhD diss., Courtauld Institute of Art, 2016); and M. A. Rossi, "Reconsidering the Early Palaiologan Period: Anti-Latin Propaganda, Miracle Accounts, and Monumental Art," in Mattiello and Rossi, *Late Byzantium Reconsidered*, 71–84 (see above, p. 34, n. 99). On Western miracles and their material implications, see, for example, C. W. Bynum, *Christian Materiality: An Essay on Religion in Late Medieval Europe* (New York, 2011), with extensive bibliography.

74 M. E. Goodich, "Miracles and Disbelief in the Late Middle Ages," *Mediaevistik* 1 (1988): 23–38; and M. E. Goodich, *Violence and Miracle in the Fourteenth Century: Private Grief and Public Salvation* (Chicago, 1995), esp. 1–2, 150–51.

75 Goffen, "Paolo Veneziano," esp. 180–81 (see above, pp. 52–53, n. 3). In this essay, Goffen also convincingly suggests that Paolo Veneziano's choice to place his signature at the bottom of the same panel conveyed the artist's personal entreaty for protection. On the *Navicella*, see S. Romano, "Il male del mondo: Giotto, Dante, e la Navicella," in *Dante und die bildenden Künste: Dialoge—Spiegelungen—Transformationen*, ed. M. A. Terzoli and S. Schütze (Berlin, 2016), 185–204. See also Cola di Rienzo's take on the subject in his public frescoes in Rome: Musto, *Apocalypse in Rome* esp. 105–12 (see above, p. 46, n. 142).

76 For a discussion of the relation between the imago pietatis and medieval rulers' images, see Puglisi and Barcham, "'The Man of Sorrows'" (see above, p. 71, n. 38).

importance of cohesiveness in times of crisis, and the reassurance that the civic community could rely on a powerful network of intercessors who sustained St. Mark's efforts to protect the city and worked with him for Venice's wellbeing. What, then, of the pala d'oro?

Facing Krisis: Byzantine Art between History and Eschaton

At a first level, the pala d'oro may also be interpreted as a response to the ongoing crisis. Encrusted with over a thousand gems at this time, the golden altarpiece may have represented an attempt on the part of the government to conceal current instability through conspicuous display, and to dazzle and reassure the civic community with a glowing vision of divine order. Moreover, the restoration was a costly enterprise: the bullion, gemstones, and workmanship lavished on the altarpiece represented expensive offerings, through which the Venetian authorities may have intended to entreat the help of the city's holy protectors at a difficult time. And the two dedicatory inscriptions seemingly reinforce these hypotheses. First, the epigraphs explicitly and repeatedly refer to the preciousness of the artifact and the jewels that adorn it, intimating that those features—and the symbolic implications of material value—mattered to the patrons of the altarpiece. Second, the inscriptions name three sets of doges and procurators who lived between the twelfth and the fourteenth centuries. In this way they convey a message of political and institutional continuity at times of turbulence and advertise the harmony and stability of Venetian institutions against current strife. Finally, the two inscribed plaques were inserted in the lower tier of the pala, the customary position for the portraits of donors or petitioners in late medieval art. This gives an additional inflection to the texts, which symbolically place the republic and its governors under divine protection and invoke the aid of Venice's saintly intercessors in times of danger.

But the epigraphs also performed another crucial function. By specifying the dates of creation and modification of the pala d'oro, and immortalizing the names of its patrons, they transformed the pala d'oro into a speaking object, which provided its beholders with the information necessary to situate it both culturally and chronologically. The information offered by the epigraphs is both detailed and highly selective. They cast the altarpiece as a public, institutional project and associate it with the political history of the city. To put it differently, the lengthy epigraphs converted what had previously been a quintessentially ritual object—the temporality of which was subsumed into liturgy—into a historical artifact that both recorded the past of Venice and had its own past recorded on its surface. Thus reframed, the pala d'oro could function flexibly as an object of historical scrutiny, a source of historical information and validation, and a site of public commemoration. In turn, this establishes a direct connection between the altarpiece and the vast program of legal and historical reforms undertaken by the Venetian government under Andrea Dandolo, who energetically promoted historical writing and the systematization of the law as crucial means of political and institutional stabilization.

The epigraphs' textual content was both enhanced and complicated by their position on the altarpiece and by their visual interactions with the surrounding imagery. The engraved plaques are prominently located below the image of Christ in Glory with the four evangelists, and on the same level as two throngs of biblical prophets. Each of the prophets carries an open, inscribed scroll (Fig. 33). Above them, the individual incipits of the four Gospels are neatly legible on the pages of the codices opened before the evangelists, encouraging viewers to reflect on the dual significance of the written word within Christian tradition, as a way both to record the past and to adumbrate the future (Fig. 34). At the center of the altarpiece, Christ holds a jewel-encrusted book in his left hand. The book, which was modified in the fourteenth century, is not legible, but turned backward (see above, Fig. 12). Obstinately concealing behind the shine of polished gems the message it contains, the book counters the legibility of the open scrolls and codices that surround it, inviting us to reconsider the relation between historical witness, prophetic writing, and the mystery of revelation, which lies beyond time.[77]

77 On books and scrolls in medieval visual art, and on their relation to revelation, see recently J. Mitchell and N. Pickwoad,

FIGURE 33. Pala d'oro, Daniel and Moses, Byzantine, twelfth century. Photo courtesy of the Procuratoria di San Marco.

The new Gothic frame added to the pala d'oro in 1343–1345 underscores similar concerns. Each enamel in the lower and upper sections of the altarpiece was encased in a gabled micro-architectural frame that enhanced the material and visual opulence of the artwork. The addition of this frame is generally discussed in specialized literature as a mere "aesthetic update" that aligned Venice with the recent developments of

European Gothic.[78] But in the late thirteenth and fourteenth centuries, frames received increasing attention from artists and patrons across the Mediterranean. Two significant examples will serve to prove this point. First, the group of fourteenth-century Italian reliquary tabernacles examined by Beth Williamson combined devotional images with a panoply of diminutive relics, inserted in small chambers. These niches were originally sealed with glass or crystal cabochons and are carved into the outer frames of the tabernacles. The placement of sacred fragments

"'Blessed Are the Eyes Which See Divine Spirit Through the Letter's Veil': The Book as Object and Idea," in *The Notion of Liminality and the Medieval Sacred Space*, ed. K. Doležalová and I. Foletti, *Convivium*, Supplement 6 (Brno, 2019), 134–59.

78 This idea is most explicitly articulated in Hahnloser and Polacco, *La pala d'oro*, 85 (see above, pp. 52–53, n. 3).

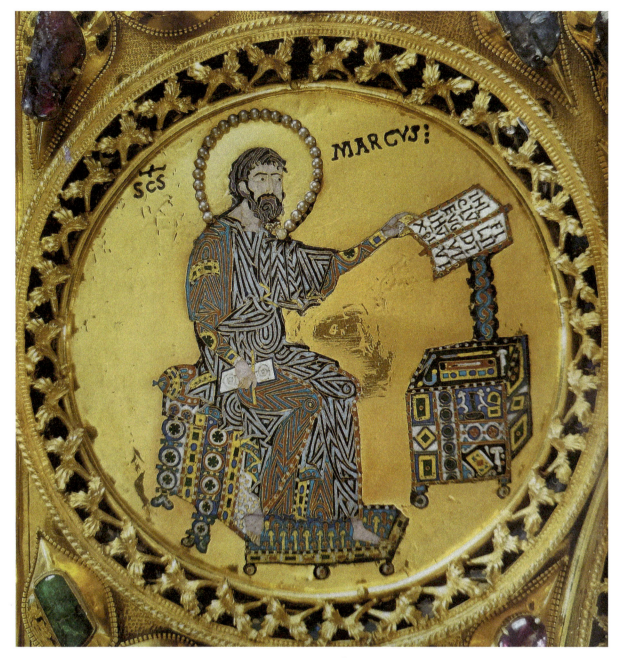

FIGURE 34. Pala d'oro, detail, St. Mark, Byzantine or Venetian, twelfth century. Photo courtesy of the Procuratoria di San Marco.

within the frame, their arrangement around a central devotional image, and the visual appearance of the relic niches, which would have looked like jewel inserts, suggest that important religious and artistic transactions took place "at the border" of those artworks.[79] Roughly at the same time, adding precious frames to existing icons became a popular choice among late Byzantine elite patrons, both individual and institutional, signaling the cultural significance of acts of material encasing and the religious and artistic richness of frames and frameworks.[80]

79 B. Williamson, *Reliquary Tabernacles in Fourteenth-Century Italy: Image, Relic and Material Culture* (Woodbridge, 2020).

80 For an introduction, see J. Durand, "Precious-Metal Icon Revetments," in Evans, *Byzantium: Faith and Power*, 242–51

As Rudolf Arnheim submits in *The Power of the Center*, from an aesthetic standpoint, frames do not simply delimit the range of visual objects intended to constitute the work of art, but also define the reality status of the artwork as distinguished from its setting.[81] More specifically, Ivan Drpić has compellingly argued that metalwork frames played an important part in mediating the relationship between viewer and sacred image in late Byzantine culture, and indicated that such adornment (*kosmos*) revealed and externalized the inherent sanctity of the religious image.[82] The new Gothic frame of the pala d'oro—markedly three-dimensional and enriched with more than a thousand translucent, multicolored gemstones set on high bezels—did precisely this. It created a bold visual and material threshold that made viewers aware that they were looking at a manufactured object, with a specific history of patronage and use that was carefully inscribed on the artwork itself. Yet, sharpening the divide between the quotidian space of the viewer and the sacred space of the images, the frame also encouraged a contemplative gaze, inviting its beholders to approach the altarpiece as a sacred image: that is, the revelation of a higher spiritual reality, which the shimmering adornment simultaneously constituted and enclosed.

As much recent scholarship has demonstrated, architectural barriers and screens and framed and layered modes of vision played a key role in late medieval experiences of the sacred, in both West and East.[83] This visual strategy reached its climax at San Marco, when the pala d'oro was transformed into a folding altarpiece through the addition of Paolo Veneziano's pala feriale. As mentioned above, the pala d'oro–pala feriale ensemble is the earliest extant folding altarpiece in the Veneto. However, specific

aesthetic precedents did exist for its stratified and temporally staged display. By this time, winged altarpieces were widespread in the Rhine region, where they had developed in the early trecento in response to new liturgical needs and as innovative reliquary shrines.[84]

Irrespective of their specific iconography and functions, movable altarpieces were sophisticated temporal devices. Because they required ritual opening and closing, they compelled the beholder to engage in a process of protracted viewing. In turn, this was carefully choreographed to provoke and structure the worshippers' devotional and contemplative experience.[85] The progressive opening of the altarpiece led the viewer on a complex visual journey, as observation of the narrative scenes depicted on the external or more peripheral sections of the altarpiece gave way to contemplation of one or more devotional images situated in the central shrine. Typically, the transition from earthly to heavenly, and from temporal to epiphanic, was signaled by the use of different artistic techniques and increasingly expensive materials: two-dimensional painting on the wings versus relief sculpture at the center, grisaille versus polychromy, or color versus gilding.[86]

These principles apply to the pala d'oro–pala feriale ensemble. The pala feriale combined icon-like images of the Man of Sorrows and the saints with an abbreviated narrative of the life of St. Mark. On display for the best part of the liturgical year, it laid emphasis on the sufferings

(see above, p. 14, n. 7). For a more comprehensive discussion of Byzantine adornment, see I. Drpić, *Epigram, Art, and Devotion in Later Byzantium* (Cambridge, 2016).

81 R. Arnheim, *The Power of the Center: A Study of Composition in the Visual Arts* (Berkeley, 1982), 52.

82 Drpić, *Epigram, Art, and Devotion*, esp. 161.

83 For a wide range of examples and approaches, see S. E. J. Gerstel, *Thresholds of the Sacred: Architectural, Art Historical, Liturgical, and Theological Perspectives on Religious Screens, East and West* (Washington, DC, 2006).

84 Although the vast majority of northern winged altarpieces had side wings, at least one example has survived that opened vertically. Dated to ca. 1290, the carved figures enshrined in the recesses of the polychrome altarpiece of the Elisabethkirche in Marburg were allegedly concealed behind panels that could be pushed upward through slits in the base of the artifact. Discussed in A. Köstler, "Paradigmenwechsel auf dem Reißbrett: Der Hochaltar der Marburger Elisabethkirche," in *Entstehung und Frühgeschichte des Flügelaltarschreins*, ed. H. Krohm, K. Krüger, and M. Weniger (Wiesbaden, 2001), 51–59. See also Kemperdick, "Altar Panels in Northern Germany," 136–37 (see above, p. 71, n. 36).

85 P. Crossley, "The Man from Inner Space: Architecture and Meditation in the Choir of St. Laurence in Nuremberg," in *Medieval Art: Recent Perspectives; A Memorial Tribute to C. R. Dodwell*, ed. G. R. Owen-Crocker and T. Graham (Manchester, 1998), 165–82.

86 On the material hierarchies of winged altarpieces, see J. S. Ackley, "Precious-Metal Figural Sculpture, Medium, and Mimesis in the Late Middle Ages," in *Faces of Charisma: Image, Text, Object in Byzantium and the Medieval West*, ed. B. M. Bedos-Rezak and M. D. Rust (Leiden, 2018), 348–85.

of Christ and on St. Mark's intercessory interventions for Venice—inspiring its viewers to meditate on the significance of the Incarnation in redeeming humankind and human time. In solemn festivities, the promise of intercession and redemption alluded to by the pala feriale was fully disclosed to the faithful, as the opening mechanism was activated to reveal the pala d'oro and its refulgent vision of divine glory.

Like their counterparts in Northern Europe, the pala feriale and the pala d'oro signaled the transition from earthly to divine through different materials and modes of representation. The human nature of Christ and the workings of the temporal world are expressed on the pala feriale in painting through the careful modeling of figures, the highly naturalistic rendering of bodily and facial expressions, and the detailed, lifelike representation of the narrative scenes in its lower register, which stand in stark visual contrast to the abstract, stylized imagery of the pala d'oro. In turn, the Byzantine altarpiece, with its profusion of gemstones and enamel and the otherworldly sheen of gold, was tasked with delivering the vision of divine splendor and cosmic order that lie beyond time.[87]

The nexus between history and eternity was a key concern of medieval Christian thought. Begun with the Fall from Eden, history—which implied transiency and death—was the direct manifestation of the fallen state of humankind. Conversely, the ultimate reunion of man with God was coterminous with the Apocalypse, and with the end of time. Nevertheless, the economy of Christian salvation was intimately entwined with history.[88] By the fullness of his grace, God had willingly entered time and become human:

the incarnation of Christ had redeemed historical time and turned history into another form of revelation. These conflicting understandings of history—as both an obfuscation of and a conduit to revelation—coexisted in the Middle Ages, inevitably informing the ways in which medieval communities approached historical practice and the material vestiges of the past.

This is a useful vantage point from which to reexamine the layout of the pala d'oro in the trecento. At this time, it bears recalling, the Venetian government became acutely aware of the key significance of history as a means of institutional and political legitimation, leading to the production of the first official chronicle of the history of Venice. Andrea Dandolo's *Chronica per extensum descripta*, it should also be added, was the first Venetian source to mention the pala d'oro, its provenance from Constantinople, and the artifact's history after its arrival in Venice.[89] From this perspective the makeover of the altar in general, and the pala d'oro specifically, may be understood as a site of reflection on the nature of history, its relation to the end of time, and the function of (Christian) political authorities as intermediaries between earthly and divine temporal realms.

Just as divine revelation required lifting the veil of history and worldly appearances, so the pala feriale had to be lifted to reveal the pala d'oro. The idea of staged viewing and gradual unveiling of divine truth was common in the late medieval Mediterranean. In addition to the layered revelation of northern winged altarpieces mentioned above, both Western retables and Byzantine icons were frequently covered with textile curtains that were ritually lifted to display the cult image underneath.[90] Furthermore, canopies

87 On the aesthetic implications of gold, precious materials, and sensuality in Byzantine art, see, for example, D. Janes, *God and Gold in Late Antiquity* (Cambridge, 1998); and B. V. Pentcheva, *The Sensual Icon: Space, Ritual, and the Senses in Byzantium* (University Park, PA, 2010).

88 A classic theological read on this subject is O. Cullmann, *Christ and Time: The Primitive Christian Conception of Time and History* (Philadelphia, 1964). See also Cohen, *Transformations of Time*, esp. 144 (see above, p. 45, n. 139); and C. Humphrey and W. M. Ormrod, eds., *Time in the Medieval World* (Woodbridge, 2001). For a number of useful reflections on Byzantine temporality and its reverberations in monumental art, see R. Ousterhout, "Temporal Structuring in the Chora Parekklesion," *Gesta* 34.1 (1995): 63–76; and Betancourt, "Prolepsis and Anticipation" (see above, pp. 48–49, n. 149).

89 Dandolo, *Chronica per extensum descripta* (see above, p. 21, n. 47), 225 (on the making of the golden altarpiece in Constantinople in 1105), 284 (on its first Venetian update, in 1209).

90 For Western examples, see V. M. Schmidt, "Curtains, 'Revelatio,' and Pictorial Reality in Late Medieval and Renaissance Italy," in *Weaving, Veiling and Dressing: Textiles and Their Metaphors in the Late Middle Ages*, ed. K. M. Rudy and B. Baert (Turnhout, 2007), 191–214. See also J. Klípa and E. Poláčková, "*Tabulae cum portis, vela, cortinae and sudaria*: Remarks on the Liminal Zones in the Liturgical and Paraliturgical Contexts in the Late Middle Ages," in Doležalová and Foletti, *Liminality and Sacred Space*, 112–33 (see above, p. 86, n. 77). On Byzantine curtains and textiles and their meanings in religious and imperial contexts, see M. G. Parani, "Mediating

and iconostases operated as (partly permeable) barriers in Byzantine churches, separating the naos of the church from the bema, but also allowing the viewer's gaze to enter the most sacred precincts of the church when the central doors of the icon screen were opened.[91] More locally, as Paul Hills has demonstrated, veils were ubiquitously employed by early Renaissance Venetian painters to index revelatory moments and the mysteries of divine epiphanies.[92]

The altarpiece of San Marco functioned similarly. Mirroring Christian belief that the Incarnation had made history necessary to the economy of salvation, the Annunciation towered behind the altar, with the figures of Gabriel and the Virgin almost suspended in midair on their dark (and thus poorly visible) columns. Just below them, under the stone ciborium, the pala feriale presented viewers with a moving image of the sacrifice of Christ, reminding them of the association between the Redeemer's Passion and universal salvation. The latter, in turn, was revealed in the form of a majestic theophany on feast days, by opening the pala d'oro.

On those occasions the pala d'oro would convey different meanings to different constituencies of viewers. Its basic message of Christian bliss would be available to all and was conveyed to the congregation gathered in the nave not so much by the iconography of the pala, which would be hardly visible, but by its radiant display of gold and saturated colors, flickering in the light of candles. To those who could approach it

and look at it carefully at close range—the doge, courtiers, and clergy of San Marco—the imagery and inscriptions of the pala d'oro would reveal a rich array of meanings. Sensitive to the details of regal and imperial iconography, and of political imagery more generally, these viewers would be in an ideal position to cogitate on the meaning of the small but subversive enameled representations of the doge in regal attire and the Byzantine empress. As already mentioned, the pala d'oro was refurbished between 1343 and 1345, only months after the financial agreement with Anna of Savoy. Although the two events were not directly connected, the recent diplomatic rapprochement between Venice and the Byzantine regent to the throne—who had asked for, and obtained, Venice's financial support to defend her son's future ascent to the imperial throne against rival pretenders—may have inflected contemporary understandings of the altarpiece, which conveniently juxtaposed the portraits of a doge and a Byzantine empress, presenting them as equals in the conspicuous absence of any Byzantine male rulers.

Aside from such topical connotations, politically minded viewers would be offered further elements for reflection. The pala d'oro memorialized the involvement of present and past doges and procurators in San Marco. Together, those individuals had preserved and enriched the altarpiece of the basilica, performing an act of public service that conveyed the piety and magnificence of the Venetian community, affirmed the collegial nature of the city's institutions, and provided a model that future officers could strive to emulate. The history of the Incarnation and the trajectory of human salvation were not separate from Venice's own journey. Before the pala d'oro and the pala feriale stood the altar, which was increasingly promoted in the fourteenth century as the shrine of the evangelist, and thus the symbolic heart of Venice. The layout and decorative program of the high altar in the mid-fourteenth century, which visually conjoins universal and local, mirror the rewriting of Venetian history by Andrea Dandolo at this time. The doge's chronicle explicitly states that the city of Venice was founded on 25 March 421, on the Feast of the Annunciation. In addition, the doge directly modeled his account of St. Mark's *praedestinatio*

Presence: Curtains in Middle and Late Byzantine Imperial Ceremonial and Portraiture," *BMGS* 42.1 (2018): 1–25.

91 Gerstel, *Thresholds of the Sacred*. See also J. Bogdanović, *The Framing of Sacred Space: The Canopy and the Byzantine Church* (Oxford, 2017). On the use of sanctuary curtains, see also W. Woodfin, "Wall, Veil, and Body: Textiles and Architecture in the Late Byzantine Church," in *The Kariye Camii Reconsidered/Kariye Camii, Yeniden*, ed. H. A. Klein, R. G. Ousterhout, and B. Pitarakis (Istanbul, 2011), 371–85, esp. 382–83; and E. D. Maguire, "Curtains at the Threshold: How They Hung and How They Performed," *DOP* 73 (2019): 217–44. See also S. de Blaauw and K. Doležalová, "Constructing Liminal Space? Curtains in Late Antique and Early Medieval Churches," in Doležalová and Foletti, *Liminality and Sacred Space*, 46–67.

92 P. Hills, *Veiled Presence: Body and Drapery from Giotto to Titian* (New Haven, CT, 2018); and Hills, "Vesting the Body of Christ" (see above, p. 38, n. 115). See also Schmidt, "Curtains, 'Revelatio,' and Pictorial Reality."

on the Gospel narrative of the Annunciation. According to the legend, Mark was journeying from Aquileia to Rome by sea, when a storm caught his vessel near Rialto. An angel promptly appeared, reassuring the saint that he would survive the storm, but that the island would one day be his resting place. A wonderful city would be built there, the angel also prophesied, that would deserve to possess his body. Because of its inhabitants' intense devotion to him, the city would obtain from the saint several benefits in return for its merits and prayers.[93] As Jamie Reuland noted, Mark's response to the angel: *Domine, fiat voluntas tua*, which cast Venice as a predestined city, was a variation of Mary's own rejoinder to Gabriel, *Fiat mihi secundum verbum tuum* (Luke 1:38).[94] Furthermore, the *Chronica per extensum descripta* declares that the evangelist's martyrdom occurred on Easter day, further connecting the Passion of Christ with that of his disciple, and Venetian history with sacred history.[95] Finally, the rediscovery of his body inside a column in the transept of the basilica in the eleventh century was favorably compared to Christ's own resurrection in the miracle manuscript discussed earlier.

The altarpiece of San Marco translated coeval preoccupations with the intersections between local and universal history into a powerful visual mechanism, whose ultimate aim is revealed by the two dedicatory epigraphs added to the golden altarpiece at this time. These texts implicitly invited their viewers to reflect on the significance of historical knowledge as a conduit to divine truth, and on the role of secular authorities and public servants in mediating between the two. The epigraphs inscribed secular history on an object that otherwise articulated a refulgent and timeless vision of divine glory. This, as I suggested, pulled the pala d'oro into the realm of historical time, exposing its nature as a "thing among things." Yet by virtue of their placement

within the vision of cosmic and timeless order advertised by the pala d'oro, the inscriptions also elevated history to a higher plane, implicating it in the manifestation of the divine on earth.

The resonance of this message can hardly be overestimated. As discussed in chapter 1, the doge's investiture took place at the altar of San Marco, and therefore near the pala d'oro. The latter juxtaposed two seemingly opposite representations of ducal authority and of the state. The inscriptions presented the Venetian government as a group enterprise and located it firmly in history. By contrast, the enamel portrait of the doge offered a refulgent, transtemporal image of ducal power: the Venetian ruler is represented in regal garb and subsumed within the "celestial hierarchy" articulated on the altarpiece. This dual understanding of the doge (as imago of the state and as *primus inter pares* among the ruling elite) was the kernel of an emerging vision of government that would reach a fuller figural articulation in the baptistery of San Marco, and that differentiated between the physical (and temporally finite) person of the ruler and the (unperishable) sovereignty of the civitas, which rulers transitorily represented.

The selective recourse to Byzantine art and visual language in every one of Dandolo's projects—and specifically in contemporary representations of political authority—needs to be understood against this process of political redefinition. For now, it is important to remark that the material and aesthetic qualities of the Byzantine pala d'oro were ideal means to convey such complex transactions between the temporal and the timeless. The technical and stylistic differences between the pala d'oro and the pala feriale alerted viewers to the antiquity of the former, whose venerable age was further emphasized by the dedicatory epigraphs. Meditating on the pala d'oro as a vestige of history, viewers would be led to reflect on the antiquity of San Marco, which was also accented by the antiquarian aesthetics of the columns of the ciborium. By extension, the visual qualities of the altar area would lead the beholders to contemplate the authority and political lineage of the Venetian government, which the church of San Marco represented and which were conspicuously asserted on the altarpiece, both visually and textually. On the other

93 Dale, "Inventing a Sacred Past" (see above, p. 49, n. 151); and D. Pincus, "Mark Gets the Message: Mantegna and the 'Praedestinatio' in Fifteenth-Century Venice," *Artibus et Historiae* 18.35 (1997): 135–46.

94 Dandolo, *Chronica per extensum descripta*, 10. For a discussion of the praedestinatio legend in relation to the Gospel passage of the Annunciation, see Reuland, "Voicing the Doge's Sacred Image" (see above, p. 24, n. 59).

95 Dandolo, *Chronica per extensum descripta*, 11.

hand, the pala d'oro's awe-inspiring, glittering, multicolored surface articulated a powerful divine vision that both enfolded and resolved historical time, and that was simultaneously consistent with the heightened spiritual power associated with Byzantine cult images in late medieval Europe, and with contemporary understandings of precious adornments (*kosmos*) in Byzantium.

The pala d'oro was the most visible, and perhaps the most sumptuous, Byzantine artifact in medieval Venice. As scholars have long recognized, this made it the ideal means to articulate notions of religious charisma and political magnificence, just as Venice rose to the status of colonial and commercial empire in the thirteenth and fourteenth centuries. However, as this chapter demonstrates, the altarpiece of San Marco also delivered a sophisticated meditation on the nature of time and history, their relation to eternity, and the role of historical knowledge as a conduit to the divine. Suspended between time and the timeless, the pala d'oro and the pala feriale reveal Venice's rising concerns with historical

accuracy and verification, which Patricia Fortini Brown so perspicuously discusses in her *Venice and Antiquity*.[96] But they also invite us to reconcile our understanding of Venetian historical consciousness—and modern preoccupations with the "pathos of distance" vis-à-vis Byzantium—with the specific worldview of medieval Christianity.[97] Within this system, history was forever bound to the afterlife and the eternal, and artifacts were too. Recording and preserving the memory of the past, the pala feriale and the pala d'oro represented receptacles of divine presence in time, and thus essential sites of mediation between man and God, and between present predicaments (and the vulnerability of the polis) and the perfected, and ageless, world to come.

96 See above, p. 48, n. 150.

97 I have borrowed the expression "pathos of distance" from A. Cutler, "The Pathos of Distance: Byzantium in the Gaze of Renaissance Europe and Modern Scholarship," in *Reframing the Renaissance: Visual Culture in Europe and Latin America, 1450–1650*, ed. C. J. Farago (New Haven, CT, 1995), 22–45.

THE CHAPEL OF SANT'ISIDORO
The Art of Conflict

Tʜᴇ ʀᴇɴᴇᴡᴀʟ ᴏꜰ ᴛʜᴇ ʜɪɢʜ ᴀʟᴛᴀʀ ᴏꜰ San Marco was only the first in a series of ambitious projects sponsored by the Venetian government under Andrea Dandolo's leadership. Despite heightened military tensions with Genoa, and the human and financial losses caused by the plague, two major artistic campaigns were undertaken in the basilica over the following years: a new baptistery, located in the south narthex of San Marco; and a chapel dedicated to the martyr St. Isidore of Chios, adjacent to the north transept. Whether the two projects were planned simultaneously, and thus originally intended to function in tandem, is uncertain. Contemporary sources agree, however, that the two shrines were built and decorated around the same time, in the latter half of Dandolo's dogate, and that both were completed by, or shortly after, his death. The two projects raise a number of questions in common, but the richness of their visual programs and their different ceremonial and liturgical functions call for separate investigation. The present chapter will discuss the chapel of Sant'Isidoro, while the baptistery will be the focus of the next chapter. The overall argument here is that the chapel of Sant'Isidoro related crisis in the dual sense introduced in chapter 1. Its visual and textual program manifested specific devotional needs and political concerns that were intensified by ongoing conflicts and strife. Simultaneously, it participated in the complex response with which

Venice's governing elite confronted uncertainty: images, inscriptions, and relics cooperated in the manufacture of "authentic" hagiographic and historical records. These in turn provided historical validation and a semblance of continuity to Venice's (new) self-image as a crusading power, and to the ongoing process of political and institutional reform by which the government strove to mitigate crisis and stabilize the state.

St. Isidore was a warrior saint, martyred on the island of Chios in the Aegean Sea in the mid-third century. His body was allegedly translated to Venice in the twelfth century under the leadership of Doge Domenico Michiel (r. 1117–1129), on the way back from a crusading expedition in the Holy Land. But both the existence of the saint's relics in San Marco and the memory of their translatio were later forgotten, until Andrea Dandolo reinvented the body more than two centuries later, and buried it in a new, purpose-built chapel that was completed the year after his death, in 1355. Thenceforth St. Isidore was celebrated annually in San Marco on 16 April, only a few days before the major patronal feast of St. Mark, celebrated on 25 April. In burying St. Isidore's earthly remains inside the church of San Marco, the government made an unprecedented decision. By the fourteenth century, Venice claimed possession of several holy bodies, which its citizens had acquired in the preceding centuries through purchases, war spoliations, and holy thefts.

Yet none of these had been buried in San Marco, which had so far remained the exclusive abode of the evangelist. What religious and ideological purposes did St. Isidore's cult serve, and why was this relatively obscure Eastern saint given pride of place in the state church of Venice during Dandolo's reign?

As a necessary step to answer these questions, we examine first how St. Isidore's vita was visually constructed in the chapel: what aspects of St. Isidore's sanctity were given specific prominence, how his cult was reconciled with that of St. Mark, and what visual and devotional experience the shrine created for its beholders. Much like the high altar, whose program confirmed and memorialized the presence of St. Mark in the basilica, the rich visual, textual, and sculptural apparatus of the chapel of Sant'Isidoro aimed to convince its audience of St. Isidore's powers as an intercessor and his "real" presence in San Marco, offering the faithful a new focus for devotion at times of increased vulnerability. Also, in the same way as Paolo Veneziano's pala feriale enhanced the cult of the evangelist while also conveying novel ideas about collective holy patronage, so the chapel of Sant'Isidoro conjoined St. Isidore's image with those of other prominent holy helpers: St. Mark, naturally, but also St. John the Baptist and St. Nicholas. Finally, pursuing the same visual strategy as the high altar, the chapel wove together hagiography and secular history, revealing the visual and performative means by which public memory was constructed, understood, and disseminated in Venice, and how the latter was marshaled to both justify and normalize political change.

The development or revival of specific saintly cults across the medieval Mediterranean was often associated with new devotional needs arising in local communities. The second section of this chapter examines what made St. Isidore—martyred and venerated on a remote island in the Aegean Sea—deserving of burial within the basilica of San Marco, the state church of Venice, and considers the demands that were made on his cult. I situate the chapel—which celebrates a military saint and memorializes a successful Venetian military and crusading expedition—against Venice's raging struggle against Genoa for hegemony in the eastern Mediterranean, and in

relation to Venice's crusading efforts in the wake of the Ottoman advance. Promoting Venice as a militant Christian power and a victorious polity at times of conflict and instability, the chapel reiterated a consolidated Venetian tradition of historical and visual memorialization that cast the city as divinely favored against current political and military uncertainty. In this way the chapel fulfilled an obvious patriotic function. In turn, this draws attention to the ability of images to store political meanings and reminds us that medieval communities defined themselves both endogenously, through the common values shared among their members, and exogenously through continuous confrontation with what was outside—the cultural and political "other." This has important implications for our understanding of the political iconography of the chapel, examined in the final section of this chapter.

The visual narrative of St. Isidore's translatio to Venice included several representations of ducal authority, both in Venice and overseas. Representations of the Venetian doge had already appeared in the mosaics of San Marco: in the chapel of San Clemente, in the south transept, and on the façade of the basilica. But in the chapel of Sant'Isidoro, the doge is represented for the first time as a military chief and is depicted outside the city of Venice, rather than exclusively as a participant in official ceremonial events within the city. The narrative program emphasizes the doge's decisiveness and effectiveness, his role as guarantor of justice, and his lawful exercise of power abroad. It also highlights the doge's piety and his respect for Venetian institutions, inviting reflection on the nature of political virtue.

Such rich visual presentation of the ducal persona invites analysis in relation to the ongoing revision of the functions of the doge and government. In the mosaics, the doge was rendered as a powerful imago of Venice's authority abroad, at a time when the city's preeminence in the eastern Mediterranean was threatened by Genoa's rising power, by unrest in the colonies, and by the advance of the Ottomans and Mamluks. In contrast to this emphatic depiction of ducal power, however, the inscription on the east wall of Sant'Isidoro recorded the names of three doges together with those of the procurators of San Marco and promoted a vision of political

rule based on collective action and institutional stability and continuity. These ostensibly divergent visions of power, which were already adumbrated in the decorative program of the high altar, will be examined in the last section of this chapter. The argument is twofold. First, the decorative program of the chapel of Sant'Isidoro manifested the ideological tensions that troubled Venice in the fourteenth century, and the effects of the gradual emergence of patrician self-awareness on Venetian attitudes toward government—and the practice of it. Second, the chapel dramatized the increasingly polarized and ambivalent role of the doge as both a public officer with limited powers *and* the living image of the state. Thus the chapel of Sant'Isidoro illuminates a new conception of the state as it began to coalesce in the trecento and offers precious insights into the mechanics and hierarchies that regulated the interactions between different branches of the Venetian government at a time of significant transition.

While this was obviously not part of the original plan, the Feast of St. Isidore—and therefore the chapel of Sant'Isidoro—soon became entwined with one of the most ominous episodes in Venetian history. The aftermath of Dandolo's death exposed the deep fractures within Venetian society in the mid-century. Dandolo's successor to the ducal throne, Marino Falier, was the main protagonist of a failed conspiracy that aimed to reinstate the doge as plenipotentiary ruler. The conspiracy was discovered on 16 April 1355, the feast of St. Isidore's translatio, and the doge and leaders of the coup were executed the next day. In May, when the memory of the dramatic event was still vivid, and as the chapel of Sant'Isidoro neared completion, the government instituted an annual ceremony to commemorate the foiling of the plot (and the preservation of the current patrician regime). This ceremony, which centered on San Marco and the chapel of Sant'Isidoro, forever conjoined public veneration for the new patron saint with potent rituals of political exorcism. The 1355 conspiracy falls outside the scope of the present study. Nonetheless, it will be briefly considered in the epilogue to this chapter, as it demonstrates the state of crisis in which Venice found itself in the mid-trecento, and the degree to which ongoing strife informed (and transformed) Dandolo's artistic projects in the basilica.

The Chapel of Sant'Isidoro and the Cult of St. Isidore in Venice: An Overview

In contrast to St. Mark's tomb, which was hidden from the view of the faithful, St. Isidore's sepulchre was both visible and accessible. The chapel of Sant'Isidoro is a small, one-bay rectangular room located in the northeast corner of the north transept.[1] St. Isidore's body rests within an elaborately sculpted shrine placed inside a niche at the east end of the chapel. The funerary monument combines a full-body sculptural portrait, which emphasizes the proximity and tangibility of the saint's presence in the chapel, with an arcosolium-type frame that stresses the antiquity and Eastern provenance of the martyr.[2] Surrounding the tomb, the walls of the chapel are clad in sumptuous marble panels, above which develops an extensive mosaic program that occupies the vault and the east and west lunettes of the chapel (see Fig. 35 for a view of the chapel and Fig. 36 for a closer view of the saint's tomb).

On the south side, the vault features significant episodes from the life, ministry, and martyrdom of St. Isidore in Chios (Fig. 37).

1 The main modern studies focusing specifically on the chapel of Sant'Isidoro include *Quaderni della Procuratoria: Arte, storia, restauri della basilica di San Marco a Venezia*, vol. 3, *La cappella di Sant'Isidoro*, ed. I. Favaretto (Venice, 2008); E. De Franceschi, "I mosaici della cappella di Sant'Isidoro nella basilica di San Marco a Venezia," *ArtV* 60 (2003): 6–29; E. De Franceschi, "Ricerche stilistiche nei mosaici della cappella di Sant'Isidoro," in Favaretto, *La cappella di Sant'Isidoro*, 24–34; E. De Franceschi, "I mosaici della cappella di Sant'Isidoro nella basilica di San Marco fra la tradizione bizantina e le novità di Paolo Veneziano," *Zograf* 32 (2008): 123–30; R. Dellermann and K. Uetz, *La facciata nord di San Marco a Venezia: Storia e restauri* (Sommacampagna, 2018); and R. Dellermann, "La cappella di Sant'Isidoro: I mosaici della 'Traslatio sancti Isidori'; Intenzione e ricezione politica," in Favaretto, *Sedici anni di studi sulla basilica*, 35–44 (see above, p. 77, n. 63). Several insightful observations on St. Isidore's funerary chapel and monument are also found in Tomasi, *Le arche dei santi* (see above, p. 81, n. 65). Regrettably, R. Dellermann, "'Iussu ducis'—auf Befehl des Dogen: Die Cappella di Sant'Isidoro in San Marco; Kunst und Heiligenpräsentation unter dem Dogen Andrea Dandolo (1343–1354) im Kontext" (PhD diss., Technische Universität, 2006), was unavailable to me while writing this study.

2 For a discussion of the *arca*, see R. Dellermann, "L'arredo e le sculture della cappella: Un linguaggio antico veneziano per l'arca di Sant'Isidoro," in Favaretto, *La cappella di Sant'Isidoro*, 35–63. On the visual associations between St. Isidore's tomb and late Byzantine *arcosolia*, see Tomasi, *Le arche dei santi*, esp. 62–63.

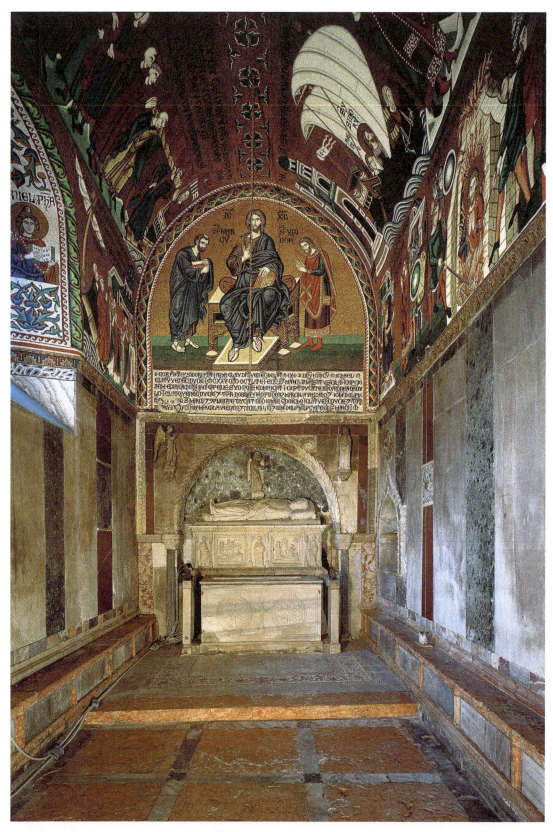

FIGURE 35. San Marco, Venice, chapel of Sant'Isidoro, ca. 1350–1355. Photo courtesy of the Procuratoria di San Marco.

FIGURE 36. St. Isidore's tomb monument, Venice, San Marco, chapel of Sant'Isidoro. Photo courtesy of the
Procuratoria di San Marco.

The vita spills over onto the north side of the vault: Isidore's entombment, which provides the narrative link between his life and the account of his translatio to Venice, occupies the westernmost portion of the vault's lower register. The narrative cycle then continues in the upper register of the north vault (Fig. 38). Proceeding west to east, the mosaics represent the arrival of Doge Domenico Michiel and the Venetian army in Chios in 1125; the *inventio* of St. Isidore's body on the island by a cleric named Cerbanus; and the discovery, initial condemnation, and scrutiny of the holy theft by Doge Domenico Michiel, followed by the transfer of the martyr's body to Venice and its solemn arrival in San Marco.[3] The last scene is depicted at

the east end of the vault, in the lower register, at the same level as the saint's entombment, implicitly inviting comparison between the martyr's pious burial by his companions in the third century and the devout reenshrinement of his body in San Marco. A monumental image of Christ seated between St. Mark and St. Isidore takes up the east wall lunette, above Isidore's tomb (Fig. 39). A representation of the Virgin and Child Enthroned between St. John the Baptist and St. Nicholas occupies the same position on

3 The invention and translation of the body of St. Isidore from the island of Chios to Venice in 1125 were allegedly

recorded in writing by one of the protagonists of the event: Cerbanus Cerbani, "Translatio mirifici martyris Isidori a Chio insula in civitatem venetam," in RHC HOcc, 5:321–34. Nevertheless, the earliest surviving copy of this text dates from the fourteenth century. For further information, see M. Palma, "Cerbani, Cerbano," *DBI* 23 (1979), http://www.treccani.it/ enciclopedia/cerbano-cerbani_(Dizionario-Biografico)/.

FIGURE 37.

Episodes from the life
of St. Isidore of Chios.
San Marco, Venice,
chapel of Sant'Isidoro.
Photo courtesy of the
Procuratoria di San Marco.

the opposite wall (Fig. 40). The figurative cycle is completed by a standing portrait of St. George, located on the wall space between two windows, and by the bust portraits of St. Francis and the prophet Daniel that occupy opposite sides of the intrados of the northwest window, and inject the space with subtle eschatological overtones.

The chapel's decorative program also includes extensive textual captions and a dedicatory inscription on the east wall. This epigraph is made in mosaic and is situated between the niche that contains St. Isidore's tomb and the Deesis above it. The inscription is structurally and functionally comparable to the dedicatory plaques on the pala d'oro, which reviewed the artifact's history and celebrated the names of the public officials responsible for commissioning and restoring it. Similarly, the epigraph in Sant'Isidoro

commemorates the translation of the saint's body from the Aegean island of Chios to Venice in 1125, under the leadership of Doge Domenico Michiel. It memorializes the subsequent recovery of the body in the basilica by Andrea Dandolo and provides key information about the construction history of the chapel (Fig. 39). Initiated by Dandolo himself—as is confirmed by other fourteenth-century sources—the chapel was completed in July 1355 by Doge Giovanni Gradenigo.[4]

4 Dandolo's close association with the chapel is confirmed by Rafaino Caresini. The latter served as ducal scribe, then as chancery notary, and eventually as Great Chancellor during and after Andrea Dandolo's dogate, and authored a chronicle of Venice that he intended as a continuation of the doge's *Chronica*. Caresini most likely drafted his chronicle in multiple phases in the mid-1380s. For a detailed discussion of the genesis of this work, its chronology, and its connections with Dandolo's chronicle, see the preface of Rafaino Caresini, *Raphayni de*

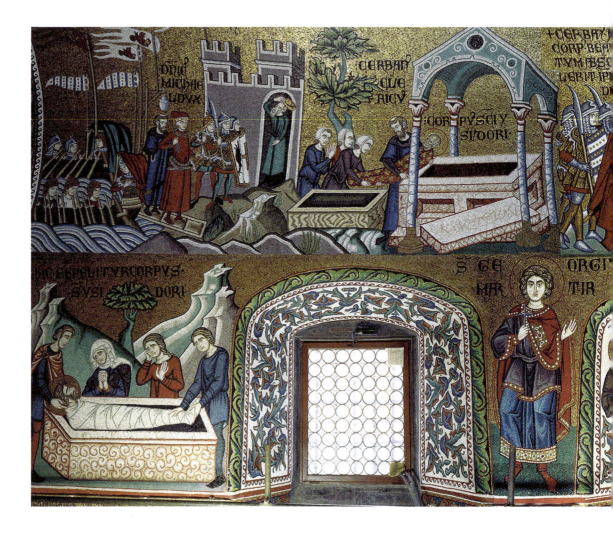

Caresinis cancellarii venetiarum chronica: aa. 1343–1388, ed. E. Pastorello, *RIS*, n.s. 12.2 (Bologna, 1942), esp. 11–13. In his account, Caresini recapitulates Dandolo's activities and identifies him as the founder of Sant'Isidoro: *Item dux, corpus beatissimi Isidori martyris, diu in ecclesia sancti Marci latitantis, reperit, ipsumque in capella, quam ibidem construi fecit, devotissime collocavit* (The doge found the body of the holy martyr Isidore, for a long time hidden in the church of San Marco, and placed it with great devotion in a chapel, which he commissioned to be erected in the same church [Caresini, *Cancellarii venetiarum chronica*, 8]). Caresini, who was probably an eyewitness to the event, attributes the saint's collocatio in the new chapel to Dandolo. Surprisingly, an inscription carved on a stone slab placed inside the sculpted sarcophagus and transcribed in an official report of the inspection of Isidore's tomb carried out in 1824 indicates that the body was placed in the new arca on 1 May 1356, by Doge Giovanni Gradenigo; see M. Da Villa Urbani, "La ricognizione del corpo del santo del 1824," in Favaretto, *La cappella di Sant'Isidoro*, 76–101, esp. 78–83. The contents of this inscription are puzzling, for they suggest that Isidore's body was placed in his new shrine a whole year after the chapel was completed in 1355. Assuming that the epigraph was transcribed correctly in 1824 (and that the stone slab was placed there in the mid-fourteenth century, rather than later), the most plausible

The inscription also implicitly provides a *terminus post quem* for the beginning of the works. Giovanni Dolfin, whose name and role as procurator of San Marco are recorded in the epigraph, was appointed to his office in 1350. Therefore the chapel of Sant'Isidoro was begun during (or after) that year. As the inscription will be referred to several times during this chapter, it is useful to report it in full:

> In this very tomb is enclosed the body of the blessed Isidore, which was brought from Chios to Venice by Lord Domenico Michiel, the illustrious doge of the Venetians, in 1125,

hypothesis seems to be that although the chapel was completed in 1355 and used immediately, St. Isidore's body may have been enshrined in a temporary sepulchre and moved to the marble arca when this was finished. On Caresini, see also A. Carile, "Caresini, Rafaino," *DBI* 20 (1977), https://www.treccani.it/enciclopedia/rafaino-caresini_(Dizionario-Biografico)/.

FIGURE 38.

St. Isidore's entombment
in Chios and episodes
from his translatio to
Venice. San Marco, Venice,
chapel of Sant'Isidoro.
Photo courtesy of the
Procuratoria di San Marco.

which remained secretly in the church of
San Marco until the beginning of the con-
struction of this chapel, [which was] built in
his name [and] begun during the rule of lord
Andrea Dandolo, the illustrious doge of the
Venetians, and at the time of the noble gentle-
men Marco Loredan and Giovanni Dolfin,
procurators of the church of San Marco. [The
chapel] was completed during the rule of lord
Giovanni Gradenigo, the illustrious doge of
the Venetians, and at the time of the noble
gentlemen Marco Loredan, Nicolò Lion, and
Giovanni Dolfin, procurators of the church
of San Marco, on 10 July 1355.

+Corp[us] B[ea]ti Ysidori, p[raese]nti
ar[c]ha claudit[ur], Venec[ias] delat[um] a
Chio p[er] D[omi]nu[m] D[omi]nicu[m]
Michael, inclytu[m] venec[iarum] duce[m],
i[n] MCXXC, q[uo]d oculte i[n] Ecc[lesia]

S[ancti] Marci p[er]ma[n]sit usq[ue] ad
i[n]ceptionem edificacio[n]is hui[us] capele
suo no[m]i[n]e edhificat[e] incept[e]
duca[n]te d[omi]no A[n]drea Da[n]dulo,
i[n]clito Venec[iarum] duce [et] t[em]p[o]r[e]
nobiliu[m] viro[rum] d[omi]nor[um] Marci
Lauredano [et] Ioh[annis] Delphin[o],
p[ro]cur[atorum] ecc[lesie] S[ancti] Marci [et]
[com]plecte duca[n]t[e] D[omi]no Ioha[nn]e
G[ra]do[n]icho i[n]clit[o] Venec[iarum] Duce
[et] t[em]p[o]r[e] nobiliu[m] viro[rum] d[om]
inor[um] Marci Lauredano [et] Nicolai Lio[n]
et ioh[annis] Delphin[o] p[ro]cur[atorum]
ecc[lesie] s[ancti] Marci i[n] MCCCLV,
me[n]se Julii, die X.[5]

5 Transcribed in Andaloro et al., *San Marco*, 2:196 (see above,
p. 46, n. 144). For a discussion of the inscription and of the
political implications of the decorative program of the chapel
of Sant'Isidoro, see S. Gerevini, "Inscribing History, (Over)
Writing Politics: Word and Image in the Chapel of Sant'Isidoro

FIGURE 39. Christ Enthroned, flanked by St. Mark and St. Isidore, and dedicatory inscription. San Marco, Venice, chapel of Sant'Isidoro. Photo courtesy of the Procuratoria di San Marco.

The inscription suggests that the martyr's body had been concealed—and therefore presumably forgotten—in the basilica following its translation from Chios in the twelfth century. Indeed, Isidore's cult is unattested in Venice before the trecento, even though the saint had been venerated in Byzantium at least since the fifth century and was known in Western Europe since the sixth century.[6] The mid-thirteenth-century

at San Marco, Venice," in *Sacred Scripture/Sacred Space: The Interlacing of Real Places and Conceptual Spaces*, ed. T. Frese, W. E. Keil, and K. Krüger (Berlin, 2019), 323–49.

6 A sixth-century bronze stamp at the Walters Art Museum in Baltimore (accession number 54.230), possibly eulogia bread stamp, testifies to the presence of Isidore's cult in the Greek-speaking Mediterranean at this time. On the object, see S. Schäfer, "Δέξαι Εὐλογίαν—der Bronzestempel mit der Darstellung des heiligen Isidor von Chios und sein möglicher Verwendungszweck," in *Für Seelenheil und Lebensglück: Das byzantinische Pilgerwesen und seine Wurzeln*, ed. D. Ariantzi and I. Eichner (Mainz, 2018), 327–42. St. Isidore was venerated

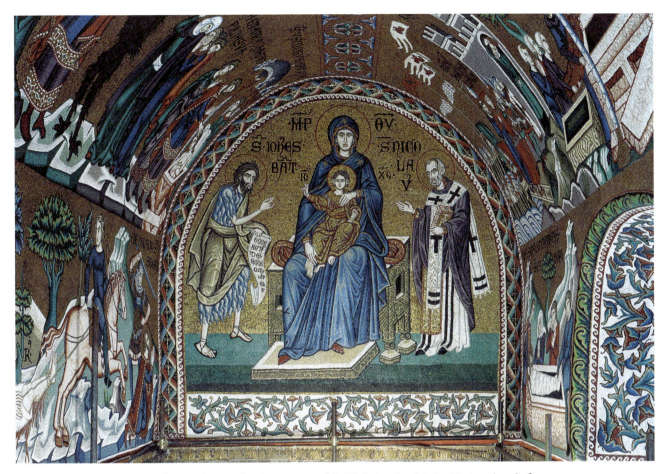

FIGURE 40. Virgin and Child, flanked by St. John the Baptist and St. Nicholas. San Marco, Venice, chapel of Sant'Isidoro. Photo courtesy of the Procuratoria di San Marco.

chronicle written by Martino da Canale does not mention the martyr's *translatio*. Instead, the episode is included in the historical works of the Franciscan Paolino da Venezia (ca. 1270–1344),

written during the fourth and fifth decades of the trecento.[7] Andrea Dandolo himself did not refer to the episode in his earlier chronicle. However, both Isidore's martyrdom in the early centuries and the importation of his body to Venice are included in the *Chronica per extensum descripta*, composed after Dandolo's election as

both on the island of Chios, where a church in his name had been erected in the fifth century, and in Constantinople at the church of Hagia Eirene, where a chapel dedicated to Isidore was also built in the fifth century. This chapel reputedly hosted some of his relics that had been taken to Constantinople from Chios by St. Markianos, *oikonomikos* of Hagia Sophia. See J. Ebersolt, *Sanctuaires de Byzance: Recherches sur les anciens trésors des églises de Constantinople* (Paris, 1921), 15; and H. Delehaye, *Les origines du culte des martyrs*, 2nd rev. ed. (Brussels, 1933), 239. Unfortunately, St. Isidore is not included in C. Walter, *The Warrior Saints in Byzantine Art and Tradition* (Farnham, 2003). As for Western Europe, Gregory of Tours mentions the saint and his healing shrine in Chios, which indicates that Isidore was known, and possibly venerated, in Western Europe at that time: Gregory of Tours, *Glory of the Martyrs*, trans. R. Van Dam (Liverpool, 1988), 93. By contrast, St. Isidore does not appear in the mid twelfth-century *Legendary* preserved in BNM, Lat. Z, 356 (=1609). See Cattin, *Musica e liturgia*, 3:315–19 (see above, p. 66, n. 26).

7 A critical edition of Paolino da Venezia's works does not yet exist. Brief references to the translatio of Isidore's body by the cleric Cerbanus Cerbani appear in all the manuscripts accessed for this book, including the fourteenth-century codex of the *Chronologia Magna* preserved in BNM, Lat. Z 399 (=1610), fol. 77r. See also Paolino da Venezia, *Historia satyrica*, Rome, Biblioteca Apostolica Vaticana, Vat. Lat. 1960, fol. 231r, and another manuscript of his *Chronologia Magna*: Paris, Bibliothèque nationale de France, Lat. 4939, fol. 101r. For an overview and chronology of these manuscripts and further references, see M. Di Cesare, "Problemi di autografia nei testimoni del *Compendium* e della *Satirica ystoria* di Paolino Veneto," *Res Publica Litterarum* 30 (2007): 39–49. For a recent appraisal of Paolino's works, see R. Morosini and M. Ciccuto, eds., *Paolino Veneto: Storico, narratore e geografo* (Rome, 2020).

doge in 1343.[8] In addition, whereas the written account of Isidore's translatio on the initiative of the cleric Cerbanus had allegedly been compiled by Cerbanus himself in the twelfth century, the only surviving manuscript of that text dates from the trecento. As Michele Tomasi notes, this manuscript has been preserved as a later addition to the thirteenth-century *Legendary* in use at the church of San Marco, suggesting that the saint was not the object of specific devotion in the basilica before the trecento.[9] Even outside San Marco, the vita of St. Isidore is memorialized for the first time in a Venetian context in the *Legendary* by Pietro Calò, also compiled in the mid-trecento.[10] Collectively, these sources demonstrate that regardless of the date of his arrival in the lagoon, Isidore's notoriety in Venice significantly increased in the later Middle Ages, and particularly in the central decades of the fourteenth century, during Dandolo's reign.

As Diana Webb argues in her now classic book *Patrons and Defenders*, the identity of the chief patron saints of Italian cities was generally established by 1200, and never changed. But changing times and new situations created in most urban centers a need to add to the number of their heavenly protectors.[11] Saintly cults and the possession of holy bodies and relics ensured the safety of the communities that venerated them. At times of increased vulnerability and strife in the later Middle Ages, urban

governments associated themselves with old and new holy patrons as a means to sanction their own authority and to disseminate ideas of continuity and tradition through phases of civic instability and change.[12] Venice was no exception. The pala feriale promoted a wider team of holy protectors alongside St. Mark. Beyond San Marco, Anna Munk has noted that the trecento was a period of increased interest in—and novel visual interactions with—holy bodies across the Venetian lagoon.[13] And Karen McCluskey draws specific attention to the rise of Venetian *santi novelli* from the duecento onward, identifying the different agents, both public and private, that sponsored the cults of local holy men and women, and the ways in which devotion toward them was stimulated (and circumscribed) by the political authorities.[14] The fostering of St. Isidore's cult took place against these developments and manifested the ongoing process of expansion and consolidation of the holy pantheon of the city around the central figure of St. Mark and under the aegis of the government

Even as it discovered the value of local sanctity, Venice retained the penchant for Eastern saints and holy relics that it had developed in earlier centuries.[15] Karin Krause and others have

8 Dandolo, *Chronica per extensum descripta* (see above, p. 21, n. 47), 22 (*vita*), 234–35 (*translatio*).

9 M. Tomasi, "Prima, dopo, attorno alla cappella: Il culto di Sant'Isidoro a Venezia," in Favaretto, *La cappella di Sant'Isidoro,* 15–23, at 17. The textual account of Cerbanus's translation follows the narrative of his life and martyrdom in BNM, Lat. IX 27 (=2797), fols. 232r–34r for Isidore's *passio*, 234r–39v for his *translatio*. The manuscript is composite; the section that includes Isidore's passio and translatio dates from the fourteenth century. For a detailed description, see the entry by S. Marcon in Cattin, *Musica e liturgia*, 1:222–24.

10 The Dominican friar Pietro Calò died in 1348, a *terminus ante quem* for the completion of his *Legendary*. The latter is yet unpublished. The earliest manuscript (BAV, Barb. Lat. 713–714) was completed before 1340. It has survived in an incomplete state, and the section that would have included St. Isidore is missing. Another fourteenth-century manuscript has survived in Venice. The latter is complete and includes the legend of St. Isidore: BNM, Lat. IX 18 (=2945), fols. 222v–24r.

11 D. Webb, *Patrons and Defenders: The Saints in the Italian City-States* (London, 1996), 135.

12 Webb, *Patrons and Defenders*, 135.

13 Munk, "Relic Cults" (see above, p. 76, n. 59).

14 K. McCluskey, *New Saints in Late-Mediaeval Venice, 1200–1500: A Typological Study* (London, 2020).

15 For a catalogue of Eastern and local holy bodies in Venice, see Frolow, "Notes sur les reliques" (see above, p. 72, n. 40). P. Chiesa, "Santità d'importazione a Venezia tra reliquie e racconti," in *Oriente cristiano e santità: Figure e storie di santi tra Bisanzio e l'Occidente*, ed. S. Gentile (Milan, 1998), 107–15; E. Morini, "Note di lipsanografia veneziana," *Bizantinistica* 1 (1999): 145–272; and Klein, "Die Heiltümer von Venedig" (see above, p. 72, n. 40). On the reception of Venice's relics and holy images by pilgrims, see among others M. Bacci, "A Power of Relative Importance: San Marco and the Holy Icons," *Convivium* 2.1 (2015): 126–47. On the acquisition of important Eastern relics in the later middle ages, see R. Blumenfeld-Kosinski and K. Petkov, eds., *Philippe de Mézières and His Age: Piety and Politics in the Fourteenth Century* (Leiden, 2012); Petkov, *Anxieties of a Citizen Class* (see above, p. 20, n. 32); and H. A. Klein, V. Poletto, and P. Schreiner, eds., *La stauroteca di Bessarione fra Costantinopoli e Venezia* (Venice, 2017). Venice was also duly concerned with the management of relics in its overseas colonies. For insightful observations regarding this matter in Venice-ruled Crete, see M. Georgopoulou, "Late Medieval Crete and Venice: An Appropriation of Byzantine Heritage," *ArtB* 77.3 (1995): 479–96; and Georgopoulou,

demonstrated that a set of precious relics of the Passion, allegedly translated from Constantinople to Venice in or after 1204, were more vigorously promoted in the fourteenth century, particularly by Andrea Dandolo.[16] As already mentioned, the Byzantine relic of St. George in the treasury of San Marco was encased in a new, sumptuous metalwork container in ca. 1325, signaling renewed interest in this Eastern holy token. Finally, Andrea Dandolo was the earliest chronicler to include a comprehensive selection of accounts of relic translations in his historical works, casting Venice as a treasure island where precious holy bodies from the East had been collected over time and distributed across a multitude of religious foundations.[17] From this angle, the chapel of Sant'Isidoro represents one particularly lavish instance of a broader initiative of Eastern relic promotion spearheaded by the Venetian government.

Of course the diverse panoply of foreign relics that punctuated the city of Venice coexisted with the civic cult of St. Mark, without ever displacing or challenging it. In the fisherman's legend discussed at the beginning of this study, and on the pala feriale, St. Mark shares his role as Venice's protector with St. George and St. Nicholas. But his grip on the city remains firm, as does his privileged position at the heart of San Marco. If anything, the cult of the evangelist was promoted further in the fourteenth century. And the details of his hagiography, particularly his apparitio in 1094, functioned as models on which to shape the literary and visual accounts of other miraculous relic inventions in Venice in the fourteenth

century.[18] David Perry and Karen Rose Mathews remind us that textual and visual accounts of relic translations performed a specific civic role in Venice throughout the Middle Ages.[19] The city's identity was predicated on its possession of the body of St. Mark and on accounts of the latter's legendary translatio from Alexandria in the ninth century. Based on this precedent, several other translatio accounts that traced the trajectory of a relic's voyage to the lagoon and celebrated its installation in the city were deployed to advertise the magnitude of Venetian networks of influence, whether actual or symbolic. The translatio sancti Marci was expanded and altered over the centuries to reflect new religious and political concerns.[20] The same happened to other narratives of translation that were developed, modified, and accumulated over time in response to novel civic preoccupations.

This was the case for St. Isidore. His heightened role in the fourteenth century embodies Venice's long-standing tradition of accumulation and promotion of Eastern holy bodies, as well as more recent tendencies on the part of the urban communities of Italian city-states to widen and diversify their civic pantheons. The topical reasons behind the selection of St. Isidore of Chios as a new patron saint for Venice will be explored later. Meanwhile, the next section considers how the chapel worked visually to persuade viewers of the worthiness of the Eastern martyr and of his real presence in San Marco—that is, how the chapel of Sant'Isidoro constructed the new saint and staged his cult in order to "make it work"—and what those visual strategies reveal about the concerns and demands that shaped St. Isidore's cult in San Marco in the trecento.

Venice's Mediterranean Colonies (see above, p. 38, n. 117). See also A. Marinković, "Hostage Relics and Venetian Maritime Control in the Eastern Adriatic," in Ein Meer und seine Heiligen: Hagiographie im mittelalterlichen Mediterraneum, ed. N. Jaspert, C. A. Neumann, and M. Di Branco (Leiden, 2018), 275–96, as well as the other essays in the same volume.

16 Krause, "Feuerprobe" (see above, p. 72, n. 40); and Klein, "Refashioning Byzantium" (see above, p. 55, n. 5). For a different interpretation that nevertheless recognizes Dandolo's role in identifying officially the relics to be associated with the sack of Constantinople in 1204, see Pincus, "Christian Relics" (see above, p. 72, n. 40).

17 See S. Gerevini, "Topografia sacra e geografie del potere a Venezia nel Trecento," in Strategie urbane e rappresentazione del potere: Milano e le città d'Europa, ed. S. Romano and M. Rossi (Milan, 2022), 202–25.

18 K. McCluskey, "Miraculous Visions: Apparitio in the Vitae of Mediaeval Venetian Saints and Beati," IKON 6 (2013): 167–81.

19 D. M. Perry, Sacred Plunder: Venice and the Aftermath of the Fourth Crusade (University Park, PA, 2015), is entirely dedicated to this subject. See also Mathews, "Reanimating the Power of Holy Protectors" (see above, p. 83, n. 71).

20 On the wider phenomenon of hagiographic rewriting, see M. Goullet, Ecriture et réécriture hagiographiques: Essai sur les réécritures de vies de saints dans l'occident latin médiéval (VIIIᵉ–XIIIᵉ s.) (Turnhout, 2005). This volume is a useful reference for several aspects discussed in the next section.

Making St. Isidore: Eastern Saints, Hagiographic Conventions, and the Staging of a New Saintly Cult in San Marco

Scholarship on pictorial and textual hagiography has long acknowledged the rhetorically sophisticated nature of saints' vitae.[21] Intended to edify and persuade, hagiographic cycles presupposed an audience whose knowledge and expectations they enlisted to achieve their goals: validating the truthfulness of the events they reported and the worthiness of the saint whose life they extolled, and bearing witness to God's immanence in the world.[22] Theoretically conceived as variations on a single theme—the imitation of Christ and the perfecting of Christian life—saints' vitae were not only carefully constructed, but relied heavily on narrative and visual repetition and intertextual and interpictorial references.[23] The use and modulation of topoi that would be familiar to medieval audiences made the *Lives* of saints easier to apprehend and remember, while also functioning as a form of authentication and confirmation of new, or updated, saintly narratives.[24]

St. Isidore's hagiographic cycle meets this description. As mentioned above, the visual narrative is neatly divided between the south and north sections of the vault, which respectively visualize the actual vita of the martyr and the fate of his body postmortem. This spatial distribution signals the chronological distance between Isidore's life in the third century and the arrival of his body in Venice in the twelfth century, simplifying the reading of the visual narrative across the architectural space. Moreover, as befitted the visual hagiography of a "new" saint whose endeavors needed to be made familiar to his religious audience, St. Isidore's vita is vividly rendered in the mosaics, but is also highly stereotypical. Following a standard pattern for martyr saints, the visual cycle recapitulates Isidore's ministry in Chios: his evangelism, his powers as a miracle worker and exorcist, and the conversion and baptism of a group of sinful women. The following episode—the saint's trial and condemnation by secular (pagan) authorities—is also common in martyrs' hagiographic cycles. In this case, the officer raises his accusing finger toward Isidore, while the saint turns his hands and head upward in prayer, signifying both his resignation and his fortitude. From the justice's act of (ill) judgment there ensue the martyr's tortures. These too fall into standard categories and would be easily decipherable by viewers with or without prior knowledge of Isidore's vita. These scenes appear to have been specifically designed to affect the viewers emotionally. In the representation of Isidore's trial by fire, one of the soldiers (to the left of the furnace) raises his shield to cover his face, a gesture that may indicate an attempt to protect himself from the heat, but also from the offensive spectacle of torture before his eyes (Fig. 41). In the next scene, streams of blood gush from the martyr's naked body as he is tied and pulled by a horse, in a representation whose visual explicitness is unmatched in other mosaics of the basilica, and that is likely to have embedded itself in the memory of the beholders (Fig. 42).

21 An expansive literature exists on the cult of saints and on the textual and visual accounts of their lives. The standard reference is still P. Brown, *The Cult of the Saints: Its Rise and Function in Latin Christianity* (Chicago, 1981). More recently, see R. Bartlett, *Why Can the Dead Do Such Great Things? Saints and Worshippers from the Martyrs to the Reformation* (Princeton, NJ, 2013), esp. 504–45 on the lives of saints. For the later Middle Ages, see, for example, A. Vauchez, *Sainthood in the Later Middle Ages* (Cambridge, 1997). Cynthia Hahn has published extensively on pictorial hagiography: see, for example, C. J. Hahn, *Portrayed on the Heart: Narrative Effect in Pictorial Lives of Saints from the Tenth through the Thirteenth Century* (Berkeley, 2001); and C. J. Hahn, "Understanding Pictorial Hagiography (with Comments on the Illustrated Life of Wandrille)," in *Hagiography and the History of Latin Christendom, 500–1500*, ed. S. K. Herrick (Leiden, 2020), 52–77. For orientation in the vast literature on Byzantine hagiography, see among others S. Hackel, ed., *The Byzantine Saint* (Crestwood, NY, 2001); and S. Efthymiadis, ed., *The Ashgate Research Companion to Byzantine Hagiography*, 2 vols. (Farnham, 2011–2014). On visual depictions of sanctity in Byzantium, see, for example, H. Maguire, *The Icons of Their Bodies: Saints and Their Images in Byzantium* (Princeton, NJ, 1996); and more recently P. Chatterjee, *The Living Icon in Byzantium and Italy: The Vita Image, Eleventh to Thirteenth Centuries* (Cambridge, 2014).

22 Hahn, "Understanding Pictorial Hagiography," esp. 52–53; Bartlett, *Great Things*, 510.

23 Hahn, *Portrayed on the Heart*, esp. 39–42. See also M. Carrasco, "Sanctity and Experience in Pictorial Hagiography: Two Illustrated Lives of Saints from Romanesque France," in *Images of Sainthood in Medieval Europe*, ed. R. Blumenfeld-Kosinski and T. K. Szell (Ithaca, NY, 1991), 33–66. On topoi in the literary lives of Greek saints, see T. Pratsch, *Der hagiographische Topos: Griechische Heiligenviten in mittelbyzantinischer Zeit* (Berlin, 2012).

24 On repetition as confirmation in hagiographic texts and saintly images, see also Maguire, *Icons of Their Bodies*.

FIGURE 41. St. Isidore's trial by fire. San Marco, Venice, chapel of Sant'Isidoro. Photo courtesy of the Procuratoria di San Marco.

In this context, the mosaics' stylistic and formal qualities are likely to have operated as means of rhetorical persuasion as well. In his seminal study on Byzantine sanctity and its visual rendition, Henry Maguire explores the complex nexus between the visual qualities of saintly images and the specific devotional expectations of their beholders, and demonstrates how different demands put on certain saints resulted in the deployment of different modes of representation in their visual hagiographies.[25] Scholars have sometimes commented on the "vernacular" style of the mosaics of Sant'Isidoro, which stand

in stark contrast with the "courtly" imagery in the baptistery, completed in the same years.[26] The formal differences between these two cycles have largely been explained in developmental terms—that is, as the trace of Venetian artists' gradual detachment from Byzantine models, and as evidence of their increasing experimentation and familiarity with continental forms.[27] But the

25 Maguire, *Icons of Their Bodies*, esp. 146–94.

26 Fortini Brown, *Venice and Antiquity*, 39 (see above, p. 48, n. 150).

27 See particularly De Franceschi, "Ricerche stilistiche" (see above, p. 95, n. 1); De Franceschi, "I mosaici della cappella di Sant'Isidoro a Venezia" (see above, p. 95, n. 1); and De Franceschi, "I mosaici della cappella di Sant'Isidoro fra la tradizione bizantina" (see above, p. 95, n. 1).

SVSI DO R̄

stylistic and formal differences between the two
mosaic programs may also be due to their differ-
ent functions. The vivid colors of the chapel of
Sant'Isidoro, the emphatic gestures performed
by individual characters, the gruesome details of
some of the scenes, the repetitive facial features of
most characters in the cycle, the linear narrative
flow, and the spatial layout that clearly separated
the saint's actual vita from his postmortem jour-
ney to Venice, together constructed a storyline
that was both gripping and easy to follow—and
thus arguably compelling.[28]

If decipherability and emotional appeal were
important elements in the design of St. Isidore's
visual hagiography, emphasizing its similarity
with the lives of other major holy intercessors
appears to have been as significant. In addition
to St. Isidore himself, the two lunettes on the east
and west walls of the chapel represent St. Mark,

28 That visual storying in the chapel of Sant'Isidoro was
intended to convince, and that its style matched this purpose, is
also noted by Fortini Brown, *Venice and Antiquity*, 39.

St. Nicholas, and St. John the Baptist, implicitly
presenting the four saints as equals. In addition,
the narrative cycle makes selective pictorial ref-
erences to the vitae of those saints, with a dual
result: enhancing Isidore's prestige by associating
him with better known and more widely vener-
ated saints and bolstering emerging ideas about a
community of powerful saints working together
to the benefit of the city.

This associative strategy is most evidently
pursued in relation to St. Mark. St. Isidore
is juxtaposed with the evangelist in the east
wall mosaic, boldly promoting the former
as St. Mark's co-patron. In addition, key ele-
ments of Isidore's vita and his translatio appear
to have been directly modeled on St. Mark's. In
the chapel, the visual account of Isidore's life
begins where Mark's own earthly travels ended,
in Alexandria—an association that would be
readily noted by a Venetian audience. The simi-
larity between the two saints was also empha-
sized in relation to their martyrdom. Textual
accounts of Isidore's martyrdom—such as that

FIGURE 43. St. Mark dragged across Alexandria, mid-thirteenth century. San Marco, Venice, Zen chapel. Photo courtesy of the Procuratoria di San Marco.

FIGURE 44. *Procession in Piazza San Marco*, Gentile Bellini, 1496. Venice, Gallerie dell'Accademia. Photo courtesy of Cameraphoto arte.

FIGURE 45.
Procession in Piazza San Marco, Gentile Bellini, 1496, detail of the inventio of St. Mark's body in 828 and departure of the Venetian ship from Alexandria. Venice, Gallerie dell'Accademia. Photo courtesy of Cameraphoto arte.

FIGURE 46.
Inventio of St. Isidore's body in Chios in 1125. San Marco, Venice, chapel of Sant'Isidoro. Photo courtesy of the Procuratoria di San Marco.

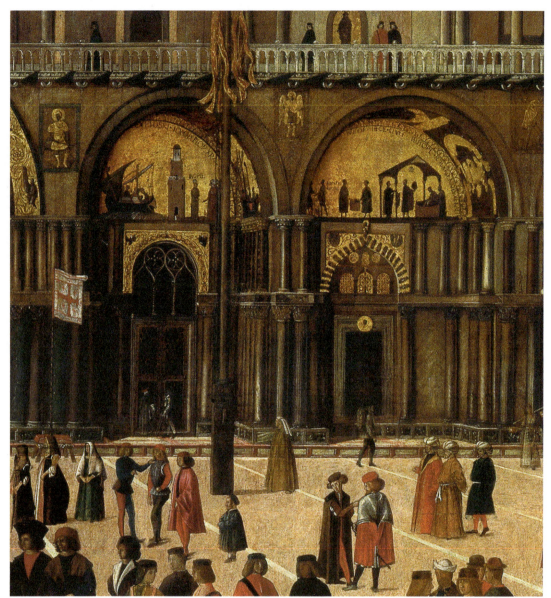

fig. 45

provided by Pietro Calò's fourteenth-century *Legendary*—list several torments. Instead, the mosaics are highly selective, picking only two exempla of torture. The first of these, trial by fire, was commonly understood in the Middle Ages as a visual testament to the purity of martyrs and was therefore a favorite subject of visual hagiographies. The other, the laceration of the saint's flesh as he is dragged by a horse across a rocky landscape, directly evoked St. Mark's martyrdom. The evangelist, too, was subjected to a similar torture (though he was dragged by men rather than a horse): the episode was represented in mosaic in the southwest corner of the atrium

of the basilica (now the Zen chapel), which was publicly accessible in the Middle Ages (compare Fig. 42 with Fig. 43).

The correspondences between St. Mark and St. Isidore's hagiographies become ever more overt in the visual accounts of their translation to Venice. As we know, the transfer of St. Mark's body from Alexandria to Venice was depicted on the west façade of the basilica. The destructive restoration of those mosaics in early modern times thwarts all attempts at a detailed comparison between the two translatio narratives. Nonetheless, the general appearance of the medieval mosaics on the western façade can be gauged

fig. 46

from Gentile Bellini's monumental painting *The Procession in Piazza San Marco* (ca. 1496), painted before the façade was redecorated in the following century (Fig. 44).

The painting, originally commissioned by the Scuola Grande di San Giovanni Evangelista, is generally regarded as accurate in its rendition of the church's architectural and artistic details. On the far right of the façade, Bellini depicted the mosaic above the southwest portal of San Marco: this represented the retrieval of St. Mark's body in Alexandria and its transfer onto a Venetian ship. In the lunette, the saint's tomb is placed under an aedicule with a pointed roof, similar in its overall

appearance to the canopy above St. Isidore's sepulchre (Figs. 45 and 46).

Returning to Bellini's painted version of San Marco, the next portal to the left represents the departure of the Venetian ship carrying the evangelist's body from Alexandria. As the vessel leaves Alexandria behind, the city's lighthouse remains well visible on the right side of the lunette. Together with the mosaics of the Zen chapel, which also include a depiction of the Pharos in the scene of the arrival of St. Mark in Alexandria, the painting offers an apt visual parallel to the representation of the Pharos in the chapel of Sant'Isidoro (see Figs. 45, 47, and 48).

Finally, the collocatio of St. Isidore's body in the basilica of San Marco by Doge Domenico Michiel in 1125 was unequivocally fashioned after the mosaic above the portal of Sant'Alipio, which survives in its original, thirteenth-century form (Figs. 49 and 50). The mosaics on the façade of San Marco were permanently accessible to Venetian viewers. The imagery in Sant'Isidoro would evoke those mosaics, establishing a parallel between Venice's chief patron and the Eastern martyr. This favorable association implicitly validated Isidore's sanctity and further promoted his role as epigone and fellow patron saint of the evangelist—an idea that is also explicitly articulated in the lunette on the east wall, and in Cerbanus's textual account of Isidore's translation to Venice.[29]

The interpictorial references between St. Isidore's life and the vitae of St. John and St. Nicholas are more conjectural, but similarly suggestive. The last scene of Isidore's vita represents his beheading (Fig. 51). The scene is located near the west corner of the chapel, roughly above its entrance. The saint awaits his own execution in perfect stillness, kneeling in prayer and looking upward to God. Within the actual physical space of the chapel, however, St. Isidore directs his gaze (and the viewer's) toward the west wall lunette, and thus in the direction of the Virgin and Child, St. John the Baptist, and St. Nicholas. Of the four figures, the one nearest the episode of the beheading is that of the Precursor. Medieval viewers would naturally be familiar with the vita of St. John, who was also martyred by decapitation. In addition, his devotional significance at San Marco was boosted by the decoration of the baptistery. The latter was renovated in the same years as the building of Sant'Isidoro, and evidently included a representation of St. John's martyrdom by beheading, offering a direct visual comparison with Isidore's execution. Further reinforcing the conceptual associations between Isidore and the Precursor, the scene immediately above St. Isidore's decapitation shows the martyr performing baptism (Fig. 52). Together, the two episodes (and their positioning) set up an implicit correspondence between St. Isidore and St. John, thus promoting the former by connection with the latter.

The pictorial vita of St. Isidore was also intended to bear some resemblance to the hagiography of St. Nicholas, whose mosaic portrait occupies a privileged position to the side of the Virgin and Child in the west wall lunette. As discussed in the previous chapter, St. Nicholas was the object of a well-established cult in Venice. In addition to the church of San Nicolò al Lido, built after St. Nicholas's body was allegedly transferred from Myra to Venice in 1100, another chapel dedicated to the saint was built in the thirteenth century.[30] The medieval visual programs of both these foundations are largely lost, making any accurate comparisons between St. Nicholas's and St. Isidore's pictorial vitae at their Venetian shrines impossible. The only figurative elements to have survived are two fragments from a fourteenth-century polyptych. The painting was most likely commissioned in the mid-1340s from Paolo Veneziano and was intended for the ducal chapel of San Nicolò. One of the surviving fragments, currently preserved at the Uffizi in Florence, represents a well-known episode from the life of the saint, *The Alms of St. Nicholas*.[31] In an act of selfless generosity, St. Nicholas was believed to have left a gift of money to an impoverished father and his three daughters, providing them with a much-needed dowry that saved them from prostitution. The image of the three girls in the panel painting closely resembles that of the three sinful women converted by St. Isidore in the mosaics of his chapel (Figs. 53 and 54). The women sport identical clothing in the two scenes, both in terms of color and cut. Their countenance

29 Cerbani, "Translatio mirifici martyris " (see above, p. 98, n. 3), 326, where St. Mark is described as St. Isidore's "co-patron" (*compatronus*).

30 The church was demolished in the sixteenth century. On its history and decorative program, see Fortini Brown, *Venetian Narrative Painting*, 259–60 (see above, p. 35, n. 106).

31 Florence, Galleria degli Uffizi, Inv. Contini Bonacossi, no. 7. The painting measures 75 × 53 cm. The other fragment from the same polyptych, also preserved at the Uffizi, represents the birth of St. Nicholas. On the polyptych, see Pedrocco, *Paolo Veneziano*, 174–75, nos. 17.1, 17.2 (see above, p. 53, n. 3); and Flores d'Arcais and Gentili, *Il Trecento adriatico*, 156–57, no. 27 (see above, p. 37, n. 114). Both entries include an extensive bibliographic apparatus. For an introduction to the cult of St. Nicholas, see, for example, M. Bacci, *San Nicola: Splendori d'arte d'Oriente e d'Occidente* (Milan, 2006).

fig. 47

fig. 48

FIGURE 47.
St. Mark arrives in
Alexandria, mid-
thirteenth century.
San Marco, Venice,
Zen chapel. Photo
courtesy of the
Procuratoria
di San Marco.

FIGURE 48.
St. Isidore departs
from Alexandria.
Venice, San Marco,
chapel of Sant'Isidoro.
Photo courtesy of
the Procuratoria
di San Marco.

FIGURE 49.
The body of St. Mark
carried into San Marco,
third quarter of the
thirteenth century.
San Marco, Venice,
portal of Sant'Alipio.
Photo by author.

FIGURE 50.
The body of St. Isidore
carried into San Marco.
San Marco, Venice,
chapel of Sant'Isidoro.
Photo courtesy of the
Procuratoria di San Marco.

fig. 49

fig. 50

FIGURE 51. St. Isidore's beheading. San Marco, Venice, chapel of Sant'Isidoro. Photo courtesy of the Procuratoria di San Marco.

FIGURE 52.
St. Isidore's ministry in Chios and his beheading.
San Marco, Venice, chapel of Sant'Isidoro.
Photo courtesy of the Procuratoria di San Marco.

and hairdo also match, but for the fact that Paolo Veneziano's painted figures wear crowns.

In addition to this iconographic similarity, the textual accounts of Nicholas's and Isidore's translations to Venice also share some significant elements. In both literary narratives, the holy theft is preceded by an invocation of the relevant saint's approval. The argument runs similarly in both: the East benefited from the saint's presence and sanctity during his lifetime, and for several centuries after his death; on these grounds, it now seems appropriate to ask the saint to visit the Occident, where he will also be greatly honored.[32] Having thus justified the theft of Nicholas's and Isidore's bodies from their resting places in the East, both texts also proceed to acknowledge Venetian sympathy toward the Greek communities that they were depriving of their holy treasures. Both Nicholas and Isidore, we are informed, had originally been buried with two other saints. In both cases, moved by the suffering of their fellow Christians, the Venetian party decided to leave behind at least one of those (relatively minor) bodies, so that the local communities would still enjoy some saintly protection.[33]

Interpictorial and intertextual references to the lives of other saints were common strategies of medieval visual hagiography. As Hahn and others have suggested, emphasizing the commonalities between the *Lives* of different saints made it easier for readers and viewers to recognize and recollect patterns of sanctity, and functioned as a means of validation of new or lesser-known saintly figures—which would have been particularly advantageous with respect to St. Isidore.[34]

32 *Historia de translationis sanctorum magni Nicolai, terra marique miraculi gloriosi, eiusdem avunculi, alterius Nicolai, Theodorique martyris pretiosi*, RHC HOcc, 5:253–92, at 263; and Cerbanus Cerbani, "Translatio mirifici martyris," 327.

33 *Historia de translationis sanctorum magni Nicolai*, 5:268; and Cerbani, "Translatio mirifici martyris," 331.

34 On interpictorial references, see C. J. Hahn, "Interpictoriality in the Limoges Chasses of Stephen, Martial, and Valerie,"

FIGURE 53.

The Alms of St. Nicholas, Paolo Veneziano.
Florence, Gallerie degli Uffizi, ca. 1346.
Photo courtesy of Gallerie degli Uffizi.

FIGURE 54.

St. Isidore and the three sinful women.
San Marco, Venice, chapel of Sant'Isidoro.
Photo courtesy of the Procuratoria di San Marco.

fig. 53

In addition, such cross-references brought into relief a central tenet of the medieval cult of saints that was of increasing importance in Venice. Holy men and women, of course, were historical individuals, each embodying a unique set of virtues and merits. Yet in the sense that the ultimate aim of saintly life was to imitate Christ's example, all saints also shared in one common life.[35] They represented a community that, in its entirety, embodied an ideal of Christian perfection and offered the faithful a potent focus for devotion and intercession. The visual program of the chapel taps into these ideas. It visualizes St. Isidore in the company of more powerful holy patrons— Mark, John, and Nicholas—in the east and west wall lunettes, and it models the former's vita on those precedents. In so doing, the mosaics implicitly uphold medieval ideas about a harmonious "community" of saints and strive to promote Isidore to membership in that club. And not unlike the upper register of the pala feriale and the legend of the storm discussed in chapter 1, they advocate the protection and intercession of a team of holy patrons (incidentally, all promoted

in *Image and Belief: Studies in Celebration of the Eightieth Anniversary of the Index of Christian Art*, ed. C. Hourihane (Princeton, NJ, 1999), 109–24; Hahn, *Portrayed on the Heart*, esp. 39–58 (see above, p. 106, n. 21); and Hahn, "Understanding Pictorial Hagiography" (see above, p. 106, n. 21). On intertextual references, see also Goullet, *Ecriture et réécriture*, 205–32 (see above, p. 105, n. 20). See also Carrasco, "Sanctity and Experience" (see above, p. 106, n. 23); and Pratsch, *Der hagiographische Topos* (see above, p. 106, n. 23).

35 The idea of saintly lives as individual instantiations of the same ideal led Gregory of Tours to state that it would be better to talk about the "life" of saints, in the singular, rather than about their "lives" in the plural: Gregory of Tours, "Liber vitae patrum," ed. B. Krusch, in MGH ScriptRerMerov (Hannover, 1885), 1.2:661–744, at 662, cited in Bartlett, *Great Things*, 520 (see above, p. 106, n. 21).

fig. 54

by the government in the mid-century) at times of increased uncertainty and strife.

From a Venetian perspective, convincing viewers of Isidore's sainthood and his powers as an intercessor was only useful if the faithful could also be made to believe that the saint's body was actually present in San Marco, and that they could therefore pray for and hopefully obtain his intervention. The program of the north vault is entirely devoted to this purpose: St. Isidore's translation is narrated in detail, from the discovery of his relics inside the altar of his church in Chios to the embarkation of his body, clad in sumptuous textiles, onto a Venetian ship, and his arrival in Venice and deposition in the church of San Marco. As others have also noted, these episodes are accompanied by lengthier textual inscriptions than those on the opposite vault.[36] The epigraphs provide the names of the main characters and describe the events that the images represent. The increased density of text could be justified by the need to explain a story that was not as widely known and easily readable as the saint's vita. But the emphasis on visual accuracy and textual information may also signal an awareness on the part of patrons and viewers that as the narrative left the realm of hagiography and entered that of public history, its strategies of visual verification and persuasion had to change, too.

The chapel of Sant'Isidoro made a strong case for Venice's truthful and legitimate possession of Isidore's body. Following the Fourth Lateran Council, the processes put in place to authenticate holy bodies and relics had become more formalized, often taking the form of veritable investigative exercises. Whenever possible, these procedures entailed the direct inspection of holy fragments or bodies. The presence and antiquity of inscriptions, whether attached to the relics themselves or engraved on their reliquaries or on the tombs where saints were buried, were also taken into account. Official processes of authentication also admitted into evidence extant written collections of miracles and translations, as well as eyewitness accounts and historical texts—anything, in other words, that could document when and how a given relic or holy body had

been acquired by a community, corroborate that acquisition's legitimacy and historical verifiability, and support the authenticity and antiquity of the relic itself.[37]

The chapel of Sant'Isidoro fulfills many of the requirements above and reveals in turn the complex processes by which historical evidence was constructed and evaluated in fourteenth-century Venice. The dedicatory inscription on the east wall explicitly informed its readers that the martyr's body had remained concealed until Doge Andrea Dandolo built a chapel in his honor. By necessity, such a rediscovery would have entailed an inspection of the holy body, fulfilling the first requirement of relics' authentications. The inscription also enlists the probatory value of tradition: the saint's relics are cleverly said to have been "hidden" (and thus present and untouched) in San Marco for a long time. Finally, the inscription includes a series of dates: publicly and

36 Tomasi, "Prima, dopo, attorno," 18 (see above, p. 104, n. 9).

37 The standard reference remains N. Herrmann-Mascard, *Les reliques des saints: Formation coutumière d'un droit* (Paris, 1975), esp. 113–36. Medieval processes of relic certification have generated lively debate. Hahn and Klein, *Saints and Sacred Matter* (see above, p. 72, n. 40), includes several important essays, many of which discuss problems of identification and authentication. On these aspects, see also P. J. Geary, "Sacred Commodities: The Circulation of Medieval Relics," in *The Social Life of Things: Commodities in Cultural Perspective*, ed. A. Appadurai (Cambridge, 1986), 169–92; P. J. Geary, *Furta Sacra: Thefts of Relics in the Central Middle Ages* (Princeton, NJ, 1990); J. M. H. Smith, "Oral and Written: Saints, Miracles, and Relics in Brittany, c. 850–1250," *Speculum* 65.2 (1990): 309–43; H. A. Klein, "Eastern Objects and Western Desires: Relics and Reliquaries between Byzantium and the West," *DOP* 58 (2004): 283–314; P. Cordez, "Gestion et médiation des collections de reliques au Moyen Âge: Le témoignage des authentiques et des inventaires," in *Reliques et sainteté dans l'espace médiéval*, ed. J.-L. Deuffic (Saint-Denis, 2006), 33–63; P. Bertrand, "Authentiques de reliques: Authentiques ou reliques?," *Le Moyen Âge* 112.2 (2006): 363–74; J. M. H. Smith, "Les étiquettes d'authentification des reliques," *Archéothéma* 36 (2014): 70–75; J. M. H. Smith, "The Remains of the Saints: The Evidence of Early Medieval Relic Collections," *EME* 28.3 (2020): 388–424; and E. Pallottini, "Monumentalisation et mise en scène des saints dans le lieu de culte: Les listes épigraphiques de reliques dans l'Occident médiéval (VIIIᵉ–XIIᵉ siècle)," in *Le pouvoir des listes au Moyen Âge*, ed. C. Angotti et al. (Paris, 2020), 1:31–60. On post-Tridentine practices of authentication, see M. Ghilardi, "*Quae signa erant illa, quibus putabant esse significativa martyrii?* Note sul riconoscimento ed autenticazione delle reliquie delle catacombe romane nella prima età moderna," in *Mélanges de l'École française de Rome: Italie et Méditerranée modernes et contemporaines* 122.1 (2010): 81–106; and K. Olds, "The Ambiguities of the Holy: Authenticating Relics in Seventeenth-Century Spain," *Renaissance Quarterly* 65.1 (2012): 135–84.

durably recapitulating the transfer of Isidore's body to Venice and the building of the chapel at the behest of three doges and a number of procurators, the epigraph ostensibly records historical facts, but—analogously to the inscriptions on the pala d'oro—it actually functions as a token of proof itself, providing official endorsement of the events represented in the mosaics. The physical presence of Isidore's body beneath the inscription (emphasized by the deceased saint's sculptural representation on the sarcophagus) and the figures of Christ and Mark above the epigraph lend credibility and authority to the epigraph, simultaneously verifying and sanctifying its contents.[38] In turn, the inscription offers the reassurance of a clear, written historical record, activating a process of mutual reinforcement and validation across media—between sculptural ensemble, visual imagery, and text. The translatio's authenticity is also corroborated narratively, in the mosaic, through the active role played by Doge Domenico Michiel. The doge carefully scrutinizes Cerbanus's deeds in Chios. He initially reprimands the cleric, authorizing the holy theft only once its lawfulness has been established (through an expedited trial). Only then does the doge supervise the transfer of Isidore's body to Venice and its deposition in the basilica. Unlike St. Mark's translation, which was performed by private citizens and only approved ex post by the political and ecclesiastical authorities of Venice, the acquisition of Isidore's relics is therefore presented as a public initiative, one that involved ducal scrutiny and formal asseveration from the start.

This exercise in visual verification and persuasion reaches its climax in the last scene of the mosaic cycle. This represents the return of the Venetian fleet to the lagoon, and the ceremonial collocatio of St. Isidore's body in San Marco under the direct supervision of the doge. Much like the translation of St. Mark above the portal of Sant'Alipio, this mosaic is both literally and symbolically a threshold image. The basilica of San Marco, which was accurately depicted above

the portal of Sant'Alipio, is represented here in a simplified manner: uniformly colored gray, with a small dome and miniature entrance, San Marco is almost unrecognizable. This is surprising, for accuracy of representation was a staple of historical and hagiographical verification in Venice. Although this can only remain speculative, it is possible that the mosaic was not intended to depict the basilica of San Marco as a whole, but the chapel of Sant'Isidoro in particular. Archaeological surveys have revealed that the chapel may have been directly accessible from the exterior—from the area that now corresponds to the Piazzetta dei Leoncini—via an intermediary space that is now occupied by the Cappella dei Mascoli, and which in the fourteenth century most likely consisted of a covered porch or closed atrium.[39] The gray surface of the building in the mosaic may have referred to the marble paneling of the north façade, which was in place by the mid-fourteenth century. If this is true, the interactions between saintly narrative and the viewer's direct experience would be especially intense.

As viewers looked on the image of the precious body being carried through the door of the chapel, they stood before the actual sepulchre of the saint: that is, in a privileged position, beyond the threshold depicted in the mosaic. This awareness transformed and complicated the beholder's role and also blurred the boundary between pictorial and real space and between historical past and the present. Initially mere observers and recipients of events that happened long before their time, the beholders—as they walked toward Isidore's tomb, moving in the same direction as the narrative of St. Isidore's transfer to Venice—were effectively involved in the story. More specifically, they were recast as participants and eyewitnesses, called upon to confirm the truthfulness of the visual and textual accounts provided in the mosaics (and therefore the reality of St. Isidore's presence in Venice) through their own lived experience in the chapel.[40] The observations above raise a

38 On the significance of *gisant* figures in confirming the presence and integrity of saintly bodies in fourteenth-century monumental tombs, including St. Isidore's, see also Tomasi, *Le arche dei santi*, 148–50 (see above, p. 81, n. 65).

39 Dellermann and Uetz, *La facciata nord di San Marco* (see above, p. 95, n. 1), 35–36 (on the western access to Sant'Isidoro), 107–8 (for the prehistory of the Cappella dei Mascoli).

40 A. Cutler, "Legal Iconicity: Documentary Images, the Problem of Genre, and the Work of the Beholder," in *Byzantine Art: Recent Studies; Essays in Honor of Lois Drewer,*

further question: did the Venetian community and government have any specific reasons to honor St. Isidore, and to do so at this particular juncture, in the early 1350s?

Holy Defenders, Military Conflict, and Crusading Ideology in the Mediterranean

The promotion of new saintly cults across the medieval Mediterranean was often the symptom, or the result, of contemporary concerns and of new religious, political, and institutional equilibria.[41] Arguably, this was also true of St. Isidore: his increased popularity in the lagoon is an eloquent example of how sanctity and sacred history were marshaled in Venice to underscore contemporary anxieties and to lend support to political authorities and the broader civic community at times of heightened tensions. In turn, the building of a new chapel in St. Isidore's honor testifies to the crucial role that public imaging and writing played in the production and dissemination of collective memories and shared visions of history. More specifically, the dedication of a new chapel to St. Isidore can usefully be examined in relation to Venice's acrimonious rivalry with the merchant city of Genoa, and in the context of the former's new self-image as a militant Christian power in the East.

ISIDORE OF CHIOS AND THE VENETO-GENOESE WARS

From a chronological perspective, the building and decoration of the chapel of Sant'Isidoro neatly coincide with the war that took place between Venice and Genoa in 1350–1355. As previously discussed, this war was the result of a long-term, fierce competition between the two maritime powers and became a matter of concern for all Mediterranean polities. Both Venice and Genoa expanded considerably in the later Middle Ages. Starting in the mid-thirteenth century, the two cities repeatedly came into commercial and diplomatic collision as they strove to gain commercial control over the eastern Mediterranean. The rise of St. Isidore's popularity in Venice in the later Middle Ages, and the dedication of a new shrine in his honor in the mid-fourteenth century, invites discussion in relation to the two cities' competing claims to commercial and political hegemony in the East.

St. Isidore's original resting place was the Aegean island of Chios. In 1125, the alleged date of St. Isidore's translation to Venice, Chios was formally under Byzantine rule. Venetian merchants, however, enjoyed freedom of trade on the island throughout the eleventh and thirteenth centuries, and briefly occupied Chios in the 1170s.[42] Venice's presence in Chios ended in 1261, when the Byzantine emperors, once they reconquered Constantinople with the military aid of the Genoese, gifted the island to Venice's rival. Chios subsequently remained in Genoese hands until 1566. In 1346, after a brief spell as a semi-independent principality ruled by the Genoese aristocratic family of the Zaccaria (1304–1329), and after an equally short-lived return of Byzantine rule in 1329, the island was put under the direct control of the Genoese government and administered through a chartered company.[43] In the 1350s, when Andrea Dandolo

ed. C. Hourihane (Turnhout, 2009), 63–80. See also B. A. Mulvaney and W. R. Cook, "The Beholder as Witness: The Crib at Greccio from the Upper Church of San Francesco, Assisi and Franciscan Influence on Late Medieval Art in Italy," in *The Art of the Franciscan Order in Italy*, ed. W. R. Cook (Leiden, 2005), 169–88.

41 This phenomenon has also been observed in Byzantium in the late thirteenth and fourteenth centuries. On this subject, see R. Macrides, "Saints and Sainthood in the Early Palaeologan Period," in Hackel, *The Byzantine Saint*, 67–87. See also A.-M. Talbot, "Old Wine in New Bottles: The Rewriting of Saints' Lives in the Palaeologan Period," in *The Twilight of Byzantium: Aspects of Cultural and Religious History in the Late Byzantine Empire*, ed. S. Curcic and D. Mouriki (Princeton, NJ, 2019), 15–26.

42 Thiriet, *La Romanie vénitienne*, 52, 60 (see above, p. 15, n. 9).

43 Lock, *Franks in the Aegean*, 158–59 (see above, p. 16, n. 17). For a brief introduction to Chios and its history, see T. E. Gregory, "Chios," in *ODB* 1:423–24. More generally, on the Genoese and Venetian presence in the Aegean: Balard, "Latins in the Aegean" (see above, p. 16, n. 17). The standard reference on Chios in the later Middle Ages is P. P. Argenti, *The Occupation of Chios by the Genoese and Their Administration of the Island, 1346–1566: Described in Contemporary Documents and Official Dispatches* (Cambridge, 1958). On the Zaccaria in Chios, see M. Carr, "Trade or Crusade? The Zaccaria of Chios and Crusades against the Turks," in *Contact and Conflict in Frankish Greece and the Aegean, 1204–1453: Crusade, Religion and Trade between Latins, Greeks and Turks*, ed. N. G. Chrissis and M. Carr (Farnham, 2014), 115–34.

erected a lavish new chapel in San Marco to honor the martyr Isidore, Venice and Genoa waged war against each other. At that time, Chios was an important Genoese stronghold in the eastern Mediterranean, whence the city conducted military and commercial raids against Venice and its colonies.[44] In this context, the significance of the textual and visual apparatus of the chapel of Sant'Isidoro in constructing and disseminating the image of the saint, and in sustaining his connections to Venice (against Genoa), can hardly be overestimated. Claiming ownership over the body of Isidore, Venice not only besought the favor and protection of yet another saint, but also implicitly challenged the legitimacy of Genoese authority over Chios, and by extension the eastern Mediterranean.[45]

The imagery of the chapel gave visual form to Venice's claims and manifested the city's rivalry against Genoa. As discussed above, the basic components of St. Isidore's hagiographic cycle mirror the translation of St. Mark's body from Alexandria to Venice as visualized on the façade and in the interiors of the basilica. Elizabeth Rodini has perceptively noted the prominence given in the mosaics of San Marco to the spatial, geographic dimension of Mark's voyage from Egypt to Venice. Such topographic emphasis conferred credibility on the sacred legend, but also materialized the reach of Venice's presence and claims in the eastern Mediterranean.[46] The mosaics of the chapel of Sant'Isidoro, too, focus on seafaring: the cycle begins and ends with a voyage by sea. They also emphasize topography and geography and celebrate Venetian proficiency in bridging distances. In contrast to the life of St. Mark, however, these mosaics also suggest military concerns. The city of Chios is represented as a fortified town, and Doge Domenico

Michiel is prominently and repeatedly rendered as a military leader. In the scene of its arrival in Chios, the Venetian army disembarks from meticulously rendered *dromons* (long, oared warships) (Fig. 55).[47] The doge carries a large and richly decorated sword, which dangles from his left side. With the other hand he holds up what looks like a ceremonial mace or baton. Made of wood and with a metal head, this most likely signals the doge's role as army chief.[48] The soldiers accompanying the doge are fully armed, and the artist put great care into the representation of their weaponry. The men are protected by (fourteenth-century) state-of-the-art coats of plates, and armed with precisely rendered glaives and short lances. And they carry the standards with the winged lion of St. Mark that symbolized Venetian presence and victory abroad.[49] At a time of crisis in the fourteenth century, when Venice's Mediterranean hegemony was in peril, visual storying in the chapel of Sant'Isidoro may have represented an opportunity to nurture patriotism and to inject courage and optimism in the Venetian political elite and citizens, by

44 Perry, *Sacred Plunder*, 172–74 (see above, p. 105, n. 19).

45 This has been variously acknowledged, for example in Goffen, "Paolo Veneziano" (see above, pp. 52–53, n. 3). See also Tomasi, "Prima, dopo, attorno"; Gerevini, "Art as Politics" (see above, p. 39, n. 121); and Dellermann, "La cappella di Sant'Isidoro" (see above p. 95, n. 1). See also Mathews, "Reanimating the Power of Holy Protectors," esp. 247–51 (see above, p. 83, n. 71).

46 E. Rodini, "Mapping Narrative at the Church of San Marco: A Study in Visual Storying," *Word & Image* 14.4 (1998): 387–96.

47 L. R. Martin, *The Art and Archaeology of Venetian Ships and Boats* (College Station, TX), 53.

48 The doge's gear in these mosaics is also described in detail, but not explained, in the only extant study on ducal insignia: Pertusi, "Quaedam regalia insignia" (see above, p. 21, n. 43), 47–48. The wooden implement held in the doge's right hand might tentatively be identified as a ceremonial mace, a common token of military leadership in medieval times, or a baton, which appears in later ducal iconography, similarly indicating his leadership of the army. On medieval maces and their meaning, see K. DeVries and R. D. Smith, *Medieval Military Technology*, 2nd ed. (Toronto, 2012), 30–32. For two examples of the ducal baton, see BMCC, 1497, fol. 27v, ca. 1375–1425; and London, British Museum, *Habito del Serenissimo in Armada* (portrait of Doge Francesco Erizzo), print, ca. 1652–1669, inv. O.2.223. Dellermann, "La cappella di Sant'Isidoro," 39–40 (see above, p. 95, n. 1), also notes that the doge is presented as a military leader in the chapel. Comparing the mosaic image with the manuscript miniature cited above, he further suggests that the mace, held upside down in the mosaic, may signal Domenico Michiel's role as a "pacific" leader. This aspect would deserve separate analysis, as the pacific nature of the expedition seems to be contradicted by the careful representation of warships and weaponry in the same scene.

49 For a description of late medieval glaives and other staff weapons, see DeVries and Smith, *Medieval Military Technology*, 29–30. On Venice's standard, see G. Aldrighetti and M. De Biasi, *Il gonfalone di San Marco: Analisi storico-araldica dello stemma, gonfalone, sigillo e bandiera della città di Venezia* (Venice, 1998).

FIGURE 55.
Domenico
Michiel and the
Venetian army
arrive in Chios.
San Marco,
Venice, chapel
of Sant'Isidoro.
Photo courtesy of
the Procuratoria
di San Marco.

visually reminding them of their city's successes overseas and its long tradition of engagement with the East.

A STONE FROM TYRE:
VISUAL STORYING, RELICS, AND CRUSADE

In addition to expressing Venice's military concerns and anti-Genoan stance, the mosaics in Sant'Isidoro openly memorialized the city's early territorial expansion, and conveniently alluded to its involvement in the Crusades. Doge Domenico Michiel had stationed in Chios in 1125 on his return journey from a highly successful crusading expedition. Before his reign, Venice—unlike

Genoa—had remained relatively uncommitted to crusading. But when the king and patriarch of Jerusalem solicited Venice's help in 1120, following a crushing defeat, the doge agreed to their request for aid. The details of the ensuing campaign, which involved intense negotiations with crusader leaders concerning both the targets of the military efforts and the rewards Venice would obtain for its support, fall beyond the scope of this study. It is pertinent, however, that the expedition led by Domenico Michiel culminated in the siege and conquest of Tyre, one of the most coveted and impregnable coastal cities of the Levant. In return for its help, Venice obtained

one third of the city and its surrounding territories, as well as extensive commercial privileges throughout the Kingdom of Jerusalem.[50]

Doge Michiel's campaign, and the significant rewards that ensued from it, remained imprinted in Venice's public memory throughout the Middle Ages. But the episode (and Venice's involvement in the Crusades more generally) was celebrated with increased ardor by Venetian chroniclers in the thirteenth and fourteenth centuries, when it became especially beneficial for Venice to emphasize its pedigree as a militant Christian polity.[51] In the trecento, both Paolino da Venezia and Andrea Dandolo mention the campaign in their historical works.[52] In addition, Marino Sanudo Torsello provides a detailed account of Michiel's campaign in *The Book of Secrets of the Faithful of the Cross*, a pro-Crusade literary treatise written between 1306 and 1321 to both encourage and assist Christian rulers in the reconquest of the Holy Land.[53] Unsurprisingly, these works praise Domenico Michiel's leadership qualities and celebrate the siege and conquest of Tyre as extraordinary triumphs. In keeping with the military character of his treatise and its propagandistic intent, Sanudo Torsello wrote at length about the wealth and desirability of Tyre, vaunting Venice's merits in conquering it. He commented on the twelve "enormously strong" towers that defended the city, remarking on the difficulty of capturing it. And he closed his report on the siege with a proud description of the hoisting of the Venetian victory standards on the walls of Tyre—an image of Venetian victory that resonates with the visual representation in the mosaics of the chapel of Sant'Isidoro of the standards of St. Mark jubilantly waving from the tower of Chios.[54]

The conquest of the city of Tyre in the twelfth century not only nurtured Venice's self-image as a crusading power in the later Middle Ages but continued to play an important role in the city's foreign policy. More specifically, Tyre's strategic importance made it an enduring site of contention between Genoa and Venice. The war fought by the two cities in 1350–1355 was only the most recent installment in a conflict that had begun a century earlier. Genoa and Venice had indirectly competed for the control of trade with the eastern Mediterranean since the twelfth century but had first openly waged war against each other in 1256. During that year, a dispute concerning some land in the region of Acre escalated into an armed conflict when Philip de Montfort, lord of Tyre and ally of Genoa, ordered the confiscation of all Venetian property in the city.[55] The war of St. Saba, as it came to be known, lasted until 1270, and left an enduring mark in the minds of contemporaries. The memory of those events was most likely revived in the wake of the violent conflict between Genoa and Venice in the trecento, inflecting contemporary understandings of Domenico Michiel's campaign in the Levant and blurring the conceptual boundary between (holy) crusading and anti-Genoan ventures.

Tyre and its siege in 1124 do not feature in the mosaics of Sant'Isidoro. But the conquest of the city was materially inscribed on the topography of the basilica in the form of a monumental stone relic, also retrieved by Domenico Michiel, which made the event physically accessible and alive to contemporaries. As Andrea Dandolo states in his chronicle, once Tyre had been captured by the crusaders, "The Franks and the Venetians, with devotion, looked for the stone on which Christ sat outside of the city [of Tyre], and once they found it, with devotion they carried it back

50 On Doge Michiel's expedition, see J. S. C. Riley-Smith, "The Venetian Crusade of 1122–1124," in *I comuni italiani nel regno crociato di Gerusalemme: Atti del colloquio "The Italian Communes in the Crusading Kingdom of Jerusalem"* (*Jerusalem, May 24–May 28, 1984*), ed. G. Airaldi and B. Z. Kedar (Genoa, 1986), 337–50, with further references.

51 Fasoli, "Nascita di un mito," 457–58 (see above, p. 21, n. 45).

52 Dandolo, *Chronica per extensum descripta*, 234–35 (see above, p. 21, n. 47). Paolino da Venezia mentions the events of 1124 in both his *Historia satyrica* and the *Chronologia magna*: BAV, Vat. Lat. 1960, fol. 233r; and BNM, Lat. Z 399 (=1610), fols. 76v, 77r.

53 Sanudo Torsello, *The Book of Secrets of the Faithful of the Cross: Liber secretorum fidelium crucis*, trans. P. Lock (Farnham, 2011), 253–55.

54 Sanudo Torsello, *Book of Secrets*, 255.

55 For a detailed discussion of Venetian presence in Tyre, and of the competitive presence of the Italian maritime republics in the city between the twelfth and the late thirteenth centuries, see M. Mack, "The Italian Quarters of Frankish Tyre: Mapping a Medieval City," *JMedHist* 33.2 (2007): 147–65, with further references on the war of St. Saba.

TRAJLAZIONE DELL'ALTARE

onto the ships."[56] Dandolo's reference to the stone relic is not isolated. Paolino da Venezia and Marino Sanudo Torsello also mention it, and confirm that the rock was brought back to Venice by Doge Michiel.[57] Dandolo and Paolino da Venezia also state that the doge had intended the stone relic and the body of St. Isidore to be located in the same space, near the church of San Marco, so that the two holy tokens, which had been acquired at the same time, could also be venerated together.[58] Whether the saint's body and the holy stone were actually preserved together before the fourteenth century, and exactly where, is unclear. We do know, however, that Andrea Dandolo recovered both, and gave them a

solemn display. Departing from Doge Michiel's original plan, Dandolo separated the two saintly treasures, moving the stone to the baptistery of San Marco, where it likely functioned as an altar table, and where it may still be seen today (Fig. 56).[59] In this way the doge distributed the two Eastern relics' charisma across the basilica, establishing a symbolic connection between the baptistery and the chapel of Sant'Isidoro. And he imparted to both shrines patriotic (and military)

56 Dandolo, *Chronica per extensum descripta*, 234–35.

57 Sanudo Torsello, *Book of Secrets*, 254–55. For Paolino da Venezia, see BAV, Vat. Lat. 1960, fol. 233r; BNM, Lat. Z 399 (=1610), fols. 76v, 77r; BnF, Lat. 4939, fol. 100v.

58 Dandolo, *Chronica per extensum descripta*, 234–35.

59 The relic of the "stone from Tyre" and its cultural history would certainly deserve a dedicated study. The relic is identified in later sources with a massive square stone slab that functions as a mensa in the baptistery. See, for example, Giovanni Stringa, "Descrittione della chiesa ducale di San Marco di Venetia," in *Vita di S. Marco Evangelista, protettore invittissimo della Sereniss. Republica di Venetia* (Venice, 1610), chap. 15 (lacks page numbers). Alternatively, antiquarian sources indicate that the relic ought to be identified with a slab of red Egyptian granite seen behind the baptistery altar in the late nineteenth century: F. Ongania, ed., *La basilica di San Marco in Venezia illustrata nella storia e nell'arte da scrittori veneziani*, vol. 6 (Venice, 1888), 879.

connotations and a distinctive anti-Genoan and militantly Christian flair.[60]

Seen against the backdrop of the Veneto-Genoese wars and the history and (resurgent) ideology of the Crusades, the chapel of Sant'Isidoro—which is dedicated to a warrior saint and also includes the standing portrait of St. George, patron saint of Genoa and crusader saint par excellence—reveals greater semantic richness than has generally been acknowledged. At a time of significant volatility and geopolitical readjustments across the Mediterranean, Domenico Michiel's exploits represented the ideal means to memorialize Venice's long-standing engagement with the East, its military prowess, and the priority of its presence in lands that were later (re)claimed by Genoa and other rivals. The chapel's mosaics also explicitly celebrated the militant piety of the Venetians, presenting Venice's wars as holy enterprises sanctioned by divine approval. Venice's retrospective self-advertisement as a crusading power was timely, for crusading ideologies and unionist causes gained traction across Europe in the wake of Ottoman and Mamluk advances. In addition, Venice's new interest in its role as a crusader state may not have been entirely unrelated to its competition with Genoa. As Merav Mack has argued, the ethos of the Crusades was central to Genoa's medieval identity, and its history was intertwined with that of the Kingdom of Jerusalem to such an extent that its written annals began with an account of Genoan involvement in the First Crusade.[61] By celebrating Venice's successful Crusade in the twelfth century, the chapel of Sant'Isidoro reenvisioned the Venetian state as a long-standing defender of Christianity, equal (or superior) to Genoa, and loyal to the Christian Church.

Imaging Authority: The Doge, the Patriciate, and Venice's "Dominion of the Sea"

The chapel of Sant'Isidoro masterfully merged pictorial hagiography, public history, and visual polemics in the service of Venice's foreign policy,

at a time when Venice labored to maintain its international standing, consolidate its overseas empire, and impose peace on its rebellious colonies. In pursuing these aims, the chapel gave unprecedented space and emphasis to the image of the doge. This section asks why, engaging with lively scholarly debates about the uses and meanings of ducal images in San Marco during Dandolo's reign, and examining the mosaics of the chapel of Sant'Isidoro in the context of the complex transformations that Venice's state and institutions underwent in the fourteenth century.

As a chief protagonist of St. Isidore's translatio to Venice, Domenico Michiel is represented four times in the narrative cycle of the chapel. His full name is also spelled out in the accompanying captions, as well as in the dedicatory inscription on the east wall. In the mosaics Domenico Michiel is rendered in full ceremonial garb, and his gestures and demeanor exude confidence and authority. This is particularly true for the first scene of the translatio cycle, where the doge is depicted as a military chief—a unique iconographic occurrence in San Marco. Clutching the pommel of his sword with one hand, he confidently disembarks from the Venetian warship, preceded and followed by fully armed soldiers. How does this emphatic display of ducal presence and authority tally with the increasing restrictions imposed on the office of the doge in the fourteenth century? And what does it reveal about the doge's status and functions?

In what follows, I will revisit consolidated interpretations of the fourteenth-century ducal imagery in San Marco as the result of Andrea Dandolo's individual aspirations to empower the office of the doge against current political reforms that pursued the opposite aim. We shall see that major artistic campaigns in the basilica resulted from processes of consultation and collective decision-making that involved the doge, his councilors, and the procurators. In this context, the textual and visual programs of the chapel of Sant'Isidoro would be unlikely to express political ideas that openly conflicted with those of Venice's governing elite. More likely, the chapel gave visual form to a political vision that was shared by, or at least acceptable to, all institutional agents involved. Based on this hypothesis, the images and texts in Sant'Isidoro are examined in

60 Anti-Genoan polemics was also implicit in the furtherance of the cult of St. John the Baptist, through patronage of the baptistery. On this, see Gerevini, "Art as Politics" (see above, p. 39, n. 121).

61 M. Mack, "Genoa and the Crusades," in Benes, *Companion to Medieval Genoa*, 471–95, with further references (see above, p. 82, n. 70).

relation to two ongoing political developments: the rise of patrician identity in the aftermath of the Serrata, and the redefinition of ducal authority that occurred at the same time. Memorializing *together* the names of individual doges and procurators, the chapel evoked ideas of nobility, shared responsibility, and collective honor that aligned with the emerging political ethos of Venice's patrician class. Simultaneously, by depicting Doge Domenico Michiel as both a supreme military leader abroad and the embodiment of restrained rule, justice, and piety within the city of Venice, the figurative cycle accorded with a multifaceted vision of the doge—as supreme representative of the state in foreign relations *and* as governor with restricted powers at home—that also began to crystallize at this time.

DUCAL IMAGE AND
DUCAL PATRONAGE AT SAN MARCO

Scholars have long noted the prominence of ducal representations in Andrea Dandolo's artistic commissions, and have largely interpreted those images as a manifestation of the doge's autocratic tendencies.[62] In a series of important studies that focused on the baptistery of San Marco, Debra Pincus interprets Dandolo's emphasis on the ducal image as an expression of his attempts to reformulate the doge as a sacral figure: a visionary of the divine plan who embodied God's special relationship with the city of Venice and brought divine revelation into the deliberations of state.[63] Meanwhile, concentrating more specifically on the chapel of Sant'Isidoro, Rudolf Dellermann understands the translatio cycle, and its presentation of Domenico Michiel as an authoritative military leader, as the means through which Andrea Dandolo expressed his view of the ducal persona as a quasimonarchic figure.[64] These

interpretations have gained wide scholarly currency and are valuable in several respects.[65] First, they aptly emphasize Dandolo's eminent role in redefining the status of the doge in a shifting political and institutional context. In addition, they illuminate the intertwining of sacred and secular that characterizes Venetian representations of political authority, and the ambivalent nature of the ducal image, swaying between the two realms.[66] Finally, they capture the potency of the ducal imagery of San Marco as a political statement that did not passively reflect predetermined notions of the ruler and the state, but rather contributed to construe (and transform) those ideas.

These considerations notwithstanding, the readings outlined above, and Giorgio Cracco's influential interpretation of Dandolo's reign as a silent "revolution" of the doge against the patriciate, leave one question unanswered.[67] They fail to explicate how Andrea Dandolo, himself a member of the patriciate, could work so relentlessly to strengthen the legal foundations of the state and to circumscribe the autonomy and power of the doge in his capacity as an administrator and lawmaker, while at the same time promoting a divinely sanctioned, and therefore quasiregal, ducal image in San Marco. This question has been addressed somewhat obliquely in discussions about the relationship of the doge to San Marco. It is an established scholarly contention that even as his political authority diminished, the doge's *ius patronatus* (patronage) over

62 Tomasi, *Le arche dei santi*, 139–40 (see above, p. 81, n. 65), represents a significant exception, expressing considerable perplexity toward this interpretation.

63 Pincus, "Hard Times and Ducal Radiance" (see above, p. 37, n. 113). For a discussion of the doge's privileged position as visionary of the divine plan in the baptistery of San Marco, to which we return in the next chapter, see also Pincus, "Venice and Its Doge" (see above, p. 36, n. 112). This interpretive line was also adopted in Fenlon, *Ceremonial City*, esp. 54–59 (see above, p. 1, n. 1).

64 Dellermann, "La cappella di Sant'Isidoro" (see above, p. 95, n. 1).

65 See Belting, "Dandolo's Dreams" (see above, p. 37, n. 114); Fenlon, *Ceremonial City*, esp. 51–55. Klein, "Refashioning Byzantium" (see above, p. 55, n. 5), provides a more nuanced reading of Dandolo's use of ducal imagery in San Marco, but also concurs that it was Dandolo's aim to establish (particularly through his historical writings and the management of relics) the doge as the primary instrument of divine will to ensure the prosperity of the Republic.

66 The interplay of sacred and secular in Venetian political iconography is also a governing concern of the decorative program devised for the ducal palace in the decades following 1340. Although the makeover of the ducal palace falls beyond the scope of the present study, we return to this question briefly in the next chapter.

67 Cracco, *Società e stato*, 399–440 (see above, p. 19, n. 30). For a different view of Dandolo's political agenda and activity, which has informed my own reading of the doge's artistic commissions, see Arnaldi, "Andrea Dandolo doge-cronista" (see above, p. 15, n. 13); Arnaldi, "La cancelleria ducale" (see above, p. 26, n. 62).

San Marco—which was originally founded as a palatine chapel—remained intact throughout the Middle Ages.[68] If the doge's patronage was absolute, then Andrea Dandolo may well have been free to advertise the doge as a powerful and divinely sanctioned ruler in San Marco, even as this sharply contrasted with the reality of the doge's diminishing political power.

Weakening the argument above, however, the doge's ius patronatus protected San Marco from potential interference from the ecclesiastical (rather than the secular) authorities of the city.[69] The doge's liberty in the basilica manifested itself primarily in his right to appoint the chaplains of San Marco without the bishop's approval.[70] In turn, the chaplains were responsible for the election of the primicerius (the religious chief) of the basilica, whose appointment was also independent of the bishop's consent, but subject to the doge's ratification.[71] Ensuring that the clergy of San Marco was appointed independently from the bishopric of Castello represented an effective means to protect the religious

autonomy of the basilica. Another essential condition for the preservation of this autonomy was to prevent the simultaneous appointment of chaplains to the cathedral chapter and the chapter of San Marco. The need to distinguish between the two was explicitly and forcefully reaffirmed by Andrea Dandolo. In his *Pro capellanis*, the doge reasserts the appointment of the clergy of San Marco as his nonderogable prerogative and forbade the chaplains of San Marco from calling themselves canons. The latter denomination potentially indicated attachment to the cathedral—and submission to the authority of the bishop—undermining the doge's jurisdiction over the clergy of San Marco and the latter's dependence on the political authorities of Venice.[72]

The doge's ius patronatus, then, was successfully and enduringly protected from ecclesiastical interference. By contrast, there is plentiful evidence that by Dandolo's time, the limitations imposed on ducal power by the Commune had encroached on his patronage of the basilica.[73] As Dandolo's promissio specifies:

In what concerns the church of San Marco, it is established that what has since antiquity and up to this day been included in this pledge concerning the freedom which the doge, and he alone, is accustomed to enjoy, be confirmed; unless a disagreement should occur between us and our councilors about a question that regards a matter pertaining to this church, and [in that case, if] six of our councilors should agree on that matter or case, then we must comply with what those six councilors say. And if only five [councilors] should be of a different opinion than ours, then those same councilors can, if they so wish, come to the Senate [lit. Council of the Rogati] and to the Council of the Forty, and there, once the affair has been illustrated and explained, then the difference [of

68 A. Galante, "Per la storia giuridica della basilica di S. Marco," *JbKw* 2 (1912): 283–98. See also Pompeo Molmenti, "Il giuspatronato del doge," in Ongania, *La basilica di San Marco*, 6:19–25; and G. Cozzi, "Il giuspatronato del doge su San Marco: Diritto originario o concessione pontificia?," in Niero, *San Marco: Aspetti storici*, 727–42 (see above, p. 49, n. 150). For a useful and concise overview of literature on San Marco as a palatine chapel (and as parish church), with further references, see Pincus, "Venice and Its Doge," 252–53. On the alleged development of San Marco from palatine to state church, see Demus, *Church of San Marco*, 44–54 (see above, p. 35, n. 108).

69 Demus, *Church of San Marco*, 44. The independence of the church of San Marco from the ecclesiastical hierarchies of the city is already explicitly affirmed in the deed with which the tenth-century doge Tribuno donated the island of San Giorgio Maggiore to the Benedictine Order. In that document, the basilica of San Marco is said to be "free from servitude to the Holy Mother Church" (*libera a servitude sancta matris ecclesiae*). L. Lanfranchi, ed., *S. Giorgio Maggiore*, vol. 2, *Documenti 982–1159* (Venice, 1968), 19–20. Also cited in Betto, *Il capitolo* 15, n. 21 (see above, p. 61, n. 17).

70 Galante, "Per la storia giuridica," 288.

71 After the patriarch and bishop, the primicerius was the most prominent ecclesiastical office in Venice. In recognition of this status, he was also authorized by the papacy in the mid-thirteenth century to wear miter, ring, and pastoral, the traditional marks of episcopal authority; see Galante, "Per la storia giuridica," 291–92. On the primicerius, see also F. Apollonio, "I primiceri di San Marco," in Ongania, *La basilica di San Marco*, 6:51–61, esp. 55, on the procedures for electing and confirming the primicerius and the papal concession granted to the bearers of that office in the thirteenth century to wear miter, ring, and pastoral.

72 Andrea Dandolo, *Pro capellanis*, in *Chronica per extensum descripta*, cii–civ. See also Betto, *Il capitolo*, 2, 35–36, 208–9. For other documentary mentions of the ducal prerogative to appoint the clergy of San Marco during Dandolo's reign, particularly in the *Chronica per extensum descripta*, see Cracco, *Società e stato*, 412.

73 Demus, *Church of San Marco*, 52.

opinion] will be resolved according to what seems fit to the above-mentioned Senate or to its majority.[74]

This passage intimates that the doge's liberty as a patron of San Marco was still significant, for at least five out of six councilors' votes were required to reverse his decisions.[75] Differently from the past, however, he was now subject to the approval of his councilors, and ultimately to the authority of the Senate. Further confirming the "imperfect" nature of the doge's autonomy as patron of the basilica, we know that the refurbishment of the pala d'oro was paid for with public money, and that the dedicated expenditure was approved by the Great Council through a public deed.[76] Finally, Andrea Dandolo's wishes concerning arrangements for the basilica were overruled on (at least) one significant occasion. In his testament, the doge entreated the procurators and governors to bury his body in the north transept of San Marco, dedicated to St. John the Evangelist.[77] Scholars have interpreted Dandolo's

demand—which would have placed him inside the church and nearer to the presbytery than any of his predecessors—as proof of his grandiose ambitions.[78] But the doge may also have had other reasons to choose that location. First, archaeological excavations in the space adjacent to the north transept have revealed that this area teems with burials, making Dandolo's choice less eccentric than may initially seem. Second, if buried in the north transept the doge would have been permanently associated with the chapel of Sant'Isidoro, which he had commissioned.[79]

Whatever the reason behind the doge's demand, he specified in writing that he would leave the decision regarding the location of his tomb to the procurators of the basilica of San Marco

74 Dandolo, *Promissione*, cii (see above, p. 21, n. 47): *In facto quidem ecclesie Sanctii Marci ordinatum est quod servetur id, quod antiquiitus et usque nunc insertum est in hac promissione, de libertate quam solitus est habere dominus dux solus; excepto quod si contingerit, super casu aliquo spectante ad factum diete ecclesie, differenciam fore inter nos et inter consiliarios nostros, et sex consiliarii nostri super illo facto seu casu erunt concordes, id observare debeamus quod dicti sex consiliarii dixerunt. Et si quinque tantum forent in diversa opinione nobiscum, tunc ipsi consiliarii possint, si voluerint venire ad consilium Rogatorum et xl, in quo exposito et declarato negotio, fiat super dicta differencia quod videbitur dicto Consilio Rogatorum vel maiori parti.* Betto, *Il capitolo*, 46–47, indicates that this clause was already included in the promissio of Doge Francesco Dandolo (r. 1329–1339) and provides archival references.

75 The doge was assisted in his tasks by the Minor Council. The latter was created in the twelfth century and by the fourteenth century comprised six members, one for each of Venice's *sestieri*. P. D'Angiolini and C. Pavone, *Guida generale degli Archivi di Stato italiani*, vol. 4, *S–Z* (Rome, 1994), 888, http://www.maas .ccr.it/h3/h3.exe/aguida/findex_pr.

76 ASV, Maggior Consiglio, *Deliberazioni*, Spiritus (1325–1349), fol. 129v, document dated to 20 May 1343. The document is published in Cecchetti, *Documenti*, 212, n. 830 (see above p. 51, n. 1).

77 V. Lazzarini, "Il testamento del doge Andrea Dandolo," *NAVen*, n.s. 7 (1904): 139–48. The passage reads: *Item eligimus sepulturam nostram in ecclesia Sancti Marci ubi melius placuerit Dominio et procuratoribus Sancti Marci, set libenter vellemus pro consolatione anime nostre esse in capella Sancti Joannis Evangeliste et quod ibi fiat sepulcrum in loco decenti et secundum honorem ducatus, in ornatum et non deformitate ecclesie, in quo si Dominatio et procuratores predicti vuluerint consentire ponatur*

etiam consors nostra (Then, we choose for our burial the church of San Marco, in the site that the Dominio and the procurators of San Marco will deem more appropriate; however, if left to our own will, we want to be, for the consolation of our soul, in the chapel of St. John the Evangelist, and that there be placed the tomb, in a spot that is appropriate to the honor of the ducate, and that will beautify and not offend the beauty of the church; and we also would want—if the Dominium and the procurators give their consent—that our spouse also be placed there).

78 Pincus, "Hard Times and Ducal Radiance," 113–14 (see above, p. 37, n. 113).

79 It should also be noted that some interpreters have (tentatively) identified a small tomb in the south wall of Sant'Isidoro with the burial of Andrea Dandolo's infant son. The burial is marked by a stone epitaph dedicated to an infant and placed below the cusped niche carved at the east end of the south wall. Bodily remains of one or more children were discovered in the wall during the late nineteenth century; see Antonio Pellanda's drawings: Venice, Archivio Storico della Procuratoria di San Marco, C19.14.01, published in Dellermann, "L'arredo e le sculture," 36 (see above, p. 95, n. 2). For a detailed archaeological survey of the south wall, see Dellermann and Uetz, *La facciata nord di San Marco*, esp. 99–102 (see above, p. 95, n. 1). On the identification of the deceased with Dandolo's son, see A. Da Mosto, *I dogi di Venezia nella vita pubblica e privata* (Milan, 1977), 118, who mentions Antonio Pasini's comment in this regard (no reference is provided). This hypothesis is repeated, without further comments, in the caption that accompanies the illustration of the south wall niche and epitaph in Dellermann, "L'arredo e le sculture," 62–63. For a thorough discussion, see D. Pincus, "Venetian Ducal Tomb Epitaphs: The Stones of History," in *The Tombs of the Doges of Venice: From the Beginning of the Serenissima to 1907*, ed. B. Paul (Rome, 2016), 243–66. On pages 248–49 of this essay, Pincus dismisses the hypothesis that the infant burial belonged to Dandolo's child. The scholar identifies the epitaph as a product of the late eleventh or early twelfth century and suggests that it was reset in its current position in the mid-fourteenth century. She also indicates that the niche in the south wall was presumably used in the fourteenth century to hold liturgical equipment.

and the Venetian government.[80] No matter how formulaic this statement may have been, its inclusion in the doge's will indicates Dandolo's awareness of the limits of ducal power in the basilica, which he presumably knew he was pushing with his request. That Dandolo's tomb was eventually positioned in the baptistery of San Marco, rather than in the north transept, gives further testimony to the influential yet clearly delimited role of the doge as *patronus* of San Marco in the fourteenth century. It also alerts us to the critical role played by other institutional agents—particularly the procurators, whose responsibilities will be examined in the next section—in shaping artistic patronage in the basilica. In turn, these observations suggest that the image of the doge in San Marco is unlikely to have been exclusively determined by one individual, no matter how influential. More likely, ducal representations expressed political ideas that were shared by, or at least acceptable to, the doge, the procurators, and Venice's governing elite.

THE PROCURATORS OF SAN MARCO

Dandolo's carefully worded testament (and its negative outcome) provides eloquent evidence of the weight of the office of the *procuratores sancti Marci* in all decision-making regarding the church. Who, exactly, were the procurators of San Marco, and what was their authority vis-à-vis the doge? Answering this question is pivotal to our understanding of the program of the chapel of Sant'Isidoro, and of the fourteenth-century artistic renovation of San Marco more comprehensively.[81] The procurators of San Marco were state employees, appointed by the Great Council. They were laymen selected from the Venetian elite and by the Venetian elite, and their office was a political appointment and a very high honor, which often constituted—as was the case with Dandolo—the preliminary step to becoming doge. The origins of the office are ancient. Although the

earliest documentary evidence of its existence dates to 1152, Venetian tradition has it that the first procurator was appointed under Pietro Tradonico (836–864) soon after the foundation of the church of San Marco, to whose administration the procurators remained forever linked.[82] The responsibilities of the procurators in the fourteenth century are precisely outlined in their *Capitolari*, compiled starting from 1308. The procurators pledged to "save, and keep for the utility of the Commune, all the belongings of the Commune that are and will be entrusted to us, and record those same goods in writing in our registers"; they also swore "to dispose of those items as prescribed by the doge and by the majority of the minor and major Council, and not to use or exploit them for our personal advantage or the advantage of others."[83] The text makes it clear that the procurators acted in the name and on the mandate of the Commune, as administrators of public property, and that they submitted their will to that of the doge and Council.

The everyday job of the procurators grew ceaselessly during the Middle Ages, reflecting the growing complexity of the Venetian political and economic infrastructure. The office gradually came to encompass the management of vast estate properties and their financial revenues, the administration of public and private funds and their investment, and the duty to act as testamentary executors and legal tutors for orphans. Such was the pressure on them that the number of procurators simultaneously in service had to be repeatedly augmented between the thirteenth and fourteenth century, and their responsibilities

80 Lazzarini, "Il testamento del doge Andrea Dandolo," 143.

81 On the need to move away from established assumptions about the doge as individual patron, and to investigate more thoroughly the role of the procurators in San Marco, see also Tomasi, *Le arche dei santi*, 139–40 (see above, p. 81, n. 65). Rosen, "Republic at Work," 59–61, also includes useful observations on the role of the procurators, and therefore of the Venetian elite, in defining and supervising artistic commissions in the basilica.

82 Mueller, "Procurators of San Marco," 108 (see above, p. 26, n. 63). See also P. Molmenti, "I procuratori di San Marco," in Ongania, *La basilica di San Marco*, 6:29–37; and "I procuratori di San Marco," in *Guida alle magistrature: Elementi per la conoscenza della Repubblica Veneta*, ed. C. Milan, A. Politi, and B. Vianello (Sommacampagna, 2003), 46.

83 ASV, Procuratores de Supra, *Commissarie*, B I, fasc. 1, no. 1, "Sacramentum": *Iuramus ad Evangelia Sancta Dei, Nos qui sumus Procuratores ecclesi(a)e S.ti Marci, quod omnia bona communis, qu(a)e sunt in manibus nostris, et ad manus nostras advenerint, salvabimus, et custodiemus ad utilitatem communis, et ipsa in scriptis ponemus in nostris quaternis, vel scribi faciemus si impediti fuerimus itaquod scribere non possimus, ac de ipsis faciemus sicut iniunctum fuerit nobis per D(omi)num Ducem, et maiorem partem consilii minoris, et maioris, sed non utemur, nec uti faciemus ipsis bonis ad nostram utilitatem, vel alicuius person(a)e aliquo modo vel ingenio.*

more precisely distributed. By 1266 four procurators were appointed at any time, and the office was divided between the procurators *de supra*, responsible for San Marco and for the legal tutorship of underage orphans, and the procurators *de ultra*, responsible for the administration of real estate. By 1318 the number of procurators had been elevated to six, and one further division, the procurators *de citra*, was introduced, and the property-management function was divided between the *de citra* and the *de ultra* units.[84]

The most prestigious office remained that of the procurators *de supra*. Their goal is summarized in the *Capitolari* as "to preserve the state and the honor of the church of San Marco," in good faith and without fraud.[85] Their specific duties were administrative and financial. They vowed to dedicate themselves diligently to "the administration of all possessions, and any other good, destined by the Commune—now and in the future—to the works and repairs needed by the church of San Marco." They promised to take direct charge of such works, and any others that pertained directly or indirectly to the church, and pledged to fulfill this objective also by increasing the revenues of the basilica and by renting the houses and shops in its possession.[86]

The procurators' responsibilities entailed their direct involvement with the daily running of the basilica: as the *Capitolari* specify, they were required to inspect all parts of the building at least once a week, and to examine any work that was being done or was necessary to undertake in the church.[87] Also, and with the exception of matters regulated by the doges' *promissio*, no repair or maintenance work in the basilica could actually begin unless the procurators (or their delegates) were physically present to give consent and to impart orders as to how such work should be carried out.[88]

The observations above indicate that in the fourteenth century the doge retained special privileges as patron of the church of San Marco, but that decisions concerning the basilica were collegial affairs, reached as the result of consultations among the doge, the procurators of San Marco, and the ducal councilors.[89] Also, they throw into relief the key part played by the procurators in the upkeep and embellishment of the basilica, and by extension in the religious and political life of Venice. In this context, scholarly arguments about Dandolo's pursuit of a quasiroyal ducal image in San Marco against contemporary patrician attempts to limit the doge's power seem less

84 Mueller, "Procurators of San Marco," 111–12.

85 ASV, Procuratores de Supra, *Commissarie*, B I, fasc. 1 (lacks foliation), no. 5: *Item statum, et honorem dict(a)e ecclesi(a)e S.ti Marci bona fide, sine fraude studebimus conservare....* The procurators of San Marco appear to have been directly involved in the refashioning of the ducal palace, which also took place in the central decades of the trecento. A. Lermer, *Der gotische "Dogenpalast" in Venedig: Baugeschichte und Skulpturenprogramm des Palatium communis Venetiarum* (Berlin, 2005), 260–64.

86 These activities are summarized in the following items from the *Capitolari* (ASV, Procuratores de Supra, *Commissarie*, B I, fasc. 1 [lacks foliation], nos. 2, 3): *Item erimus studiosi ad executiendum totum havere, et omnia bona quae pro communi Venetiare [Venetiarum] deputata sunt, et erunt, pro operibus, et laborerio Ecclesi(a)e S.(anc)ti Marci, et pro aliis quae deputata sunt et erunt pro dicto opere* (We will endeavor to administer all possessions and other goods which will be assigned on behalf of the Commune for the works and repairs of the church of San Marco, and that will be destined to the aforesaid work on behalf of others) and *Studiosi quoque erimus in faciendis operibus supradictis, et omnibus aliis qu(a)e dictum opus atque utilitatem ipsius pertinent, et pertinebunt, et etiam in amplificandis redditibus predicti operis, et in afficandis domibus, et stationibus ad dictum opus, et Ecclesiam pertinentibus, sicut melius fieri poterit.* This passage is confusing, for the term *opus* seems to be used both to indicate the works carried out by the procurators and the *opera* of San Marco. A possible translation is: "And we will

also endeavor to do the aforesaid works, and all other things that pertain and will pertain in the future to this *opera* and to its utility, and also to increase the revenues of this *opera*, and to rent the houses and lodgings that pertain to the *opera* and to the Church, as well as we can."

87 ASV, Procuratores de Supra, *Commissarie*, B I, fasc. 1 (lacks foliation), no. 33: *Item tenemur una die in hebdomada ad minus ire, et temptare ecclesiam S.ti Marci, tam de suptus, quam de supra, et videre opera, qu(a)e fiunt in dicta ecclesia, et qu(a)e essent necessaria fienda* (We are also required to go to the church of San Marco at least once a week, and to inspect it both upstairs and downstairs, and to see the works that are being done in the said church, and those that it may be necessary to undertake).

88 ASV, Procuratores de Supra, *Commissarie*, B I, fasc. 1 (lacks foliation), no. 37: *Item quod aliquod laborerium, in eccl(esi)a S(an)cti Marci, ... possit incipi, nisi nos procuratores, aut alter nostru(s) de voluntate alterius pr(a)esens fuerit ad videndum dictum laborerium antequ(am) incipiat(ur), et ordinandum quomodo fieri debeat salvis contentis in promissione Domini Duci.*

89 An example of the complexity of those consultations, the occasional frictions that could arise from them, and the relative responsibilities of the doge and his councilors, the procurators, and the Venetian Council in the early fourteenth century is reported in ASV, Procuratores de Supra, *Commissarie*, B I, fasc. 1 (lacks foliation), no. 56.

cogent, requiring additional scrutiny of the textual and visual means by which the doge's authority and role were envisioned in the basilica.[90]

INSCRIBING DUCAL AUTHORITY AND PATRICIAN IDENTITY

The dedicatory inscription on the east wall of the chapel of Sant'Isidoro is a good point of departure to reconsider the articulation of ducal authority in San Marco in the fourteenth century. The text bears the names of three Venetian doges: Domenico Michiel (r. 1116–1129), Andrea Dandolo (r. 1343–1354) and Giovanni Gradenigo (r. 1355–1356). Engraving the names of individual and institutional patrons was standard practice in late medieval Italy, but not in the church of San Marco. Here the personal names of doges had never been monumentally memorialized before, except on their tombs. Ducal effigies, including those on the upper wall of the chapel of San Clemente, above the portal of Sant'Alipio, and in the *Apparitio* and *Inventio* scenes on the west wall of the south transept, were exclusively identified by the impersonal *titulus* dux.[91] Recording the personal names of three doges, then, the inscription in the chapel of Sant'Isidoro marked a break from the tradition of ducal anonymity in San Marco that could hardly be unintentional, and that imbued the space of the chapel with ducal presence and an extra layer of political overtones. Andrea Dandolo, it should be recalled, had already experimented with inscribing ducal history in the basilica, albeit on a smaller scale, as part of the refurbishment of the pala d'oro in 1343–1345. On that occasion, the enamels in the lower register of the golden altarpiece were rearranged to make space for a lengthy dedicatory inscription, engraved on two rectangular plaques.

That inscription, discussed at length in the previous chapter, is much smaller and significantly less visible than the dedicatory epigraph in the chapel of Sant'Isidoro (see above, Figs. 9 and 10). Nevertheless, it shares some key features with it. It is placed in a symbolically prominent position, on the high altar of the church, and just below an enameled representation of Christ in Majesty. The text is clearly written in Gothic majuscule, and neatly arranged in black characters on two golden (or gilded) sheets. The regular rectangular shape and plain background of the metal supports evoke the pages of a book or a charter, signaling—just like the dedicatory text in the chapel of Sant'Isidoro, which is designed to imitate the appearance of a deed written on parchment— the official nature of the epigraph's contents. Finally, and crucially, the inscription on the pala d'oro, like its mosaic equivalent in Sant'Isidoro, brings together the distant past of Venice and its current history with a "ducal triplet." It celebrates the object's initial creation by Doge Ordelaffo Falier in 1105, as well as its subsequent modifications by Doge Pietro Ziani (in 1209), and under Dandolo himself in 1345. In addition, just like the chapel of Sant'Isidoro, the pala d'oro bears the visual effigy of the earliest of the three doges who are celebrated in the inscription, as Ordelaffo Falier is depicted, in enamel, next to the epigraph.

These dedicatory texts foreground ducal authority in a way that was unprecedented in San Marco. They set specific examples of ducal virtue and emphasize the significance of doges as emblems of the Venetian state, seemingly supporting scholarly arguments about Dandolo's attempts to promote a quasiregal ducal figure. Also for the first time in the basilica, however, the pala d'oro and the chapel of Sant'Isidoro supplement such ducal references with the full names of the procurators of San Marco. The commemoration of the secular officers chosen by the Great Council from among the Venetian nobility to administer the basilica and ensure its upkeep is highly meaningful, for it redefines the two artistic commissions as collaborative, institutional projects rather than mere ducal memorials. In so doing, these inscriptions expose the delicate balance of freedom and control that regulated ducal activity in San Marco, and implicitly affirm the collective nature of Venetian political authority, guarding it against (potentially unwarranted) ducal pretensions.

90 On this point, see also the brief reference in Tomasi, "Prima, dopo, attorno," 21 (see above, p. 104, n. 9).

91 A partial exception to the rule of ducal anonymity is the twelfth-century inscription that commemorates the decoration of the lower registers of the chapel of San Clemente in San Marco, with marble panels during the dogate of Vitale Michiel. Unlike the epigraphs in the chapel of Sant'Isidoro, however, this inscription was not widely accessible or visible. See H. Hubach, "Pontifices, clerus—populus, dux: Osservazioni sul significato e sullo sfondo storico della più antica raffigurazione della società veneziana," in Niero, *San Marco: Aspetti storici*, 370–97, at 373 (see above, p. 49, n. 150).

In this context, the recording of the doges' and procurators' full names (rather than their first names or the titles of their offices alone) deserves specific mention. As discussed in chapter 1, in the decades that followed the Serrata (1297) the Venetian nobility engaged in a gradual process of social and political self-demarcation and differentiation. The latter also entailed a progressively more accurate recording of the births and marriages of noble Venetians, whose families came to form the political census of the city. The definitive classification of patrician families was only completed during the Renaissance, culminating in the establishment of the so-called Golden Book (*Libro d'Oro*) in 1506. But the earliest attempts to officially identify and delimit the number of individuals and families with access to government date from the fourteenth century. By 1315 all applicants for admission to the Great Council were required to be registered with the *Quarantia*;[92] and in 1317, the *Avogadori del Comun* (state attorneys) were given authority to investigate doubtful claims to noble status.[93]

At the same time as those initial institutional steps were taken to identify and record individuals and families eligible for office, Venetian historians also became increasingly concerned with the identity, origins, and history of the most ancient (and therefore noble) families of Venice. The so-called *Cronaca Giustiniana*, compiled between 1348 and 1358, is an ideal case in point. Compiled by Piero Giustiniani, himself a member of the city's patrician elite, the chronicle included a comprehensive list of noble families,

the *Proles nobilium*.[94] The list—which has been defined as a "well-informed snapshot of the composition and history of Venetian nobility in the mid-fourteenth century"—aimed to catalogue both the ancient and more recent nobility, as well as their original provenance.[95] Testifying to the political implications of contemporary interest in noble birth, the catalogue of patrician families is followed by another list-based appendix, the *Regimina*.[96] The latter recorded the names of Venetian "rectors"—that is, colonial governors and top officers—organized by region and in chronological order. Unsurprisingly, the overwhelming majority of those officials belong to families that are listed in the *Proles nobilium*.

The artistic renewal of San Marco directed by Andrea Dandolo was undertaken only a few years before the completion of the *Proles nobilium* and expressed a similar interest in celebrating the antiquity and virtue of old Venetian patrician families as well as their merits and responsibilities in governing the city and its growing overseas territories. Domenico Michiel, Andrea Dandolo, and Giovanni Gradenigo, all mentioned in the dedicatory inscription on the east wall of the chapel of Sant'Isidoro, were representatives of the highest echelons of Venice's nobility, and their families were all included

92 ASV, Maggior Consiglio, *Deliberazioni*, Clericus-Civicus (1315–1318), fol. 10r (fol. 58r in pencil). Published in Kohl and Mueller, "Serrata of the Greater Council," 24–25, no. 22 (see above, p. 19, n. 30). The document is also cited in Rösch, "The Serrata," 86, n. 37 (see above, p. 19, n. 30). The same author suggests that this roster (which has not survived) may have represented an early predecessor of Venice's later registry of noble births, which was formalized in the sixteenth century in the *Libro d'Oro*. A similar argument is advanced by Lane, "Enlargement," 258 (see above, p. 19, n. 30). However, this list registered applicants to the council, rather than those admitted to it; see Chojnacki, "Social Identity," 345.

93 ASV, Maggior Consiglio, *Deliberazioni*, Clericus-Civicus (1315–1318), fol. 121v, cited in Rösch, "The Serrata," 75, n. 39. For a similar document dating from 1319, see Kohl and Mueller, "Serrata of the Greater Council," 27–28, no. 25.

94 The *Proles nobilium* was first published in R. Cessi and Bennato, eds., *Venetiarum historia vulgo Petro Iustiniano Iustiniani filio adiudicata* (Venice, 1964), 255–76. This edition is based on BNM, Lat. X 36a (=3326). This manuscript dates from the second half of the fourteenth century, and the *Proles nobilium* comprises fols. 152r–67r. The (earlier) autograph manuscript, which Piero Giustiniani annotated with family events between 1348 and the date of its interruption in 1358, is preserved in BnF, Lat. 5877. In this manuscript, the *Proles nobilium* occupies fols. 56r–64r. For a careful examination of the manuscript tradition of this chronicle, and a new edition based on the BnF manuscript, see L. Fiori, "Il codice autografo di Piero Giustinian: Un esempio di genesi ed evoluzione della cronachistica medievale" (PhD diss., Alma Mater Studiorum, Università di Bologna, 2014). See p. xliii on the dating of the BnF manuscript to 1348–1358. The list of families included in the *Proles nobilium* is believed by several interpreters to be based on contemporary public registers of candidates for the Great Council. See Kohl and Mueller, "Serrata of the Greater Council," 5, with further references.

95 I borrow the definition of the *Proles nobilium* as a "snapshot" from Chojnacki, "La formazione della nobiltà" (see above, p. 19, n. 30).

96 The *Regimina* is published in Cessi and Bennato, *Venetiarum historia vulgo Petro Iustiniano Iustiniani*, 277–322.

among the oldest clans in the *Proles nobil-ium*. The same is true for the families of doges Ordelaffo Falier (r. 1102–1117) and Pietro Ziani (r. 1205–1229), mentioned on the pala d'oro. The procurators of San Marco commemorated in the same inscriptions were evidently noble as well. The families of Angelo Falier, Francesco Querini, and Giovanni Dolfin prided themselves on being members of the oldest patrician clans. Marco Loredan and Nicolò Lion were members of powerful if newer noble families. These latter two had risen to political promi-nence in the mid- and late thirteenth centuries, respectively—a testament to the complexity and stratification of the Venetian nobility in the mid-trecento.[97] Notably, the noble status of these officials was explicitly referred to in the dedica-tory inscriptions in Sant'Isidoro and on the pala d'oro, which unambiguously designates the proc-urators as *nobiles viri*: noble gentlemen.

In sum, the dedicatory inscriptions in Sant'Isidoro and on the pala d'oro represented the earliest joint celebrations of ducal and patri-cian identities in San Marco, at a time when both were reformulated in the aftermath of the Serrata, and as the eligibility for political office (and the responsibilities that derived from it) was also renegotiated. The two sets of epigraphs merge their tribute to ducal authority with contempo-rary concerns with nobility and family status. Each doge was singled out for his own merits, but collectively the two series of doges conveyed the honor and stability of the ducal office as a whole. In addition, the texts connected the indi-vidual achievements of each ruler to the history and merits of his household, whose prestige and antiquity the epigraphs also celebrated. Finally, the inscriptions memorialized several illustri-ous Venetian families, emphasizing their col-lective contribution to Venice's advancement as well as the institutional stability and continuity of rule ensured by their succession on the ducal

seat and in the procurators' office. The epigraph in Sant'Isidoro occupies a prominent position on the east wall. Highly visible and easily legible, the epigraph presumably held significant authority and would have informed the ways in which con-temporaries apprehended the visual imagery of the chapel. Bearing in mind the complex balance (and potential tensions) between ducal promi-nence and shared government that the epigraph reveals, we can finally turn to the visual represen-tation of Doge Domenico Michiel in the mosaics. Our argument in the next section will be that the doge was represented in the mosaics in a dual role: as a plenary ruler and chief of the army, when abroad, and as a civil servant and the guarantor of lawfulness and civic piety when in Venice.

ENVISIONING DUCAL AUTHORITY IN AND OUTSIDE OF VENICE

In the mosaics of Sant'Isidoro, Domenico Michiel is represented in a range of different capacities. In the first scene of the translatio cycle, the doge is rendered as commander in chief of the army and the fleet, which sails under the *vexillum Sancti Marci* and the doge's family standard. The former features the familiar image of a lion on a white or red ground.[98] In turn, the Michiel family banner—which is smaller than the Venetian ban-ner and is hoisted beneath it—consists of alter-nating white and blue stripes, with golden dots (see above, Fig. 55). The same coat of arms is also represented in a fourteenth-century manuscript of the *Proles nobilium* (Fig. 57), which illustrates the Michiel banner before and after the capture of Tyre, claiming that the golden dots were added to the crest following that military victory.[99] We shall return to these banners below.

97 The Loredan family had allegedly been admitted to the Great Council by Doge Ranieri Zen (r. 1253–1268). The Lion family had moved to Venice from Acre in the late thirteenth century after the fall of the city and was granted noble status as late as 1303, soon coming to occupy important positions in government. The history of these two families, and of all other clans discussed in this paragraph, is brilliantly summa-rized in Chojnacki, "La formazione della nobiltà," with further references.

98 In ducal processions, the white-grounded vexillum sig-naled peace, while the red ground expressed a state of war; see E. Muir, *Civic Ritual in Renaissance Venice* (Princeton, NJ, 1981), 117. While Muir's interpretation of the banner colors is based on Renaissance sources, it provides a plausible explanation for the presence of both white- and red-ground banners in the mosaics of Sant'Isidoro.

99 BNM, Lat. X 36a (=3326), fol. 152v. For a full catalogue of Venetian coats of arms, see V. Coronelli, *Arme, blasoni o inse-gne gentilitie delle famiglie patritie esistenti nella Serenissima Republica di Venetia* (Venice, 1701), 62, 75, for the Michiel bla-zons. Interestingly, in the mosaics of Sant'Isidoro, Venetian war-ships do not sail under the *vexillum Sancti Petri*, the papal banner that Pope Callixtus II allegedly bestowed on the Venetian doge

FIGURE 57. *Proles nobilium*, with illustration of the Michiel family's coat of arms before and after the conquest of Tyre. Venice, Biblioteca Nazionale Marciana, Lat. X 36a (=3326), fol. 152v. Photo courtesy of the Biblioteca Nazionale Marciana.

The representation of a doge at war was unprecedented in San Marco and may partly be explained as an expression of the renewed importance of military activities in 1350–1355, during Venice's confrontation with Genoa. But presiding over the army was an essential ducal prerogative. The office of the doge most likely originated in early medieval times as that of a military commander who also held civilian power.[100] The early phases of Venetian expansion between the eleventh and thirteenth centuries were led by doges who, like Michiel, went to war with their troops.[101] In the later Middle Ages, professional captains of the fleet and the army took over the coordination of military operations, and ducal appearances at the head of the army became infrequent.[102] Nonetheless, the ceremony of ducal investiture continued to refer to the doge's role as military commander. When the doge ceremonially entered the basilica of San Marco after being elected by the Great Council, he processed to the altar. There he was invested with the vexillum, the same standard with the lion of St. Mark that accompanied the army into battle, and signaled Venetian presence and control in territories overseas.[103] With the consignment of the

in 1122. See Muir, *Civic Ritual*, 117; and C. Erdmann, *The Origin of the Idea of Crusade* (Princeton, NJ, 1977), 187.

100 For a recent reconsideration of the origins of the dogeship and its developments in the early Middle Ages, with comprehensive bibliography, see S. Gasparri, "The First Dukes and the Origins of Venice," in *Venice and Its Neighbors from the 8th to 11th Century: Through Renovation and Continuity*, ed. S. Gelichi and S. Gasparri (Leiden, 2018), 5–26.

101 In addition to Domenico Michiel's involvement with the Crusades, notorious military campaigns led personally by the doge include Pietro Orseolo II's expedition to Dalmatia in the

year 1000, and of course Enrico Dandolo's leadership during the Fourth Crusade in 1204. See Nicol, *Byzantium and Venice*, 43, 124–53, respectively (see above, p. 13, n. 5).

102 On the Venetian army and its organization, see A. A. Settia, "L'apparato militare," in *Storia di Venezia: Dalle origini alla caduta della Serenissima*, vol. 2, *L'età del commune*, ed. G. Cracco and G. Ortalli (Rome, 1995), 461–505; and M. E. Mallett and J. R. Hale, *The Military Organisation of a Renaissance State: Venice c. 1400 to 1617* (Cambridge, 1984), 7–19.

103 Beginning in the late thirteenth century, Venetian doges pledged to give or send a standard of St. Mark to all polities that

banner—to use Muir's formulation—the new doge accepted custody, for the duration of his life, of an undying authority that was the source of legitimacy for the entire government.[104] At an unknown time between the late thirteenth and the sixteenth centuries, this ritual was modified to include the admiral of the Venetian fleet. The meaning of the ceremonial, however, did not change. Upon his investiture, the doge ceremonially consigned the vexillum to the admiral, signaling both his own authority over the military, which he held on behalf of the Commune, and the delegation of the same authority to the commander in chief.[105]

The representation of Domenico Michiel as an efficient and determined military commander who leads forth the fleet and the land army into Chios follows this tradition. Not only does it not contradict the limits of ducal authority, but it illustrates one of the key responsibilities of the ducal office. In this context, the inclusion of the doge's family coat of arms performs a function similar to the addition of the family names of doges and procurators in the dedicatory inscription on the east wall. The ducal banner accompanies the *vexillum Sancti Marci* but is dutifully positioned below it on the masts of Venetian vessels, honoring the personal authority of the doge on the battlefield but also reiterating his submission to the authority of the Venetian state. Furthermore, the Michiel family standard situates the doge within the history of its kin, and by extension of the Venetian patriciate, testifying to the antiquity and audacity of the families that most contributed to Venice's ascent to international power.

Although the depiction of an identifiable ducal banner in the chapel of Sant'Isidoro is unique in the mosaics of San Marco, ducal coats of arms were a visible and permanent fixture of the basilica in medieval times. Starting from 1252, ducal escutcheons were affixed to the galleries of San Marco on the occasion of the doge's death and remained in the basilica as perpetual memorials.[106] Over the centuries these heraldic decorations became cumbersome affairs, forcing the Great Council to limit the size of individual blazons. In 1688, it was established that ducal *scudi* were not to exceed five feet in height by three feet in width. The measure was taken out of concern that the weight of the escutcheons might damage the walls of the church, or that they might fall off and injure visitors to the basilica, but it is also an indication that these were large, highly visible artworks.[107] While the size of ducal shields in the fourteenth century is unknown, we do know that several family crests would already be visible at this time within the space of the basilica, honoring ducal authority and presenting it as the expression of a collegial governing enterprise shared by the elite families of Venice.

So far, we have purposefully ignored one significant detail. The depiction of Domenico Michiel as a military chief is noticeably set overseas, *outside* the city of Venice. This is unlikely to have been accidental. Venice's political vision increasingly differentiated between the role of the doge *within* the city of Venice and toward the citizens and his role vis-à-vis the territories subject to Venetian control. Edward Muir compellingly summarizes this point in the concept of the "paradoxical prince," which played out most dramatically in the annual ducal ceremony of the Marriage of the Sea, celebrated yearly on Ascension Day (known in Venice as *Fiera della Sensa*). A brief examination of this important feast—which conveyed Venice's ambitions as an international power—will assist us in explaining the figurative cycle of Sant'Isidoro and the prominent image of Doge Domenico Michiel as "conqueror of the sea." It will also enable us to situate this image within the framework of fourteenth-century ideas about rulership, territorial conquest, and subject communities.

took an oath of allegiance to Venice. See Dandolo, *Promissione*, xcix, no. 86 (see above, p. 21, n. 47). For the same clause in earlier ducal pledges, see Giovanni Dandolo's (1280) and Pietro Gradenigo's (1289) promissiones: Graziato, *Le promissioni*, 130, 158, respectively (see above, p. 21, n. 48).

104 Muir, *Civic Ritual*, 285.

105 Pertusi, "Quaedam regalia insignia," 74–79 (see above, p. 21, n. 43), with reference to primary sources. See also Muir, *Civic Ritual*, 260, for the doge acting on behalf of the state.

106 See Demus, *Church of San Marco*, 52 (see above, p. 35, n. 108). On the origins of this tradition, see Cecchetti, *Documenti*, 12, n. 95 (see above, p. 51, n. 1). The ducal coats of arms, accumulated over centuries, were finally removed in 1722 due to their weight, which threatened the integrity of the basilica's walls: Cecchetti, *Documenti*, 137–38, n. 637, 222, n. 962.

107 Cecchetti, *Documenti*, 113–14, n. 550.

The *Fiera della Sensa* was one of the most solemn feast days in the Venetian medieval calendar.[108] It probably originated in the eleventh century, following Pietro II Orseolo's successful military ventures in Dalmatia. It initially consisted of a ritual blessing of the Adriatic Sea, performed by the bishop in the presence of the doge and the Venetian community. The blessing fulfilled a twofold function: it was a propitiatory rite that invoked divine protection for Venetians at sea, and it was also a ritual manifestation of Venice's incipient imperialist ambitions over the Adriatic. The latter connotation was amplified in subsequent centuries. By the time Martino da Canale wrote his chronicle in the third quarter of the thirteenth century, a ceremonial *desponsatio*—marriage—between the doge and the sea had already been appended to the religious blessing and also officiated by the bishop. Writing shortly afterward, Salimbene of Parma (1221–1288) also commented on the rituals, which were intended "to demonstrate that the Venetians have the dominion of the sea."[109]

What matters for the present study is that the *Fiera della Sensa* was an exclusively outward-facing ritual. Its essential political point was that in marrying the sea, the doge established his legitimate rights of domination over the trade routes and coasts of the Adriatic.[110] By metaphorically casting the Venetian doge as a husband who lawfully took the sea (and its coasts) as his bride, the ritual drew on family law and its political ramifications to justify and explicate the unequal relationship between Venice and the territories subject to its rule. Venice would protect and exercise authority over such territories, and benefit from their income, in the same way that the husband administered his wife's dowry.[111]

If the *Fiera della Sensa* presented the doge as the master of overseas territories, the rituals were nonetheless far from a constitutional definition of the doge's powers over or within the res publica, and they had no bearing on the doge's role and status within the city of Venice.[112] The topography of the *Fiera della Sensa* made this very clear. The ceremony was celebrated near the Lido: far from Rialto and San Marco, it took place at the physical threshold between the Venetian lagoon and the open sea. That threshold was both symbolically and administratively important. As the reader will recall, Bocca di Porto was the narrative focus of the legend of the storm: there, at the boundary between the lagoon and the Adriatic, Venice's holy defenders intervened to save the city from the diabolic storm. This invisible water boundary also marked the outer limits of the doge's free mobility in the trecento. As we learn from his promissio, Andrea Dandolo pledged that "we cannot and must not leave the dukedom of Venice, unless by the will of our Minor and Major Council, or by will of the majority of each of the two councils. Also, we cannot cross the port of Malamocco, nor the bishopric of Torcello, unless by will of our Minor Council or of its majority."[113] Together, this provision and the ceremonies of the *Fiera della Sensa* testify to the contradictory role of the doge: a powerful representative of the Venetian state abroad, and a ruler with limited powers at home. This oscillation is adumbrated in the mosaics of Sant'Isidoro. In the scene of the arrival in Chios, the doge is represented as a powerful commander. In his study of the chapel, Dellermann identifies this representation—at odds with the increasing limitations imposed on the ducal office in the trecento—as a visual expression of Dandolo's autocratic ambitions.[114] But the scene is set at sea—that is, it ostensibly takes place outside of Venice, in an environment where the doge

108 The account that follows is largely based on Muir, *Civic Ritual*, 119–34. For a detailed description of the rituals, and of their alleged association with the Peace of 1177, see also G. Renier Michiel, *Origine delle feste veneziane* (Milan, 1829), 1:116–41.

109 Salimbene of Parma, *Cronica fratris Salimbene de Adam ordinis Minorum*, ed. O. H. Egger and B. Schmeidler, MGH SS 32 (Hannover, 1905), 565. Also mentioned in Fasoli, "Nascita di un mito," 459 (see above, p. 21, n. 45).

110 Muir, *Civic Ritual*, 124.

111 Muir, *Civic Ritual*, 126.

112 Muir, *Civic Ritual*, 127.

113 Dandolo, *Promissione*, xcix–c, no. 92: *Preterea non possumus nec debemus exire ducatum Venecie, nisi de voluntate nostri minoris et maioris consilii vel maioris partis utriusque consilii. Item non possumus transire portum Methamauci, nec episcopatum Torcelli, nisi de voluntate nostri minoris consilii vel maioris partis.* Malamocco is located on the south end of the island of the Lido.

114 Dellermann, "La cappella di Sant'Isidoro," 39–40 (see above, p. 95, n. 1).

legitimately personifies, and acts on behalf of, Venice and its government in their relations with foreign interlocutors. In this context, the doge's military gear, as well as his efficacy and determination, is more likely to have expressed the aspirations of Venice's governing elite to expand and consolidate the city's dominion overseas than Dandolo's anachronistic desire to amplify the ducal office.

The representation of the doge in the narrative's last episode (the collocatio) stands in stark contrast to his depiction as a military leader in the first scene. In the collocatio, which is set in Venice, Domenico Michiel is represented in a thoroughly traditional fashion, as he piously and authoritatively oversees the ceremonial entry of the martyr's body in the basilica. Stressing the doge's visual prominence in the scene, Dellermann offers an interpretation of this episode as yet another iteration of Dandolo's autocratic agenda.[115] The dual status of the doge—who acted as a military leader invested with broad political powers when abroad, and as a governor working within strict limits when in Venice—provides an alternative explanation for the scene, and one perhaps more consistent with Venice's political milieu in the mid-fourteenth century, and with the collective and institutional nature of artistic patronage in San Marco at this time. Unlike the preceding episodes, in this domestic scene the doge does not bear a sword and is accompanied by a secular attendant in ceremonial gear. The latter stands behind the doge and close to him, seemingly supervising the religious ceremony. The dismissal of the sword has a narrative reason, of course: having completed his military enterprise, Michiel no longer needs to wear a weapon. Nonetheless, the partial change in uniform—and crucially the appearance of the public official behind the doge—also signals a return to normality, and to a regime of strict limits on the doge's function and prerogatives within Venice.

In addition to emphasizing the doge's virtue as military leader, and his civic piety, the mosaics of the chapel capture him in the exercise of another important ducal prerogative: justice. In the third scene from the left, Domenico Michiel

is depicted as he scrutinizes the lawfulness of Cerbanus's theft. In this capacity, he initially condemns a deed that he deems illicit. As we also know from the textual accounts of Isidore's translation, the doge reprimands the cleric for acting without his (and therefore the signoria's) permission, and orders that the body be taken off the Venetian ships and back onto the island. In the next scene, having verified the legitimacy of the theft, the doge himself orders St. Isidore's body to be taken on board a Venetian vessel. Together, these two scenes capture three important elements of fourteenth-century understandings of community, hierarchy, and authority in Venice. First, the interaction between the doge and the cleric reiterates the superiority of Venice's secular authorities over its religious members, an idea that—as seen above—Andrea Dandolo also aired in his *Pro capellanis*. Second, the mosaics emphasize that the translatio is not the result of an individual initiative, but rather the outcome of a collective *impresa*, requiring the orderly collaboration of all members of the Venetian delegation: the doge, his retinue, the army, and the cleric Cerbanus.[116] Third, orderly operations require the respecting of authority and hierarchy, themselves circumscribed by the law. In the scene of the reprimand the doge, acting abroad on behalf of the state, ensures that individual initiative—no matter how motivated by religious fervor—be legitimate. It is only after a formal trial that the doge allows the transfer of the martyr's body to Venice, and the caption above the scene is clear: the body is boarded "on order" of the doge, and therefore on behalf of the government, turning Cerbanus's private theft into a public, state-approved affair.

Of course, staging a trial in order to justify what could be perceived by contemporaries as an unholy theft was a topos of medieval hagiography. Nonetheless, the iconography of the chapel omitted other episodes that were known through texts, and that could have been marshaled to demonstrate Isidore's favor toward Venice and his approval of the translation of his body to Italy. Before lifting the saintly body from his tomb, Cerbanus allegedly delivered an impassioned

115 Dellermann, "La cappella di Sant'Isidoro," 41.

116 This is also noted by Tomasi, "Prima, dopo, attorno," 21 (see above, p. 104, n. 9).

address, asking the saint to let the cleric find his body if he so wished, but forbidding the inventio if he preferred to stay in Chios. Needless to say, Cerbanus did find the body, and proceeded to lift it from its tomb. Following the initial theft, the text also describes the curious and somewhat self-defeating reasoning of the local Greek monks, who determined that the Venetians should take the body of the saint because they were the first and only foreigners to have found it. Finally, St. Isidore performed a series of miracles en route to Venice, saving the Venetian fleet from shipwreck and from the plague.[117] Forgoing these miracles, and all other signs of Isidore's predilection for Venice, the mosaics focus exclusively on the doge's formal scrutiny of the inventio, which is also accompanied by the lengthiest caption in the chapel—a sign of its importance for both patrons and viewers.

The trial of St. Isidore's "thieves" is remarkably similar in its basic narrative structure to the official hearing of the fisherman in the legend of the storm. There, the fisherman's account of the holy patrons' miraculous intervention to save Venice was also verified by the doge, who acted as the spokesman and representative of Venice's institutions. The doge, with the procurators and the Signoria, was also responsible for recognizing the fisherman's contribution to Venice's well-being and granting him a suitable reward. In other words, in both the legend and the mosaics of Sant'Isidoro, the narrative revolves around a trial, conducted by public authorities on the basis of arguments and material evidence. Within this framework, the doge acts as guarantor of the law, and as the appointed intermediary between the individual and the state and between the different components of Venice's community. In this role he oversees all proceedings, ensuring the equity and legitimacy of public decisions. This emphasis on legality, order, and due process resonates powerfully with the legal and institutional reforms spearheaded by Andrea Dandolo during his reign, inviting us to consider, in conclusion, the interactions between the doge's artistic patronage and his administrative work.

Conclusion: History Writing, Image Making, and Political Krisis

The Venetian government, led by Andrea Dandolo, responded to the challenges of the mid-century through a comprehensive program of political legitimation that relied on the simultaneous construction of religious memory, historical narrative, and juridical evidence—and on their convergence, which in turn rested upon a constellation of interrelated sources orchestrated by the government of Venice. Andrea Dandolo's chronicle, a wide-ranging historical work that celebrated Venice's achievements and indirectly guaranteed the legitimacy of its political regime and its claims overseas, was produced in the ducal chancery. When it reached completion in 1352, the text was officially presented to the Great Council with a preface by the Great Chancellor, Benintendi Ravegnani, confirming the work's public character. The decoration of the chapel of Sant'Isidoro overlapped with the composition of the *Chronica per extensum descripta*, which obviously included an account of Doge Michiel's reign and of the translatio of Isidore's body to Venice.

The writing of the *Chronica per extensum descripta* and the building of the new chapel were preceded by the substantial activities of legal systematization discussed in chapter 1. Just after his election as doge in 1343, Andrea Dandolo established a committee for the revision of the city statutes that had first been codified by Jacopo Tiepolo in 1242. As soon as this task was accomplished in 1346, the doge charged the chancery with collecting Venice's foreign treaties in two comprehensive registers: the *Liber Albus*, comprising Venetian pacts with Eastern polities; and the *Liber Blancus*, containing treatises with the Italian mainland. The compiling of these books responded to a specific need. By Dandolo's time Venice controlled a vast and diverse territorial state, the government of which required developing stable infrastructures and networks of communication between the city and its colonies. In addition, the geopolitical balance in the Adriatic and eastern Mediterranean was rapidly shifting, and Venice's presence overseas was increasingly challenged—primarily but not exclusively by Genoa. As more amply discussed in previous chapters, the combined pressure that derived from the expansion and consolidation

117 These are all recorded in Cerbani, "Translatio mirifici martyris" (see above, p. 98, n. 3).

of Venice's *dominio*, the growing external threats to Venetian overseas rule, and resistance and rebellions in the colonies led—among other provisions—to the creation of the *Liber Albus* and the *Liber Blancus*, which aimed to clarify the city's status and rights overseas, and to give firmer legal ground to its possessions against the pretensions of rivals and enemies.

The different means of public and political expression deployed by the Venetian doge and government (historical writing, legal codification, and monumental epigraphy and imagery) all covered much the same ground. What is more, there existed between them a system of reciprocal validation and reinforcement. Archival documents like the *Liber Albus* and *Liber Blancus* provided Dandolo's historical work with factual basis and conceptual force. In turn, his chronicle gave those documents meaning, by integrating them within a comprehensive narrative of Venice's past that both framed and justified the city's present ambitions. The textual and visual programs of the chapel of Sant'Isidoro were pivotal to this complex, intermedial discourse. At one level they performed an evidentiary function, publicizing events that had already happened and recording information that was available elsewhere, in Dandolo's chronicle and the textual records of the chancery. At another level, these mosaics corroborated and gave material substance to those historical realities, and to the political ambitions and imagination that they underscored. By resurrecting the cult of St. Isidore, Andrea Dandolo and the Venetian government associated themselves with an early Christian martyr and an Eastern military saint who testified to the city's successful long-term engagement overseas, and whose presence in Venice was auspicious for the current war efforts. The monumental celebration of St. Isidore also entailed the memorializing of Doge Domenico Michiel, offering an opportunity to advertise Venice's role as a crusading power and articulate the meanings of ducal virtue. In turn, this provided an eminent model (and justification) for Dandolo's own dogeship, his role as military commander, and his activities of relic promotion. To be clear, the imagery and epigraphs in Sant'Isidoro are not a "political manifesto"—that is, derivative visual records of a fully formed theory of ducal power

and the state. Instead, they register a process of ideological renegotiation, a redefinition of the nature and workings of political rule that was in the making. In this context the artistic palimpsest of Sant'Isidoro, much like the laws and archival records produced in the same years, functioned as a primary source. As the historical manifestation of ongoing attempts to "think more clearly" about the state, images and epigraphs participated in the process of history making, and actively contributed to the process of institutional and political molding that was underway. The ducal images in Sant'Isidoro were themselves instantiations of change: the constitutive components of a state in transition, which had not yet coalesced into its definitive form and which needed to recover its "common sense."

Epilogue: Catastrophe, Averted

Andrea Dandolo ruled between 1343 and 1354, while Giovanni Gradenigo was not elected until 21 April 1355. The list of doges memorialized in the dedicatory inscription is therefore incomplete: the missing name is that of Doge Marino Falier, elected on 11 September 1354, shortly after Andrea Dandolo's death. Falier's dogate was brief and painful. Following his failed attempt to overturn the oligarchic government of the city, he was the first and only doge in the history of Venice to be publicly executed, and died on the monumental stairs of the ducal palace, the very same spot where he had pledged loyalty to the Venetian state a few months before.[118] The conspiracy generated huge tumult in Venice, and the doge's violent death became an enduring symbol of the exemplary punishment that befell traitors to the Venetian republic, and a powerful reminder of the limits of ducal authority.[119]

118 Lazzarini, "Marino Faliero" (see above, p. 12, n. 2); and Ravegnani, *Il traditore di Venezia*, esp. 75–134 (see above, p. 12, n. 2).

119 The sentiment of contemporaries toward the conspiracy is eloquently encapsulated in a letter written by Petrarch shortly after the events, to which we return in the next chapter: "To all future doges, I say: always bear this in mind, and learn from these events that doges are dukes, not lords; actually, that they are not even dukes, but honorable servants of the republic," from Francesco Petrarch, *Lettere di Francesco Petrarca delle cose familiari libri ventiquattro, lettere varie libro unico: Ora la prima volta raccolte, volgarizzate e dichiarate con note da Giuseppe Fracassetti,*

This dark episode of Venetian political history is highly significant for our understanding of how the chapel of Sant'Isidoro would have been seen and understood by coeval viewers. Marino Falier's conspiracy was discovered on 16 April 1355, the feast of the translation of St. Isidore. The doge and the leaders of the coup were executed the next day, while several of their accomplices were sentenced to death or life imprisonment over the following weeks.[120] In May, when the memory of the dramatic event was still vivid, and as the chapel of Sant'Isidoro neared completion, the government instituted an annual ceremony to commemorate the foiling of the plot. Each year, on the feast of St. Isidore, the doge, government, and major confraternities formed a procession that circled around Piazza San Marco and entered the basilica, where a solemn mass was celebrated.[121] Although the original deliberation does not explicitly mention the chapel of Sant'Isidoro, it seems highly plausible that the shrine would have been involved in the rituals of the day, as is also confirmed by later sources. In his account of the life of Doge Francesco Foscari (r. 1423–1457), Marino Sanudo explicitly indicates that the doge attended Mass in the chapel of Sant'Isidoro on 16 April.[122] Other Renaissance and early modern sources describe the procession in some detail. The ducal cortege, wearing black, entered the basilica through the central portal. Once inside the church, the doge visited St. Isidore's shrine, where he knelt to gain the indulgence (*a prender il perdono*). Following this ritual act of penance, the doge moved to the choir of the church, where he attended Mass, before the procession reformed, leaving San Marco from the central portal.[123] The conspiracy

and the rituals through which it was subsequently commemorated and exorcised are likely to have affected the ways in which coeval viewers saw and understood the chapel of Sant'Isidoro and its mosaics, projecting further meanings onto them.

Dated 10 July 1355, the dedicatory epigraph on the east wall captures the state of affairs of the Venetian government in the aftermath of Marino Falier's death. The disgraced doge is omitted from the inscription, which memorializes instead his successor Giovanni Gradenigo. In addition, the epigraph celebrates the name of Nicolò Lion, the Venetian aristocrat who had alerted the Venetian government to Falier's conspiracy and was subsequently rewarded for his loyalty with the prestigious appointment as procurator of San Marco.[124] Whether the absence of Falier's name represented a deliberate omission or was due to the brevity of his time in office is difficult to establish. Nevertheless, it would probably have been noticed by coeval Venetian viewers, who would have interpreted it in relation to the annual rituals of commemoration. The Venetian doges, who solemnly visited the chapel on 16 April each year, and the magistrates and members of the confraternities who took part in the solemn procession, would likely have experienced the chapel as a powerful visual reminder of the responsibilities that derived from power, and of the consequences of political turmoil. In this context the inscription, which celebrated an array of virtuous doges and procurators but omitted Falier's name, may have fulfilled a dual function, both preserving ducal memory and enforcing sanctions against it. The provisions made by the Venetian government indicate that Falier was the object of explicit and repeated iterations of public *damnatio*, which were achieved not only through the active destruction of textual or visual records but also by means of textual silences and omissions. The report of the deliberations issued by the Council of the Ten in the year 1355 has survived, but as scholars

ed. G. Fracassetti (Florence, 1866), 4:191. The English translation is by the present author.

120 Caresini, *Cancellari venetiarum chronica*, 9–10 (see above, pp. 99–100, n. 4); and Lazzarini, "Marino Faliero," 104–7, with further references.

121 The Council's act is transcribed in Flaminio Cornaro, *Ecclesiae venetae antiquis monumentis nunc etiam primum editis illustratae ac in decades distributae*, vol. 10, *De basilica ducale sancti Marci* (Venice, 1749), 109. See also Lazzarini, "Marino Faliero," 295–96, with reference to further primary sources.

122 Marin Sanudo il Giovane, *Le vite dei dogi (1423–1474)*, vol. 1, *1423–1457*, ed. A. Caracciolo Aricò (Venice, 1999), 314.

123 For descriptions of the ceremonies held on 16 April, see Sansovino, *Venetia* [1663 edition], 510–11 (see above, p. 82,

n. 69); and BMCC, P.D. 517b, "April" (folios not numbered). Both are also cited in Muir, *Civic Ritual*, 218. See also Renier Michiel, *Origine*, 3:171–73 (see above, p. 136, n. 108). The procession appears still to have been held in the late eighteenth century, before the fall of the Republic. See Agostino Valerio, *Dell'utilità che si può ritrarre dalle cose operate dai Veneziani*, ed. N. A. Giustiniani (Padua, 1787), 144, no. (a).

124 Ravegnani, *Il traditore di Venezia*, 122.

have noted, the page that should have recorded Falier's death sentence was deliberately left blank, following the cryptic phrase *non scribatur*: "[the matter] shall not be put down in writing."[125] In 1366, eleven years after Falier's death, the memory of his conspiracy was still offensive enough for the Council of the Ten to have the doge's effigy removed from the gallery of official portraits set up in the ducal palace. Following the tradition of *pitture infamanti*, it was initially suggested that the portrait should be replaced with a new effigy of Marino Falier, depicted upside down and with his head half severed from the neck. This proposal was rejected, but the picture was nevertheless removed, together with the doge's coat of arms, and the empty space that it left on the wall was filled with plain blue paint and inscribed in white letters *Hic fuit locus ser Marini Faletro decapitati pro crimine proditionis*, "This used to be the place of Sir Marino Falier, beheaded for the crime of betrayal."[126] This memorial by omission was preserved even after

the ducal palace was redecorated in the sixteenth century, following a devastating fire in 1577. The space next to Andrea Dandolo's portrait, painted by Domenico Tintoretto (1580–1590), was filled with a fictive black veil, inscribed with the phrase *Hic est locus Marini Faletro, decapitati pro criminibus*.[127] While the mosaics of the chapel of Sant'Isidoro do not refer to the disgraced doge, the ceremonies of regulated oblivion held on 16 April would encourage viewers to experience the shrine in relation to the overt repression of his memory in other public spaces.

The annual commemorations of Marino Falier's defeat engaged the epigraph and imagery of the chapel of Sant'Isidoro in a ritual of public condemnation and exorcism that both confirms and complicates the role of images and inscriptions in San Marco, and their relation to ongoing crisis. Monumental imagery and inscriptions were durable, material archives upon which public Venetian memory was inscribed, verified, and preserved. Moreover, they offered the governing elite an opportunity to visualize and disseminate new political ideas, normalizing them by connection with history and tradition. Nevertheless, public visual and textual statements in San Marco also represented sites of the sanction and obliteration of memory, where more uncomfortable leftovers of history could be overwritten, written out, or reframed, instructing the Venetian community not only what to remember, but also how to forget.

125 Lazzarini, "Marino Faliero," 5–8, who also suggests that the proceedings of the doge's trial were recorded more extensively in a different archival file.

126 The original documents with the two alternative suggestions are published in G. Lorenzi, *Monumenti per servire alla storia del palazzo ducale di Venezia: Ovvero, Serie di atti pubblici dal 1253 al 1797, che variamente lo riguardano tratti dai Veneti archivii e coordinati da Giambattista Lorenzi*, vol. 1, *Dal 1253 al 1600* (Venice, 1868), 38–39. For a discussion, see P. Fortini Brown, "Committenza e arte di Stato," in Arnaldi, Cracco, and Tenenti, *Storia di Venezia*, 3:783–824 (see above, p. 14, n. 9). On Marino Faliero's *damnatio memoriae*, see also G. Ortalli, "... *pingatur in Palatio* ...": *La pittura infamante nei secoli XIII–XVI* (Rome, 1979), 168–69.

127 G. Ravegnani, "Falier, Marino," *DBI* (1994), https://www.treccani.it/enciclopedia/marino-falier_(Dizionario-Biografico).

THE BAPTISTERY OF SAN MARCO
Visual Constitutions

THE BAPTISTERY OF SAN MARCO IS THE largest, most ambitious, and semantically richest among the projects undertaken during Andrea Dandolo's reign. Located in the south arm of the atrium of San Marco, it is enclosed between the main body of the basilica, the treasury room, and the portion of the west atrium that later became the Zen chapel. On the south side, the baptistery faces the Piazzetta San Marco and the ducal palace, the renovation of which started in 1340 and continued throughout Andrea Dandolo's dogeship. The baptistery's liminal position, situated at the intersection between the centers of Venice's religious, political, and judicial life, is suggestive not only of the interactions between sacred and secular spheres in the city, but also of the significance of baptismal ritual, and baptismal art, in mediating between the two.

The sacrament of baptism cleansed its recipients of original sin, making it possible for them to achieve redemption. In addition, through baptism the catechumens became members of the universal Christian community and were admitted into its more localized incarnations, the parish (or the diocese) and the city. The dual significance of medieval baptism as a ritual of communal inclusion and demarcation, both religious and civic, structures the interpretation of the baptistery of San Marco that is offered in this chapter.

Like the high altar and the chapel of Sant'Isidoro, the mosaic cycle in the baptistery places emphasis on collective devotion and divine assistance, connecting this shrine with the climate of crisis that characterizes this period. In continuity with the other two monumental projects, the baptistery also integrates religious iconography and overt political imagery, inviting reflections about the function of government within the economy of salvation. Finally, the baptistery juxtaposes visual narrative with (atemporal) sacred images, stimulating viewers to consider the relationship between history and God's eternal order outside of time. But in contrast to Dandolo's earlier projects, which emphasized local Venetian history, Venice's local past is conspicuously absent from the baptistery. Instead, its decorative program focuses on the universal, providing an abbreviated overview of Christian history—from the origins of time to divine revelation at the end of time—and weaving it together with a vision of cosmic order and hierarchy.

The first section of this chapter examines the visual program of the baptistery of San Marco in relation to its primary function, the yearly celebration of communal baptisms on Holy Saturday, and explores the range of theological, liturgical, and devotional insights that viewers would gain from the mosaics on that occasion. The sacrament of baptism was administered during the solemn Easter Vigil and included the doge and his

retinue. Therefore the rich messages of divine rescue, individual death and rebirth, and collective salvation conveyed by the religious ceremonies of Holy Saturday inevitably overlapped with political ceremony and symbolism, imbuing the baptistery with further meaning.

The themes of community, hierarchy, and sovereignty, which were central to the theology and liturgy of medieval baptism, also played a prominent part in Venetian social and political consciousness in the mid-fourteenth century. Thus they provide ideal frameworks within which to examine the mosaics and to consider how they would have been received and understood by contemporaries.

We turn first to a discussion of community and disunity, advancing a twofold argument. First, the baptistery of San Marco, like most other baptisteries in late medieval Italy, was renovated in a climate of increased insecurity and social fragmentation. In this context—and consistent with the primary meaning of baptism as a ritual of inclusion and communion—the baptistery encouraged a sense of unity and cohesion among contemporaries against the reality of civil strife. Yet in defining who belonged to the civitas, medieval baptism also established the outer boundaries of civil communities and the rules of exclusion from them. Ensuing from the Serrata and the expansion and consolidation of Venice's *Stato da Mar* in the (formerly Byzantine) East, concerns with identification, citizenship, assimilation, and exclusion were of paramount importance in Venice. The mosaics of the baptistery provided powerful biblical paradigms of social interaction, assimilation, and unity in difference. In so doing, they both reflected and addressed the same concerns.

Medieval baptism was a public ritual, carefully orchestrated from above. Through baptism, the religious and secular authorities of medieval cities articulated, from a position of power, the internal organization and hierarchies of the civitas, and by extension the authority and legitimacy of their government. Both these concerns were crucially important in Venice. The city's political and social structures were under considerable stress in the fourteenth century, when the organs of its government were redefined along with the responsibilities and relative

prerogatives of the different officials who worked for the Venetian state. In turn, preoccupations with institutional organization and political order may have inflected the meaning of the baptistery mosaics, which directly engage issues of (divine) authority and its transmission, executive power, and hierarchy as the governing principle of the cosmos.

It has been a central tenet of this book that the artistic renovation of San Marco participated in the process of critical questioning and (re)formation of the state through which Venice responded to crisis. This exercise of political imagination reached its pinnacle on the east wall of the baptistery, where three secular figures—a doge and two officers, all depicted anonymously—are represented as kneeling suppliants within a monumental mosaic of the Crucifixion. This image simultaneously draws on and transforms Byzantine and Western visual representations of rulers' atonement and humility, marking a significant departure from Dandolo's other projects in San Marco. Unlike the chapel of Sant'Isidoro and the pala feriale, where Venetian governors were depicted exclusively in historical cycles, the baptistery situates the doge and lay officers within a sacred image, thereby providing an abstract "state portrait" that simultaneously expressed a political reality and suggested a political ideal. The mosaic rendered Venice's doge as a humble ruler and represented the activity of government as a collective enterprise. In this way, the image reflected the increasingly restricted position of the doge within the Venetian state. It gave visual form— and therefore intelligibility and substance—to a new vision of government as public service and shared responsibility, as it gradually emerged from Venice's political and institutional reforms during the trecento. And it offered a visual counterpart to broad theoretical questions about the nature of sovereignty and the distribution of power in urban regimes that were intensely debated in fourteenth-century Italy, and that ultimately transformed Western attitudes toward public life and the state.

This interpretation transforms our understanding of the political implications of Byzantine art in fourteenth-century Venice. As we shall see, the selective recourse to and adaptation of Byzantine visual elements in the baptistery did

not translate an existing (and stable) imperial ideology that Venice strove to appropriate through artistic emulation. Instead, it represented one significant component within a broader range of politically inflected visual traditions which Dandolo's commissions drew upon creatively, and which together embodied a search for suitable aesthetic means to express emerging concerns about community, identity and difference, and a new political ideal in the face of uncertainty.

The Baptistery of San Marco: An Overview

The baptistery of San Marco was initiated during the dogate of Andrea Dandolo (r. 1343–1354), and may have been completed before his death in 1354, eventually becoming his funerary chapel.[1] In keeping with his other projects, Dandolo's intervention in the baptistery entailed the architectural renewal and artistic aggrandizement of an existing space. As a result, and unlike other Italian city-states where baptisteries were freestanding buildings with a centralized plan, the baptistery of San Marco is a rectangular, three-bay room located in the southwest corner of the basilica, in the space directly adjacent to the western atrium and the so-called Zen chapel.

The exact architectural facies and the function of the area now occupied by the baptistery before the fourteenth century are unknown and would deserve a separate and systematic archaeological investigation. Meanwhile, scholarship has converged around two hypotheses.[2] First, the space may originally have consisted of an open porch abutting the south walls of the basilica and its west atrium. Second, the porch was transformed into a closed atrium at a later stage, possibly after 1230. During that year, a devastating fire allegedly destroyed the (wooden) treasury rooms of San Marco and their contents, prompting the construction of new, dedicated rooms on the southwest side of the church, where the treasury is still preserved. The porch that later became the baptistery may have been turned into a closed atrium or chapel around this date.[3]

This space had already been decorated with frescoes before the thirteenth century. The overall extent and iconography of this painterly program are unknown, as is the exact date of its execution. The portions that have survived beneath the fourteenth-century marble cladding of the baptistery walls are generally dated to the mid- or late twelfth century.[4] The largest and best known among those fresco fragments is located on the lower half of the north wall of the baptistery's eastern bay. It represents an orant Virgin surrounded by apostles, indicating that the wall painting represented the Ascension of Christ.[5] For this reason, Otto Demus has posited a connection between the mural painting and the religious and civic rituals held in Venice since the eleventh century on the Feast of the Ascension (the Fiera della Sensa, discussed in the previous chapter).

Although Demus rejects the possibility that this space may have been used for the celebration of baptismal rituals before the trecento, there is some counterevidence against his assertion.[6] Restoration undertaken in the baptistery in the early twentieth century uncovered an ecclesiastical burial that was later identified on the basis of

1 Caresini, *Cancellari venetiarum chronica* 8 (see above, pp. 99–100, n. 4).

2 O. Demus, "Ein Wandgemälde in San Marco, Venedig," in *Okeanos: Essays Presented to Ihor Ševčenko on His Sixtieth Birthday by His Colleagues and Students*, ed. C. Mango and O. Pritksak, *HUkSt* 7 (Cambridge, MA, 1984), 125–44; and E. Merkel, "Affreschi poco noti a San Marco," in *Storia dell'arte Marciana: I mosaici; Atti del convegno internazionale di studi (Venezia, 11–14 ottobre 1994)*, ed. R. Polacco (Venice, 1997), 135–45.

3 Demus, "Ein Wandgemälde," 133, suggests that the enclosure of the porch followed the building of the treasury room. For a summary of the (still very uncertain) building history of the south narthex and baptistery, see G. Horn, *Das Baptisterium der Markuskirche in Venedig: Baugeschichte und Ausstattung* (Bern, 1991), 37–51; and E. Vio, "Dai restauri del battistero della basilica di San Marco alcune indicazioni per la facciata sud," in *Scienza e tecnica del restauro della basilica di San Marco: Atti del convegno internazionale di studi, Venezia, 16–19 maggio 1995*, ed. E. Vio and A. Lepschy (Venice, 1999), 2:515–49. On page 520, Vio speculatively suggests that the west bay of the baptistery may have been built under doge Giovanni Soranzo to connect the west and south arms of the narthex.

4 The frescoes under discussion have been attributed to different intervals of the twelfth century on stylistic and historical grounds. For a succinct summary of scholarly positions, and further references, see Merkel, "Affreschi poco noti," 136–37. See also Demus, "Ein Wandgemälde," 137–38. Less convincingly, the frescoes were dated to the eleventh century in M. Stoyanova-Cucco, "La preistoria ed i mosaici del battistero di San Marco," *AttiVen* 147 (1989): 17–28.

5 Furlan, *Venezia e Bisanzio* (see above, p. 64, n. 22), no. 50 (lacks page number).

6 Demus, "Ein Wandgemälde," 134.

an inscribed epigraph as the tomb of Hermann of Aurach. The latter was a twelfth-century bishop of Bamberg who accompanied Alexander III but died shortly before the celebration of the Peace of Venice in 1177. As Dellermann and Pincus have noted, this archaeological finding bears directly on our understanding of the history of the baptistery of San Marco.[7] The bishop is mentioned in the *Historia ducum Venetorum*, a chronicle of the history of Venice composed in the first half of the thirteenth century. The chronicle's author indicates that the ecclesiastic was buried "near San Marco, in the church of San Giovanni Battista."[8] This passage indicates that the area now occupied by the baptistery was an oratory, and not an open portico, when the *Historia ducum Venetorum* was written, and that the chapel was dedicated to St. John the Baptist. This has led some interpreters to suggest that the space may have had a baptismal function well before Dandolo's overhaul.[9] Even though it is plausible, in the absence

of systematic surveys of the area this hypothesis must remain speculative.

Regardless of its previous usage, the building campaign undertaken during Dandolo's reign transformed the south narthex of San Marco into a lavish and semantically rich space. In its trecento form the baptistery comprises three bays, aligned west to east (see Fig. 4, above, for a ground plan, and Fig. 58 for a general view of the space). The first bay (sometimes identified in literature as an antebaptistery) consists of a rectangular room surmounted by a barrel vault, oriented transversely to the main axis of the baptistery. By contrast, the central and eastern bays comprise roughly square spaces, covered by domes. The baptistery has three entrances. The first, in the west wall of the vestibule, connects the baptistery with the southwest section of the atrium of San Marco, and therefore with the Porta da Mar. Another portal, in the south wall of the first bay, would have allowed access to the baptistery directly from the Piazzetta. Finally, a third door pierces the north wall of the central bay, directly linking the baptistery to the south aisle of the basilica. The baptismal font is at the center of the central bay and is immediately visible to viewers accessing the chapel via the north or west wall doors.[10] Beyond the baptismal font, the eastern bay of the baptistery hosts the altar. The medieval mensa, which is thought to incorporate the stone from Tyre discussed in the previous chapter, was apparently tampered with in the mid-twentieth century, presumably to adapt it to new liturgical rules (see above, Fig. 56). Before this modification, the altar stood closer to the east wall of the baptistery and was aligned with a sculpted triptych on the east wall (still extant) and with the mosaic representation of the

7 On the recovery of Bishop Hermann of Aurach's burial, his role in the events of 1177, and the meaning of this finding, see A. Fumo, "Notizie dall'archivio: La sepoltura del vescovo di Bamberga in San Marco," in *Quaderni della Procuratoria: Arte, storia, restauri della basilica di San Marco a Venezia*, vol. 4, *Il coronamento gotico*, ed. I. Favaretto (Venice, 2009), 91–92; and R. Dellermann, "Le tombe del vescovo Hermann II (1170–1177) a Bamberga e nel battistero di San Marco," in Favaretto, *Il coronamento gotico*, 93–95. See also Pincus, "Venice and Its Doge," 254, n. 21 (see above, p. 36, n. 112).

8 The Latin version reads *Hermanus Bamburgensis episcopus, qui iacet apud sanctum Marcum in ecclesia sancti Ioannis Baptiste*. L. A. Berto, ed., *Testi storici veneziani (XI–XIII secolo)* (Padua, 2000), 56. The manuscript version of the chronicle is preserved in Venice, Biblioteca del Seminario Patriarcale, 951, fols. 35–45. The chronicle runs from the reign of the doge Ordelaffo Falier (1102–1118) to the death of the doge Pietro Ziani (1228). It was probably composed shortly after the latter ruler's death: L. A. Berto, "Historia ducum Venetorum," in *Encyclopedia of the Medieval Chronicle*, ed. G. Dunphy and C. Bratu (Leiden, 2016), https://referenceworks.brillonline.com/entries/encyclopedia-of-the-medieval-chronicle/historia-ducum-venetorum-SIM_01313?s.num=21&s.start=20.

9 Dellermann, "Le tombe," 94; and Pincus, "Venice and Its Doge," 254, n. 24. The space of the baptistery is sometimes referred to as the chapel or church "of the children" in Venetian sources. This expression is only employed in later sources, however, such as the sixteenth-century *Cronaca Carolda*, which describes it as a "cappella di S. Z. Battista delli putti," or "chapel of St. John the Baptist of the children." BNM, It. VII 141 (=7146), 1:282, cited in D. Pincus, *The Tombs of the Doges of Venice* (Cambridge, 2000), 90, 209, n. 51. For a bibliography on the chronicle (which is still unpublished), see G. Vespignani, *La cronachistica veneziana: Fonte per lo studio delle relazioni tra Bisanzio e Venezia* (Spoleto, 2018), 83–84.

10 The bronze cover of the baptismal font is a Renaissance artifact, designed by Jacopo Sansovino and manufactured by Tiziano Minio and Desiderio da Firenze in 1545. In 1565 Francesco Segala, a bronze caster from Padua, added the figure of St. John the Baptist that crowns the font. For a brief description of the work, see "Jacopo Sansovino's Baptismal Font Cover for the Basilica di San Marco," Save Venice, https://www.savevenice.org/project/baptismal-font-cover. The font itself—which looks remarkably similar to that depicted in the mosaic of the central dome, next to St. Mark—was already extant. Plausibly, it was already in its current position in the fourteenth century, as the eastern bay was then occupied by the large altar. Sansovino's work is documented in Cecchetti, *Documenti*, 43, with reference to the archival source (see above, p. 51, n. 1).

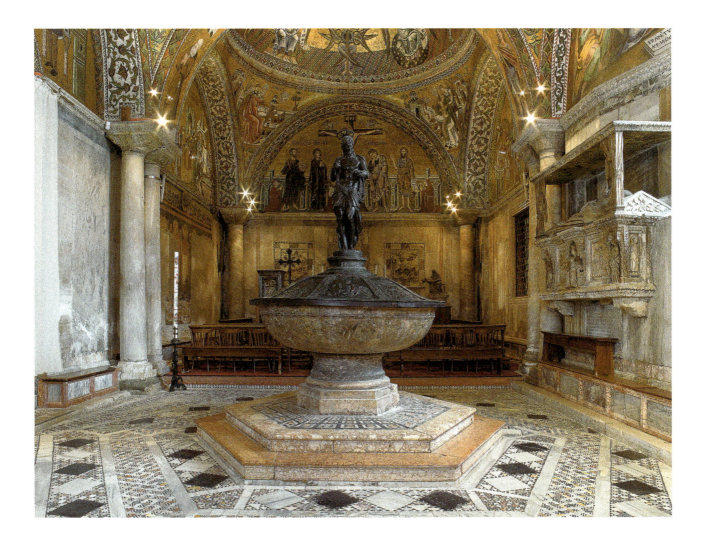

FIGURE 58.
General view of
the baptistery,
completed ca. 1354.
San Marco, Venice,
baptistery. Photo
courtesy of the
Procuratoria di
San Marco.

Crucifixion above it. Whereas the lower walls of the baptistery are encrusted with marble panels, the upper registers, vaults, and domes are decorated with an extensive cycle of mosaics that, as will emerge in the course of our analysis, combine well-established Venetian elements, Palaiologan motifs, and visual modules that circulated widely across the Adriatic in the thirteenth and fourteenth centuries.[11] Regrettably, the baptistery was heavily restored in the nineteenth century: large expanses of the original mosaics were lifted, thrown away, and replaced with new tesserae, hindering detailed analysis of its formal qualities.[12] Before this modern restoration, more limited (but equally destructive) repairs also took place in the sixteenth and seventeenth centuries that entailed the replacement of individual mosaic scenes, and that also hinder our understanding of this space.

11 A detailed, scene-by-scene examination of the iconography and style of the mosaics and of their possible models falls beyond the scope of this study. On these questions, see Horn, *Das Baptisterium der Markuskirche*; V. Pace, "Il ruolo di Bisanzio nella Venezia del XIV secolo: Nota introduttiva a uno studio sui mosaici del battistero marciano," *Ateneo Veneto*, ser. 3, 12.1 (2013): 243–53; and E. De Franceschi, "I mosaici del battistero, fra il rinnovamento bizantino-paleologo e la produzione pittorica veneta dei primi decenni del Trecento," in Vio, *San Marco: La basilica*, 1:309–17 (see above, p. 13, n. 5).

12 See A. Zorzi, *Osservazioni intorno ai restauri interni ed esterni della Basilica di San Marco con tavole illustrative di alcune iscrizioni armene esistenti nella medesima* (Venice, 1877); P. Saccardo, *Saggio d'uno studio storico-artistico sopra i musaici della chiesa di S. Marco in Venezia* (Venice, 1864), 447–79; and P. Saccardo, *Les mosaïques de Saint-Marc à Venise* (Venice, 1896). See Horn, *Das Baptisterium der Markuskirche*, for a brief survey of the physical condition of individual mosaics in the baptistery. On the involvement of the Compagnia Salviati in clumsy restorations of mosaics inside and beyond San Marco, see I. Andreescu-Treadgold, "Salviati a San Marco e altri suoi restauri," in Vio and Lepschy, *Scienza e tecnica*, 2:467–513.

FIGURE 59.
Annunciation to
Zachariah, Zachariah's
dumbfounding, and
the meeting between
Zachariah and
Elizabeth. San Marco,
Venice, baptistery.
Photo courtesy of
the Procuratoria di
San Marco.

The mosaic cycle combines the most salient episodes from the life of St. John the Baptist with those of the infancy and Passion of Christ. It begins on the south wall of the eastern bay, with representations of the Annunciation to Zachariah, his dumbfounding, and his encounter with Elizabeth (much restored) (Fig. 59). It continues across the central bay with a representation of St. John's Nativity (replaced in the seventeenth century).[13] Wrapping around the western bay, the story continues with John's withdrawal to the desert and with episodes of his ministry that include his preaching and the baptism of Christ (Figs. 60 and 61). The narrative then continues on the north wall of the central and eastern bay, with a representation of Salome's dance replete with courtly details and fashionable fourteenth-century clothing accessories. The next lunette features renditions of the Precursor's beheading, Salome's presentation of his head to Herod, and the burial of the saint's body (Fig. 62). A selection of scenes from the infancy of Christ—the

Magi's visit to Herod, the Adoration of the Magi and Joseph's dream, the Flight into Egypt and the Massacre of the Innocents—is clustered in the lower sections of the barrel vault of the western bay, above the life of the Precursor.[14] A monumental scene of the Crucifixion, fully visible from the western entrance to the baptistery, dominates the east wall. The scene includes figures of St. Mark (left) and St. John the Baptist (right), as well as a representation of the doge kneeling at the feet of the cross, and of two secular officers, represented in more peripheral positions near the Precursor and the evangelist (Fig. 63).

The narrative episodes are reserved for the lower sections of the vaults and the walls. In contrast, the upper tiers of the baptistery feature an unusual iconography, without exact parallels in late medieval Italy or Byzantium: on the barrel vault of the western bay, Christ is represented as the Ancient of Days, surrounded by prophets (Fig. 64). The dome above the baptismal font represents the Mission of the Apostles, while the eastern dome bears an image of Christ in Glory,

13 The fourteenth-century mosaic was replaced in 1628; the new scene was designed by Girolamo Pilotti and made by Lorenzo Ceccato (Saccardo, *Les mosaïques*, 321, n. 79, with further references).

14 Saccardo indicates that the scenes of the Visit to Herod and the Massacre of the Innocents were renovated in the nineteenth century (Saccardo, *Les mosaïques*, 118).

fig. 60

fig. 61

FIGURE 62. The beheading of St. John the Baptist, Salome offers the saint's head to Herod, and St. John's entombment. San Marco, Venice, baptistery. Photo courtesy of the Procuratoria di San Marco.

FIGURE 63. The Crucifixion, with doge and officers. San Marco, Venice, baptistery. Photo courtesy of the Procuratoria di San Marco.

FIGURE 64.

Ancient of Days
and prophets.
San Marco, Venice,
baptistery. Photo
courtesy of the
Procuratoria di
San Marco.

surrounded by the celestial hierarchies (Figs. 65 and 66). The spandrels of the central and eastern domes carry images of the Eastern and Western doctors of the Church.[15] Finally, the arches that separate the baptismal area proper from the western and eastern bays, respectively, carry representations of the four evangelists (almost entirely reworked in postmedieval times) and of St. Theodore, St. Isidore of Chios, the Blessed Pietro Orseolo, and the Blessed Anthony of Brescia. Among this second group, only the images of St. Isidore and the Blessed Pietro Orseolo are medieval, while the other two saints have been reworked or replaced at a later stage.[16]

The artistic program of the baptistery also includes a small group of aniconic sculpted reliefs, as well as three figural panels arranged on the east wall behind the altar (Fig. 67).[17] The central and largest of these panels features a concise version of the baptism of Christ and diminutive representations of standing prophets and saints in the frame, all identified by written captions. Two smaller, square panels are arranged on either side of the central relief. Each of these bears the image of a warrior saint, riding a charging horse and slaughtering a monster. The saints are labeled as St. George (left) and St. Theodore (right) by their tituli. Together, the three reliefs would

have composed a sculpted polyptych, offering a striking contrast to the mosaic interior of the baptistery.

In addition to its primary function as a chief site of Christian initiation, the baptistery of San Marco also doubled as a funerary chapel for two doges.[18] Both monuments have been comprehensively studied by Debra Pincus, who reveals their importance as sites of articulation of the doge's status in the Venetian state in the aftermath of the Serrata. The earlier tomb belongs to Doge Giovanni Soranzo (r. 1312–1328) and occupies an elevated position on the north wall of the first bay of the baptistery, beneath the mosaic of the baptism of Christ. The monument has a relatively simple design, with plain marble façades, a sculpted figure of St. John the Baptist holding the *Agnus Dei* at the center of the front panel, and two standing bishops holding crozier and book on the two side corners (Fig. 68). The *arca* is complemented by an elaborate sculpted interlace panel, placed immediately below the mosaic, and by the Soranzo family crest, which invites us to situate this tomb within the broader phenomenon of patrician self-representation discussed in the previous chapter. Soranzo's monument was presumably placed in its current position soon after the doge's death in 1328, and therefore before the renovation of the space during Dandolo's

15 The figure of St. Basil was remade in 1876 (Saccardo, *Les mosaïques*, 260).

16 St. Theodore was remade in 1678 by Stefano Bronza; the image of the Blessed Anthony of Brescia is modern, but the name of the mosaicist is unknown (Saccardo, *Les mosaïques*, 261).

17 For an overview of different scholarly positions on these reliefs, see W. Wolters, *La scultura veneziana gotica (1300–1460)*, vol. 1, *Testo e catalogo* (Venice, 1976), 150–51, no. 9, with extensive bibliography.

18 The dual function of baptisteries as sites of Christian initiation and funerary chapels is also attested elsewhere in medieval Italy. See, for example, Fina Buzzacarini's monumental tomb in the baptistery of Padua, discussed in A. Derbes, *Ritual, Gender, and Narrative in Late Medieval Italy: Fina Buzzacarini and the Baptistery of Padua* (Turnhout, 2020). On other Carrara burials in the baptistery, see, for example, H. Saalman, "Carrara Burials in the Baptistery of Padua," *ArtB* 69.3 (1987): 376–94.

fig. 65

fig. 66

dogeship. We do not know what images, if any, originally decorated the wall above the doge's tomb. Whether a portal already existed in the south wall of the chapel before Dandolo's intervention is also uncertain. In its current position, however, Soranzo's tomb is aligned with the entrance from the Piazzetta and would have been immediately visible to viewers accessing the space through this doorway. As Pincus has observed, the juxtaposition of the ducal tomb and the mosaic of the baptism of Christ was likely deliberate and would have encouraged consideration of the connections between baptismal rite, death, and salvation that were entirely consistent with the semantics of medieval baptisteries.[19]

Andrea Dandolo is also buried in the baptistery. His sepulchral monument is more elaborate than Soranzo's, comprising an elevated chest tomb, the sculpted effigy of the deceased doge, and a canopy with a sculpted and painted starry ceiling as well as the sculpted representations of two angels pulling away (stone) curtains to reveal Dandolo's effigy (Fig. 69). The chest also includes two narrative reliefs: the martyrdom of St. John the Evangelist on the left, and that of the doge's namesake St. Andrew on the right.

19 Pincus, *Tombs of the Doges*, 92.

Standing figures of the Virgin Mary and the archangel Gabriel respectively occupy the left and right corners of the front side of the tomb, forming an Annunciation. A high relief of the Virgin and Child holds the central position on the same panel, while two full-figure representations of saints (identified by Pincus as St. Leonard and St. Isidore) fill the sides of the tomb. A lengthy inscription, placed beneath the sepulchre, completes Dandolo's monumental funerary commemoration. As discussed in the previous chapter, Andrea Dandolo had initially envisaged his tomb being placed in the chapel of St. John the Evangelist, in the north transept. Contravening his wish, the procurators and the government positioned the monument in the baptistery. This eleventh-hour decision, presumably taken once the overall design of this space had been implemented, resulted in the positioning of Dandolo's tomb in a privileged but very awkward location, against the south wall of the central bay of the baptistery and opposite the doorway that linked the chapel with the basilica. The presence of Dandolo's tomb in the baptistery has inflected scholarly interpretations of this space, which is routinely understood as a primary stage for the doge's individual self-aggrandizement. The tomb, however, was a late addition to the baptistery

FIGURE 67.
Sculpted triptych with baptism of Christ, St. Theodore, and St. George. San Marco, Venice, baptistery. Photo courtesy of the Procuratoria di San Marco.

FIGURE 68. Giovanni Soranzo's tomb, ca. 1328. San Marco, Venice, baptistery. Photo courtesy of the Procuratoria di San Marco.

FIGURE 69. Andrea Dandolo's tomb, ca. 1354. San Marco, Venice, baptistery. Photo courtesy of the Procuratoria di San Marco.

program. Admittedly, once in its current position the monument probably encouraged visitors to honor Andrea Dandolo as patron of the chapel, and to identify him with the kneeling doge represented in the mosaic of the Crucifixion on the east wall. But Dandolo's individual celebration was not the original purpose of that image, which offered instead an anonymous (and therefore impersonal) representation of the ducal office and presented the activity of government as one of mediation between divine law and human time, and therefore as an agent in the economy of salvation.

Medieval Baptism between Religious Initiation and Civic Induction

For us to understand more accurately how contemporary viewers would have received and interpreted the imagery in the baptistery of San Marco, it will be useful to review the meaning of the sacrament of baptism for medieval Christians, its ritual unfolding, and its liturgical connections with the paschal liturgy. This analysis will also illuminate the public (and therefore civic) nature of medieval baptism in urban contexts, providing the basis for the interpretative sections that follow.

For medieval Christians, baptism was a necessary condition for redemption. Indeed, the possibility of individual salvation—and by extension of universal Christian redemption—rested on two elements. Historically, it was made possible by Christ's sacrifice on the cross and by his resurrection. Sacramentally, it relied on baptism, which was conceptualized as a form of ritual death of a sinful past and a spiritual rebirth that cleansed catechumens from the stain of original sin and enabled them to attain eternal life. As expressed in St. Paul's Epistle to the Romans, these two planes neatly converged in Christian thought:

> Or don't you know that all of us who were baptized into Christ Jesus were baptized into his death? We were therefore buried with him through baptism into death in order that, just as Christ was raised from the dead through the glory of the Father, we too may live a new life. For if we have been united with him in a death like his, we will certainly also

be united with him in a resurrection like his (Romans 6:3–5).

In addition to providing an authoritative shorthand for the theology of baptism, St. Paul's reference to the sacrament as the reenactment of Christ's death and resurrection explains why early Christian communities administered baptism on Holy Saturday and Pentecost, and why it remained customary to celebrate the solemn rite of communal initiation on Holy Saturday throughout the medieval West—including Venice—even as the practice of *quam primum* baptism became ubiquitous.[20] On the night before Easter Sunday, medieval communities participated in an elaborate ritual of transition, during which the *tenebrae* of Christ's death on the cross were dissipated by the illuminating glory of his resurrection. Enshrined within this liturgy of loss and renewal, baptism also marked a fundamental transformation: the purging of individuals of original sin, their rebirth as Christians, and their admission into the universal community of the Church.

The ritual structure of baptism, enshrined in the paschal liturgy, similarly expressed the sacrament's meaning as a *transitus* from death to rebirth.[21] The baptismal liturgy began with

20 On medieval baptism, see M. E. Johnson, *The Rites of Christian Initiation: Their Evolution and Interpretation*, rev. ed. (Collegeville, MN, 2007), 219–67. On the enduring popularity of Holy Saturday and Pentecost baptisms in late medieval Italian cities, see A. Thompson, *Cities of God: The Religion of the Italian Communes, 1125–1325* (University Park, PA, 2005), esp. 313–17. On medieval baptism, see also A. G. Martimort, *L'Église en prière: Introduction à la liturgie* (Paris, 1961), 514–51; F. Cabrol and H. Leclercq, "Baptême," in *DACL* (Paris, 1910), 12.1:251–346. For further references, see also R. W. Pfaff, *Medieval Latin Liturgy: A Select Bibliography* (Toronto, 1982), 40–41.

21 The standard formula of consecration of the baptismal font used by bishops on Holy Saturday reads: "Everyone who enters this sacrament of regeneration may be reborn in a new infancy of true innocence." E. C. Whitaker, *Documents of the Baptismal Liturgy*, ed. M. E. Johnson, 3rd rev. ed. (Collegeville, MN, 2003), 234. Our discussion of baptismal rituals in San Marco, and the ensuing investigation of Easter rituals in the basilica, is based on Cattin, *Musica e liturgia* (see above, p. 66, n. 26). While this study sheds considerable light on the Easter liturgy and the blessing of the baptismal font, it does not include detailed descriptions of the baptismal rituals in use in the fourteenth century. Cattin, however, indicates that following the late thirteenth-century reforms undertaken by Simeone Moro (primicerius between 1287 and 1291), the liturgy of San Marco retained some of its specifics but was made to conform more

elaborate formulas of exorcism. Following these preliminary rituals, which generally occurred *in limine ecclesiae* (at the threshold of the church or baptistery), the baptizands and their adult escorts were admitted into the baptistery proper. Once inside, the ritual sequence continued with the rite known as *effetà*, wherein the priest symbolically opened the ears and nostrils of the little catechumen by touching them with spittle.[22] There followed the renunciation of Satan, recited by the godparents on the child's behalf; the anointment of the child, which signaled Christ's deliverance; and the recitation of the Lord's Prayer and the Creed.[23] The actual sacrament was performed after these rites. The priest recited the formula, "And I baptize thee in the name of the Father, the Son, and the Holy Spirit," and immersed the child's head or poured water on it three times, once for each person of the Trinity.[24] Following the baptism by water, the priest anointed the neophyte with chrism a second time, reminding the baby that, now cleansed from the original sin, he or she may have eternal life. Finally, the rite ended with the ritual vestment, as the neophytes received a white garment signifying their newly acquired purity.[25] The baptizands were then generally given the Eucharist, sealing their membership in the community of Christians.

As a sacrament that introduced individuals to membership in the Church, baptism was inherently connected with notions of kinship, community, and solidarity, both religious and social.[26] Through baptism, the individual joined the *universitas* of Christians, and gained a legitimate place in the Christian cosmos. On the same occasion, the catechumen was also officially admitted into more localized Christian assemblies such as the parish and the diocese, which welcomed the newborn into their fold. In addition, the rituals of Christian initiation, during which children were given their official names, marked the official ingress of the little catechumens into the civic realm, establishing them as full members of a community that was both religious and sociopolitical.

Although primarily a sacrament of inclusion and belonging, in practice baptism also manifested the internal ordering of medieval communities, and assigned the catechumens a specific position, both social and political. Each child was accompanied and assisted during the rite by his or her parents and by one or more godparents. Before the ritual commenced, the adults in the group announced the child's name and his or her will to be baptized. As per the description above, throughout the rite the parents and godparents acted on behalf of the child, renouncing Satan and reciting the Creed. Through these ritualized actions they performed a dual role. First, they publicly identified the child as a member of a specific family: this situated the infant very precisely within the social hierarchies of the community, for the child's civic rights and duties (including, prominently, the right to citizenship) originated largely in his or her blood ties. Second, through the appointment of godparents—primarily adults who were not related to the child by blood, but who took on a spiritual responsibility for the infant—baptism reinvigorated or created new bonds of kinship, which expanded the child's spiritual, personal, and social network as well as

closely to the Roman liturgy—allowing us to follow the Roman ritual in our analysis of baptismal rites (Cattin, *Musica e liturgia*, 1:33–36).

22 M. Andrieu, ed., *Le pontifical romain au moyen-âge*, vol. 2, *Le pontifical de la Curie romaine au XIII^e siècle* (Vatican City, 1940), 473. In earlier liturgical sources (such as the Gelasian Sacramentary), the reciting of the Creed and the *effetà* are described as taking place on the morning of Holy Saturday, before the Easter Vigil during which baptism was performed. H. A. Wilson, ed., *The Gelasian Sacramentary: Liber sacramentorum Romanae Ecclesiae* (Oxford, 1894), 45–60.

23 Both phases of the ritual are attested in Andrieu, *Le pontifical romain*, 2:474.

24 Andrieu, *Le pontifical romain*, 2:476–77: *Et ego te baptizo in nomine Patris. Et mergat semel. Et filii. Et mergat secondo. Et Spiritus Sancti. Et Mergat tertio. Ut habeas vitam eternam* (And I baptize thee in the name of the Father. And [the priest] shall immerse [the catechumen] once. And of the Son. And he shall immerse [the catechumen] for the second time. And of the Holy Spirit. And he shall immerse [the catechumen] for the third time. So that you may have eternal life).

25 Andrieu, *Le pontifical romain*, 2:477.

26 For an introduction to the communal implications of baptism, see R. M. Jensen, *Baptismal Imagery in Early Christianity: Ritual, Visual, and Theological Dimensions* (Grand Rapids, MI, 2012), 53–90. For a detailed discussion of the communal and social implications of baptism in Florence, see A. R. Bloch, "Baptism, Movement, and Imagery at the Baptistery of San Giovanni in Florence," in *Meaning in Motion: The Semantics of Movement in Medieval Art*, ed. N. Zchomelidse and G. Freni (Princeton, NJ, 2011), 131–60.

that of his or her family.[27] Thus baptism did not simply celebrate communal unity and concord. It also functioned as a ritual of social publicity and differentiation, which performed and reinforced interfamilial relationships. On the one hand, baptism identified the child as a member of the civitas: that is, a religious, social, and political whole. On the other, it defined the child's position within this collective: a position that infants inherited from their families of origin, and that was further qualified by the number, social ranking, and prestige of the godparents who escorted and welcomed a child into the community.

In medieval cities, baptism could, in theory, be administered by the bishop only in the cathedral.[28] This custom changed as the population of urban centers grew, and as the practice of quam primum baptism replaced the early Christian tradition of holding group baptisms exclusively on Holy Saturday and Pentecost. Gradually, bishops extended the right to baptize to other churches, explaining why San Marco, which was not the cathedral of Venice in the fourteenth century, was nonetheless entitled to have a baptistery.

Baptismal churches—which are variously referred to as *plebes*, *ecclesiae matrices*, or *ecclesiae baptismales* in contemporary sources—were given permission to give baptism throughout the year to all children who were born within their administrative precincts. Nonetheless, even as baptismal rights were more widely distributed among local ecclesiastical establishments, the cathedral usually retained its prerogative to hold the solemn baptismal ceremony on Holy Saturday. This public ritual, which involved all children born in the city during the preceding weeks, unfolded in the presence of the entire civic community, reaffirming the central role of the bishop and his church in catering to the religious and spiritual needs of the urban community.[29]

Venice was evidently an exception. Bearing witness to the religious preeminence of the basilica over San Pietro in Castello in the later Middle Ages, baptism was also administered in San Marco on that day, as part of an elaborate sung service. On the occasion, the doge was required to make two separate wax donations: a wax candle of the weight of ten pounds, specifically intended "for baptism," and "three larger candles, and two smaller ones for the candlesticks" for more general use during the liturgy of Holy Saturday.[30]

Unfortunately, baptismal records are absent in Venice for the fourteenth century, leaving us in ignorance of who exactly was baptized in the basilica and elsewhere, and how often baptism was celebrated in San Marco throughout the year. Early modern sources refer to San Marco as an *ecclesia matrix*, and Pincus has reasonably suggested that the basilica also functioned as a parish church in earlier centuries.[31] If this hypothesis is correct, then any Venetian resident born within the administrative precincts of San Marco would presumably be entitled to be baptized there, at any time during the year. But fourteenth-century evidence of San Marco's specific functions as a parish church is ambivalent,

27 On the institution of godparenthood and on its functioning in premodern and early modern times, see J. Bossy, "Blood and Baptism: Kinship, Community and Christianity in Western Europe from the Fourteenth to the Seventeenth Centuries," in *Sanctity and Secularity: The Church and the World; Papers Read at the Eleventh Summer Meeting and the Twelfth Winter Meeting of the Ecclesiastical History Society*, ed. D. Baker (Oxford, 1973), 129–43; and G. Alfani, *Fathers and Godfathers: Spiritual Kinship in Early-Modern Italy* (Farnham, 2009).

28 This paragraph is largely based on D. Rando, "Aspetti dell'organizzazione della cura d'anime a Venezia nei secoli XI–XIII," in *La chiesa di Venezia nei secoli XI–XIII*, ed. F. Tonon (Venice, 1988), 53–72; and D. Rando, "Le strutture della chiesa locale," in *Storia di Venezia: Dalle origini alla caduta della Serenissima*, vol. 1, *Origini—Età ducale* ed. L. Cracco Ruggini et al. (Rome, 1992), 645–75. See also P. Vuillemin, *Parochiæ Venetiarum: Les paroisses de Venise au Moyen Âge* (Paris, 2017).

29 Thompson, *Cities of God*, 313.

30 Betto, *Il capitolo* (see above, p. 61, n. 17): the wax donation for the rituals of baptism is mentioned on page 185, no. cxvii. See also Betto, *Il capitolo*, 115, no. xxxvi, for the wax donations required from the doge for the liturgy of Holy Saturday. At least until the early fourteenth century, solemn baptismal ceremonies appear to have been held at San Pietro in Castello as well; see Rando, "Aspetti dell'organizzazione," 56, with reference to primary sources. The celebration of Holy Saturday baptism at both San Marco and San Pietro would deserve a dedicated study, for it raises a number of questions regarding how the baptizands were assigned to either establishment, how the ecclesiastical and political authorities of the city divided themselves between the cathedral and basilica, and whether the celebration of the public ritual at both shrines should be interpreted in the context of the long-term conflicts that opposed bishops and government in Venice in the Middle Ages.

31 Pincus, "Venice and Its Doge" (see above, p. 36, n. 112); and Pincus, "Geografia e politica," 459–73 (see above, p. 49, n. 150).

leaving open the possibility that the baptistery of the basilica could have been reserved for specific social groups (for example, members of the patriciate or of the citizen class) or for special ceremonial circumstances.[32] Regardless of the specific identity and social status of the catechumens, however, it is certain that baptism was celebrated in the basilica at least once a year, on Holy Saturday, and that the rituals of communal baptism were public events, participated in by the political authorities of the city and attended by a wide audience. Armed with this knowledge, we can now return to the imagery and explore its religious and political semantics.

Imagery, Eschatology, and Liturgy

Our main argument concerns the civil and political implications of the baptistery of San Marco. Yet the mosaics' ability to store and convey political meaning simultaneously rested on and expanded their primary religious content. Therefore, the ensuing pages explore the range of theological, spiritual, and eschatological insights that medieval viewers gained from the baptistery program, and that guided their understanding of any ulterior civil semantics of the space.

At a first level, the baptistery mosaics articulate the history (and destiny) of human salvation, from the Old Testament prophetic announcements to the fulfillment of those prophecies in the advent, death, and resurrection of the Savior. Most of the wall space is devoted to the life of St. John, with the saint's martyrdom fittingly placed nearest the mosaic of the Crucifixion of Christ, to signal their kinship during their lifetimes and in their deaths. St. John the Baptist, the last of a long succession of Old Testament prophets, was a witness to the coming of Christ to the world, and thus his figure is one of mediation between the Old and New Testaments. The decorative program of the baptistery expresses precisely this message, situating the life and passio of St. John between the group of prophetic figures clustered in the western vault and the infancy and Passion of Christ on the east and west walls of the chapel. The domes that surmount the central and eastern bays may also be explained

in connection with the universal economy and history of salvation, as well as with the actual liturgy performed in the room. The figures of the apostles performing baptism in the central dome hover just above the baptismal font, offering a mirror image of the actual ritual that took place in the space below, and demonstrating visually the contiguity between biblical events and their historical and liturgical reenactment. Finally, the eastern dome with its imaginative rendition of the hierarchies of angels and Christ in Majesty would recall images of the Last Judgment, and project the biblical events represented in the baptistery, as well as the lives of those baptized within this space, into the teleology of human salvation.

In addition to plotting the trajectory of human redemption, the baptistery mosaics also referred to specific aspects of the baptismal ritual, inviting viewers to engage with the sacred narrative and to establish direct parallels between those biblical events and their own lived experience in the space. This is most explicit in the central dome, situated above the baptismal font. The mosaic in the cupola represents the twelve apostles as they administer baptism in different regions and to different peoples across the world. Each apostle faces an adult baptizand, who is immersed in a baptismal font from the chest down and faces outward toward the viewer. Each saint imposes one hand onto the catechumen's head, while blessing the baptizand or holding a distinctive attribute with the other. While most of these baptismal scenes are rather formulaic, some of the gestures performed by the apostles may refer to particular phases of the baptismal ritual. For example, St. Philip holds the catechumen's head with both hands, touching his ears in a gesture that recalls the effetà ritual. Also, differently from all other scenes in the dome, St. James's attendant holds a white garment, evoking the white vestment given to infant neophytes at the end of the rituals of baptism. That viewers were intended to relate the biblical baptisms above to the actual liturgy taking place in San Marco may also be supported by another iconographic detail. The baptismal fonts in the dome vary in shape, material, and color. All, however, are square or cruciform, except one: St. Mark administers baptism to a man immersed in an elevated, round

32 Rando, "Aspetti dell'organizzazione," 58.

FIGURE 70.
St. Mark, St. John,
St. James, and
St. Philip performing
baptism. San Marco,
Venice, baptistery.
Photo courtesy of
the Procuratoria
di San Marco.

basin made of pink veined stone that is virtually identical to the font that currently occupies the central bay of the baptistery (Fig. 70).

The narrative episodes depicted on the walls of the baptistery also bore more or less direct associations with the rituals of baptism. In the later Middle Ages, the sacrament was administered largely to infants.[33] Accordingly, it was common

for baptismal programs to include cycles of the infancy of Christ and of the Precursor, which additionally expressed medieval understandings of baptism as newly found innocence. This was true of San Marco, where episodes involving

33 On the origins of infant baptism, see E. Ferguson, "Inscriptions and the Origin of Infant Baptism," *JTS* 30.1 (1979): 37–46; E. Ferguson, "The Beginning of Infant Baptism," in *Early Christians Speak: Faith and Life in the First Three Centuries*, 3rd ed., (Abilene, TX, 1999), 53–64; Johnson, *The Rites of Christian Initiation*, 257–65 (see above, p. 156, n. 20). On the same practice in Venice, see Alfani, *Fathers and Godfathers*, esp. 15; J.-F. Chauvard, "'Ancora che siano invitati molti compari al battesimo': Parrainage et discipline tridentine à Venise (XVIᵉ siècle)," in *Baptiser: Pratique sacramentelle, pratique sociale (XVIᵉ–XXᵉ siècles)*, ed. G. Alfani, P. Castagnetti, and V. Gourdon (Saint Etienne, 2009), 341–68; and the important study by Vuillemin, *Parochiæ Venetiarum*. On pages 246–53, Vuillemin discusses Venetian primary sources: these are scant for the Middle Ages, but become numerous in the fifteenth century.

By the early quattrocento, many Venetian parish churches possessed *libri de batizar*, liturgical books that described the rituals of baptism. During the same century, some Venetian families also started to compile family memoirs, although they did so later and less often than families in other Italian cities; see J. S. Grubb, "Memory and Identity: Why Venetians Didn't Keep *Ricordanze*," *Renaissance Studies* 8.4 (1994): 375–87. Finally, in the sixteenth century Venetian churches began to keep baptismal records. Collectively, these documents provide ample evidence that infant baptism was ubiquitous in Venice (although adult baptism survived in the city until the sixteenth century). Further testament to the pervasiveness of infant baptism in Italy in the Middle Ages is given by M. Crow, C. Zori, and D. Zori, "Doctrinal and Physical Marginality in Christian Death: The Burial of Unbaptized Infants in Medieval Italy," *Religions* 11.12 (2020): 678, https://www.mdpi.com/2077-1444/11/12/678/htm.

children are primarily concentrated in the first bay.[34] John's ministry was also a suitable subject for the decoration of baptisteries, as it alluded to another key aspect of the rites of Christian initiation: instruction in the faith and conversion. These elements are given particular emphasis in San Marco, where the Precursor's preaching and ministry occupy a large portion of the antebaptistery. One scene is particularly meaningful in light of the rituals performed in this space: the lunette above the west portal renders St. John as he receives his cloak from an angel. He holds a scroll that reads, in Greek, Μετανοείτε—

a shorthand reference to Matthew 3:2, which describes John's preaching (Fig. 71).[35] Translated as "repent" in the English Bible, the Greek word indicates more precisely a "change of mind," that is, a conversion.[36] John's intimation to turn people's minds away from sin was fulfilled in the baptismal ritual, during which infant catechumens were physically turned toward the east, symbolizing their rejection of sin and affirming their

FIGURE 71.
St. John the Baptist receives a cloak from the angel. San Marco, Venice, baptistery. Photo courtesy of the Procuratoria di San Marco.

34 A detailed analysis of individual scenes and of their sacramental implications falls outside of the purview of this study and will be the object of a separate publication. Meanwhile, Anne Derbes's masterful study of the late fourteenth-century frescoes of the baptistery of Padua, and of the exegetical tradition underpinning the selection of biblical stories for its decoration, provides an ideal template within which to understand the rich religious meanings of the Venetian mosaics: Derbes, *Ritual, Gender, and Narrative* (see above, p. 151, n. 18).

35 The full Gospel passage reads: "In those days, John the Baptist came preaching in the wilderness of Judea: 'Repent, for the kingdom of heaven is at hand'" (Matt. 3:1–2).

36 Μετανοείτε is the word employed in the Greek New Testament and means literally "change your minds." It was translated as *paenitentiam agite* (make penance) in the Vulgate and is rendered as "repent" in the English Standard Version. Reinforcing the message of conversion conveyed by the antebaptistery, the prophets Jeremiah, Elijah, Abraham, and Joel—directly visible to those who entered the baptistery and faced eastward—also hold inscribed scrolls that allude to staunch faith, conversion, and the effusion of the Holy Spirit.

FIGURE 72.
St. John the Baptist
is interrogated by the
Levites. San Marco,
Venice, baptistery.
Photo courtesy of
the Procuratoria
di San Marco.

faith in Christ.[37] As the catechumens moved away from darkness and toward light, both bodily and spiritually, all participants in the rituals would also turn eastward. As they did, they caught sight of the baptismal font, placed in the central bay, and of the mosaic of St. John's interrogation by the Levites, located above their heads in the antebaptistery, on the east side of the barrel vault (Fig. 72). Departing from the Gospel narrative, but in accordance with the rituals performed in the chapel, this scene unusually includes a transcription of the standard Latin

baptismal formula, "I baptize in the name of the Father, the Son, and the Holy Spirit."[38] Most importantly, as they turned eastward, the faithful

37 Derbes, *Ritual, Gender and Narrative*, 198–200, 202–5 (on the image of the Crucifixion in baptismal contexts).

38 In this mosaic, the Forerunner stands before a group of men: the priests and Levites sent from Jerusalem to scrutinize St. John. The mosaic inscription above the group reports their question: "Then why are you baptizing, if you are neither the Christ, nor Elijah, nor the Prophet?" (John 1:25). In the mosaic, John answers: EGO BAPTIZO I[N] NOMI[N]E PATRIS ET FILII [ET] SP[IRITU]S S[AN]C[TI] (I baptize in the name of the Father, the Son, and the Holy Spirit). This significantly departs from the Gospel text, where he announces the coming of Christ: "John answered them, 'I baptize with water, but among you stands one you do not know, even he who comes after me, the strap of whose sandal I am not worthy to untie'" (John 1:26–27).

would also gaze directly onto the monumental mosaic of the Crucifixion on the east wall. The choice and positioning of this scene were evidently apt. As mentioned above, Christ's sacrifice on the cross, followed by his resurrection, was the pivot of human redemption and victory over sin, and baptism was conceptualized as the reenactment of Christ's death and resurrection. The mosaic on the east wall, and the refulgent vision of Christ in Majesty in the dome above it, reminded the community of believers gathered in the baptistery of the transformative nature of sacraments, and alerted them to the mysterious contiguity between eternity and human time. In turn, these ideas—and the central role of Christ's sacrifice and humiliation within the economy of salvation—represented the core of the political vision that was articulated in the baptismal space, and that we will explore in the next sections.

The prominent placement of the Crucifixion mosaic on the east wall also expressed the liturgical convergence between baptismal rituals and paschal ceremonies on Holy Saturday. The solemn rituals of the Easter night watch were preceded and prepared by the divine office, held during the day. At San Marco, the readings for Holy Saturday comprised lengthy passages from the Lamentations, as well as Augustine's homily on John 19:31 from his *Tractates on the Gospel of John*; and the Venerable Bede's homily on Matthew 28:1–2.[39] The former comments on Christ's death on the cross and the abuses that his body endured immediately after he expired. As such, it offers an ideal textual parallel to the monumental image of the Crucifixion in the baptistery. Augustine devotes specific attention to the piercing of Christ's side, from which flowed blood and water. In this passage, Christ's wound is directly associated with the sacraments, and with baptism and the Eucharist

more specifically.[40] Augustine's reference to the baptismal implications of Christ's issue of water and blood was not an isolated instance. On the contrary, the association was almost a theological trope in the Middle Ages and is likely to have been familiar to medieval audiences.[41] Against this background, the spurt of blood and water gushing from Christ's side in the mosaic on the east wall of the baptistery acquires specific meaning. Visualized by means of two adjacent bands of white and red tesserae, the water and blood shed by the Savior made specific reference to the two sacraments of baptism and Eucharist, which were given to infant catechumens in sequence, on the same day (Fig. 73).[42] Venetian viewers were particularly attuned to the semantic implications of Christ's blood, shed during his Passion. As mentioned in our analysis of the makeover of the high altar, the basilica possessed a precious relic of the Holy Blood. Kept in the treasury and preserved in a stained rock crystal container that evoked both the transparency of water and the garnet-like color of blood, the relic was offered to the congregants for veneration on two occasions: Holy Friday (that is, the day before communal baptism) and the Ascension (Fig. 74).[43] Looking at the mosaic of the Crucifixion on the east wall, and at the red and white rivulet issuing from Christ's side, the beholders would be in an ideal position to link the two liturgical events: the commemoration of Christ's death on the cross on Holy Friday, its opening of "the door of true life" for all Christians, and the sacrament of baptism,

39 Cattin, *Musica e liturgia*, 2:345 (see above, p. 66, n. 26). Augustine's homily is published in PL 35, 1952–55, and was translated in Augustine of Hippo, *Tractates on the Gospel of John 112–24: Tractates on the First Epistle of John*, trans. J. W. Rettig (Washington, DC, 1995), 50–55. Bede's homily is published in Bede the Venerable, *The Complete Works of Venerable Bede: In the Original Latin, Collated with the Manuscripts, and Various Printed Editions, Accompanied by a New English Translation of the Historical Works, and a Life of the Author*, vol. 5, *Homilies*, ed. J. A. Giles (London, 1843), 23–31.

40 "One of the soldiers with a spear opened His [Christ's] side, and immediately there came out blood and water. The Evangelist used a wide-awake word so that he did not say 'pierced his side,' or 'wounded' or anything else, but 'opened,' so that there, in a manner of speaking, the door of life was thrown open, from which the mystical rites of the Church flowed, without which one does not enter into the life which is true life. That blood was shed for the remission of sins; that water provides the proper mix for the health-giving cup, it offers both bath [i.e., baptism] and drink [i.e., Eucharist]" (Augustine of Hippo, *Tractates on the Gospel of John 112–24*, 50). On the same page, note 4 explains the metaphor of the bath and drink as signifying the sacraments of baptism and the Eucharist.

41 For a rich array of medieval sources likening Christ's wound to the saving effect of the waters of baptism, see Derbes, *Ritual, Gender, and Narrative*, 202.

42 E. C. Whitaker, *The Baptismal Liturgy*, 2nd ed. (London, 1981), 11.

43 Betto, *Il capitolo*, 154, no. xviii (see above, p. 61, n. 17).

FIGURE 73.
Detail of the
Crucifixion.
San Marco, Venice,
baptistery. Photo
courtesy of the
Procuratoria di
San Marco.

which, celebrated on Holy Saturday, represented the sacramental enactment of the faithful's death and rebirth with Christ.

Just as the Crucifixion mosaic engages in a productive dialogue with Augustine's homily, Bede's Homily 4—which was also part of the divine office for Holy Saturday—can be put in conversation with the theophany in the eastern dome. In his homily, Bede comments on Christ's resurrection, and places significant emphasis on its timing: during the night after the Saturday, at the break of dawn. His homily focuses on the relation between darkness and light, and is replete with light metaphors, culminating in the statement, "The Lord, who created and imparted order to time, (and) who resurrected at the end of the night, rendered it joyous and gleaming with the light of his resurrection."[44] Bede's hom-

ily agrees beautifully with the imagery of the eastern dome of the baptistery. The cupola offers the viewers a glowing vision of Christ's victory over death. Christ sits in glory, both hands raised in a gesture of victory or double blessing. This iconography was uncommon in Italy in the fourteenth century but was widely employed in the monumental arts of Serbia and the Balkans, particularly in representations of the Last Judgment and of Christ as Divine Wisdom.[45] In the dome of the baptistery, Christ is enclosed within a dark blue,

44 Bede the Venerable, *The Complete Works of Venerable Bede*, 5:25: *Dominus auctor et ordinator temporum, qui in ultima noctis*

huius parte surrexit, totam eam nimirum eiusdem resurrectionis luce festivam reddidit et coruscam.

45 Variants of this iconography can be found in the fourteenth-century frescoes of the monasteries of Dečani (Last Judgment, Church of Christ Pantokrator, Dečani Monastery, mid-fourteenth century), Lesnovo (St. Michael Archangel, *katholikon* of Lesnovo Monastery, sanctuary, Christ raises both hands in a gesture of blessing, as a serving priest in the Heavenly Liturgy, 1341–1343), and Markov (Christ as Holy Wisdom, narthex of the katholikon, 1376–1377 or 1380–1381).

FIGURE 74. Reliquary of the Holy Blood, tenth century (Fatimid rock crystal) and thirteenth century (Venetian metalwork mount). Venice, Treasury of San Marco. Photo courtesy of the Procuratoria di San Marco.

Exultet, a lengthy proclamation sung throughout the medieval West on Holy Saturday. The singing of the Exultet accompanied the ceremonial lighting of the paschal candle and all other luminaries in the church, which had been extinguished on Holy Friday. The lighting of the paschal candle and the singing of the Exultet lent tangible form to the abstract notion of the light of Christ dispelling the darkness of death. Together they produced a spectacular and sensorially saturated ritual moment that most likely impressed itself in the minds of contemporaries and informed their understanding of the imagery that framed the ceremony.[46]

The blessing of the paschal candle was followed by the reading of the Holy Saturday prophecies, a sequence of Old and New Testament readings that focused on themes of divine judgment, punishment, and deliverance, and had distinctive baptismal connotations.[47] Immediately after the prophecies—and thus not long after the singing of the Exultet and the lighting of the paschal candle—a procession was formed that proceeded to the baptismal font for the solemn blessing of the water and the baptism of children. This procession presumably entered the baptistery through its north wall door, gaining direct access to the central bay. From that position, as they faced east, the viewers would behold the monumental mosaic of the Crucifixion as well as the dome above it, with its scintillating representation of the resurrected Christ surrounded by angels, aflame with light.

This visual ensemble, and the baptistery program as a whole, appealed primarily to the religious imagination of its viewers. But the public nature of the baptism and Easter rituals and

starry circle that evokes the "night of Saturday" during which the resurrection occurred. Spiky golden rays of light radiate outward, and Christ's garments are made of glittering gold and silver tesserae, evoking Bede's poetic image of the night set alight by the Lord's resurrection, as well as wider notions of divine light and wisdom (Fig. 75).

Evidently the metaphor of Christ's resurrection as a blazing light that defeated the darkness of death was also central to the liturgy of the Easter night watch. The latter culminated in the

46 Andrieu, *Le pontifical romain*, 3:588 (see above, p. 157, n. 22). For a brief introduction to the *Exultet*, see G. Cavallo, "Exultet," in *Enciclopedia dell'arte medievale*, ed. A. M. Romanini (Rome, 1995), 6:60–68, with further references. For a clear and concise introduction to the rituals of Holy Saturday, see also D. Hiley, *Western Plainchant: A Handbook* (Oxford, 1995), 38–39.

47 W. J. Lallou, "The Prophecies on Holy Saturday," *The Catholic Biblical Quarterly* 6.3 (1944): 299–305. The prophecies read in San Marco on Holy Saturday included five Old Testament readings, followed by two New Testament excerpts: Gen. 1:1–31, 2:1–2; Exod. 14:24–31, 15:1; Isa. 4:1–6; Deut. 31:22–30; and Isa. 54:17, 55:1–11. These were followed by Col. 3:1–4 and Matt. 28:1–7 (Cattin, *Musica e liturgia*, 2:451).

FIGURE 75.
Christ in Majesty.
San Marco, Venice,
baptistery. Photo
courtesy of the
Procuratoria di
San Marco.

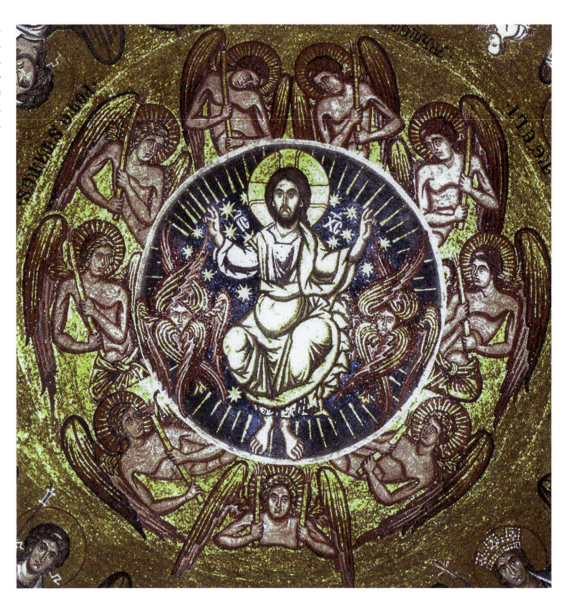

the active participation of the doge in both ceremonies intimate that the spiritual and theological realities conveyed in the baptistery also played a part in the civil and political life of the Venetian community.

Monumental Crisis?
Community, Disunity, and Assimilation

The baptistery project in San Marco conformed to a time-honored tradition of Italian city-states that allotted considerable resources to the construction and upkeep of baptismal buildings. In such urban contexts baptisteries represented key stages for the performance of communal identities—a role that was rooted in the dual significance of baptism as a rite of inclusion and social demarcation that was introduced above, and that was both amplified and complicated at times of increased strife or accelerated change. The meaning of urban baptisteries as sites of civic identification, mediation, and reconciliation provides an ideal framework within which to examine the baptistery of San Marco, and to introduce its rich social and political meanings.

The interweaving of religious, social, and political spheres was intrinsic to the rituals of baptism since their establishment in early Christian times, but it took on particular relevance in the autonomous city-states of late medieval Italy,

where religious and civic belonging significantly converged.[48] In this urban context, baptisteries—which were often built through the concerted financial and managerial efforts of the bishopric and government—came to serve a variety of civic purposes. They were repositories for documents of public relevance,[49] and meeting halls for committees that oversaw matters of civic interest.[50] Commonly, baptisteries functioned as solemn stages for public rituals of investiture (ceremonies of knighting and oath-taking by civic officers) and for the pardoning of prisoners.[51] Frequently the military insignia of the city, as well as its war trophies—for example, the *carrocci* of defeated enemies—were also displayed within baptismal edifices.[52] In sum, baptisteries were highly symbolic places where urban governments celebrated the resolution of internal and external conflicts, and where the bonds of loyalty and service between individuals, civic institutions, and the community at large were sealed and confirmed.[53]

For all the above reasons, the building or aggrandizement of baptisteries in medieval Italian city-states commonly coincided with phases of religious and political transition or episodes of strife that intensified the need to reaffirm the unity and concord of urban communities. In this vein, Ludovico Geymonat has argued for a dual role of the baptistery of Parma, as both a catalyst for and a site of mediation of the long-standing conflict between the bishopric and city government over the administration of justice in the city and its territories in the thirteenth century.[54] Anne Derbes cites Padua's crushing defeat in the war against Venice as a likely trigger for the rebuilding of the city's baptistery in the 1370s.[55] And George Bent reads the baptistery of Florence, which was decorated between the late thirteenth and the early fourteenth centuries, as the canvas on which the newly established Republican government of Florence crafted its complex self-identity, celebrating the triumph of Republican aspirations and expressing its fear of tyrannical rule.[56]

These considerations provide a first interpretive perspective within which to approach the baptistery of San Marco. The Venetian government undertook to rebuild the baptistery of San Marco at a time of severe domestic and international challenges, the cumulative thrust of which called into question the stability, the cohesion, and the boundaries of Venice's community, and forced the government to probe, and gradually clarify, what it meant to be Venetian, both culturally and legally. More specifically, in the central decades of the fourteenth century the public authorities began to spell out the norms by which individuals could acquire (or lose) their status as citizens, the processes by which citizenship rights were verified, and the privileges and responsibilities associated with different tiers of citizenship. By its nature as a sacrament of induction into a community, baptism was profoundly entangled with these developments, both practically and conceptually. In turn, baptismal imagery represented an ideal means to reaffirm the importance of community and collective harmony at

48 The standard reference on this subject remains E. Cattaneo, "Il battistero in Italia dopo il Mille," in *Miscellanea Gilles Gérard Meersseman*, Italia sacra 15–16 (Padua, 1970), 1:171–95. See also Thompson, *Cities of God* (see above, p. 156, n. 20). Excellent work has also been done on individual cities and their baptismal shrines, which we refer to throughout this chapter.

49 This was the case in Orvieto and Pistoia, for example. For the former, see Cattaneo, "Il battistero in Italia," 190, with further references. On Pistoia, see N. Bottari Scarfantoni, *Il cantiere di San Giovanni Battista a Pistoia (1353–1366)* (Pistoia, 1998), 50.

50 In Parma, the election of the officers in charge of the Canale Maggiore (a major water canal in the city) took place in the bishop's palace or in the baptistery: L. V. Geymonat, "The Parma Baptistery and Its Pictorial Program" (PhD diss., Princeton University, 2006), 45–46, with further references. On the various civic meetings held at the baptistery of San Giovanni in Florence, see Cattaneo, "Il battistero in Italia," 188–89, with further references.

51 On the pardoning of prisoners, see M. Boskovits, *The Mosaics of the Baptistery of Florence* (Florence, 2007), 12, with n. 10. On other civic functions of the Florentine baptistery, see Cattaneo, "Il battistero in Italia," 188–89. On the knighting ceremonies that were celebrated at the threshold of the baptistery of Parma, see Geymonat, "The Parma Baptistery," 46.

52 A survey of towns that displayed their own carrocci, or those of defeated enemies, in the city baptistery can be found in Geymonat, "The Parma Baptistery," 50–51, with further references.

53 P. Cramer, *Baptism and Change in the Early Middle Ages, c. 200–c. 1150* (Cambridge, 1993), 268; and Cattaneo, "Il battistero in Italia." On the funding mix of baptisteries and the varying responsibilities of secular and religious authorities in Italian cities, see Geymonat, "The Parma Baptistery," 62–65.

54 Geymonat, "The Parma Baptistery," esp. 56–61, 89.

55 Derbes, *Ritual, Gender, and Narrative*, 77 (see above, p. 151, n. 18).

56 G. Bent, *Public Painting and Visual Culture in Early Republican Florence* (Cambridge, 2016), 239, 255.

times of instability, while also addressing contemporary concerns about social difference and civil inclusion, exclusion, and assimilation.

DEBATING CITIZENSHIP

As discussed in chapter 1, the plague of 1348 took a severe toll on Venice's community, testing the solidity and reliability of parish and neighborhood networks and confraternities and the infrastructures of public assistance.[57] What matters more to the present discussion, however, is that the heavy demographic losses pushed the government to implement extraordinary strategies of repopulation, in order to attract a qualified workforce, stimulate commercial activities and consumption, and increase Venice's fiscal revenues. In 1349, the Council proceeded to pardon and free imprisoned debtors and recall exiled citizens, as well as those who lived in the colonies and those who had fled the city for the country during the epidemic. The government also approved a "relief package," extending financial and fiscal benefits to foreign merchants and qualified workers who were willing to relocate to Venice with their wives and children. Finally, the Council devised an exceptional, expedited naturalization process, through which eligible foreigners could obtain Venetian citizenship at the end of only two years of continued residency, instead of the much longer standard residency requirement set in the early fourteenth century at fifteen years.[58] These rulings provide compelling evidence of the Venetian government's determination to rebuild the civic community ravaged by the epidemic. In turn, concerns with the survival and well-being of the Venetian community represent a valuable matrix within which to situate the government's decision to renew the baptistery of San Marco: introducing infants to the civic and religious community and extending the promise of eternal salvation to all those who were baptized in it, the baptistery conveyed an auspicious message to the local community in the aftermath of an epidemic that had decimated the city.

Ideas of collective redemption and universal cohesion also agree with Venice's new self-image as political intermediary and guardian of Christianity in the East, which the city developed in response to Ottoman advances. Modern interpreters have argued that in its new role as member of the Christian League, Venice developed a new sensitivity to the strategic importance of concord among Orthodox and Latin communities. In turn, the new importance attributed to Christian unity and ecumenicity may have informed attitudes toward baptism and baptismal imagery, which—by definition—evoked ideas of a universal and unified community of Christians and separated it from the religious "other."[59]

Whereas the instability of the period may have given renewed importance to ideas of communal cohesion and universal Christian concord in the eyes of Venice's governing elite, concerns with boundary demarcation, assimilation, and exclusion were of equal importance. And Venice's commitment to the Christian League was most likely connected with the city's chief international preoccupation: its ongoing rivalry with Genoa. The war against Genoa, it bears repeating, occurred between 1350 and 1355, at the same time that the baptistery was under construction. The conflict represented a serious threat to the survival and autonomy of Venice, and to its political and commercial interests overseas. Compared with the chapel of Sant'Isidoro, the baptistery is less overtly suggestive of the conflict between the two powers. But St. John the

57 On the complex ways in which communities responded to the plague crisis, see S. K. Wray, *Communities and Crisis: Bologna during the Black Death* (Leiden, 2009).

58 On the process of expediting citizenship, see Brunetti, "Venezia durante la peste del 1348," 5–42 with references to primary sources (see above, p. 18, n. 24). On Venetian citizenship, see R. C. Mueller, *Immigrazione e cittadinanza nella Venezia medievale* (Rome, 2010). On the standard residency requirement for citizenship grants in medieval Venice, and on its developments over time, see D. Jacoby, "Venetian Citizenship and Venetian Identity in the Eastern Mediterranean," in *Cultures of Empire: Rethinking Venetian Rule, 1400–1700; Essays in Honour of Benjamin Arbel*, ed. G. Christ and F.-J. Morche (Leiden, 2020), 125–52, at 127–28.

59 Maria Da Villa Urbani associates coeval concerns with ecumenism with the bilingualism of the baptistery mosaics. The spandrels below the central and eastern domes feature representations of the Eastern and Western doctors of the Church, respectively. But the Greek Fathers hold scrolls inscribed in Latin, while their Latin counterparts are visualized as they write their books in Greek. Da Villa Urbani tentatively explains the "inversion" of Greek and Latin with reference to Venice's concerns with Christian unity. M. Da Villa Urbani, "Le iscrizioni nei mosaici di san Marco: Alcune novità nei testi e proposte di lettura," in Niero, *San Marco: Aspetti storici*, 334–42.

Precursor was the civic patron of Genoa, giving the renewal of the Venetian baptistery an implicit polemical twist.[60] Also, the altar of the baptismal chapel was obtained from the so-called stone of Tyre (discussed in the previous chapter), amplifying the anti-Genoan overtones of this space. What matters most to our argument, though, is that the conflict between the two powers specifically pressed the question of identification and "national" belonging. Andrea Dandolo, we recall, specifically invoked the notion of patria (fatherland) in his justification of the war to Petrarch, signaling contemporary sensitivity to ideals of civic identification. At a practical level, questions of national belonging were particularly relevant in the "contact zones" of the Morea and the Aegean, where the population was ethnically mixed, armed conflict was waged more violently, and Venice's grip was less firm. Venice urgently needed the loyalty of local residents in those regions. To secure their loyalty, it needed them to feel Venetian, or at least more Venetian than Genoese. The granting of citizenship status—which entailed significant fiscal and commercial privileges and the protection of Venetian jurisdiction in legal matters—was a powerful means to obtain and cement allegiances. Evidently aware of the persuasive power of citizenship benefits, the Venetian government used this leverage discerningly during the war: in 1353, the Latin residents of Venetian Methone, Korone, and the major Cretan cities were offered full citizenship status, provided that they settle with their families in those same cities or in the Venetian quarter of Negroponte.[61]

In what measure did preoccupations with the notion of patria and the identification of minority groups in the Venetian East inflect the semantics of the baptistery and of its vision of universal membership? Before we attempt to address this question, it bears stressing that the Genoese conflict was one highly significant episode within a more complex process of expansion and consolidation of Venice's *Stato da Mar*. Over time, the flow of migration between Venice and its colonies intensified. As permanent diasporic communities

formed both in Venice and in the territories subject to its control, the nature of Venetian identity and Venetian citizenship became more stratified and more difficult to define, both culturally and legally. Simultaneously, in the aftermath of the Serrata, eligibility for public service and political office came to depend respectively on citizenship and noble status. In this context, the manner in which Venetian citizenship could be acquired and how it might be lost became crucial matters. Tellingly, the use of such terms as *civis* and *citadinancia* intensified in official Venetian charters during the 1320s.[62] During the same period, a clearer distinction began to be made among different tiers of citizenship that entitled individuals to a diverse range of tax privileges: in Venice (citizens *de intus*), in its overseas territories (*de extra*), and everywhere (*ubique*).[63]

Venetian citizenship was transmitted along the male line and regardless of the place of residence: in theory, the offspring of Venetian citizens who settled in the colonies automatically inherited citizenship rights, even if they were born and raised abroad. For how many generations this rule remained in force, and to what extent the right to Venetian citizenship was affected by intermarriage between colonial residents of different ethnicities or nationalities, is less clear. As a consequence, applications were often considered case by case, and the details of the applicant's family history, as well as his ability to speak Venetian, were carefully scrutinized. The status of non-Venetian residents of Venice's territories abroad was also highly diverse. Under certain circumstances—which varied by time and location—Venetian subjects could apply for "permanent resident status" in the colonies or in the capital. In some rare cases they were also entitled to apply for full Venetian citizenship, producing a jigsaw of legal, fiscal, and cultural identities.

Compounding this complexity, while specific bureaucratic procedures gradually emerged to identify patricians and citizens, Venice's larger social formation—the *popolo*—lacked a specific legal definition, making this category both

60 See Gerevini, "Art as Politics" (see above, p. 39, n. 121).

61 Jacoby, "Venetian Citizenship," 141, with further references.

62 Jacoby, "Venetian Citizenship."

63 Mueller, *Immigrazione e cittadinanza*, 86–95; these are also discussed in Jacoby, "Venetian Citizenship," 128.

fluid and highly diverse. The condition of "being Venetian" (which did not necessarily coincide with citizenship status) gave individuals the right to live and work in Venice, as well as to receive basic assistance and to appeal to the city's system of justice. It was therefore crucial to distinguish those who belonged to the community from those who did not. The basic rule of civic identification was easy enough: every person who was born in Venice of Venetian parents was automatically a Venetian. The question was far more complex for non-natives: at what point did a foreigner, or his descendants, cease to be an alien resident and gain full membership in the city? How was the status of non-native permanent residents verified? And what was the status of children born in Venice of a Venetian and a non-Venetian parent?[64] These were pressing concerns for many Italian Republican cities that struggled to define with precision the outer borders of their civic bodies in the later Middle Ages.[65] But the number and diversity of foreign residents and colonial subjects in Venice—and the growing divide between citizenry and *popolo*—made questions of civic belonging, foreignness, and integration specifically relevant.[66]

Baptism was entwined with the developments described above, both practically and metaphorically. Before the establishment of baptismal

registries and the systematization of public registers of patrician births in the fifteenth century, producing proof of a person's date and place of birth, and therefore demonstrating his right to citizenship, could be a sticky affair. Determining the status of noncitizens as alien or domestic residents was even more complex until the sixteenth century, when the Venetian government began to issue visas and work permits in the form of paper certificates, to be carried by all foreigners.

In this context the identification of Venetian "nationals," the outcome of citizenship applications, and in more dubious cases the certification of noble status depended significantly on social networks, and on the availability of reliable witnesses who could testify to a person's identity, genealogy, and whereabouts. Arguably, having been baptized in Venice represented an important qualification, for it provided proof that an individual had been born in the city and that he or she had long belonged to the local communities of the parish and *sestiere*. In addition, the institution of godparenthood may have played a part in building the social curriculum of Venetians. As already mentioned, godparents represented the embodiment of a family's social ties and networks of friendship that were formalized and publicly advertised through the forging of a baptismal bond.[67] Godfathers and godmothers were often chosen from among members of higher social echelons, or from families of peers in the case of patricians, and the baptismal bond was used to formalize existing ties of friendship, clientele, or patronage, as well as to forge new ones or to seal the reconciliation of rival clans.[68] The Council of Trent limited the number of permitted godparents to one godfather and one godmother. Before this, multiple adults could be summoned to introduce the little catechumens to Christian life, imbuing the ritual of baptism with even more patent social and political overtones. Conventions varied across time, geography, and social rank, and one or few godparents seems to have been a common choice and was preferred by ecclesiastical authorities.[69] On occasion, however,

64 For an excellent introduction to Venice's *popolo* and the methodologies available for its study, see C. J. de Larivière and R. M. Salzberg, "The People Are the City," *Annales: Histoire, Sciences Sociales* 68.4 (2013): 1113–40.

65 P. Gilli, "Comment cesser d'être étranger: Citoyens et non-citoyens dans la pensée juridique italienne de la fin du Moyen Âge," in *L'étranger au Moyen Âge*, ed. C. Gauvard (Paris, 2000), 59–77.

66 Specific protocols of identification and monitoring of foreign visitors and residents were only devised in the sixteenth century. Before then, the process of integration of strangers was one of gradual and informal social assimilation: R. M. Salzberg and C. J. de Larivière, "Comment être Vénitien? Identification des immigrants et 'droit d'habiter' à Venise au XVIᵉ siècle," *Revue d'histoire moderne et contemporaine* 64.2 (2017): 69–92. For a rich conceptual analysis of the category of trans-imperial subjects—that is, individual who straddled different civil and political affiliations—in early modern Venice, see Rothman, *Brokering Empire* (see above, p. 38, n. 117). For a brief but compelling discussion of the role of baptism (and rebaptism) in the integration of Byzantine subjects ransomed from foreign lands, and of self-proclaimed Christian Turks living within the borders of the Byzantine Empire, see R. Shukurov, *The Byzantine Turks, 1204–1461* (Leiden, 2016), 59–64.

67 Bossy, "Blood and Baptism," 133 (see above, p. 158, n. 27).

68 Alfani, *Fathers and Godfathers*, 53 (see above, p. 158, n. 27).

69 Alfani, *Fathers and Godfathers*, 23–24, points out that several church councils in the thirteenth century attempted to

a single infant was accompanied by as many as twenty godparents. This custom, which is attested in Venice, produced a small civic procession that encapsulated the rich meanings of baptism and amplified its significance as a ritual of identification and social and civic demarcation.[70]

THE CENTRAL DOME: VISIONS OF DIFFERENCE, PARADIGMS OF ASSIMILATION

The renovation and monumental redecoration of the baptistery of San Marco, which imparted increased solemnity and magnificence to the rite of baptism in the basilica, should be understood against the complex environment described above, and in relation to contemporary preoccupations with the nature and meaning of community, citizenship, and sociopolitical order. To be clear, the baptistery imagery did not function as a visual manifesto of Venice's immigration and citizenship policies. Instead, it gave visual form to concerns about belonging and integration that were central to Venice's political and social consciousness in the fourteenth century.[71] Those concerns crystallize with particular intensity in the iconography of the baptistery's central dome.

Debra Pincus has convincingly related the dome's depiction of the Mission of the Apostles to Venice's colonial claims. Each apostle is represented in the mosaic (the primary model for which the scholar identifies with a ninth-century Byzantine manuscript of the *Homilies* of Gregory of Nazianzos) as he performs the sacrament of baptism in a different region of the world.[72] These

regions are all carefully labeled, and the characters animating the scenes are meticulously differentiated by means of colorful costumes and facial features. The Eastern flair of the image and its topographic and ethnographic accuracy represent a primary example of Venetian self-concerned maneuvering of sacred history and religious imagery. The regions of the apostles' missions marked the furthest reach of Venice's own commercial empire, and the ultimate horizon of the city's economic and political claims. Thus the Mission of the Apostles, like the visual hagiography of St. Isidore, both reflected and legitimized Venice's international ambitions.[73]

But Venice's colonial expansion also forced the government and civic community to question the meaning of Venetian identity and its boundaries. More specifically, the administration of Venice's expanded state—a vast but territorially fragmented space inhabited by communities of different ethnic, cultural, and religious affiliations—compelled Venice to renegotiate ideas of foreignness, integration, and inclusion. And it required its governors to establish ways to identify, legally differentiate, and rule over the residents of the different enclaves that formed the Venetian polity. Awareness of these concerns provides an additional interpretative layer for the iconography of the dome. The Mission of the Apostles, with its vivid representation of all nations of the earth being "made one" in and through the sacrament of baptism, is an image of Christian unity in difference. Hence the dome did not manifest only Venice's imperialist impetus. Instead, by ideally bringing together all Christianized lands, the dome invoked an ecumenical ideal, consistent with contemporary unionist debates and with Venice's emerging self-perception as appointed champion of Christianity in the East. In addition, the mosaic evoked the diversity of the social fabric that derived from Venice's expansionism, and the complex balance between practices of assimilation and differentiation that Venice's expanded state entailed.

limit the number of godparents, probably indicating that the practice of including multiple godparents was widespread.

70 Chauvard, "'Ancora che siano'" (see above, p. 160, n. 33).

71 These concerns had already materialized in an earlier artistic intervention, to which Pincus has rightly called scholarly attention. In 1346, at the same time as the high altar was renewed, Andrea Dandolo also supervised the restoration of the thirteenth-century sculptures above the central portal of the basilica. As scholarship has amply discussed, those sculptures powerfully conveyed notions of cosmic and social order and hierarchy. Their restoration in the trecento signals the renewed importance of those notions in Dandolo's times. See above, chapter 1.

72 Pincus, "Venice and Its Doge," 259 (see above, p. 36, n. 112), relates this iconography to the ninth-century *Homilies* by Gregory of Nazianzos, BnF, Gr. 510, fol. 426v. Leslie Brubaker notes that in Byzantium this manuscript remains isolated in its emphasis on the actual rite of baptism: L. Brubaker, *Vision and Meaning in Ninth-Century Byzantium: Image as*

Exegesis in the Homilies of Gregory of Nazianzus (Cambridge, 1999), 245. I am thankful to the author for sharing this reference with me.

73 Pincus, "Geografia e politica" (see above, p. 49, n. 150).

FIGURE 76. Central aisle, dome of the Pentecost, twelfth century. San Marco, Venice. Photo courtesy of the Procuratoria di San Marco.

Perhaps most intriguingly, the Mission of the Apostles offered a scriptural and visual paradigm of assimilation that was metaphorically significant for ongoing processes of identification, assimilation, and exclusion within the enlarged Venetian state. In the Middle Ages, foreigners were routinely identified by their unfamiliar clothes, and clothing was a potent means of identification.[74] In this context the mosaic of the dome, which differentiates the nations primarily

74 On fashion as a distinctive marker of foreignness in Venetian sources, see Larivière and Salzberg, "People Are the City," 793. The nations of the earth also appear in the eleventh-century decoration of the eastern dome of Hosios Loukas: there they are confined to the spandrels, and differences in clothing and headgear are less prominent.

through meticulous rendering of their local costumes, provides a vigorous representation of variety and foreignness. Admittedly this was not the first visual representation of ethnic diversity in San Marco: the nations of the earth had already been differentiated by dress and headgear in the twelfth-century Pentecost dome (Fig. 76), and the Old Testament mosaic cycle executed in the thirteenth century in the west atrium placed great emphasis on the visible aspects of ethnic and religious otherness.[75] If foreignness had already been conveyed through clothing and skin color in the basilica, the central dome of the baptistery was nonetheless uniquely explicit in visualizing how such differences might be reconciled into unity by means of conversion. In contrast with the rich diversity of the attendants' clothing—and with the exception of the Ethiopian neophyte, whose skin color is visibly darker—the catechumens immersed in the baptismal fonts form a visually homogenous group, within which individuals are differentiated only by age and hairstyle. Literally "stripped bare" of their most apparent markers of identity, the neophytes express the unifying force of baptism, which renders all men equal before God and gives them a new (Christian) identity.[76] At a time when the Venetian social and political bodies were being fundamentally redefined, this

image (and the rite of baptism celebrated in this space) provided its viewers with an opportunity to reflect on how communities are made and organized, what keeps them together, and how differences and contradictions may be reconciled into an orderly, cohesive whole.[77]

HIERARCHY, AUTHORITY, AND INVESTITURE

As a ritual of individual initiation that was nonetheless public in nature, baptism significantly contributed to defining and stabilizing medieval communities and affirming their internal structures and hierarchies. Through baptism the neophytes joined the civitas. In so doing, they acquired a range of political and social rights, and secured for themselves the protection and safety that derived from membership in an ordered polity. Yet entering the civic community also implied accepting and subscribing to its norms and hierarchies. This sheds important light on the nexus between medieval baptistery building and urban crises. Crises forced subjects-citizens and governors to question the grounds of their living together: the foundations and justice of the laws by which they all abided, the legitimacy and authority of the institutions that issued those laws and that were given the coercive power to ensure that they be respected, and—crucially—the fairness of the principles and modes of participation of individuals and social groups to the res publica. In a word, crises invited medieval communities to readdress three interconnected questions: what was the civitas, who ruled it, and how? From this perspective, the semantics of medieval baptism and baptisteries was fundamentally political, as was the vision of orderly and unified fraternity that they performed against the contradictions of civic life. In turn, these observations provide a useful framework within which to interpret the visual program of the baptistery of San Marco, with its emphasis on iconographies of power and hierarchy.

75 Blake De Maria interprets the Pentecost mosaic as a public representation of human diversity that reflected the prevailing attitude in Venice: De Maria, *Becoming Venetian*, 15–16 (see above, p. 35, n. 105). On the representation of ethnic and religious difference in the atrium of San Marco, and for a reading of its imagery in relation to Venice's mercantile ethos and political ambitions in the East in the thirteenth century, see T. E. A. Dale, "Pictorial Narratives of the Holy Land and the Myth of Venice in the Atrium of San Marco," in Büchsel, Kessler, and Müller, *Atrium of San Marco*, 247–70 (see above, p. 43, n. 134). Most recently, Dandolo's visual programs in San Marco were examined through the interpretative lens of race in T. E. A. Dale, "Cultural Encounter, Race, and a Humanist Ideology of Empire in the Art of Trecento Venice," *Speculum* 98.1 (2023): 1–48. This stimulating article was published after the completion of my manuscript. Examining fourteenth-century Venetian approaches to race, genealogy, and religious difference as they were manifested in the visual programs of San Marco and the ducal palace, Dale's study provides an ideal counterpart to our reflections on Venetian attitudes toward citizenship and assimilation. I am very grateful to the author for alerting me to his publication.

76 On questions of baptism and assimilation in medieval theory and practice, see among others M. L. Colish, *Faith, Fiction, & Force in Medieval Baptismal Debates* (Washington, DC, 2014).

77 On the political resonance of the Mission of the Apostles, and of ethnically diversified representations of the nations of the earth in medieval art, see P. H. D. Kaplan, "Introduction to the New Edition," in *The Image of the Black in Western Art*, vol. 2, pt. 1, *From the Demonic Threat to the Incarnation of Sainthood* ed. D. Bindman and H. L. Gates Jr. (Cambridge, MA, 2010), 1–30; and P. H. D. Kaplan, "Black Africans in Hohenstaufen Iconography," *Gesta* 26.1 (1987): 29–36.

Authority and investiture are a main thrust of the mosaic cycle, which combines a range of visual types widely employed in the Byzantine East with iconographies that were primarily or exclusively popular in Italy and Western Europe, producing a distinctive visual meditation on the nature of divine power and its transmission. At the summit of the western barrel vault, conspicuous rays of light connect the effigy of the Ancient of Days to the prophets below him; and a similar luminous beam descends onto Christ in the scene of the baptism, manifesting the illuminating power of divine grace and the authority that proceeds from divine investiture. The iconographic type of the Ancient of Days (based on the prophetic vision in Daniel 1) was uncommon in late medieval Italy, but widespread in the monumental and portable arts of the late Byzantine and Orthodox world. Byzantine theologians alternately identified the object of this vision as God the Father, Christ, or the manifestation of the divine glory that was shared by the Father and Son. Regardless of these theological differences, most medieval commentators interpreted the Ancient of Days as an image of power and dominion over time, and as a visual metaphor for the bestowal of divine authority on Christ.[78] As an image that addressed universal power, its origin, and its transfer, the Ancient of Days represented an ideal incipit to the baptistery's religious and political program.

In the light of Venetian concerns about authority and its transmission, the mosaics of the central and eastern domes also acquired additional meanings. The Mission of the Apostles offers a paradigm for how power is transmitted and received. In the Gospel of Luke, Jesus "called the Twelve together and *gave them power and authority*," before sending them to proclaim the kingdom of God (Luke 9:1–2). The mosaic in the central dome of the baptistery reveals similar emphasis on the proceedings of authority and the meaning of executive power. Christ's unfurled scroll delivers a direct order, expressed in the imperative: "Going

into the world, preach the gospel to all creatures. Whoever will believe and will be baptized [and will be saved]." The apostles conscientiously execute the order, demonstrating by their example the nexus between authority, investiture, and compliance with a higher command.

The iconography of the eastern dome, too, which represents Christ in Majesty surrounded by the nine angelic hosts, is concerned with order and hierarchy. To be sure, the image's primary function is religious. It powerfully relates the eschatological implications of baptism, and the role of angels as assistants on the path to (individual and collective) salvation.[79] Yet representations of the heavenly hierarchy naturally also manifested widely held ideas about cosmic order, and the notion that all beings emanated from God's wisdom and were arranged hierarchically according to their proximity to him. In addition, medieval understandings of the Last Judgment, which the dome also evokes, engaged contemporary ideas about justice, order, and authority both earthly and divine: medieval men and women believed that human history would culminate in an authoritative legal proceeding, within which each soul would be carefully scrutinized.[80]

As promulgators of divine dispositions, angels were specifically identified in medieval political theory as an embodiment of the law, and as impartial assistants in God's judgment at the end of time.[81] More specifically, the idea of an orderly hierarchy of angels had long been thought of as the heavenly model of earthly *taxis*, in both Byzantium and the West.[82]

78 See G. K. McKay, "The Eastern Christian Exegetical Tradition of Daniel's Vision of the Ancient of Days," *JEChrSt* 7.1 (1999): 139–61; and G. K. McKay, "Illustrating the Gospel of John: The Exegesis of John Chrysostom and Images of the Ancient of Days in Eleventh-Century Byzantine Manuscripts," *Studies in Iconography* 31 (2010): 51–68.

79 The ultimate goal of angelic activity, as medieval theologians saw it, was to assist humankind on its path to salvation, leading men and women into beatitude. S. Chase, *Angelic Spirituality: Medieval Perspectives on the Ways of Angels* (New York, 2002), esp. 2. On the role of angels in leading humans toward salvation, and on all other aspects of medieval angelology, see also D. Keck, *Angels and Angelology in the Middle Ages* (Oxford, 1998).

80 K. Shoemaker, "The Devil at Law in the Middle Ages," *RHR* 228.4 (2011): 567–86. For a compelling discussion of the connections between baptismal rite, the decoration of late medieval baptisteries, and the apocalypse, see Derbes, "Washed in the Blood of the Lamb" (see above, p. 46, n. 143).

81 S. Sinding-Larsen, ed., *Christ in the Council Hall: Studies in the Religious Iconography of the Venetian Republic, ActaIRNorv* 5 (Rome, 1974), 173.

82 See Keck, *Angels and Angelology*, 67, n. 90, with further references.

Owing to their theological importance, cherubs, seraphs, and other angelic figures proliferate in the monumental arts of Byzantium and the West. In Byzantine domes and spandrels they appear as attendants of Christ, either physically supporting his mandorla or surrounding the central image of the Pantokrator or the Virgin and Child. In other instances, angelic throngs occupy the lower portions of the dome or drum, as in the parekklesion of the Chora church in Constantinople. They feature as participants in the Heavenly Liturgy, or they support the luminous disc or

throne on which Christ sits as Judge or as Divine Wisdom. The eastern dome of the baptistery taps into these visual traditions: as mentioned above, Christ lifts both his hands in a gesture of double blessing that is unusual in Italy, but common among fourteenth-century fresco cycles in the Balkans, and he is surrounded by fiery angels holding candles (see above, Fig. 75, and Fig. 77 for a comparative example).

Monumental renditions of the nine angelic orders, though conceptually developed in the late antique East by pseudo-Dionysios the

FIGURE 78.
Angel weighing
souls, from the
Heavenly Hierarchies,
Guariento di Arpo,
completed by 1354.
Padua, Museo d'Arte
Medievale e Moderna.
Photo courtesy of
Comune di Padova.

FIGURE 79.
Angel weighing souls,
from the baptistery.
San Marco, Venice,
baptistery. Photo
courtesy of the
Procuratoria di
San Marco.

fig. 78

Areopagite, are uncommon in Byzantium.[83] Instead, they became common currency in the painterly traditions of late medieval Europe, where angelic hierarchies offered a visual translation of coeval notions of order, both social and cosmic.[84] Closest to Venice, the lords of Padua erected and decorated a new private chapel in their palace in the 1350s. Built at the same time as the baptistery of San Marco, the Cappella

83 On the theological genesis of the nine orders of angels in early Syrian writings, see B. Bruderer Eichberg, *Les neuf choeurs angéliques: Origines et évolutions du thème dans l'art du Moyen Âge* (Boulogne-Billancourt, 1998), 8–9.

84 Bruderer Eichberg, *Les neuf choeurs angéliques*, 9.

fig. 79

dei Carraresi also included a majestic sequence of painted panels bearing images of the angelic orders that share precise iconographic similarities with those in San Marco (Figs. 78 and 79). The Paduan chapel, which was decorated by Guariento di Arpo, also featured an Old Testament fresco cycle that gave further prominence to angelic intervention, and emphasized the role of angels as divine helpers and executors of divine will.[85] The program of this space

85 For an introduction and extensive bibliography, see D. Banzato, F. Flores d'Arcais, and A. M. Spiazzi, eds., *Guariento e la Padova carrarese* (Venice, 2011), 129–37, no. 16; and Z. Murat, *Guariento: Pittore di corte, maestro del naturale* (Cinisello Balsamo, 2016), 91–94, 132–47. See also the earlier reconstruction by I. Hueck, "Proposte per l'assetto originario

is routinely understood as a visual encomium to the lords of Padua, whom it implicitly casts as recipients of God's favor and command, imparted through the ministry of the angels.[86] This generic interpretation of angelic presence as a sign of divine approval may be extended to the baptistery of San Marco, where the angelic hosts hover above the representation of Venice's governors on the east wall, simultaneously granting divine legitimation and celestial assistance to the city's leaders.

Yet late medieval thought attributed more cogent political significance to the orderly organization of angelic ranks, which were specifically understood as a metaphor for the orderly organization of the state. Drawing on a long-standing tradition, Jacobus de Voragine indicated in the *Golden Legend* that angelic hierarchies were analogous to the orders of earthly powers. According to his interpretation, the highest ranks (Seraphim, Cherubim, and Thrones) were the celestial equivalents of chamberlains, councilors, and assessors, the officers who worked in immediate contact with the ruler. Other officials have duties pertaining to the overall government of the kingdom: the commanders of the army and the judges in the courts of law belong to this class and are akin to the second trio of angelic orders. Finally—Jacobus concludes—the state comprises minor officials, such as prefects, bailiffs, and the like, who are put in charge of a particular aspect of the regime: these are similar in function to the lowest triplet of angelic ranks.[87] The political potency of this image, which combined medieval ideals of a three-tiered society with a richer and more complex hierarchical paradigm for the organs and functions of government, was

familiar to medieval communities, and was flexibly exploited by Republican and seigneurial governments alike.[88] This offers an intriguing, if speculative, interpretive perspective within which to examine the eastern dome of the baptistery.

Outside of San Marco, Venice's governors were eager to exploit the full potential of angelic ranks as an *imago* of the orderly state and a paradigm of corporate harmony and public service. In 1365 (a decade after the completion of the baptistery) the government set out to decorate the newly completed council hall in the ducal palace.[89] The centerpiece of the program, which also included a series of ducal portraits and historical narratives on the side walls, was a monumental fresco of the Coronation of the Virgin in Paradise. The fresco was commissioned from Guariento di Arpo, presumably with full knowledge of his involvement in the painting of the angelic cycles in the Cappella dei Carraresi in Padua. Guariento's fresco in the ducal palace was nearly destroyed by fire in 1577, and only survives in poorly legible fragments (Fig. 80).

In its original arrangement, the Coronation occupied the vast surface of the east wall of the council room, and was positioned immediately above the ducal throne, serving as a visual backdrop for the assemblies of the Great Council.[90]

delle tavole del Guariento nell'ex cappella carrarese di Padova," in *Attorno a Giusto de' Menabuoi: Aggiornamenti e studi sulla pittura a Padova nel Trecento; Atti della giornata di studio 18 dicembre 1990*, ed. A. M. Spiazzi (Treviso, 1994), 83–96.

86 Murat, *Guariento*, 71. See also I. Hueck, "La corte carrarese e i rapporti con Carlo IV di Boemia," in Banzato, Flores d'Arcais, and Spiazzi, *Guariento*, 81–86, for an interpretation of the Old Testament cycle with reference to the relations between the rulers of Padua and Charles IV of Bohemia, who visited the city in 1354.

87 Jacobus de Voragine, *Golden Legend*, 589 (see above, p. 76, n. 56). For reference works on medieval approaches to social hierarchies, see above, p. 29, n. 74.

88 See Boskovits, *Mosaics*, 259 (see above, p. 167, n. 51), where the representation of the angelic hierarchies is connected with Brunetto Latini's discussion of angels and angelic orders in his political works.

89 On the decoration of the hall, see Sinding-Larsen, *Christ in the Council Hall*; A. Martindale, "The Venetian Sala del Gran Consiglio and Its Fourteenth-Century Decoration," in *Painting the Palace: Studies in the History of Medieval Secular Painting* (London, 1995), 144–92; C. A. Wamsler, "Merging Heavenly Court and Earthly Council in Trecento Venice," in *Negotiating Secular and Sacred in Medieval Art: Christian, Islamic, and Buddhist*, ed. A. Walker and A. Luyster (Farnham, 2009), 55–73; and C. A. Wamsler, "Picturing Heaven: The Trecento Pictorial Program of the Sala del Maggior Consiglio in Venice" (PhD diss., Columbia University, 2006).

90 The original iconography of the fresco has been reconstructed on the basis of the fifteenth-century altarpiece of the cathedral of Ceneda, which modern interpreters have understood as a direct imitation of Guariento's work in Venice. The layout of the council room is generally derived from sixteenth-century representations of the hall. On the iconography of the fresco, see Banzato, Flores d'Arcais, and Spiazzi, *Guariento*, 54. In the same volume, see also the catalogue entry authored by F. Riccobono, "Paradiso," in Banzato et al., *Guariento*, 212–15, no. 38. The Ceneda altarpiece is currently preserved in the Gallerie dell'Accademia di Venezia (inv. 1). On the arrangement

Rows of angels, saints, and prophets flanked the central image of Christ and the Virgin, conjuring an image of the heavenly court. As scholars have long noted, the members of the celestial hierarchy sat on thrones that were set at right angles to the central throne of the Virgin and Christ, and this arrangement mirrored that of the Venetian council hall itself. The magistrates' seats were arranged in long rows that did not face the east wall and the doge but were instead aligned with the longitudinal walls of the room (Fig. 81).[91] The symmetry between the orderly rows of angels, prophets, and saints in the fresco and the seating of the Venetian magistrates effectively blurred the boundary between sacred and secular realms. As Caroline Wamsler has persuasively argued,

the image, offering a paradigm of order, hierarchy, and legitimate transmission of authority, was both descriptive and normative. On the one hand, the fresco invited viewers—primarily the members of the Great Council—to appreciate the continuity and similarity between the organization of the celestial hierarchies and the order of the Venetian state. On the other hand, the image indicated how the state *ought* to function, and the ways in which individual officers and different ministries within government ought to relate to each other and to the higher components of the state. The spatial functioning of the room sustained the analogy between earthly and heavenly hierarchies, while also firmly placing the Venetian state and its rulers under the protection and jurisdiction of the Virgin and Christ.[92]

FIGURE 80.
Coronation of the Virgin in Paradise, Guariento di Arpo, ca. 1365. Venice, ducal palace. Photo courtesy of the Fondazione Musei Civici di Venezia.

of the council hall, see Martindale, "Sala del Gran Consiglio," 80, figs. 3, 92.

91 Wamsler, "Picturing Heaven," 204–6, with further references.

92 Wamsler, "Merging Heavenly Court." See also Wamsler, "Picturing Heaven." For a concise but factually detailed introduction to Guariento's Paradise and to the overall decorative

FIGURE 81. The Great Council Hall of the ducal palace prior to the fire of 1577, from Giacomo Franco, *Habiti d'huomeni et donne venetiane con la processione della Serma Signoria [. . .]* (Venice, 1610) (lacks pagination). Digitized by the Getty Research Institute, https://archive.org/details/habitidhvomenietoounse/page/n27/mode/2up.

In the baptistery, the program's political implications were inevitably subordinated to the liturgical functions of the space, as well as to its theological and devotional meanings. Yet like the ducal palace, the baptismal space provided a stage for the ritual appearance of the doge and the Signoria during the Easter Vigil and may have invited comparisons between the ranks of Venetian governors who were physically present in the space and the heavenly orders represented in the dome. Such comparisons would be further encouraged by the Crucifixion mosaic on the east wall of the baptistery, which was the backdrop for the religious rituals of Holy Saturday. For the first time in Venice, the east wall lunette presented a doge and two officials, all rendered anonymously, kneeling at the foot of the cross. How would contemporaries have received and understood the mosaic, and what vision of government did it convey? The next three sections attend to this question, first by situating the mosaic within its local and broader visual environments, and then by examining it in relation to two critical

program of the council hall, and further references, see Murat, *Guariento*, 82–86, 194–99.

concerns in late medieval political theory: the meaning of "temperate rule" and the locus of sovereign power within the state.

A Humble Sovereign?
The Crucifixion Mosaic as a State Portrait

Scholars have long focused their attention on the monumental mosaic of the Crucifixion on the east wall of the baptistery. Located in the most sacred and best visible area of the chapel, behind the altar and to the east of the baptismal font, this wall memorializes the Incarnation and sacrifice of Christ, on which pivots the visual discourse of salvation that is articulated in the baptismal space, as well as the pictorial meditation on the divine ordering of time and the cosmos. At this level, the image of the doge and courtiers gathered in prayer at the foot of the cross and surrounded by the holy patrons of Venice may legitimately be read as an act of public supplication.

Images of supplicants—rendered as private citizens or in their public uniforms—were popular in fourteenth-century Venice, where male and female devotees were variously represented in painting and sculpture as they sought the intercession of the Virgin and the saints.[93] Like the donors in those images, the Venetian leader and his retinue besought the help of Christ and Venice's supernatural patrons to restore the well-being of their community. In addition, the image of collective piety would provide an appropriate visual accompaniment to the liturgies and devotions of the paschal week, which conspicuously involved the doge and Venice's governing elite, and which included rituals of prostration before the cross on Holy Friday. Also, the inclusion of a state portrait within the Crucifixion signaled the dual significance of baptism as both a religious sacrament and a ritual of civic initiation. Finally, it provided an image of public contrition and devotion that befitted the space's function as a ducal funerary chapel.

Indeed, the closest visual parallels for the east wall mosaic are found in ducal funerary art.

To be clear, no other monumental image of doges kneeling at the foot of the crucifix has survived from before the decoration of the baptistery. But two fourteenth-century ducal tombs included portraits of the deceased doge as a supplicant.[94] Doge Bartolomeo Gradenigo (r. 1339–1343), Andrea Dandolo's immediate predecessor, was buried in the northwest corner of the atrium of San Marco. The front of his chest tomb included a stone relief of the Virgin and Child with St. Mark and (presumably) St. Bartholomew, as well as a diminutive portrait of the doge kneeling at the feet of the Virgin (Fig. 82). A more direct visual precedent for the baptistery mosaic is provided by the tomb monument of Doge Francesco Dandolo (r. 1329–1339), situated in the chapter hall of the Franciscan foundation of Santa Maria Gloriosa dei Frari. The tomb includes a lunette-shaped panel painting executed by Paolo Veneziano. Placed under a stone aedicule and immediately above the doge's sculpted sarcophagus, the painting features a central image of the Virgin and Child flanked by St. Francis and St. Elizabeth. The doge and his wife are portrayed as kneeling supplicants on either side of the Virgin and Child: represented roughly on the same scale as the surrounding saintly figures, the doge and dogaressa are being introduced to the central couple by their namesakes, who touch

93 For a useful repertoire of images of supplicants in Venice, see A. M. Roberts, "Donor Portraits in Late Medieval Venice c. 1280–1413" (PhD diss., Queen's University, 2007).

94 A third, and earlier, example may have existed in the church of San Salvador. Marino Sanudo briefly mentions that Doge Marino Morosini (r. 1249–1253) commissioned a "mosaic tomb" in the church of San Salvador: Sanudo, *Vitae ducorum*, 555 (see above, p. 1, n. 1). According to this passage, the doge was represented in a kneeling position before the image of Christ. Regrettably, Sanudo provides no indication concerning the specific iconography of Christ's image. Confusingly, Dandolo, *Chronica per extensum descripta*, 304 (see above, p. 21, n. 47), connects Morosini with an extensive mosaic campaign in San Salvador but makes no reference to the doge's tomb, leaving open the question of the position and iconography of the latter and the relation between the tomb and the decoration of the main apse. Modern authors have suggested that in keeping with the dedication of the church, the doge's tomb probably featured a representation of Christ enthroned. E. Concina, "San Salvador: La fabbrica, l'architettura," in *La chiesa di San Salvador: Storia, arte, teologia*, ed. G. Guidarelli (Padua, 2009), 9–28. On the importance of distinguishing between the mosaic decoration of the apse and that of the tomb, sometimes conflated by scholars, see S. Piazza, "Mosaici d'oro nelle chiese di Venezia (IX–XIV secolo): Luci sull'ingente patrimonio perduto," *Convivium* 7.1 (2020): 54–79, at 72–74.

FIGURE 82.
Tomb of Doge
Bartolomeo Gradenigo,
ca. 1343. San Marco,
Venice, narthex.
Photo courtesy of
the Procuratoria di
San Marco.

them on the shoulder as a sign of protection and favor (Fig. 83).[95]

The overall composition of the baptistery mosaic is markedly similar to Paolo Veneziano's painting. Also comparable is the choice to depict saintly and secular figures within the same pictorial space. Yet the mosaic also significantly departs from that image. To begin with, it is not directly attached to or visually aligned with a ducal tomb. Further, the devotional image of the Virgin and Child is replaced by the Crucifixion, which had never before been included in a ducal funerary monument. Third, the doge is not being introduced by any intercessory figures. Instead, he kneels in close proximity to Golgotha, and his clasped hands and upward-facing gaze mirror the bodily posture of the Virgin, while she stands

behind the doge without touching or gesturing toward him. Fourth, the doge is not represented alone (as in Gradenigo's tomb), nor is he accompanied by his spouse or family (as in Francesco Dandolo's funerary monument). And he is not identified by any titulus or dedicatory inscription. Together, these elements indicate that the mosaic may have allowed funerary associations, but the commemoration of a deceased doge was not its primary function.[96]

95 See C. Guarnieri, "Il monumento funebre di Francesco Dandolo nella sala del capitolo ai Frari," in *Santa Maria Gloriosa dei Frari: Immagini di devozione, spazi della fede*, ed. C. Corsato and D. Howard (Padua, 2015), 151–62, with comprehensive references.

96 Contemporaries evidently appreciated both the potential and the limits of the baptistery image as funerary iconography. Doge Michele Morosini's tomb monument, set up in 1382 in the Dominican church of Santi Giovanni e Paolo, includes a representation of the deceased doge kneeling at the foot of the crucifix. This image, executed in mosaic, unambiguously evokes the Crucifixion mosaic in the baptistery. Unlike the latter, however, it resorts to the usual conventions of funerary art: the doge is accompanied by his namesake, the archangel Michael, who explicitly gestures toward him (as does the Virgin). Also, as in Francesco Dandolo's funerary painting, Morosini is accompanied by the dogaressa, who is represented as a supplicant on the opposite side of the crucifix and is also introduced by her namesake St. John. On the ducal tombs in

FIGURE 83.
Tomb of Doge
Francesco Dandolo,
ca. 1339. Santa Maria
Gloriosa dei Frari,
Venice. Photo courtesy
of Curia Patriarcale
di Venezia.

Instead, the east wall mosaic lends itself to further interpretations that pertain specifically to the political sphere, and more precisely still to questions of political visualization.[97] The depiction of governors as humble suppliants

had a long tradition in both Byzantine and Western political iconography: as we shall see, the mosaic in San Marco significantly transformed both those models, adapting them to reflect the reality of the doge's role as an officer with limited power and the collegial nature of Venetian government.

Representations of imperial *proskynesis* survive (either physically or in the written records) in the monumental and portable arts of Byzantium from the ninth century and became particularly popular during Palaiologan times. From the thirteenth century, images of kneeling emperors offering gifts, praying, or atoning before celestial figures became a favorite visual means to express ideas of imperial humility, debasement, and gratitude, and

Santi Giovanni e Paolo, see, for example, Pincus, *Tombs of the Doges*, 148–66 (see above, p. 146, n. 9); and T. Franco, "Scultura e pittura del Trecento e del primo Quattrocento," in *La basilica dei Santi Giovanni e Paolo: Pantheon della Serenissima*, ed. G. Pavanello (Venice, 2013), 67–75.

97　In an important essay, Hans Belting explicitly raises this question, stating that the Crucifixion must have had a political meaning for its patrons, and evokes the possibility that the image may have reflected a situation of political uncertainty. He concludes, however, that for the time being the precise message conveyed by the mosaic remained obscure. Belting, "Bizanzio a Venezia" (see above, p. 37, n. 114).

fig. 84

FIGURE 84.
Emperor in proskynesis, ninth century.
Hagia Sophia, Istanbul, narthex. Creative
Commons CC0 1.0 Universal Public
Domain Dedication, https://commons
.wikimedia.org/wiki/File:Hagia
_Sophia_Imperial_Gate_mosaic_2.jpg.

FIGURE 85.
Hyperpyron of Michael VIII Palaiologos,
1258–1282. Washington, DC, Dumbarton
Oaks Coins and Seals Collection,
inv. BZC.1948.17.3590. Photo courtesy
of Dumbarton Oaks, Coins and Seals
Collection, Washington, DC.

fig. 85

were used widely in Palaiologan art and gold coinage (see, for example, Figs. 84 and 85).[98]

These artworks render Byzantine emperors as they bow before saints, angels, the Virgin, and Christ, represented either standing or sitting enthroned. However, to the best of my knowledge, images of imperial proskynesis do not appear in conjunction with the Crucifixion—an indication perhaps that the latter was deemed unsuitable to communicate the ideal of universal, unrestricted power that underpinned even the most modest of Byzantine imperial effigies. This also appears to be so in the political imagery of Byzantium's rival dynasties in the fourteenth century. The example of Serbia is particularly apposite, as King Stefan Uroš IV Dušan's coronation as emperor in 1346 (and his death in 1355) neatly coincided with Dandolo's dogeship. In continuity with his royal predecessors, Dušan exploited the potential of public imagery to sustain and cement his political claims. But unlike his ancestors, who had worked within the ideological (and iconographic) boundaries of kingship, Dušan competitively fashioned himself as a universal ruler analogous to the Byzantine emperor.[99] In his monumental portraits, the sovereign appears alone or in the company of other members of his dynasty. He is routinely represented in full figure, and ostensibly dons Byzantine imperial regalia. In agreement with Palaiologan imperial iconography, Emperor Dušan is occasionally represented as he performs proskynesis, as was probably the case in the sculpted lunette above the portal of the church of the Holy Archangels at Prizren, Dušan's mausoleum.[100] However, to the best

of my knowledge, in none of his monumental imperial portraits—which explicitly aimed to present the Serbian emperor as legitimate holder of and successor to the Byzantine *imperium*— does Dušan kneel before the crucifix.[101]

By contrast, the iconography of a ruler prostrate at the foot of the crucifix had a long tradition in the West. There, as Robert Deshman has argued in relation to Carolingian examples, images of kings or emperors kneeling before the Crucifixion manifested ideas about the meanings and purpose of rulership that were compatible with the concepts of humility and atonement conveyed by Byzantine proskynesis images, but that had more specific political implications than their Byzantine counterparts (Fig. 86). The Crucifixion was the ultimate paradigm of *humilitas* and *humiliatio*. Christ, the celestial ruler, had willingly submitted himself to physical suffering, derision, and an unjust, violent death for the salvation of humankind. In this way Christ offered an authoritative definition of rulership as public service, and identified the ideal ruler as a servant who was worthy of governing precisely because he was capable of putting his self-interest aside and humbling himself for the sake of his community. Images of prostration of a royal worshipper before the crucifix (which mirrored actual practices of adoration of the cross on Good Friday) echoed the Savior's humility and his self-effacing sacrifice, producing a political image that was at once one of exaltation and humbleness. On the one hand, humility was cast as a key political virtue, and a necessary condition for the legitimate and balanced exercise of power. On the other hand, the sovereign was reaffirmed

98 Reference works on imperial proskynesis and images of emperors as suppliants and *ktetors* are A. Cutler, *Transfigurations: Studies in the Dynamics of Byzantine Iconography* (University Park, PA, 1975), 53–110; and Hilsdale, *Byzantine Art and Diplomacy*, 122–46 (see above, p. 14, n. 8).

99 For an introduction and further bibliography, see S. Marjanović-Dušanić and D. Vojvodić, "The Model of Empire: The Idea and Image of Authority in Serbia (1299–1371)," in *Sacral Art of the Serbian Lands in the Middle Ages*, ed. D. Vojvodić and D. Popović (Belgrade, 2016), 299–315, at 302.

100 D. Popović, "Predstava Vladara nad 'Carskim Vratima' Crkve Svetih Arhanđela kod Prizrena," *Saopštenja* 26 (1994): 25–36. Stefan Dušan is also represented as he performs proskynesis in front of St. Nicholas in the well-known icon donated by the Serbian rulers to the basilica of San Nicola in Bari. The icon was made before Dušan was crowned king and emperor,

and he is represented as a youth in the panel: Bacci, *San Nicola*, 247, no. 4.7, 25–261, with further references (see above, p. 112, n. 31).

101 In a few significant cases—such as the frescoes on the east wall of the room on the second floor of the belfry tower at the Ascension Church at Žiča Monastery (painted in 1221–1227), the frescoes of the narthex at Chilandar on Mount Athos, and at Mileševa—the dynastic portraits of Serbian rulers were arranged near the scene of the Crucifixion. But the sovereigns were not depicted within the scene, nor were they kneeling at the foot of the cross: V. Deur-Petiteau, "Images, spatialité et cérémoniel dans le narthex des églises en Serbie médiévale," in *Visibilité et présence de l'image dans l'espace ecclésial: Byzance et Moyen Âge occidental*, ed. S. Brodbeck and A.-O. Poilpré (Paris, 2019), 329–54, with further bibliography.

as the representative of Christ on earth and as the recipient of his authority.[102]

Prizing humility as a political virtue and presenting the activity of government as a form of public service was not only rooted in Christian understandings of power, both Western and Byzantine. It was also specifically suited to Venice's political and institutional ethos in the trecento. As we have seen, the mid-century was a turning point in Venice's political and institutional history, and the doge emerged from this period of transition as a uniquely ambivalent figure who combined the symbolism of charismatic leadership with the limitations of civil service. The mosaic on the east wall ideally captured the complex and ambivalent nature of ducal authority, thereby helping to give visual form to a new idea and a novel practice of government as they began to coalesce in the mid-fourteenth century.

In the baptistery mosaic, the doge occupies a position of great privilege, proximate to Golgotha. He is nearer to Christ than the Virgin Mary herself, his mantle brushing against the stones of Golgotha, streaked with bright red lines that visually recall the rivulets of blood issuing from Christ's feet (Fig. 87). The doge is represented in full ceremonial attire, wearing the red mantle lined with ermine and the pointed berretta that constituted the uniform of ducal authority in the trecento, and that also appeared in contemporary Venetian coinage. Unlike his two companions, who occupy marginal areas of the composition and are ostensibly being introduced into the sacred scene by St. Mark and St. John, he does not appear to require the intercession of the Virgin, who stands nearby but does not gesture to him. The doge's persona is placed at the heart of the

102 R. Deshman, "The Exalted Servant: The Ruler Theology of the Prayerbook of Charles the Bald," *Viator* 11 (1980): 385–432. See also W. Falkowski, "The Humility and Humiliation of the King—Rituals and Emotions," in *State, Power, and Violence*, ed. M. Kitts et al. (Wiesbaden, 2010), 163–96; and B. Weiler, "The 'rex renitens' and the Medieval Idea of Kingship, ca. 900–ca. 1250," *Viator* 31 (2000): 1–42.

FIGURE 87.
Detail of the
Crucifixion.
San Marco, Venice,
baptistery. Photo
courtesy of the
Procuratoria di
San Marco.

composition, and—as Pincus has succinctly put it—in full view of divine order, as spelled out in the dome above him.[103]

Nonetheless, the choice to publicly represent the ruler as a supplicant at the foot of the cross, rather than, for example, near the image of Christ enthroned, places more emphasis on

service and sacrifice than on privilege and personal power. In addition, the doge is not alone in his devotion and contemplation of Christ's sacrifice, nor is he accompanied by figures that would amplify his personal authority. He is prominently *not* escorted by his wife and children, as was customary for dynastic portraits of kings and emperors at the foot of the cross, such as the near-contemporary representations of Robert

103 Pincus, "Venice and Its Doge," 271 (see above, p. 36, n. 112).

fig. 88

FIGURE 88. Crucified Christ worshipped by Robert of Anjou and Sancha of Majorca, Master of the Franciscan tempera, 1331–1336. Milan, private collection. Photo in the public domain (https://www.mdpi.com/2673-8392/1/3/62).

FIGURE 89. The bishop and doge welcome the arrival of St. Mark's body in Venice, twelfth century. San Marco, Venice, chapel of San Clemente. Photo courtesy of the Procuratoria di San Marco.

FIGURE 90. Communal prayer and *Apparitio*, mid thirteenth-century. San Marco, Venice, south transept. Photo courtesy of the Procuratoria di San Marco.

PONTIFICES · CLERVS · PLS · DVX MTE SERENVS LAVDIB AQ CHORIS EXCIPIVN TDVLCE CANORIS ·

fig. 89

+ TRIDVO PLEBS IEIVNAT DMQ PRECANTR.
PETRA PATET SCM · MOX COLLIGIT & COLLOCANT ·

fig. 90

of Anjou and his wife Sancha of Mallorca (Fig. 88) or Charles IV and his consort Elizabeth of Pomerania, represented as supplicants on either side of a painted Crucifixion in St. Wenceslas chapel in Prague.[104]

Furthermore, no ecclesiastical authorities appear next to the doge in the baptistery mosaic, as they had in the (earlier) ducal imagery in the chapel of San Clemente, above the portal of Sant'Alipio, and in the south transept (Figs. 89 and 90). Instead, in the Crucifixion mosaic the doge is flanked by two lay officers. The "corporate" nature of the image sets it apart from both Byzantine iconographic traditions of imperial atonement and devotion and Western images of royal and imperial humility and turns the mosaic into a powerful statement about the limits of ducal power, the collegial, participatory nature of Venice's government, and the legitimation and accountability mechanisms that ensured its functioning.[105]

Scholars have offered a range of different identifications for the two side figures in the mosaic. Pincus and Belting have separately suggested that the character on the left should be identified with Venice's great chancellor, the (nonpatrician) notary at the helm of the ducal chancery.[106] The latter was the heart of Venice's bureaucratic apparatus. By the fourteenth century the ducal chancery was charged with the production and preservation of all Venetian public deeds, including the deliberative and judicial records issued by the organs of government. Notaries from the chancery were required to attend and take minutes of the discussions and decisions taken by the Great Council, and to intervene—with or without being solicited—in case of incorrect or conflicting interpretations of the law during said councils. In addition, chancery employees supported the organs of government in their daily activities and acted as diplomatic envoys, both on their own authority and accompanying Venetian ambassadors.[107] The chancery's crucial role in ensuring the stability and smooth running of the state would justify the representation of its chief officer in the prestigious context of the baptistery. It would also agree with the privileged position that the great chancellor occupied in civic processions: sixteenth-century sources indicate that on the occasion of the highly ritualized *andate ducali*, the chancellor walked in close proximity to the

104 On the chapel of St. Wenceslas in St. Vitus's cathedral, Prague, see L. Ormrod, "The Wenceslas Chapel in St. Vitus' Cathedral, Prague: The Marriage of Imperial Iconography and Bohemian Kingship" (PhD diss., Courtauld Institute of Art, 1997). See also H. Sedinova, "The Symbolism of the Precious Stones in St. Wenceslas Chapel," *Artibus et Historiae* 20.39 (1999): 75–94; and H. Sedinova, "The Precious Stones of Heavenly Jerusalem in the Medieval Book Illustration and Their Comparison with the Wall Incrustation in St. Wenceslas Chapel," *Artibus et Historiae* 21.41 (2000): 31–47. On the depiction of King Robert of Anjou and Queen Sancha, which was presumably located in the chapel of the Annunciation in Santa Maria Maddalena, Naples, and is now in a private collection in Milan, see A. S. Hoch, "Pictures of Penitence from a Trecento Neapolitan Nunnery," *ZKunstg* 61.2 (1998): 206–26; and K. Weiger, "The Portraits of Robert of Anjou: Self-Presentation as Political Instrument?," *Journal of Art Historiography* 17 (2017), https://arthistoriography.files.wordpress.com/2017/11/weiger.pdf.

105 On the broader strategies of visual self-fashioning of Venetian administrators, with emphasis on Renaissance and early modern times, see H. K. Szépe, "Distinguished among Equals: Repetition and Innovation in Venetian Commissioni," in *Manuscripts in Transition: Recycling Manuscripts, Texts and Images*, ed. B. Dekeyzer and J. Van der Stock (Leuven, 2005), 441–47; and H. K. Szépe, *Venice Illuminated: Power and Painting in Renaissance Manuscripts* (New Haven, CT, 2018). The same scholar has also concisely looked at ducal representations in the legal works of Andrea Dandolo: H. K. Szépe, "Doge Andrea Dandolo and Manuscript Illumination," in *Miniatura: Lo sguardo e la parola; Studi in onore di Giordana Mariani Canova*, ed. F. Toniolo and G. Toscano (Cinisello Balsamo, 2012), 158–62.

106 Pincus, "Venice and Its Doge," 271; and Belting, "Dandolo's Dreams," 149 (see above, p. 37, n. 114). Although later visual evidence ought to be used with caution, the Great Chancellor's ceremonial gear in a sixteenth-century ink and watercolor illustration comports with our mosaic: "A Grand Chancellor," *Mores Italiae*, New Haven, CT, Yale University Library, Beinecke 457 (lacks page number), published in M. Widener and C. W. Platts, *Representing the Law in the Most Serene Republic: Images of Authority from Renaissance Venice* (New Haven, CT, 2016), 8, no. 6.

107 M. Pozza, "La cancelleria," in Cracco and Ortalli, *Storia di Venezia*, 2:349–69 (see above, p. 134, n. 102); M. Pozza, "La cancelleria," in Arnaldi, Cracco, and Tenenti, *Storia di Venezia*, 3:51–85 (see above, p. 14, n. 9). See also Arnaldi, "La cancelleria ducale" (see above, p. 26, n. 62); F. de Vivo, "Heart of the State, Site of Tension: The Archival Turn Viewed from Venice, c. 1400–1700," *Annales: Histoire, Sciences Sociales* 68.3 (2013): 699–728; and G. Trebbi, "Il segretario veneziano," *AStIt* 144 (1986): 35–73.

doge, directly preceding the bearers of the ducal throne and crown.[108]

The figure on the opposite side of the lunette has generated more controversy. Debra Pincus has suggested that the figure may represent a young nobleman at the beginning of his *cursus honorum*.[109] Rudolf Dellermann has alternatively proposed that the character may be identified with a procurator of San Marco.[110] The latter hypothesis is supported by coeval visual evidence: the earliest written oath of office to have been preserved for the office of the procurators of San Marco is Paolo Belegno's (1367).[111] As was customary in documents recording the duties of public officials, the illuminated initial of this *commissione* includes a representation of a procurator: his outfit and long headgear are distinctly reminiscent of those sported by the character in the baptistery lunette, and suggest that the latter may be identified as a procurator of San Marco (Fig. 91). This identification would be in line with the increased emphasis placed on the procurators' office both in the chapel of Sant'Isidoro and on the pala d'oro, which permanently recorded the individual names of several procuratori alongside those of doges. Furthermore, the presence of a patrician civil servant and a *cittadino* public officer alongside the doge would ideally allude to Venice's two main social groups and their contribution to the running of the res publica.

Regardless of the specific identification of the two side characters in the lunette, their presence inflects the semantics of the humble ruler. In addition to presenting a vision of power as service, the east wall visually asserts that the Venetian state was based not on individual charisma but on shared and well-organized responsibilities. Reinforcing this message, the doge and the lay officers wear different uniforms but perform identical gestures: they all kneel with clasped hands and look upward toward the crucifix. And they are all deprived of names, suggesting that they are not intended to be viewed as individuals. Instead, each of them stands for the public office that he holds, while collectively the doge and officers represent the government of Venice as a cohesive and unified group, intent on enhancing the well-being of the community. Also enshrined in this image of political collaboration and cohesion is a powerful message about political legitimation and accountability. Kneeling at the foot of the cross, and below the image of Christ in Majesty in the east dome, the doge and officers rule together, with God's endorsement and the support of the city's holy patrons. Notably, the Venetian state is represented in direct contact with the divine, and therefore as directly invested with it. Yet unlike images of imperial or royal power, the Venetian state is rendered here as a plurality. Divine investment and the sovereignty that derives from it are shared among the different branches of Venice's government: no individual officer—not even the doge—can claim them exclusively, and each branch of government simultaneously sustains and oversees the other organs.

The representation of Venice's doge and civil servants praying in unison compares interestingly with other images of rulership in the baptistery. Opposite the east wall, the western vault of the antebaptistery presents its viewers with two strikingly different instantiations of kingship: Herod and the Magi (Figs. 92 and 93). Medieval thought habitually identified Herod as the first enemy of Christ, and the foremost paradigm of the unjust and violent tyrant.[112] By contrast, the three Magi, who were given great visual prominence in the Venetian baptistery,

108 Muir, *Civic Ritual*, 190–200 (see above, p. 133, n. 98). Muir indicates that the transition to a processional form that segregated citizens and patricians, organizing them into two separate groups that processed before and after the doge, took place between the thirteenth and sixteenth centuries, intensifying after the Serrata of 1297.

109 Pincus, "Venice and Its Doge," 271.

110 Dellermann, "'Iussu ducis,'" 277–83 (see above, p. 95, n. 1), cited in Pincus, "Venice and Its Doge," 271.

111 *Giuramento di Paolo Belegno, procuratore di San Marco de Ultra*, BMCC, cl. 3, 315. The oath was sworn on 9 March 1367.

112 M. A. Skey, "Herod the Great in Medieval Art and Literature" (PhD diss., University of York, 1976); M. A. Skey, "Herod the Great in Medieval European Drama," *Comparative Drama* 13.4 (1979): 330–64; and W. B. Gwyn, "Cruel Nero: The Concept of the Tyrant and the Image of Nero in Western Political Thought," *History of Political Thought* 12.3 (1991): 421–55.

FIGURE 91.
Incipit of Paolo Belegno's *commissione*. Venice, Biblioteca del Museo Civico Correr, cl. 3, 315, fol. 11r. Photo courtesy of the Fondazione Musei Civici di Venezia.

were routinely interpreted as models of legitimate, divinely inspired political judgment, and occasionally (and more pointedly) promoted by secular governments as biblical exempla of the independence of political rule from spiritual authorities and ecclesiastical investiture.[113]

Complementing this brief catalogue of biblical sovereigns, the north wall provides two further examples of royal misconduct, vice, and misuse of power in the figures of Herod, Herodias, and

113 For a detailed discussion of the political implications of the Magi in the fourteenth century, particularly in relation to

ideas of sacral kingship and the autonomy of secular power from spiritual authorities, see M. C. Brown, "The 'Three Kings of Cologne' and Plantagenet Political Theology," *Mediaevistik* 30 (2017): 61–85.

fig. 92

fig. 93

FIGURE 92. The Magi visit Herod. San Marco, Venice, baptistery. Photo courtesy of the Procuratoria di San Marco.

FIGURE 93. Adoration of the Magi. San Marco, Venice, baptistery. Photo courtesy of the Procuratoria di San Marco.

FIGURE 94.
Salome's Dance.
San Marco, Venice,
baptistery. Photo
courtesy of the
Procuratoria di
San Marco.

her daughter Salome (see above, Fig. 62, and Fig. 94).[114] Evoking the dangers of tyranny that were intrinsic to monarchic rule, these deviant rulers stand in sharp contrast to the remissive stance of the doge and public officers on the east wall, as well as with another—more secluded, yet highly relevant—depiction of ducal authority: the effigy of Doge Pietro I Orseolo, situated on the intrados of the arch that connects the central and eastern bays, deserves specific discussion in relation to the political semantics of the baptistery (Fig. 95).

Pietro I Orseolo (928–987), who was actively promoted as a *santo novello* in Venice in the fourteenth century, was elected doge in 976. He occupied the ducal seat only for a brief time, for in 978 his piety pushed him to abdicate the throne and leave Venice, taking vows as a Benedictine

monk at a monastery in the Pyrenees.[115] In the baptistery, he is represented as a tonsured clergyman clad in a white tunic and black mantle. He stares up toward the dove of the Holy Spirit, his eyes penetrated by a ray of divine light that signifies his divine inspiration. His identity as both blessed *and* doge is clarified by the accompanying inscription, which reads: "Blessed Pietro Orseolo, doge of Venice." Notably, the figure casually holds the bejeweled ducal *corno* in his lowered hand, rather than wearing it on his head—signaling his humility and his voluntary abandonment of the ducal office.

As Karen McCluskey has convincingly argued, this unique visual representation of the tenth-century doge should be examined in connection with the nearly contemporary textual account of his life provided by Andrea Dandolo in his

114 For an introduction to medieval understandings of Salome, see W. C. Jordan, "Salome in the Middle Ages," *Jewish History* 26.1/2 (2012): 5–15.

115 M. Pozza, "Pietro Orseolo, santo," *DBI* 83 (2015), https://www.treccani.it/enciclopedia/santo-pietro-orseolo_(Dizionario-Biografico)/.

FIGURE 95. Doge Pietro I Orseolo. San Marco, Venice, baptistery. Photo courtesy of the Procuratoria di San Marco.

Chronica per extensum descripta.[116] The chronicle explicitly presents Pietro Orseolo as an ideal doge and an exemplum of self-sacrifice and civic

virtue.[117] Initially reluctant, Orseolo was only persuaded to take up the ducal office at the insistence of his fellow citizens, who implored him to restore order and stability after his predecessor, Pietro IV

116 K. McCluskey, "Official Sanctity alla Veneziana: Gerardo, Pietro Orseolo and Giacomo Salomani," *Conserveries Mémorielles* 14 (2013), http://journals.openedition.org/cm/1718; and McCluskey, *New Saints* (see above, p. 104, n. 14).

117 Dandolo, *Chronica per extensum descripta*, 179–84 (see above, p. 21, n. 47).

Candiano, had selfishly attempted to establish a ruling dynasty, against the Venetian custom of electing their rulers, and was therefore deposed and murdered during a civic revolt. Called in to remedy the instability that followed, Pietro Orseolo agreed to rule as doge, solely out of his exceptional sense of civic responsibility and piety, and remained in office for two years. After restoring the orderly running of the state, he left the ducal seat and retreated to the Pyrenees, where—as Dandolo specifies—he died in the odor of sanctity, performing several miracles after his death.[118]

The baptistery portrait condenses this narrative into a single, powerful image. Some interpreters have argued that the mosaic underscores Orseolo's divinely inspired rule, and by extension Andrea Dandolo's own attempts to promote the doge as a quasiregal ruler.[119] But Pietro Orseolo wears a religious habit, rather than the ducal uniform, and holds the berretta in his hand rather than sporting it on his head. Piercing his eyes, divine light leads him away from political office rather than guiding his decisions as a ruler. Whether the image was intended to represent the doge in the aftermath of his abdication, at the moment of his departure from office, or in his dual identity as saint and ruler, it unquestionably suggests that Pietro I Orseolo was entirely oblivious to personal political ambition and intent instead on following God's call. As the perfect incarnation of the medieval notion of "reluctant ruler"—hesitant to take power and armed with the utmost humility, modesty, and justice—the portrait of the tenth-century doge simultaneously reinforced and offered historical legitimation to the vision of humble rulership conveyed by the Crucifixion mosaic.[120]

Juxtaposing the doges and officers of Venice with biblical rulers and saintly figures, the baptistery cycle situated the past and present of Venice firmly within the history of salvation. This has traditionally been interpreted as direct evidence of Venice's established ideas of civic predestination, and as a further manifestation of the city's triumphal stance and imperial aspirations. I have argued differently. The state portrait on the east wall attended to the question of "how to rule" at a time when Venice was embroiled in the uncertainties and instability of accelerated change. In this context, the mosaic—which built on but also significantly modified Byzantine and Western visual representations of humble leadership—visualized political authority as a form of service and a corporate enterprise, and it presented the doge as a paradigm of both distinction *and* self-effacement, simultaneously conforming to and participating in the process of critical political reflection and reconfiguration that took place during Dandolo's dogeship in response to ongoing institutional and societal tensions.

My interpretation rests on a strong assumption: that notions of corporate government, shared rulership, and public service (or comparable concepts) were actually available to fourteenth-century Venetians to think about and imagine the state. In an essay on the thirteenth-century mosaic decoration of the atrium of San Marco, Henry Maguire advocates the integration of late medieval political thought into our understanding of the art of San Marco. More specifically, Maguire suggests that the Old Testament cycles in the west and north atrium of the basilica reflected the same ideological transformations discussed throughout this book, and the changing role of the doge within the government. In his view, the emphasis placed on the lives of Joseph and Moses in the atrium mosaics, and the (otherwise unexplained) omission of the life cycles of such paradigmatic biblical kings as David and Solomon, had significant political implications. Joseph and Moses were good administrators, who acted as just guides and protectors for their subjects. But they were *not* royal figures, which made them more suitable biblical models for the office of the doge at a time of consolidation of the communal structures of the city's government in the thirteenth century.[121]

118 Dandolo, *Chronica per extensum descripta*, 184.

119 McCluskey, *New Saints*, 73–79; and McCluskey, "Official Sanctity," which builds on Pincus's broader interpretation of Dandolo's political vision. Pincus, *Tombs of the Doge* (see above, p. 146, n. 9); Pincus, "Hard Times and Ducal Radiance" (see above, p. 37, n. 113); and Pincus, "Venice and Its Doge."

120 On the reluctant ruler, see Weiler, "'Rex renitens'" (see above, p. 186, n. 102).

121 H. Maguire, "The Political Content of the Atrium Mosaics," in Büchsel, Kessler, and Müller, *Atrium of San Marco*, 271–79 (see above, p. 43, n. 134).

Maguire's argument allows us to situate the mosaics of the baptistery within a longer history of interactions between political theory, institutional transformation, and image making in San Marco. Yet it also indirectly testifies to the radical novelty of the fourteenth-century mosaics, and of the Crucifixion image in particular. The political message of the atrium mosaics was implicit: its transmission relied on medieval viewers' ability to draw analogies between sacred history and current political realities. Instead, the Crucifixion mosaic explicitly depicted the Venetian government, providing us with an ideal vantage point from which to explore the imbrications between political imagery and political thought. In what follows, I do not intend to argue that the mosaic translated a specific political theory or tract into images. Rather, I wish to suggest that texts and images were equally constitutive in nature. They both had an active agency, exercising the political imagination of contemporaries and enabling them to understand, describe, and enact political change. In this context, ongoing theoretical debates about the state serve not so much to explain the Crucifixion image as to illuminate the conceptual horizon within which the imagery of the baptistery was created, and therefore the broad questions and concerns that its visual program most likely addressed.

THE CRUCIFIXION MOSAIC IN CONTEXT (1): VENICE AS TEMPERATE RULE

Scholarship on Venice has amply debated rulership as service and self-sacrifice in relation to the early modern myth of the city. The Venetian governing elite, it is generally assumed, purposefully crafted over time an idealized public image of the city as a stable and harmonious polity that rested on the selfless public service of its patricians and the orderly organization of its constitution and institutions. Successfully disseminated (both internally and abroad) through a vast textual and visual apparatus, this idealized image placed Venice at the heart of Renaissance and early modern discussions about republicanism and civic virtue.[122]

This overwhelming emphasis on the myth of Venice and its impact on early modern European political thought has often deflected scholarly attention from the fact that ideas of power limitation and government as public service were already central to theoretical debates about the state in the fourteenth century, particularly in the writings of the legal and political theorists of Italian city-states. More specifically, ideas of political representation, limited power, and shared government were explicitly developed in the thirteenth and fourteenth centuries by legal and political thinkers dealing with the theoretical and practical challenges of giving legitimation to urban governments and wrestling with the crisis of communal regimes across Italy.[123]

Before the thirteenth century, medieval political discourse, however varied, had been based on two tenets. First, the need for organized government originated in the fall of man, which—by precipitating humankind into the state of sin—made it necessary to establish the dominion of one person (or institution) over others, to repress and punish evil actions and maintain order. Second, all forms of rule were God-given lordships, and the best form of government was (in abstract terms at least) monarchy, wherein one virtuous individual worked for the benefit of

122 On the artistic embodiment of the myth of Venice, see, for example, Rosand, *Myths of Venice* (see above, p. 35, n. 105); and Fenlon, *Ceremonial City* (see above, p. 1, n. 1). On the history and historiography of the myth of Venice, see the essays gathered in Martin and Romano, *Venice Reconsidered* (see above, p. 19, n. 30); and E. Crouzet-Pavan, *Venice Triumphant: The Horizons of a Myth* (Baltimore, 2002). On Venice's idealized image in foreign political thought, see F. Chabod, "Venezia nella politica italiana ed europea del Cinquecento," in *La civiltà veneziana del Rinascimento*, ed. D. Valeri (Florence, 1958), 29–55; F. Gaeta, "Alcune considerazioni sul mito di Venezia," in *Bibliothèque d'Humanisme et Renaissance* 23.1 (1961): 58–75; R. Pecchioli, "Il 'mito' di Venezia e la crisi fiorentina intorno al 1500," *Studi Storici* 3.3 (1962): 451–92; F. Gilbert, "The Venetian Constitution in Florentine Political Thought," in *Florentine Studies: Politics and Society in Renaissance Florence*, ed. N. Rubenstein (London, 1968), 463–500.

123 A review of literature on this topic falls beyond the scope of this chapter. For an introduction to medieval political thought, and for contributions on several of the questions addressed in this section and in the next, with further bibliography, see J. H. Burns, ed., *The Cambridge History of Medieval Political Thought c. 350–c. 1450* (Cambridge, 1988). For a very concise introduction, and discussion of Mendicant political theories (which I do not address here), see J. Coleman, "Medieval Political Theory c. 1000–1500," in *The Oxford Handbook of the History of Political Philosophy*, ed. G. Klosko (Oxford, 2011), 180–205. For a rather different focus (primarily on territorial kingdoms), see also Canning, *History of Medieval Political Thought* (see above, p. 43, n. 133).

his subjects. Within this framework, sovereignty rested with the ruler, who held it personally and irrevocably and transmitted it through hereditary succession.[124] These beliefs came under scrutiny in the late thirteenth and fourteenth centuries, a period of intense theoretical reflection and practical political experimentation in both Europe and Byzantium.[125]

Political ferment was particularly intense in Italy, where Republican city-states attempted to justify their own existence and to explain the functioning of their elective governments. The stability of Italian communes was severely challenged by internal strife and institutional fragility, which frequently led to painful transitions to seigneurial rule over the course of the trecento. Simultaneously, the communes' autonomy and propensity for self-rule clashed with the universal political claims of empire and papacy, under whose authority the urban governments of Italy formally operated. Ideas of civil liberty, power balance and limitation, and political representation and accountability emerged as responses to this tension, and gradually transformed the ways in which medieval communities perceived themselves and their governors.[126] The reform of the Venetian state—which did not neatly conform either to the model of monarchy or to that of other urban republics—took place in this context, as did the redecoration of San Marco. This invites us to reconsider the visual program of the baptistery, and the Crucifixion mosaic more specifically, in relation to those broader developments.

In the second half of the thirteenth century, the translation of Aristotle's *Politics* into Latin provided political commentators with novel terminology and a new theoretical framework to explain the political realities of their time and the complex and diverse institutional fabric of Italian city-states.[127] Aristotle's *Politics* became available in Latin around 1260, when William of Moerbeke translated it at Thomas Aquinas's request.[128] The tract—which enjoyed immense fortune in the later Middle Ages—both expanded and challenged earlier political beliefs.[129] Following Aristotle, it was no longer necessary to conceptualize temporal power as—exclusively—a remedy against human evil and depravity. Instead, medieval theorists were now able to embrace the possibility that living together in an orderly polity might be "altogether natural to mankind," as Aquinas put it;

124 Q. Skinner, *Visions of Politics*, vol. 2, Renaissance Virtues (Cambridge, 2002), 2:15, with further references. These basic tenets applied to both Eastern and Western conceptions of power, but the irrevocability of imperial power and the superiority of dynastic succession were more disputed in Byzantium, where other means of accession—including usurpation—were also considered exceptionally acceptable, insofar as they manifested divine will and resulted in effective rulership. See D. Angelov, *Imperial Ideology and Political Thought in Byzantium, 1204–1330* (Cambridge, 2007), esp. 116–33. For a comparative analysis, see D. Angelov and J. Herrin, "The Christian Imperial Tradition—Greek and Latin," in *Universal Empire: A Comparative Approach to Imperial Culture and Representation in Eurasian History*, ed. P. F. Bang and D. Kolodziejczyk (Cambridge, 2012), 149–74.

125 The most comprehensive study of Byzantine political theory in the later Middle Ages is Angelov, *Imperial Ideology*. Unfortunately, the chronological span of Angelov's study does not include the period of the civil war in the central decades of the fourteenth century. This period still awaits thorough consideration. For a historical overview of the complex political events of this period, see Nicol, *Last Centuries* (see above, p. 13, n. 5); and Nicol, *Reluctant Emperor* (see above, p. 13, n. 5).

126 The political framework for this interpretation of the Venetian program is provided by Quentin Skinner's reading of the political theory and history of Italian communes in the fourteenth century. See particularly Skinner, *Foundations* (see above, p. 43, n. 132); Skinner, *Visions of Politics*, esp. vol. 2. Other influential works that have informed the following sections are

N. Rubinstein, "Le origini medievali del pensiero repubblicano del secolo XV," in *Studies in Italian History in the Middle Ages and the Renaissance*, vol. 1, *Political Thought and the Language of Politics: Art and Politics*, ed. G. Ciappelli (Rome, 2004), 365–81; N. Rubinstein, "Political Theories in the Renaissance," in *The Renaissance: Essays in Interpretation*, ed. A. Chastel (London, 1982), 153–200; Harding, *Medieval Law* (see above, p. 43, n. 133); and J. M. Blythe, *Ideal Government and the Mixed Constitution in the Middle Ages* (Princeton, NJ, 2014).

127 This and the following paragraphs largely follow Skinner, *Visions of Politics*, 2:10–38.

128 Aristotle, *Aristotelis Politicorum libri octo cum vetusta translatione Guilelmi de Moerbeka*, ed. F. Susemihl (Leipzig, 1872). An earlier and partial translation by the same author has also been published as *Aristoteles Latinus*, vol. 29, pt. 1, *Politica (libri 1–2.11): Translatio prior imperfecta interprete Guillelmo de Moerbeka*, ed. P. Michaud-Quantin (Bruges, 1961).

129 See, for example, Rubinstein, "Political Theories"; J. Coleman, "Some Relations between the Study of Aristotle's Rhetoric, Ethics and Politics in Late Thirteenth-Century and Early Fourteenth-Century University Arts Courses and the Justification of Contemporary Civic Activities (Italy and France)," in *Political Thought and the Realities of Power in the Middle Ages*, ed. J. Canning and O. G. Oexle (Göttingen, 1998), 127–57; Skinner, *Visions of Politics*, 2:10–38; and E. Schütrumpf, *The Earliest Translations of Aristotle's Politics and the Creation of Political Terminology* (Paderborn, 2014).

and that living in a city was "living in a perfect community."[130] Concerned with how such living together might best be organized in practice, Aristotle had posited the existence of three types of government: monarchy and aristocracy—both of which were known to medieval writers—and the less familiar category of *politia*, a polity where "the body of the people acts in the name of the common good."[131] This category proved critical to contemporary understanding of the Venetian state, and it offers a useful matrix within which to situate the baptistery mosaic.

In the *Politics*, the three types of constitution described above were discussed as similarly deserving: each of them potentially allowed communities to thrive, and all were equally vulnerable to aberrations. This idea marked a paradigm shift in medieval thought, for it called into question the universal belief that monarchy was the best (indeed, the only viable) form of government. Furthermore, Aristotle reintroduced in the West another cutting-edge category: the mixed constitution. A passage of the *Politics*, as translated by Moerbeke, reads: "there are some experts who maintain that the very best form of polity will be one in which there is a mixture of these different forms of government."[132] The category of mixed constitution—defined as a hybrid form of government that combined elements of different simple regimes—and the positive value attached to it in the *Politics* enabled medieval commentators gradually to move away from established monarchic theories. Beginning with Thomas Aquinas, political writers began to advocate new forms of elective monarchy or rectorship, where the power of the ruler was mitigated by the law and by other branches of government. Even more radically, a growing number of those writers openly supported republican regimes, and endorsed constitutions within which citizens were involved in public affairs and participated in

government, and where—crucially for the argument of this chapter—power was reconceptualized as a form of civil service.[133]

The importance of these discussions for our understanding of Venice's political structures and of contemporary views about its government is hard to overestimate, not least because the city features in some prominent political treatises of this time. In these texts Venice is described as a political anomaly and identified as the closest thing to an embodiment of Aristotle's mixed constitution. Ptolemy of Lucca's influential *De regimine principum* is a case in point. A student of Thomas Aquinas, Ptolemy (ca. 1240–1327) served as the bishop of Torcello between 1318 and 1327, and therefore spent considerable time in Venice.[134] Ptolemy was among the earliest writers to explicitly praise republican regimes over monarchies, based on the (revolutionary) argument that kingship was inevitably coterminous with tyranny. Commenting on the urban governments of Italy, whose governments were based on the principle of short-term appointment, he said, "No one could have rule for life except by the path of tyranny." In this context, Venice's dogeship was discussed as a (positive) political outlier: "The exception is the doge of Venice, who has a temperate rule (*qui temperatum habet dominium*)."[135] Ptolemy did not further elaborate on his statement, nor did he explain exactly what he meant by "temperate rule." Broadly speaking, Latin *temperare* indicates the activities of dividing, measuring, moderating, and refraining—suggesting that Ptolemy identified the limitations imposed on the authority of the doge as a primary antidote against any tyrannical degeneration. Other fourteenth-century writers were more explicit in discussing the structure of the Venetian government and its merits. In his *Treatise on the Four Cardinal Virtues*, Henry of Rimini—who was also a resident of Venice,

130 Thomas Aquinas, *De regimine principum ad regem Cypri*, in *Opuscula Philosophica*, ed. R. M. Spiazzi (Turin, 1973), 257–358, at 257, cited in Skinner, *Visions of Politics*, 2:31.

131 Aristotle, *Politicorum libri*, 179: *quando autem multitudo ad commune conferens vivit*. Translated in Skinner, *Visions of Politics*, 2:32.

132 Aristotle, *Politicorum libri*, 92: *Quidam quidem igitur dicunt, quod oportet optimam politiam ex omnibus esse civibus mixtam*. Translated in Skinner, *Visions of Politics*, 2:32.

133 In addition to Skinner, *Visions of Politics*, see Blythe, *Ideal Government*.

134 On Ptolemy of Lucca (alias Bartolomeo Fiadoni), see L. Schmugge, "Fiadoni, Bartolomeo," *DBI* 47 (1997), https://www.treccani.it/enciclopedia/bartolomeo-fiadoni_(Dizionario-Biografico)/.

135 Both citations as in Ptolemy of Lucca and Thomas Aquinas, *On the Government of Rulers: De regimine principum*, trans. J. M. Blythe (Philadelphia, 1997), 239.

following his appointment as the prior of the Dominican foundation of Santi Giovanni e Paolo in 1304—devotes a lengthy passage to the city.[136] He explains that the "tempering" of rule that differentiated Venice from both monarchical and republican regimes was made possible by the city's mixed constitution, that is, by the fact that power was shared among different offices, and that each governing organ was limited and controlled by the others. This, as he intimated, made Venice the closest—indeed, the only extant—incarnation of Aristotle's ideal "political rule," or *regimen mixtum*.[137]

Both Henry of Rimini and Ptolemy of Lucca lived in Venice in the decades that followed the Serrata of 1297. They were therefore eyewitnesses to the political and institutional transitions that unfolded in the lagoon in the fourteenth century, and it is not implausible that their writings may have expressed views and concerns that were more widely shared in the city. Henry's treatise may have been composed as a preaching aid for Dominican friars, and as a teaching tool for use within the Dominican *studium* of Santi Giovanni e Paolo.[138] If this is true, his ideas (including his praise of Venice) may have enjoyed wide circulation across the city. Intriguingly, Venice emerges

from Henry's and Ptolemy's treatises as an exception within the political landscape of Italy, and as a "threshold" regime: the embodiment of an otherwise abstract ideal of tempered government and mixed constitution that Ptolemy, Henry, and other medieval writers had recently rediscovered through Aristotle's *Politics*.[139]

The discussion above indicates that contemporaries approached Venice as a "threshold" polity that defied established political categories and challenged contemporary political imagination. Also, they specifically identified the Venetian state as a "temperate" regime, where the power of the political leader (the doge) was limited, and where authority was shared among different organs. These ideas resonate with the Crucifixion mosaic and its innovative iconography. By its nature as a state portrait, the mosaic was tasked with visualizing the Venetian state. But Venice was neither a monarchy nor a republic. Thus, no ready-made, established iconography existed to accurately render its regime and the "tempered" authority of the doge, an elected ruler who was nonetheless in office for life. By what means could the specific relations between head of state, government, and civic community be visualized? And how could Venice's unique regime be accommodated within Christian ideologies (and iconographies) of divine legitimation? From this perspective, the visual cycle of the baptistery emerges as a profound exercise in political imagination. New ideas about the state and novel practices of government began to emerge in Venice in response to the challenges of the mid-century and found expression in a novel normative vocabulary that had become available

136 On Henry of Rimini, see C. Casagrande, "Enrico da Rimini," *DBI* 42 (1993), https://www.treccani.it/enciclopedia/enrico-da-rimini_(Dizionario-Biografico)/.

137 *Inter omnes politias que nostris temporibus in populo Christiano fuerunt politia gentis Venetorum ad hoc regimen mixtum videtur appropinquare....* The passage continues with a detailed description of Venice's government and electoral system. It is drawn from Henry of Rimini, *Tractatus de quattuor virtutibus cardinalibus* (Speyer, 1472), treatise 2, chap. 4, pts. 15, 16, as edited and published in D. Robey and J. E Law, "The Venetian Myth and the 'De Republica Veneta' of Pier Paolo Vergerio," *Rinascimento* 15 (1975): 3–59, at 54–56. It was translated in Blythe, *Ideal Government*, 281: "Among all polities that exist among the Christian people in our time, the polity of the nation of Venetians seems to come closest to that mixed government." The treatise's exact date is unknown, but it is generally assigned to the last decades of the thirteenth or early fourteenth century, perhaps during the years immediately following the Serrata in 1297. On Henry of Rimini's view of Venice, see Skinner, *Visions of Politics*, 2:34–35. See also H. A. Siddons, "Virtues, Vices, and Venice: Studies on Henry of Rimini O.P." (PhD diss., University College London, 2000), 274–75, for a review of secondary literature on the subject. Henry of Rimini's treatise makes various references to Venice and would deserve separate treatment in relation to the political structures of the city and to Venice's public imagery in the trecento.

138 Siddons, "Virtues, Vices, and Venice," 262–71.

139 Intriguingly, the identification of Venice as a mixed regime appears to have first appeared in the twelfth century in Byzantium, where Aristotle's *Politics* was known throughout the Middle Ages: M. Hakkarainen, "Regimen mixtum—μικτὴ πολιτεία," in *Roma, magistra mundi: Itineraria culturae medievalis; Mélanges offerts au Père L. E. Boyle à l'occasion de son 75e anniversaire*, ed. J. Hamesse (Turnhout, 1998), 1:111–21. Nonetheless, discussions of Venice as a mixed constitution became more frequent and more systematic from the fourteenth century onward, making it a relevant concept for our discussion of the mosaics of San Marco. For a concise summary of different positions regarding the development of this idea, see S. Toffolo, *Describing the City, Describing the State: Representations of Venice and the Venetian Terraferma in the Renaissance* (Leiden, 2020), esp. 149. More extensively, see also Robey and Law, "The Venetian Myth."

after the translation of Aristotle's *Politics*. As the earliest monumental rendition of ducal authority as an anonymous (and therefore impersonal) office and as a form of public service, and of the activity of government as a shared responsibility among different organs, the Crucifixion mosaic stands as a visual counterpart to contemporary theoretical speculations and institutional experimentations and enters a productive dialogue with those developments.

THE CRUCIFIXION MOSAIC IN CONTEXT (2): SOVEREIGNTY AND REPRESENTATION

As we have seen, the Crucifixion mosaic depicts the doge and officers in the presence of the divine. Thus, like Byzantine images of imperial proskynesis and Western representations of kneeling kings and emperors, the mosaic implies divine endorsement. Yet unlike those images—which emphasized the individual charisma of the king or emperor, and therefore his imperium—the Crucifixion mosaic is ambivalent as to exactly who receives God's investiture. As discussed above, the doge is closest to the crucifix, indicating his priority within the city's religious and political hierarchy. Yet there is no direct engagement between the doge and Christ: no exchange of gaze, no direct contact, and most definitely no sign of divine coronation. This restrained image of ducal power agrees with the increasing limits imposed on the doge's authority at this time. It also conforms to another important development in late medieval political thought and practice: the recovery of classical ideas of *universitas* and legal representation, which we explore in the next section. Taking these debates into consideration will enable us to further illuminate the key role of public imagery in producing and disseminating new ideas about the state.

According to both Byzantine and Western imperial and monarchic theory, legitimate rule had to be based on consent: any ruler's right to rule rested on the original approval of his subjects, who conferred sovereign power on him. Traditionally, this devolvement of sovereign power had been thought of as irreversible: once conceded, sovereignty pertained to the ruler (and was generally transmitted as a hereditary right). The thirteenth and fourteenth centuries witnessed the partial demise of this cornerstone of

monarchic theory. In Byzantium, such intellectuals as Manuel Moschopoulos (born ca. 1265) articulated ideas of imperial rulership as a social covenant, an allegiance between sovereign and citizens that was not divinely imposed, but agreed on by the subjects of the empire to ensure stability and peace.[140] In the West, advocates of the republican governments of Italian city-states were able to repudiate ideas of the irrevocability of the ruler's power through the recovery of ancient ideas of *universitas* and political representation.[141] These developments shed significant light on the transformation of ducal authority in Venice in the fourteenth century, and by extension on its visual representation.

As Quentin Skinner explains, in Cicero's classical formulation, the term *gerere personam* indicated, in essence, the capability of speaking for or in the name of somebody else. This understanding of the concept of persona had a key bearing on ancient and medieval notions of political representation: if representation is conceived as nothing more than acting in the name and on behalf of others, then it follows that in addition to personating actual individuals it is also possible for someone to represent collectives, or even fictional and purely legal entities.[142] Cicero applied this view specifically to the political sphere. For him, it was "the distinctive duty of the magistrate to understand that he bears the person of the civitas."[143] This idea (which separated the notions of legal and physical person and interpreted public duty as an act of personation) gained common currency in the city-states of late medieval Italy, as they

140 Angelov, *Imperial Ideology*, 310–47 (see above, p. 198, n. 124).

141 The paragraphs that follow are largely based on Q. Skinner, "Classical Rhetoric and the Personation of the State," in *From Humanism to Hobbes: Studies in Rhetoric and Politics* (Cambridge, 2018), 12–44. See also Q. Skinner, "Hobbes and the Purely Artificial Person of the State," *The Journal of Political Philosophy* 7.1 (1999): 1–29. I am very grateful to the author for bringing these essays to my attention. For a range of different perspectives on medieval political representation, see also H.-Y. Lee, *Political Representation in the Later Middle Ages: Marsilius in Context* (New York, 2008); and M. Damen, J. Haemers, and A. J. Mann, *Political Representation: Communities, Ideas and Institutions in Europe (c. 1200–c. 1690)* (Leiden, 2018).

142 Skinner, "Classical Rhetoric," 14.

143 Marcus Tullius Cicero, *De officiis*, trans. W. Miller, Loeb 30 (Cambridge, MA, 1913), 126, quoted in Skinner, "Classical Rhetoric," 14.

strove to justify their autonomy and describe how power was devolved in republican regimes.

In this context, legal and political theorists began to use the classical phrase *gerere personam* and the early Christian lemma *repraesentatio* interchangeably, and to identify civic communities as instances of *universitates personarum* and *personae re-praesentate*: that is, as forms of association in which someone was given the power to act on behalf of the institution as a whole.[144] Within this framework, the authority to rule was no longer discussed as a personal and irrevocable prerogative, but—for the first time since antiquity—it was reconceptualized in terms of representation. That is, the power to govern was granted to the ruler on condition that it be exercised in the name of the collective (*in nomine universitatis*), turning the status of the governor into that of a minister or public servant.[145] Groundbreakingly, the covenant between cities and their rulers is described as conditional. It was a temporary concession that the commune could revoke at any time because the *civitas* itself was (and remained) the locus of sovereign power.[146]

The trajectory of ducal authority in the trecento ideally embodied contemporary debates about representative rule. The doge was the head of state, and—unlike the *podestà* who presided over other Italian communal governments—held a lifetime appointment, which gave his reign durability and an elevated status. Also, as chief representative of the Signoria, the doge bore insignia of power that signified the supreme power to rule. But he was elected to the ducal office rather than born into it and did not transmit his power to his descendants. He was subject to the law and was restrained in his power by other branches of government. Crucially, when a doge died, his family coats of arms were displayed upside down next to his bier, and he was ceremonially relieved of all insignia and robes of honor, a potent signal that sovereignty, which did not reside in the individual or his family, had returned to the republic, where it belonged.

These ideas, which jurists and political theorists began to articulate as a way to explicate republican regimes and extricate them from the yoke of papacy and empire, have already been associated with at least one example of Venetian public imagery: a sculpted roundel prominently displayed on the west façade of the ducal palace, where it was most likely positioned in the central decades of the fourteenth century (Fig. 96). The roundel, which had a rich iconographic progeny in Venice, represents a crowned woman, identified by an inscription as the city of Venice. The personified city holds a sword (the *gladius* that symbolized sovereign power in the Middle Ages) and a scale, signifying the exercise of justice. A scroll near her left shoulder reads "Just and courageous on my throne, I keep the furious sea beneath my foot." The image, as Quentin Skinner has argued, does not merely represent Venice as Justice, but metaphorically asserts that the ruler of the city is in fact the *civitas* itself.[147]

This brings us back to the Crucifixion image in the baptistery. Much like the sculpted roundel on the façade of the ducal palace, ducal images in San Marco were both durable and widely visible, and therefore represented highly authoritative means to visualize and advertise the image of the ruler and the state. Representing the doge, the Venetian state, and the fabric and functioning of the Venetian *civitas* demanded a balancing act of political imagination. Representing the doge as a supplicant at the foot of the cross, the Crucifixion cast the doge as an (eminent) servant of the city, rather than its overlord, and presented the activity of government as a *ministerium*—that is, a service exercised by individuals for the betterment of, and in the name of, the community (or *universitas*) that was gathered in the baptistery. Also, by rendering the doge and the two representatives

144 Skinner, "Classical Rhetoric," esp. 21, 29.

145 See the formulation by Giovanni da Viterbo (1304–1374), cited in Skinner, "Classical Rhetoric," 24.

146 See Skinner, "Classical Rhetoric," esp. 31 (on the view of Bartolo di Sassoferrato [1313–1357]), 40.

147 Skinner, "Classical Rhetoric," 32. For a more traditional interpretation of the roundel as personification of Venice as Justice, see Rosand, *Myths of Venice*, 26–33 (see above, p. 35, n. 105). On the roundel, see also Wolters, *La scultura veneziana gotica*, 1:46–47, nos. 49, 178–79 (see above, p. 151, n. 17); Lermer, *Der gotische "Dogenpalast,"* 229–34 (see above, p. 130, n. 86); and Pincus, "The Turn Westward" (see above, p. 37, n. 113).

of the Venetian state as a group, and by situating them *within* the sacred scene, the mosaic intimated that the activity of government was a shared responsibility, and that divine sanction (and therefore, sovereignty) lay with the entire government of Venice rather than exclusively with its doge. Third, by conspicuously omitting the names of the individuals represented in the mosaic, the image suggested that at every level of government authority resided in the office, not in the person holding it—thereby turning the traditional topos of the humble sovereign into a conduit for new ideas of rulership as representation and public service. Much as Christ died on the cross for the salvation of humankind, and just as his actions affected the universal community of Christians, so the Venetian doge and officers act in the name of the Venetian community. Their decisions affect the whole civitas, to which nonetheless they submit, and which they serve. As Petrarch succinctly put it, with characteristic poetic vigor, doges are "dukes, not lords;

actually, they are not even dukes, but honorable servants of the republic."[148]

Conclusion

The baptistery project articulated a complex visual message that was at once religious and political. Its mosaics were designed to offer a sophisticated visual backdrop for the rituals of Christian initiation celebrated in the space. As such, they bore specific connections with the theology of baptism and with its liturgy, as well as with the paschal rituals during which communal baptism was celebrated in San Marco. Consistently with medieval understandings of baptism as the necessary condition for individual and collective redemption, the baptistery of San Marco also articulated a rich visual meditation on divine order and the trajectory of human

148 Petrarch, *Lettere di Francesco Petrarca*, 4:191 (see above, p. 140, n. 119).

FIGURE 96.
Personification of Venice, ca. 1340. Ducal palace, Venice, west façade. Photo by author.

salvation. Finally, and in addition to its religious meanings, the baptistery's mosaic program lends itself to a political reading, suggested by the important civic functions of baptismal buildings in medieval Italy as well as the specific political concerns of Venetian leaders in the mid-century. From this perspective, the mosaics illuminate the complex strategies of visual representation through which the Venetian doge and government explored ideas of authority and its exercise in a changing cultural and political landscape. The medium of mosaic, which was widely used across the Christian Mediterranean; the combination of Latin and Greek alphabet; and the visual emphasis on ethnic difference in the central dome together manifested ideas of a united Christian cosmos and "unity in difference" that emerged at this time in response to Venice's colonial expansion and Ottoman advances in the East. Furthermore, the mosaics offered a visual (biblical) meditation on the meaning of communities and the protocols of their formation and maintenance. Finally, they drew on a diverse repertoire of politically inflected images—to name only two, the Byzantine Ancient of Days and the angelic choirs that were prevalent among the courts of late medieval Italy—to provide a powerful vision of cosmic order and hierarchy at a time of severe instability. In performing such wide-ranging functions, the visual cycle of the baptistery ultimately testifies to the ability of images to "make krisis": that is, to participate in the exercise of critical reflection and reform that was at the heart of all three monumental projects examined in this book, and that enabled the Venetian leaders and their community to ask fundamental questions, defying stasis and enacting change in the face of adversity.

CONCLUSION

Art as Politics

THIS BOOK HAS ARGUED THAT IN THE mid-fourteenth century, Venice faced a phase of instability so severe as to threaten the very foundations of communal living. The crisis challenged the legitimacy, stability, and efficacy of Venetian public institutions. It destabilized its political structures and called into question the rules that regulated the life of the civitas— prompting the government to reckon with fundamental questions about the nature of authority and community and to clarify and reaffirm the legal, political, and administrative foundations of the Venetian state. This questioning was translated into a series of important initiatives, both institutional and artistic, which together reconfigured the Venetian state and its self-image.

The former included significant legal, diplomatic, and historical works. Under Andrea Dandolo's dogeship, the civic statutes were reordered and extended, and the relative responsibilities of government and judges in generating and administering the law were more precisely articulated. The criteria of eligibility for Venetian citizenship were more clearly specified, and the chancery was charged with gathering and organizing the vast and disordered collection of Venice's international treatises, enabling the city more efficiently to ascertain (and advocate) its international privileges and duties and to situate itself more accurately on the world stage. In addition, the first official history of Venice

was also produced at this time, under the doge's supervision. The *Chronica per extensum descripta* comprised a comprehensive review of extant written chronicles and archival documents and resulted in a stable public record of Venice's origins, core values, and institutions, just as they wavered under the combined pressure of natural disasters, the plague, an international war, and dramatic changes in the world order.

This legal and historical opus stemmed from current instability. As the doge wrote in the prefaces to his legal works, legislative reforms represented institutional responses to situations of "urgent necessity," as well as the means through which the government might attempt to remedy "the ugliness of perturbed order" (see above, pp. 27 and 28). Each of those institutional projects entailed the scrutiny, selection, and collation of sources, and the reorganization of scattered data into coherent (and usable) information systems that would allow Venice's governors to take better-informed administrative and political decisions. In other words, as they sifted through messy records and misplaced documents to shed light on Venice's history, diplomatic relations, and constitutional laws, the members of the Venetian chancery and their leaders responded to crisis with a prodigious exercise of collective discernment, aimed at making uncertainty more intelligible and adversity more manageable. Using both the original meaning of the Greek word and modern

theoretical accounts of how crisis can be seen as a pivotal moment of choice, we could say that they responded to crisis with krisis. Reckoning with core political questions, the government's response was as radical as the challenges that prompted it, promoting a new vision of government as service, and of the state as a set of representative institutions. Inevitably for a medieval Christian polity, clarifying "what Venice was" and how it functioned as an organized community also involved a comprehensive review of the city's place in history and in the divinely ordained cosmos.

Throughout this book, we have argued that the artistic renovation of San Marco was pivotal to fulfilling the same purposes as the institutional initiatives just described, and to the dissemination of Venice's emerging self-image. Andrea Dandolo's artistic campaigns were equally significant in relating crisis, in its threefold meaning of boundary situation, discernment, and (last) judgment. First, they manifested the predicaments that afflicted Venice, expressing the concerns of the city's governors and community in the face of those events and offering a visual meditation on the reciprocal relation between human suffering, divine order, and eternal salvation. Second, they lent visual form to emerging ideas about community, authority, and rulership, actively contributing to the vast program of state (re)formation and institution building undertaken by the government at this time. Finally, they *presaged* crisis. Dandolo's projects subsumed strife into a vision of eternal and universal order, within which the activity of government was presented as a form of mediation—both fallible and indispensable—between the contingencies of history and the stability of divine law.

The altar area—the liturgical and political heart of the basilica of San Marco—was the first to undergo a thorough restoration during Dandolo's rule. In its new configuration, the altar powerfully reasserted the presence of St. Mark in the basilica, and his unfaltering intercessory role on behalf of Venice and its government. It also promoted a new image of the evangelist as a solicitous protector of the sick, poor, and underprivileged, adjusting his saintly profile to accommodate the individual devotional needs of pilgrims and Venetian faithful. In addition, Dandolo's renovation transformed the altar area

into a site of historical certification and political legitimation whose message dovetailed with the agenda of the government's historical and documentary initiatives. The dedicatory inscription on the pala d'oro recapitulated and certified the history of the altarpiece, tying it to the names of the doges and procurators who had commissioned and renovated the artwork over time. This textual addition subtly inflected the semantics of the pala d'oro, whose antiquity came to stand as material proof of the stability and continuity of Venetian political institutions against evidence of change in the mid-fourteenth century. Memorializing doges and procurators together, the inscription also projected onto the past an image of government as a collegial, patrician enterprise that fully emerged on Venice's political horizon only in the aftermath of the Serrata. In this way the high altar simultaneously registered a significant shift in Venice's political ideology and contributed to realizing and normalizing what was in fact a highly disputed constitutional reform. Finally, the altar program capitalized on the different aesthetic qualities of the Byzantine pala d'oro and of Paolo Veneziano's pala feriale, and on the semantic potential of visual and material contrast. It combined painting and enamel work, and juxtaposed lively narrative representations of Venice's miraculous past with the stillness of iconic saintly portraits. And it brought together a touching, fleshly image of the Man of Sorrows with the radiant representation of Christ enthroned at the center of an orderly celestial hierarchy. In so doing, the high altar created a visual and material palimpsest that served not so much to illustrate as to embody the Christian mysteries of the incarnation and revelation and intimated that human history and its inscrutable twists were compatible with God's orderly plans for humankind and eternal life.

The complex interplay between the contingencies of history, the functions of government, and the economy of salvation was also central to the visual program of the chapel of Sant'Isidoro. Built during the war against Genoa, the chapel demonstrates the importance of conflict and alterity in the (re)definition of medieval communal identities. It promoted into the Venetian pantheon a saint whose origins in Chios spoke to Venice's engagement with the eastern

Mediterranean and its rivalry with Genoa. By advertising St. Isidore's physical presence and protection, the chapel evidently served to justify and sanction Venice's military efforts in the Aegean as well as its newly recovered identity as a crusading power. In addition to its overt patriotic and polemical functions, and in continuity with the renovation of the high altar, the chapel of Sant'Isidoro also catered to the devotional needs of a community in danger. On a first level, St. Isidore's pictorial vita presented its beholders with a model of Christian faith and endurance through trials that may have offered comfort and intercession to Venice's leaders and community. On a second level, the chapel's mosaics addressed the relation between Christian excellence and political virtue. As men and women who had achieved perfection during their earthly existence, saints inevitably prompted questions about the attainability of Christian virtue by ordinary individuals and communities, and about the relation between earthly conduct and the reward of eternal life. In the chapel of Sant'Isidoro, this question receives a specific political inflection. St. Isidore's vita faces the visual account of Doge Domenico Michiel's military expedition to Chios, setting up a visual parallel between the early Christian military saint and the twelfth-century doge commander. This juxtaposition in turn encouraged reflections on the compatibility between the pursuit of Christian virtue and the requirements and challenges of political leadership, probing the meaning of "just rule."

How to rule well—that is, how to ensure the safety and stability of the city while conforming to divine law—was a key concern of every medieval polity, but it was also Andrea Dandolo's specific preoccupation as a leader in times of crisis. This emerges clearly from the prefaces to his legal collections as well as from the epistle that the doge addressed to Petrarch in the wake of the war with Genoa. The decision to wage war was troubled and contentious, and ultimately justified as an extreme measure to defend peace and the homeland. In this context, the chapel of Sant'Isidoro and its visual account of Domenico Michiel's military campaign offered an eminent historical precedent for Dandolo's role as a wartime doge. The mosaics portrayed Domenico Michiel as a strong military leader, a guarantor of justice, and a pious Christian ruler, providing a paradigm of ducal conduct that both oriented and validated Dandolo's own comportment.

Ostensibly presented as an exercise in historical recollection, the chapel nonetheless expressed a number of new political ideas. In San Marco, the mosaics first explicitly cast the doge as a member of the patrician elite of the city. Also for the first time, they lent visual form to the doge's dual role as imago of the Venetian state abroad and an officer with limited powers at home. This innovative representation of ducal authority was complemented by the inscription on the east wall. This epigraph functioned similarly to the dedicatory inscription on the pala d'oro, celebrating together the doges and procurators who attended to the construction of the martyr's shrine, and thereby promoting an image of the Venetian state as a cohesive and stable set of institutions and a collegial enterprise shared among peers. Overall, the chapel of Sant'Isidoro mobilized hagiography and secular history to explore the meaning of good leadership and to illuminate the duties and responsibilities of governors in steering their communities towards Christian excellence, and thus salvation.

While the chapel of Sant'Isidoro marshaled the power of narrative and microhistory—one saintly vita and one episode from the Venetian past—to articulate new ideas about political virtue, the baptistery addressed those issues on a cosmic scale, by turning to the paradigmatic and universal. The mosaic program traced the history of human salvation from the times of Old Testament prophecies, through the activity of St. John the Baptist, the advent of Christ and his death on the cross, and the mission of the apostles to the glorious vision of Christ as universal ruler at the end of time. In parallel, the mosaics also offered a vision of cosmic order that encompassed the three domes and placed specific emphasis on the making of communities, the nature of hierarchy, and the proceedings of divine authority. As an ensemble, then, the baptistery mosaics addressed how divine law unfolded in time and what structure it imparted to the universe and signaled the direct relation between the purifying effects of baptism and the achievement of individual and communal salvation at the end of time.

The key civic role played by baptisteries in the life of medieval urban communities imbued the religious program of the baptismal chapel of San Marco with additional political meaning. At the same time as international geopolitical realignments, social frictions and administrative adjustments in the colonies, and domestic strife challenged Venice's stability and civic harmony, the imagery of the baptistery articulated a grand (and reassuring) vision of communal cohesion, cosmic order, and ineluctable historical progress leading to divine revelation. In addition, the mosaics provided their viewers with biblical paradigms of orderly collective action and communal inclusion and assimilation and invited them to reflect on the transmission of divine authority and the role of executive powers in ensuring a peaceful and ordered communal life. In so doing, they mirrored contemporary debates about the nature of citizenship and community and about authority and its delegation.

The baptistery represented the Venetian doge and civil officers as witnesses to the Crucifixion, and therefore assigned to the city's government a place in the economy of the cosmos, as well as direct responsibility in realizing the trajectory of salvation. This image has traditionally been interpreted as evidence of Venice's self-assurance and triumphal ideology in the fourteenth century. I have argued differently. At a time when the question of "how to rule" and how to live together peacefully became matters of vital concern, the mosaic articulated a powerful reflection on the functions and purposes of the state, redefining political office as service and self-sacrifice, and government as a set of institutions that acted on behalf of and for the well-being of the entire community.

I have argued that the artistic renovation of San Marco was a political intervention, and an exercise in critical imagination aimed at thinking through and redefining the foundations of the state at times of instability. This enables us to reconsider the meaning of artistic interaction and visual diversity in Venice and beyond. Crises, to paraphrase Arendt, are disruptive situations that call into question the validity and efficacy of established beliefs, norms, and patterns of behavior. They challenge "common sense," pushing individuals and communities to read-dress fundamental questions in order to reassert

the validity of previously shared answers or create new ones. Images and artifacts both engage with and produce such "common sense." They may embed, endorse, resist, or challenge prevailing cultural, social, and political beliefs. Yet whatever their specific inflection or posture, they inevitably exercise the core values of the community that produces and views them, and they partake in the interactions, tensions, and collaborations that transform the collective worldview over time. If this is true, then the visual is unlikely to remain unaffected in situations of environmental and epistemic instability. On the contrary, radical uncertainty will cause established aesthetic habits and hierarchies to vacillate. Conversely, visual forms will register patrons', artists', and viewers' ongoing search for appropriate means to express and understand the new reality, their experiences of it, and the new questions (and answers) that arise from the encounter with uncertainty.

Positing a relation between art and crisis does not dictate the specific formal qualities by which the visual will manifest ongoing instability in any given context. It does, however, provide a new mode of inquiry into the vexed question of artistic diversity—no longer interpreted as a mere symptom of artistic progress (or lack thereof), or as the generic emulation of more prestigious artistic traditions, but as a visual response to uncertainty.

To begin with, crisis encourages us to appreciate more fully the active, generative nature of Dandolo's projects, their experimental character, and the finesse with which they select and combine specific visual means to fulfill precise expressive purposes. To state the obvious, all three monumental projects were "visually diverse." But what defined visual diversity was different in each case: the physical juxtaposition of artworks of different origins and chronologies, the architectural reframing of an Eastern relic, the commixture of political and religious iconographies from different geographic and cultural realms. The ways in which old and new, and foreign and local, were combined were also different, as was the visual experience that each project created for its viewers. The high altar juxtaposed a Byzantine metalwork retable with a Venetian painted altarpiece, creating a visual exemplum that engaged the beholders in a complex meditation about

history and eternity and the role of government as an intermediary between earthly and divine. The ensemble formed by the pala d'oro and pala feriale had no direct precedents, and created a prototype so admired as to be imitated widely across the region. The chapel of Sant'Isidoro was less innovative in its design, suggesting perhaps that the promotion of a "new" and yet poorly known saint required orthodox props to be successful. Yet the chapel combined a three-dimensional funerary portrait of the saint, which may have emphasized St. Isidore's real presence in the chapel, with an arcosolium-type niche that, as the preferred tomb structure of Palaiologan elites, may have been intended to evoke Isidore's Eastern origins and his high status. Finally, the baptistery delivers its complex theological and political messages through an "elevated" visual language that draws primarily on the iconographic and stylistic conventions of fourteenth-century Balkan paintings and late Byzantine mosaics, but transforms them freely—most notably, in the mosaics of the east wall and eastern dome—to produce strikingly new visual types and political representations. To put it simply: however indebted to local, Balkan, Byzantine, or broadly defined "Gothic" artistic traditions, the projects examined in this book were also remarkably *unlike* any of their models, asserting the ability of Venetian patrons and artists to generate, rather than simply emulate, visual paragons, and their capacity to carefully tailor the material and aesthetic qualities of artworks to meet specific expressive aims.

Crisis also compels us to define more precisely the significance of the monumental campaigns in San Marco as public projects and state commissions. Each project entailed the intellectual and technical efforts of several artists. In two cases, their names are known: Paolo Veneziano's name is conspicuously inscribed on the pala feriale, and the name of the Venetian goldsmith Bonensegna, responsible for the makeover of the pala d'oro, is (invisibly) carved on the carpentry of the altarpiece. For the most part, however, the identities and geocultural affiliations of the artists involved in the makeover of San Marco remain unknown. This leaves important questions about the relative agency of artists and patrons in defining the specific visual qualities of each project unanswerable. Yet it also amplifies

the role of patrons—that is, of the (noble) civil officers whose names are ostentatiously displayed on the high altar and in the chapel of Sant'Isidoro. Furthermore, the high altar, the baptistery, and the chapel of Sant'Isidoro were viewed by different constituencies of beholders: the doge and his councilors, the clergy of San Marco, the families of children baptized on Holy Saturday, Venetian residents, foreign visitors, residents of the colonies, and pilgrims. The viewing conditions for each of these groups were different, as were the frequency with which they visited San Marco and the expectations, concerns, and visual knowledge that they projected onto its imagery. On one level, this invites us to embrace the semantic complexity and open-endedness of those images, which may have been received differently by different viewers. Dandolo's projects, however, were means of public communication, and as such were designed to address and affect a broad and diverse audience.

These considerations justify, and even require, that we reconcile the visual eclecticism of the fourteenth-century monumental campaigns in San Marco with the political and social concerns that occupied the Venetian governors at this time. From this angle, the San Marco projects invite us to expand and refine the dominant view that artistic reuse and visual hybridity in San Marco consistently translated Venice's imperialism, its triumphalist stance, and its claims as heir to Byzantium. As lavish and expensive artistic commissions, Dandolo's projects naturally conveyed ideas of civic magnificence and international reach. But alongside these ideas, the eclectic visual lexicon of Dandolo's projects also testifies to the significance of public imagery as a locus of articulation of conflict and difference and manifests the complexity of the social and political networks within which images and artifacts produced meaning. And most significantly, it reveals how visual and political idioms were *simultaneously* transformed (at both a conscious and a less conscious level) to respond to crisis.

Conflict with Genoa, rivalry with neighboring Italian city-states, struggles to retain power in the colonies, and concerns with Christian unity against the Ottoman threat all contributed to shaping Venetian visual language in the trecento as well as the ways in which the

government conscripted images as means of political communication. In this context, the conceptual arsenal of artistic and visual "dualism," with its emphasis on the East/West divide and one-to-one interactions between cultures, does not provide an adequate representation of the multifaceted aesthetic transactions that occurred between patrons, viewers, and artworks in Venice and in the broader Mediterranean. Visual mixedness and artistic reuse participated in complex networks of confrontation and competition. In this context the selective appropriation of Byzantine art assisted rival powers—including Genoa, Venice, Serbia, and many others—to stake their claims to Mediterranean hegemony, but also to construct or advertise (real or potential) political alliances and religious and cultural proximity. For example, the body of the Eastern martyr Isidore of Chios was newly promoted in the context of Venice's rivalry with Genoa, rather than exclusively to manifest Venice's relations with Byzantium. Similarly, the massive "stone of Tyre" that was repurposed as an altar in the baptistery connected the chapel to Venice's previous crusading enterprises in the East, and by extension promoted the city's present ambitions as champion of Christianity as well as its status as international power. Likewise, the sumptuous reframing of the pala d'oro on the high altar may have evoked the recent rapprochement between the Byzantine crown and Venice, but also symbolically advertised the political legitimacy and divine investiture of the Venetian state more broadly (and competitively). Complex, nonbinary relations among different social groups also existed *within* medieval communities, and internal tensions were particularly significant in fourteenth-century Venice. In this context, as specifically suggested in relation to the domes of the baptistery, iconographic and stylistic diversity were mobilized to convey ideas of inclusion, unity in difference, and identification, both within the civitas and among the different social, linguistic, and ethnic groups that made up its growing imperial possessions.

In the fourteenth century, mounting awareness of social and ethnic difference within the Venetian state coexisted with the gradual rise of the patriciate as the ruling class of Venice. The projects examined in this book manifested this sociopolitical transformation and registered the tensions and ambiguities that it engendered. In other geo-cultural contexts, scholars have often associated the rise of a new political or social elite with the search for, and formation of, new literary or figurative styles or art forms, variously dubbed "courtly" or "aristocratic." For example, the concept of International Gothic—which is flexibly (if problematically) employed to describe the sophisticated and richly ornamented formal qualities shared by paintings produced across Europe between ca. 1375 and ca. 1425—rests on ideas of aristocratic refinement and rivalry and aesthetic competition among the rising urban and courtly elite of Europe. Similarly, the sophisticated monumental commissions of Palaiologan nobles are often read as a way for powerful individuals both to construct their aristocratic identities and to advertise their membership in the refined intellectual and artistic milieu of the urban, courtly elite. Although Venice's ruling elite were not, strictly speaking, a "court," a similar interpretative perspective may apply to the fourteenth-century makeover of San Marco, which exhibits dexterity with a variety of new artistic trends and deep awareness of their cultural and political implications. In this perspective, Paolo Veneziano's pala feriale aligned San Marco not only with recent developments in panel painting or church adornment, but also with the language of institutional distinction that was expressed through the patronage of sumptuous altarpieces across late medieval Europe. The pala d'oro can also be regarded as a sophisticated piece of "aristocratic art." The Byzantine enamels connected San Marco with the courtly arts of Constantinople, where enamel had been a favored medium for imperial diplomatic gift giving, and where it continued to be commissioned (or reused) for the decoration of portable objects commissioned by members of the Palaiologan aristocracy. In turn, the new metalwork frame of the pala d'oro, comprising microarchitectural aedicules and studded with gemstones, placed the artwork at the forefront of fourteenth-century metalworking techniques and connected it with the magnificent goldsmith works that were exchanged as gifts among members of the wealthiest elite of Europe. The chapel of Sant'Isidoro celebrated the nobility explicitly in textual

form, and visually through the representation of Domenico Michiel's coat of arms in the mosaics. The medium of mosaic, in vogue in Venice since the eleventh century (at the latest), related the city's own artistic traditions while also associating Venice with other chief centers of religious and political charisma across the Mediterranean. Finally, Debra Pincus has persuasively argued that the sculptural projects commissioned in the ducal palace and in San Marco in the mid-fourteenth century demonstrate a keen interest in the "prestige culture" and courtly ethos of northern Italian cities and the French court: the sculpted portrait of St. Isidore neatly conforms to this description.[1] In turn, the mosaics of the baptistery include sophisticated depictions of contemporary luxury clothing and banqueting, and individual scenes can productively be compared with works commissioned by the elite of Constantinople, Serbia, and mainland Greece, often as the means to enhance their social prestige or as a form of competitive emulation of imperial patronage.

Venice's merchant nobility was internationally minded. In the fourteenth century, the consolidation of the city's territorial possessions overseas increased (and complicated) the opportunities for interaction and revealed the importance of cosmopolitanism as a (necessary) cultural and political virtue. In this context the material costliness and cosmopolitan visual lexicon of Dandolo's projects created, among other things, a new "aristocratic" artistic identity for Venice's patriciate and contributed to the complex process of its self-fashioning as a Mediterranean elite. Its international vocation notwithstanding, the ideology of Venice's patriciate rested firmly on notions of locality and rootedness: the most noble families (and the most distinguished citizen clans) were those who had resided in Venice since its foundation, or as soon as possible thereafter. Those families represented the highest echelons of Venetian society, and doges and procurators were regularly chosen from their ranks. Dandolo's projects recovered or renovated "things past," pursuing a careful aesthetic balance between tradition and innovation. And they exploited the power of visual contrast and the potency of the written word to stimulate

viewers to reflect on history and temporality. In this they were fully compatible with those values of continuity and respect for the past that became associated not only with ducal authority but with Venice's patrician ethos at large.

Finally, the monumental projects considered in this book testify to the power of the visual not only to convey but to produce political meaning through form. The three monumental projects sponsored by the government in the basilica during Andrea Dandolo's dogeship contributed to giving visual shape and intelligibility to new ideas of rulership and of the state, as they were beginning to coalesce in the fourteenth century. Venice's new constitution emerged gradually over the course of the century. The normative vocabulary to describe and interpret the Venetian state also developed progressively and tentatively in the same decades, as did a new and more nuanced terminology to describe Venetian citizenship. In the same period, the Venetian government commissioned several key artistic projects: those considered in this study, plus a series of monumental campaigns in the ducal palace. With each commission, the government experimented with dramatically different techniques, iconographies, and styles: the architecture of the new ducal palace looked to the *palazzi pubblici* of Italian communes, but also integrated architectural motifs drawn from Islamic palatial architecture. The sculptural program of the palace has been described as a Gothic encyclopedic compendium rooted in the courtly cultures of Europe, both in its contents and style. And the new Great Council Hall, finished in 1365, was decorated by the eminent Paduan court artist Guariento di Arpo, with a richly ornamented painterly representation of Paradise intended to mirror the organization of the Venetian state. In this context, artistic "eclecticism" acquires positive meaning, as the manifestation of an ongoing search for appropriate visual means to express a new political ideal and a nascent political reality, and as evidence of the multidirectional entanglements between artistic choices and sociopolitical transformations. Similarly, artistic reuse, and the insistent reframing of the "old" with the "new" that characterizes each of the fourteenth-century monumental projects in the basilica, not only disseminated Venice's claims to an apostolic or Byzantine past but also

1 Pincus, "The Turn Westward" (see above, p. 37, n. 113).

embodied the ambivalent attitudes of contemporaries toward tradition and innovation, and their efforts (whether conscious or not) to express, mitigate, and normalize political change through the visual.

In one of her most cited quotes, visual artist and poet Etel Adnan intimates that the books she wrote were homes that she built for herself.[2] This statement captures two ideas that are central to my study. Much like book writing, art making is fundamentally connected with how individuals and communities imagine their world. It represents a primary means by which they make that world into a home: a place that is understandable and secure. The need for a home becomes stronger as the outer environment becomes more complex. In the mid-fourteenth century, the Venetian government set out to (re)define what Venice was, who belonged to it, and how it was run. The imagery in San Marco, together with Dandolo's legal collections and historical works, were the means by which Venice's leaders strove to address those questions. They were, in essence, Venice's constitution in images—Venice's *krisis*.

2 E. Adnan, "Of Cities and Women (Letters to Fawwaz)," in *To Look at the Sea Is to Become What One Is: An Etel Adnan Reader* (New York, 2014), 2:127.

BIBLIOGRAPHY

Abbreviations

ActaIRNorv	*Acta ad archaeologiam et artium historiam pertinentia*, Institutum Romanum Norvegiae	Loeb	Loeb Classical Library
AH	*Art History*	LSJ	H. G. Liddell, R. Scott, H. S. Jones et al., *A Greek-English Lexicon* (Oxford, 1968)
AHR	*American Historical Review*	*MarbJb*	*Marburger Jahrbuch für Kunstwissenschaft*
ArtB	*Art Bulletin*		
ArtV	*Arte veneta*	MGH ScriptRerMerov	Monumenta Germaniae historica, Scriptores rerum Merovingicarum
AStIt	*Archivio storico italiano*		
ASV	Archivio di Stato di Venezia	MGH SS	Monumenta Germaniae historica, Scriptores
AttiVen	*Atti dell'Istituto veneto di scienze, lettere ed arti*, Classe di scienze morali e lettere	*NAVen*	*Nuovo archivio veneto*
		NCMH	*The New Cambridge Medieval History* (Cambridge, 1995–2005) [successor to *CMH*]
AVen	*Archivio veneto*		
BAV	Biblioteca Apostolica Vaticana		
BMCC	Biblioteca del Museo Civico Correr	*ODB*	*The Oxford Dictionary of Byzantium*, edited by A. Kazhdan et al. (New York, 1991)
BMGS	*Byzantine and Modern Greek Studies*		
BnF	Bibliothèque nationale de France	*OHBS*	*The Oxford Handbook of Byzantine Studies*, edited by E. Jeffreys, J. Haldon, and R. Cormack (Oxford, 2008)
BNM	Biblioteca Nazionale Marciana		
DACL	*Dictionnaire d'archéologie chrétienne et de liturgie* (Paris, 1907–1953)		
DBI	*Dizionario Biografico degli Italiani* (Rome, 1960–2020)	PL	*Patrologiae cursus completus*, Series Latina, ed. J.-P. Migne (Paris, 1844–1880)
DOP	*Dumbarton Oaks Papers*		
EME	*Early Medieval Europe*	RHC HOcc	Recueils des historiens des Croisades, Historiens occidentaux (Paris, 1844–1895)
FlorMitt	*Mitteilungen des Kunsthistorischen Instituts in Florenz*		
HUkSt	*Harvard Ukrainian Studies*	*RHR*	*Revue de l'histoire des religions*
HZ	*Historische Zeitschrift*	*RIS*	*Rerum italicarum scriptores*, ed. L. A. Muratori (Milan, 1723–1751)
JbKw	*Jahrbuch für Kunstwissenschaft*		
JEChrSt	*Journal of Early Christian Studies*	*RIS*, n.s.	*Rerum italicarum scriptores*, new series (Città di Castello-Bologna, 1900–)
JMedHist	*Journal of Medieval History*		
JÖB	*Jahrbuch der Österreichischen Byzantinistik*	*StVen*	*Studi veneziani*
		ZKunstg	*Zeitschrift für Kunstgeschichte*
JTS	*Journal of Theological Studies*	*Δελτ. Χριστ. Ἀρχ. Ἑτ.*	*Δελτίον τῆς Χριστιανικῆς ἀρχαιολογικῆς ἑταιρείας*
JWarb	*Journal of the Warburg and Courtauld Institutes*		

Manuscripts and Archival Sources

Florence, Galleria degli Uffizi, Inv. Contini Bonacossi.

London, British Museum, *Habito del Serenissimo in Armada*.

New Haven, CT, Yale University Library, Beinecke 457.

Paris, Bibliothèque Nationale de France, Gr. 510.

Paris, Bibliothèque Nationale de France, It. 318.

Paris, Bibliothèque Nationale de France, Lat. 4939.

Paris, Bibliothèque Nationale de France, Lat. 5877.

Rome, Biblioteca Apostolica Vaticana, Barb. Lat. 713–714.

Rome, Biblioteca Apostolica Vaticana, Vat. Lat. 1960.

Venice, Archivio di Stato di Venezia, Maggior Consiglio, *Deliberazioni*, Clericus-Civicus (1315–1318).

Venice, Archivio di Stato di Venezia, Maggior Consiglio, *Deliberazioni*, Spiritus (1325–1349).

Venice, Archivio di Stato di Venezia, *Pacta*, Liber Albus.

Venice, Archivio di Stato di Venezia, *Pacta*, Liber Blancus.

Venice, Archivio di Stato di Venezia, Procuratores de Supra, *Commissarie*, B I.

Venice, Archivio Storico della Procuratoria di San Marco, C19.14.01.

Venice, Biblioteca del Museo Civico Correr, 1497.

Venice, Biblioteca del Museo Civico Correr, cl. 3, 315.

Venice, Biblioteca del Museo Civico Correr, cl. 3, 327.

Venice, Biblioteca del Museo Civico Correr, ms. Gradenigo Dolfin 228.

Venice, Biblioteca del Museo Civico Correr, P.D. 517b.

Venice, Biblioteca del Seminario Patriarcale, 951.

Venice, Biblioteca Nazionale Marciana, It. VII 49–50 (=9274–75).

Venice, Biblioteca Nazionale Marciana, It. VII 141 (=7146).

Venice, Biblioteca Nazionale Marciana, Lat. I 100 (=2089).

Venice, Biblioteca Nazionale Marciana, Lat. I 101 (=2260).

Venice, Biblioteca Nazionale Marciana, Lat. III 111 (=2116).

Venice, Biblioteca Nazionale Marciana, Lat. III 172 (=2276).

Venice, Biblioteca Nazionale Marciana, Lat. IX 18 (=2945).

Venice, Biblioteca Nazionale Marciana, Lat. IX 27 (=2797).

Venice, Biblioteca Nazionale Marciana, Lat. X 36a (=3326).

Venice, Biblioteca Nazionale Marciana, Lat. Z 356 (=1609).

Venice, Biblioteca Nazionale Marciana, Lat. Z 399 (=1610).

Washington, DC, Dumbarton Oaks Research Library and Collection, *Otto Demus Papers and the San Marco Mosaics Project and Corpus of North Adriatic Mosaics Papers*, Series 8, 1979.

Works Cited

Ackley, J. S. "Precious-Metal Figural Sculpture, Medium, and Mimesis in the Late Middle Ages." In *Faces of Charisma: Image, Text, Object in Byzantium and the Medieval West*, edited by B. M. Bedos-Rezak and M. D. Rust, 348–85. Leiden, 2018.

Adnan, E. "Of Cities and Women (Letters to Fawwaz)." In *To Look at the Sea Is to Become What One Is: An Etel Adnan Reader*. Vol. 2, 65–129. New York, 2014.

Agazzi, M. "Questioni marciane: Architettura e scultura." In Vio, *San Marco: La basilica*, 1:91–109.

———. "San Marco: Da cappella palatina a cripta contariniana." In *Le cripte di Venezia: Gli ambienti di culto sommersi della cristianità medievale*, edited by M. Zorzi, 25–51. Treviso, 2018.

Aldrighetti, G., and M. De Biasi. *Il gonfalone di San Marco: Analisi storico-araldica dello stemma, gonfalone, sigillo e bandiera della città di Venezia*. Venice, 1998.

Alexander, P. J. *The Byzantine Apocalyptic Tradition*. Berkeley, 1985.

Alfani, G. *Fathers and Godfathers: Spiritual Kinship in Early-Modern Italy*. Farnham, 2009.

Andaloro, M., M. Da Villa Urbani, I. Florent-Goudouneix, R. Polacco, and E. Vio, eds. *San Marco: La Basilica patriarcale in Venezia*. Vol. 2, *I mosaici, le iscrizioni, la pala d'oro*. Milan, 1991.

Andreescu-Treadgold, I. "Salviati a San Marco e altri suoi restauri." In *Scienza e tecnica del restauro della Basilica di San Marco: Atti del convegno internazionale di studi, Venezia, 16–19 maggio 1995*, edited by E. Vio and A. Lepschy, 2:467–513. Venice, 1999.

Andrieu, M., ed. *Le pontifical romain au moyen-âge*. Vol. 2, *Le pontifical de la Curie romaine au XIIIᵉ siècle*. Vatican City, 1940.

Angelov, D. *Imperial Ideology and Political Thought in Byzantium, 1204–1330*. Cambridge, 2007.

Angelov, D., and J. Herrin. "The Christian Imperial Tradition—Greek and Latin." In *Universal Empire: A Comparative Approach to Imperial Culture and Representation in Eurasian History*, edited by P. F. Bang and D. Kolodziejczyk, 149–74. Cambridge, 2012.

Angelov, D., and M. Saxby, eds. *Power and Subversion in Byzantium: Papers from the 43rd Spring Symposium of Byzantine Studies, Birmingham, March 2010*. Farnham, 2013.

Angheben, M. *Alfa e Omega: Il giudizio universale tra oriente e occidente*. Edited by V. Pace. Castel Bolognese, 2006.

Apollonio, F. "I primiceri di San Marco." In Ongania, *La basilica di San Marco*, 6:51–61.

Aquinas, Thomas. *De regimine principum ad regem Cypri*. In *Opuscula philosophica*. Edited by R. M. Spiazzi, 257–358. Turin, 1973.

Arendt, H. "The Crisis in Culture: Its Social and Its Political Significance." In *Between Past and Future: Six Exercises in Political Thought*, 1961, 194–222. Reprint, New York, 2006. Citations refer to the 2006 edition.

———. "The Crisis in Education." In *Between Past and Future: Six Exercises in Political Thought*, 1961, 170–93. Reprint, New York, 2006. Citations refer to the 2006 edition.

Argenti, P. P. *The Occupation of Chios by the Genoese and Their Administration of the Island, 1346–1566: Described in Contemporary Documents and Official Dispatches.* Cambridge, 1958.

Aristotle. *Aristoteles Latinus.* Vol. 29, pt. 1, *Politica (libri 1–2.11): Translatio prior imperfecta interprete Guillelmo de Moerbeka.* Edited by P. Michaud-Quantin. Bruges, 1961.

———. *Aristotelis Politicorum libri octo cum vetusta translatione Guilelmi de Moerbeka.* Edited by F. Susemihl. Leipzig, 1872.

Armstrong, P. *Authority in Byzantium.* Farnham, 2013.

Arnaldi, G. "Andrea Dandolo doge-cronista." In *Cronache e cronisti dell'Italia comunale*, 165–298. Spoleto, 2016.

———. "La cancelleria ducale fra culto della 'legalitas' e nuova cultura umanistica." In *Cronache e cronisti dell'Italia comunale*, 507–43. Spoleto, 2016.

Arnaldi, G., G. Gracco, and A. Tenenti, eds. *Storia di Venezia: Dalle origini alla caduta della Serenissima*, vol. 3, *La formazione dello stato patrizio.* Rome, 1997. https://www.treccani.it/enciclopedia/la-lotta-contro-genova_(Storia-di-Venezia)/.

Arnheim, R. *The Power of the Center: A Study of Composition in the Visual Arts.* Berkeley, 1982.

Aston, T., ed. *Crisis in Europe 1560–1660: Essays from Past and Present.* London, 1965.

Aston, T. H., and C. H. E. Philpin, eds. *The Brenner Debate: Agrarian Class Structure and Economic Development in Pre-Industrial Europe.* Cambridge, 1985.

Augustine of Hippo. *Tractates on the Gospel of John 112–24: Tractates on the First Epistle of John.* Translated by J. W. Rettig. The Fathers of the Church 92. Washington, DC, 1995.

Bacci, M. "L'arte delle società miste del Levante medievale: Tradizioni storiografiche a confronto." In *Medioevo: Arte e storia; Atti del convegno internazionale di studi Parma, 18–22 settembre 2007*, edited by A. C. Quintavalle, 339–54. Milan, 2008.

———. "Greek Madonnas and Venetian Fashion." *Convivium* 7.1 (2020): 152–77.

———. "A Power of Relative Importance: San Marco and the Holy Icons." *Convivium* 2.1 (2015): 126–47.

———. *San Nicola: Splendori d'arte d'Oriente e d'Occidente.* Milan, 2006.

———. "Some Thoughts of Greco-Venetian Artistic Interactions in the Fourteenth and Early-Fifteenth Centuries." In *Wonderful Things: Byzantium through Its Art; Papers from the Forty-Second Spring Symposium of Byzantine Studies, London, 20–22 March 2009*, edited by A. Eastmond and L. James, 203–28. Farnham, 2013.

———. "Veneto-Byzantine 'Hybrids': Towards a Reassessment." *Studies in Iconography* 35 (2014): 73–106.

Bagnoli, M., H. A. Klein, G. Mann, and J. Robinson, eds. *Treasures of Heaven: Saints, Relics, and Devotion in Medieval Europe.* London, 2011.

Bakirtzis, C. "Pilgrimage to Thessalonike: The Tomb of St. Demetrios." *DOP* 56 (2002): 175–92.

Balard, M. "Latins in the Aegean and the Balkans in the Fourteenth Century." In *NCMH* 6:825–38.

———. "La lotta contro Genova." In Arnaldi et. al, *Storia di Venezia*, 3:87–126. Rome, 1997, https://www.treccani.it/enciclopedia/la-lotta-contro-genova_(Storia-di-Venezia)/.

———. *La Romanie génoise, XIIᵉ–début du XVᵉ siècle.* Rome, 1978.

Banzato, D., F. Flores d'Arcais, and A. M. Spiazzi, eds. *Guariento e la Padova carrarese.* Venice, 2011.

Barnand, T. V. "The Complexity of the Iconography of the Bilateral Icon of the Virgin Hodegetria and the Man of Sorrows, Kastoria." In *Wonderful Things: Byzantium through Its Art; Papers from the Forty-Second Spring Symposium of Byzantine Studies, London, 20–22 March 2009*, edited by A. Eastmond and L. James, 129–38. Farnham, 2013.

Baron, H. *The Crisis of the Early Italian Renaissance: Civic Humanism and Republican Liberty in an Age of Classicism and Tyranny.* Princeton, NJ, 1955.

Bartlett, R. *Why Can the Dead Do Such Great Things? Saints and Worshippers from the Martyrs to the Reformation.* Princeton, NJ, 2013.

Bascapè, G. C. "Sigilli delle repubbliche marinare." In *Sigillografia: Il sigillo nella diplomatica, nel diritto, nella storia, nell'arte.* Vol. 1, 245–62. Milan, 1969.

Bauer, F. A. *Eine Stadt und ihr Patron: Thessaloniki und der Heilige Demetrios.* Regensburg, 2013.

Bauer, W., and F. W. Danker, eds. *Greek-English Lexicon of the New Testament and Other Early Christian Literature.* 3rd ed. Chicago, 2000.

Beaucamp, E., and P. Cordez, eds. *Typical Venice? The Art of Commodities: 13th–16th Centuries.* Turnhout, 2020.

Bede the Venerable. *The Complete Works of Venerable Bede: In the Original Latin, Collated with the Manuscripts, and Various Printed Editions, Accompanied by a New English Translation of the Historical Works, and a Life of the Author.* Vol. 5, *Homilies*, edited by J. A. Giles. London, 1843.

Belting, H. "Bisanzio a Venezia non è Bisanzio a Bisanzio." In *Il Trecento adriatico: Paolo Veneziano e la pittura tra Oriente e Occidente*, edited by F. Flores d'Arcais and G. Gentili, 71–79. Milan, 2002.

———. "Dandolo's Dreams: Venetian State Art and Byzantium." In *Byzantium: Faith and Power (1261–1557); Perspectives on Late Byzantine Art and Culture*, edited by D. T. Brooks, 138–53. New Haven, CT, 2006.

———. "An Image and Its Function in the Liturgy: The Man of Sorrows in Byzantium." *DOP* 34/35 (1980): 1–16.

———. *The Image and Its Public in the Middle Ages: Form and Function of Early Paintings of the Passion.* New Rochelle, NY, 1990.

Benes, C. E. "Civic Identity." In Benes, *Companion to Medieval Genoa*, 193–217.

———, ed. *A Companion to Medieval Genoa*. Leiden, 2018.

Bent, G. *Public Painting and Visual Culture in Early Republican Florence*. Cambridge, 2016.

Bergamo, M. *Alessandro, il cavaliere, il doge: Le placchette profane della pala d'oro di San Marco*. Rome, 2022.

Bergmeier, A. F. "Natural Disasters and Time: Non-Eschatological Perceptions of Earthquakes in Late Antique and Medieval Historiography." *Millennium* 18.1 (2021): 155–74.

———. "The Production of Ex Novo Spolia and the Creation of History in Thirteenth-Century Venice." *FlorMitt* 62.2/3 (2020): 127–57.

Bertelè, T. "I gioielli della corona bizantina dati in pegno alla Repubblica Veneta nel sec. XIV e Mastino II della Scala." In *Studi in onore di Amintore Fanfani*, 2:89–177. Milan, 1962.

Berto, L. A. "Historia ducum Venetorum." In *Encyclopedia of the Medieval Chronicle*, edited by G. Dunphy and C. Bratu. Brill Medieval Reference Library Online. Leiden, 2016. https://referenceworks.brillonline.com/entries/encyclopedia-of-the-medieval-chronicle/historia-ducum-venetorum-SIM_01313?s.num=21&s.start=20.

———, ed. *Testi storici veneziani (XI–XIII secolo)*. Padua, 2000.

Bertrand, P. "Authentiques de reliques: Authentiques ou reliques?" *Le Moyen Age* 112.2 (2006): 363–74.

Betancourt, R. "Prolepsis and Anticipation: The Apocalyptic Futurity of the Now, East and West." In *A Companion to the Premodern Apocalypse*, edited by M. A. Ryan, 177–205. Leiden, 2016.

Betto, B. *Il capitolo della Basilica di S. Marco in Venezia: Statuti e consuetudini dei primi decenni del sec. 14*. Padua, 1984.

Binski, P. *Gothic Sculpture*. New Haven, CT, 2019.

———. "Hierarchies and Orders in English Royal Images of Power." In *Orders and Hierarchies in Late Medieval and Renaissance Europe*, edited by J. Denton, 74–93. London, 1999.

Blaauw, S. de. "Altar Imagery in Italy Before the Altarpiece." In Kroesen and Schmidt, *The Altar and Its Environment*, 47–56.

———, and K. Doležalová. "Constructing Liminal Space? Curtains in Late Antique and Early Medieval Churches." In Doležalová and Foletti, *Liminality and Sacred Space*, 46–67.

Bloch, A. R. "Baptism, Movement, and Imagery at the Baptistery of San Giovanni in Florence." In *Meaning in Motion: The Semantics of Movement in Medieval Art*, edited by N. Zchomelidse and G. Freni, 131–60. Princeton, NJ, 2011.

Blok, J. *Citizenship in Classical Athens*. Cambridge, 2017.

Blumenfeld-Kosinski, R., and K. Petkov, eds. *Philippe de Mézières and His Age: Piety and Politics in the Fourteenth Century*. Leiden, 2012.

Blythe, J. M. *Ideal Government and the Mixed Constitution in the Middle Ages*. Princeton, NJ, 2014.

Boeck, E. N., ed. *Afterlives of Byzantine Monuments in Post-Byzantine Times: Proceedings of the Session Held at the 12th International Congress of South-East European Studies (Bucharest, 2–6 September 2019)*. Études byzantines et post-byzantines, n.s. 3. Bucharest, 2021.

Bogdanović, J. *The Framing of Sacred Space: The Canopy and the Byzantine Church*. Oxford, 2017.

Bois, G. *Crise du féodalisme: Économie rurale et démographie en Normandie orientale du début du XIVᵉ siécle au milieu du XVIᵉ siécle*. Paris, 1976.

———. "On the Crisis of the Late Middle Ages." *The Medieval History Journal* 1.2 (1998): 311–21.

Borsari, S. *L'Eubea veneziana*. Venice, 2007.

Boskovits, M. *The Mosaics of the Baptistery of Florence*. Corpus of Florentine Painting 1.2. Florence, 2007.

Bossy, J. "Blood and Baptism: Kinship, Community and Christianity in Western Europe from the Fourteenth to the Seventeenth Centuries." In *Sanctity and Secularity: The Church and the World; Papers Read at the Eleventh Summer Meeting and the Twelfth Winter Meeting of the Ecclesiastical History Society*, edited by D. Baker, 129–43. Oxford, 1973.

Bottari Scarfantoni, N. *Il cantiere di San Giovanni Battista a Pistoia (1353–1366)*. Pistoia, 1998.

Braun, J. *Der christliche Altar in seiner geschichtlichen Entwicklung*. Munich, 1924.

Brown, M. C. "The 'Three Kings of Cologne' and Plantagenet Political Theology." *Mediaevistik* 30 (2017): 61–85.

Brown, P. *The Cult of the Saints: Its Rise and Function in Latin Christianity*. Chicago, 1981.

Brubaker, L. *Vision and Meaning in Ninth-Century Byzantium: Image as Exegesis in the Homilies of Gregory of Nazianzus*. Cambridge, 1999.

Bruderer Eichberg, B. *Les neuf choeurs angéliques: Origines et évolutions du thème dans l'art du Moyen Âge*. Boulogne-Billancourt, 1998.

Brunetti, M. "Venezia durante la peste del 1348." *Ateneo Veneto* 32.1 (1909): 289–311.

———. "Venezia durante la peste del 1348." *Ateneo Veneto* 32.2 (1909): 5–42.

Büchsel, M., H. L. Kessler, and R. Müller, eds. *The Atrium of San Marco in Venice: The Genesis and Medieval Reality of the Genesis Mosaics*. Berlin, 2014.

Buckton, D., ed. *The Treasury of San Marco, Venice*. Milan, 1984.

———, and J. Osborne. "The Enamel of Doge Ordelaffo Falier on the Pala d'Oro in Venice." *Gesta* 39.1 (2000): 43–49.

Burckhardt, J. *Reflections on History*. London, 1944. Originally published in German as *Weltgeschichtliche Betrachtungen*. Berlin, 1905.

Burke, E. C. *The Greeks of Venice, 1498–1600: Immigration, Settlement and Integration*. Turnhout, 2016.

Burns, J. H., ed. *The Cambridge History of Medieval Political Thought c. 350–c. 1450*. Cambridge, 1988.

Bynum, C. W. *Christian Materiality: An Essay on Religion in Late Medieval Europe*. New York, 2011.

Bynum, C. W., and P. H. Freedman. "Introduction." In *Last Things: Death and the Apocalypse in the Middle Ages*, edited by C. W. Bynum and P. H. Freedman, 1–17. Philadelphia, 2000.

Cabrol, F., and H. Leclercq. "Baptême." *DACL* 12.1:251–346.

Caferro, W., and D. G. Fisher, eds. *The Unbounded Community: Papers in Christian Ecumenism in Honor of Jaroslav Pelikan*. New York, 1996.

Calabi, D. "Gli stranieri e la città." In Tenenti et. al, *Storia di Venezia*, 5:913–46.

Campagnari, G. "Gli altari della Basilica di San Marco: Ricerche e ipotesi per la comprensione della fase medioevale." MA thesis, Università Ca' Foscari Venezia, 2015.

Campbell, C., and A. Chong, eds. *Bellini and the East*. London, 2005.

Canale, Martino da. *Les estoires de Venise: Cronaca veneziana in lingua francese dalle origini al 1275*, edited by A. Limentani. Florence, 1972.

Canning, J. *A History of Medieval Political Thought: 300–1450*. London, 1996.

Caresini, Rafaino. *Raphayni de Caresinis cancellarii venetiarum chronica: aa. 1343–1388*. Edited by E. Pastorello. *RIS*, n.s. 12.2. Bologna, 1942.

Carile, A. "Caresini, Rafaino." *DBI* 20 (1977). https://www.treccani.it/enciclopedia/rafaino-caresini_(Dizionario-Biografico)/.

Carr, M. *Merchant Crusaders in the Aegean, 1291–1352*. Martlesham, 2015.

———. "Trade or Crusade? The Zaccaria of Chios and Crusades against the Turks." In *Contact and Conflict in Frankish Greece and the Aegean, 1204–1453: Crusade, Religion and Trade between Latins, Greeks and Turks*, edited by N. G. Chrissis and M. Carr, 115–34. Farnham, 2014.

Carrasco, M. "Sanctity and Experience in Pictorial Hagiography: Two Illustrated Lives of Saints from Romanesque France." In *Images of Sainthood in Medieval Europe*, edited by R. Blumenfeld-Kosinski and T. K. Szell, 33–66. Ithaca, NY, 1991.

Carruthers, M. *The Craft of Thought: Meditation, Rhetoric, and the Making of Images, 400–1200*. Cambridge, 1998.

———. *The Experience of Beauty in the Middle Ages*. Oxford, 2013.

Carson, A. *Glass, Irony, and God*. New York, 1995.

Casagrande, C. "Enrico da Rimini." *DBI* 42 (1993). https://www.treccani.it/enciclopedia/enrico-da-rimini_(Dizionario-Biografico))/.

Caselli, L., ed. *San Pietro e San Marco: Arte e iconografia in area adriatica*. Rome, 2009.

Cattaneo, E. "Il battistero in Italia dopo il Mille." In *Miscellanea Gilles Gérard Meersseman*, 1:171–95. Italia sacra 15–16. Padua, 1970.

Cattin, G., ed. *Musica e liturgia a San Marco: Testi e melodie per la liturgia delle ore dal 12 al 17 secolo; Dal graduale tropato del Duecento ai graduali cinquecenteschi*. Vol. 1. Venice, 1990.

Cavallo, G. "Exultet." In *Enciclopedia dell'arte medievale*. Vol. 6, edited by A. M. Romanini, 60–68. Rome, 1995.

Cecchet, L., and A. Busetto. *Citizens in the Graeco-Roman World: Aspects of Citizenship from the Archaic Period to AD 212*. Leiden, 2017.

Cecchetti, B., ed. *Documenti per la storia dell'augusta ducale Basilica di San Marco in Venezia dal nono secolo sino alla fine del decimo ottavo dall'Archivio di Stato e dalla Biblioteca Marciana in Venezia*. Venice, 1886.

Cerbani, Cerbanus. "Translatio mirifici martyris Isidori a Chio insula in civitatem venetam." RHC HOcc 5.321–34.

Cesca, G. *La sollevazione di Capodistria nel 1348: 100 documenti inediti*. Verona, 1882.

Cessi, R., and F. Bennato, eds. *Venetiarum historia vulgo Petro Iustiniano Iustiniani filio adiudicata*. Venice, 1964.

Chabod, F. "Venezia nella politica italiana ed europea del Cinquecento." In *La civiltà veneziana del Rinascimento*, edited by D. Valeri, 29–55. Florence, 1958.

Chambers, D. S. "Merit and Money: The Procurators of St. Mark and Their Commissions, 1443–1605." *JWarb* 60 (1997): 23–88.

Chantraine, P., ed. "Κρίνω." In *Dictionnaire etymologique de la langue grecque: Histoire des mots*, 584–85. Paris, 1999.

Chase, S. *Angelic Spirituality: Medieval Perspectives on the Ways of Angels*. New York, 2002.

Chatterjee, P. *The Living Icon in Byzantium and Italy: The Vita Image, Eleventh to Thirteenth Centuries*. Cambridge, 2014.

Chatzēdakē, N. M. *Da Candia a Venezia: Icone greche in Italia, XV–XVI secolo*. Athens, 1993.

Chauvard, J.-F. "Ancora che siano invitati molti compari al battesimo': Parrainage et discipline tridentine à Venise (XVIᵉ siècle)." In *Baptiser: Pratique sacramentelle, pratique sociale (XVIᵉ–XXᵉ siècles)*, edited by G. Alfani, P. Castagnetti, and V. Gourdon, 341–68. Saint Etienne, 2009.

Chiesa, P. "Santità d'importazione a Venezia tra reliquie e racconti." In *Oriente cristiano e santità: Figure e storie di santi tra Bisanzio e l'Occidente*, edited by S. Gentile, 107–15. Milan, 1998.

Chirban, J. T. *Holistic Healing in Byzantium*. Brookline, MA, 2010.

Chojnacki, S. "La formazione della nobiltà dopo la Serrata." In Arnaldi et al. , *Storia di Venezia*, 3:641–725.

———. "In Search of the Venetian Patriciate: Families and Factions in the Fourteenth Century." In *Renaissance Venice*, edited by J. R. Hale, 47–90. London, 1973.

———. "Political Adulthood in Fifteenth-Century Venice." *AHR* 91.4 (1986): 791–810.

———. "Social Identity in Renaissance Venice: The Second *Serrata*." *Renaissance Studies* 8.4 (1994): 341–58.

Christ, G., F.-J. Morche, R. Zaugg, W. Kaiser, S. Burkhardt, and A. D. Beihammer. *Union in Separation: Diasporic Groups and Identities in the Eastern Mediterranean (1100–1800)*. Rome, 2015.

Christe, Y. *Jugements derniers*. Saint-Léger-Vauban, 1999.

Cicero, Marcus Tullius. *De officiis*. Translated by W. Miller. Loeb 30. Cambridge, MA, 1913.

Cohen, S. *Transformations of Time and Temporality in Medieval and Renaissance Art*. Leiden, 2014.

Cohn, N. *The Pursuit of the Millennium: Revolutionary Millenarians and Mystical Anarchists of the Middle Ages*. Fairlawn, NJ, 1957.

Coleman, J. "Medieval Political Theory c. 1000–1500." In *The Oxford Handbook of the History of Political Philosophy*, edited by G. Klosko, 180–205. Oxford, 2011.

———. "Some Relations between the Study of Aristotle's Rhetoric, Ethics and Politics in Late Thirteenth-Century and Early Fourteenth-Century University Arts Courses and the Justification of Contemporary Civic Activities (Italy and France)." In *Political Thought and the Realities of Power in the Middle Ages*, edited by J. Canning and O. G. Oexle, 127–57. Veröffentlichungen des Max-Planck-Instituts für Geschichte 14. Göttingen, 1998.

Colish, M. L. *Faith, Fiction, and Force in Medieval Baptismal Debates*. Washington, DC, 2014.

Concina, E. *Fondaci: Architettura, arte e mercatura tra Levante, Venezia e Alemagna*. Venice, 1997.

———. "San Salvador: La fabbrica, l'architettura." In *La chiesa di San Salvador: Storia, arte, teologia*, edited by G. Guidarelli, 9–28. Padua, 2009.

Cordez, P. "Gestion et médiation des collections de reliques au Moyen Âge: Le témoignage des authentiques et des inventaires." In *Reliques et sainteté dans l'espace médiéval*, edited by J.-L. Deuffic, 33–63. Saint-Denis, 2006.

Cormack, R. "The Making of a Patron Saint: The Power of Art and Ritual in Byzantine Thessaloniki." In *World Art: Themes of Unity in Diversity; Acts of the XXVIth International Congress of the History of Art*. Vol. 3, edited by I. Lavin, 547–56. University Park, PA, 1989.

———. *Writing in Gold: Byzantine Society and Its Icons*. London, 1985.

Cornaro, Flaminio. *Ecclesiae venetae antiquis monumentis nunc etiam primum editis illustratae ac in decades distributae*. Vol. 10, *De basilica ducale sancti Marci*. Venice, 1749.

Coronelli, V. *Arme, blasoni o insegne gentilitie delle famiglie patritie esistenti nella Serenissima Republica di Venetia*. Venice, 1701.

Cozzi, G. "Il giuspatronato del doge su San Marco: Diritto originario o concessione pontificia?" In Niero, *San Marco: Aspetti storici*, 727–42.

Cracco, G. "La cultura giuridico-politica nella Venezia della 'Serrata.'" In *Storia della cultura veneta*. Vol. 2, edited by G. Arnaldi, 238–71. Vicenza, 1976.

———. *Società e stato nel medioevo veneziano: Secoli XII–XIV*. Fondazione Giorgio Cini, Civiltà veneziana, Studi 22. Florence, 1967.

Cracco, G., and G. Ortalli, eds. *Storia di Venezia: Dalle origini alla caduta della Serenissima*, vol. 2, *L'età del comune*. Rome, 1995. https://www.treccani.it/enciclopedia/la-cancelleria_res-43686455-03f2-11e2-87e1-d5ce3506d72e_(Storia-di-Venezia)/.

Cracco Ruggini, L., M. Pavan, G. Cracco, and G. Ortalli, eds. *Storia di Venezia: Dalle origini alla caduta della Serenissima*, vol. 1, *Origini–Età ducale*, 645–75. Rome, 1992. https://www.treccani.it/enciclopedia/le-strutture-della-chiesa-locale_(Storia-di-Venezia)/.

Cramer, P. *Baptism and Change in the Early Middle Ages, c. 200–c. 1150*. Cambridge, 1993.

Crawford, M. "Citizenship, Roman." In *The Oxford Companion to Classical Civilization*, edited by S. Hornblower and A. Spawforth, 174–75. 2nd ed. Oxford, 2014.

Crescenzi, V. "La *Summula statutorum* di Andrea Dandolo secondo il manoscritto Montecassino, 459." *Initium* 12 (2007): 623–97.

Crossley, P. "The Man from Inner Space: Architecture and Meditation in the Choir of St. Laurence in Nuremberg." In *Medieval Art: Recent Perspectives; A Memorial Tribute to C. R. Dodwell*, edited by G. R. Owen-Crocker and T. Graham, 165–82. Manchester, 1998.

Crouzet-Pavan, E. "Cultures et contre-cultures: À propos des logiques spatiales de l'espace public vénitien." In *Shaping Urban Identity in Late Medieval Europe*, edited by M. Boone and P. Stabel, 89–117. Leuven, 2000.

———. *Venice Triumphant: The Horizons of a Myth*. Baltimore, 2002.

Crow, M., C. Zori, and D. Zori. "Doctrinal and Physical Marginality in Christian Death: The Burial of Unbaptized Infants in Medieval Italy." *Religions* 11.12 (2020): 678. https://www.mdpi.com/2077-1444/11/12/678/htm.

Cullmann, O. *Christ and Time: The Primitive Christian Conception of Time and History*. Philadelphia, 1964.

Cutler, A. "Legal Iconicity: Documentary Images, the Problem of Genre, and the Work of the Beholder." In *Byzantine Art: Recent Studies; Essays in Honor of Lois Drewer*, edited by C. Hourihane, 63–80. Turnhout, 2009.

———. "The Pathos of Distance: Byzantium in the Gaze of Renaissance Europe and Modern Scholarship." In *Reframing the Renaissance: Visual Culture in Europe and Latin America, 1450–1650*, edited by C. J. Farago, 22–45. New Haven, CT, 1995.

———. *Transfigurations: Studies in the Dynamics of Byzantine Iconography*. University Park, PA, 1975.

DaCosta Kaufmann, T. "Periodization and Its Discontents." *Journal of Art Historiography* 2 (2010), https://arthistoriography.files.wordpress.com/2011/02/media_152489_en.pdf.

Dale, T. E. A., "Cultural Encounter, Race, and a Humanist Ideology of Empire in the Art of Trecento Venice." *Speculum* 98.1 (2023): 1–48.

———. "Cultural Hybridity in Medieval Venice: Reinventing the East at San Marco after the Fourth Crusade." In Maguire and Nelson, *San Marco, Byzantium, and the Myths of Venice*, 151–91.

———. "Epiphany at San Marco: The Sculptural Program of the Porta da Mar in the Dugento." In Vio, *San Marco: La basilica*, 2:38–55.

———. "Inventing a Sacred Past: Pictorial Narratives of St. Mark the Evangelist in Aquileia and Venice, ca. 1000–1300." *DOP* 48 (1994): 53–104.

———. "Pictorial Narratives of the Holy Land and the Myth of Venice in the Atrium of San Marco." In *The Atrium of San Marco in Venice: The Genesis and Medieval Reality of the Genesis Mosaics*, edited by M. Büchsel, H. Kessler, and R. Müller, 247–70. Berlin, 2014.

———. *Relics, Prayer, and Politics in Medieval Venetia: Romanesque Painting in the Crypt of Aquileia Cathedral*. Princeton, NJ, 1997.

Damen, M., J. Haemers, and A. J. Mann. *Political Representation: Communities, Ideas and Institutions in Europe (c. 1200–c. 1690)*. Leiden, 2018.

Da Mosto, A. *I dogi di Venezia nella vita pubblica e privata*. Milan, 1977.

Dandolo, Andrea. *Andreae Danduli ducis Venetiarum chronica per extensum descripta: aa 46–1280 d.C.*, edited by E. Pastorello. *RIS*, n.s. 12.1. Bologna, 1942.

———. *Pro capellanis*. In *Andreae Danduli ducis Venetiarum chronica per extensum descripta: aa 46–1280 d.C.*, edited by E. Pastorello, cii–civ. *RIS*, n.s. 12.1. Bologna, 1942.

———. *Promissione*. In *Andreae Danduli ducis Venetiarum chronica per extensum descripta: aa 46–1280 d.C.*, edited by E. Pastorello, lxxix–cii. *RIS*, n.s. 12.1. Bologna, 1942.

D'Angiolini, P., and C. Pavone. *Guida generale degli archivi di Stato italiani*. Vol. 4, *S–Z*. Rome, 1994.

Davies, J. K. "Citizenship, Greek." In *The Oxford Companion to Classical Civilization*, edited by S. Hornblower and A. Spawforth, 173–74. 2nd ed. Oxford, 2014.

Da Villa Urbani, M. "L'Annunciazione' dietro il ciborio e la 'Madonna di Marzo.'" In *Quaderni della Procuratoria: Arte, storia, restauri della basilica di San Marco a Venezia*. Vol. 10, *Le colonne del ciborio*, edited by I. Favaretto, 33–38. Venice, 2015.

———. "Le iscrizioni nei mosaici di san Marco: Alcune novità nei testi e proposte di lettura." In Niero, *San Marco: Aspetti storici*, 334–42.

———. "La ricognizione del corpo del santo del 1824." In Favaretto, *La cappella*, 76–101. Venice, 2008.

Davis, K., and M. Puett. "Periodization and 'The Medieval Globe': A Conversation." *The Medieval Globe* 2.1 (2016): 1–14.

De Franceschi, E. "I mosaici del battistero, fra il rinnovamento bizantino-paleologo e la produzione pittorica veneta dei primi decenni del Trecento." In Vio, *San Marco: La basilica*, 1:309–17.

———. "I mosaici della cappella di Sant'Isidoro nella basilica di San Marco a Venezia." *ArtV* 60 (2003): 6–29.

———. "I mosaici della cappella di Sant'Isidoro nella basilica di San Marco fra la tradizione bizantina e le novità di Paolo Veneziano." *Zograf* 32 (2008): 123–30.

———. "Ricerche stilistiche nei mosaici della cappella di Sant'Isidoro." In Favaretto, *La cappella*, 24–34. Venice, 2008.

———. "Lo spazio figurativo del battistero marciano a Venezia: Una introduzione." *Ateneo Veneto*, ser. 3, 12.1 (2013): 253–65.

Delehaye, H. *Les origines du culte des martyrs*. 2nd rev. ed. Brussels, 1933.

Dellermann, R. "L'arredo e le sculture della cappella: Un linguaggio antico veneziano per l'arca di Sant'Isidoro." In Favaretto, *La cappella*, 35–63. Venice, 2008.

———. "La cappella di Sant'Isidoro: I mosaici della 'Traslatio sancti Isidori'; Intenzione e ricezione politica." In *Quaderni della Procuratoria: Arte, storia, restauri della basilica di San Marco a Venezia*. Vol. 15, *Sedici anni di studi sulla basilica: Il punto della situazione*, edited by I. Favaretto, 35–44. Venice, 2021.

———. "'Iussu ducis'—auf Befehl des Dogen: Die Cappella di Sant'Isidoro in San Marco; Kunst und Heiligenpräsentation unter dem Dogen Andrea Dandolo (1343–1354) im Kontext." PhD diss., Technische Universität, 2006.

———. "Le tombe del vescovo Hermann II (1170–1177) a Bamberga e nel battistero di San Marco." In *Quaderni della Procuratoria: Arte, storia, restauri della basilica di San Marco a Venezia*. Vol. 4, *Il coronamento gotico*, ed. I. Favaretto, 93–95. Venice, 2009.

Dellermann, R., and K. Uetz. *La facciata nord di San Marco a Venezia: Storia e restauri*. Sommacampagna, 2018.

De Marchi, A. "Polyptiques vénitiens: Anamnèse d'une identité méconnue." In *Autour de Lorenzo Veneziano: Fragments de polyptyques vénitiens du XIVᵉ siècle*, edited by A. De Marchi and C. Guarnieri, 13–44. Cinisello Balsamo, 2005.

———. "La postérité du devant-d'autel à Venise: Retables orfévrés et retables peints." In Kroesen and Schmidt, *The Altar and Its Environment*, 57–86.

De Maria, B. *Becoming Venetian: Immigrants and the Arts in Early Modern Venice*. New Haven, CT, 2010.

Demus, O. *The Church of San Marco in Venice: History, Architecture, Sculpture*. Dumbarton Oaks Studies 6. Washington, DC, 1960.

———. *The Mosaics of San Marco in Venice*. 2 vols. Chicago, 1984.

———. "Venetian Mosaics and Their Byzantine Sources: Report on the Dumbarton Oaks Symposium of 1978." *DOP* 33 (1979): 337–43.

———. "Ein Wandgemälde in San Marco, Venedig." In *Okeanos: Essays Presented to Ihor Ševčenko on His Sixtieth Birthday by His Colleagues and Students*, edited by C. Mango and O. Pritksak, 125–44. *HUkSt* 7. Cambridge, MA, 1984.

———, and G. Tigler. *Le sculture esterne di San Marco*. Milan, 1995.

Denton, J., ed. *Orders and Hierarchies in Late Medieval and Renaissance Europe*. Manchester, 1999.

Deprez, E., and G. Mollat, eds. *Clément VI (1342–1352): Lettres closes, patentes et cuiales, intéressant les pays autres que la France*. Bibliothéque des écoles françaises d'Athenes et de Rome, ser. 3. Vol. 2. Paris, 1960.

Derbes, A. *Ritual, Gender, and Narrative in Late Medieval Italy: Fina Buzzacarini and the Baptistery of Padua*. Turnhout, 2020.

———. "Washed in the Blood of the Lamb: Apocalyptic Visions in the Baptistery of Padua." *Speculum* 91.4 (2016): 945–97.

———, and A. Neff. "Italy, the Mendicant Orders, and the Byzantine Sphere." In Evans, *Byzantium: Faith and Power (1261–1557)*, 449–61.

Deshman, R. "The Exalted Servant: The Ruler Theology of the Prayerbook of Charles the Bald." *Viator* 11 (1980): 385–432.

Deur-Petiteau, V. "Images, spatialité et cérémoniel dans le narthex des églises en Serbie médiévale." In *Visibilité et présence de l'image dans l'espace ecclésial: Byzance et Moyen Âge occidental*, edited by S. Brodbeck and A.-O. Poilpré, 329–54. Byzantina Sorbonensia 30. Paris, 2019.

DeVries, K., and R. D. Smith. *Medieval Military Technology*. 2nd ed. Toronto, 2012.

Di Cesare, M. "Problemi di autografia nei testimoni del *Compendium* e della *Satirica ystoria* di Paolino Veneto." *Res Publica Litterarum* 30 (2007): 39–49.

Di Fabio, C. "Giotto, Giovanni Pisano e Marco Romano: Rapporti fra pittura e scultura nella Cappella degli Scrovegni." *Bollettino del Museo Civico di Padova* 100 (2011): 143–84.

———. "Memoria e modernità: Della propria figura di Enrico Scrovegni e di altre sculture nella Cappella dell'Arena di Padova, con aggiunte al catalogo di Marco Romano." In *Medioevo: Immagine e memoria; Atti del convegno internazionale di studi: Parma, 23–28 settembre 2008*, edited by A. Quintavalle, 532–46. Milan, 2009.

Di Manzano, F., ed. *Annali del Friuli, ossia Raccolta delle cose storiche appartenenti a questa regione*. Vol. 5. Udine, 1865.

Doležalová, K., and Ivan Foletti, eds. *The Notion of Liminality and the Medieval Sacred Space*. Convivium, supplement 6. Brno, 2019.

Donega, M. "I reliquiari del sangue di Cristo del tesoro di San Marco." *Arte documento* 11 (1997): 64–71.

Drpić, I. *Epigram, Art, and Devotion in Later Byzantium*. Cambridge, 2016.

Duby, G. *The Three Orders: Feudal Society Imagined*. Chicago, 1980.

Durand, J. "Precious-Metal Icon Revetments." In Evans, *Byzantium: Faith and Power (1261–1557)*, 242–51.

Dursteler, E. R. *Venetians in Constantinople: Nation, Identity, and Coexistence in the Early Modern Mediterranean*. Baltimore, 2006.

Ebersolt, J. *Sanctuaires de Byzance: Recherches sur les anciens trésors des églises de Constantinople*. Paris, 1921.

Edbury, P. "Christians and Muslims in the Eastern Mediterranean." In *NCMH* 6:864–84.

Efthymiadis, S. *Hagiography in Byzantium: Literature, Social History and Cult*. Farnham, 2011.

———, ed. *The Ashgate Research Companion to Byzantine Hagiography*. 2 vols. Farnham, 2011–2014.

Emmerson, R. K. *Apocalypse Illuminated: The Visual Exegesis of Revelation in Medieval Illustrated Manuscripts*. University Park, PA, 2018.

English Frazer, M. "The Pala d'Oro and the Cult of St. Mark in Venice." *JÖB* 32.5 (1982): 273–80.

Erdmann, C. *The Origin of the Idea of Crusade*. Princeton, NJ, 1977.

Evans, H. C., ed. *Byzantium: Faith and Power (1261–1557)*. New York, 2004.

Evans, H. C., and W. D. Wixom, eds. *The Glory of Byzantium: Art and Culture of the Middle Byzantine Era, A.D. 843–1261*. New York, 1997.

Falkowski, W. "The Humility and Humiliation of the King—Rituals and Emotions." In *State, Power, and Violence*, edited by M. Kitts, B. Schneidmüller, G. Schwedler, E. Tounta, H. Kulke, and U. Skoda, 163–96. Wiesbaden, 2010.

Fasoli, G. "Liturgia e cerimoniale ducale." In *Scritti di storia medievale*, edited by A. I. Pini, F. Bocchi, and A. Carile, 529–61. Bologna, 1974.

———. "Nascita di un mito." In *Scritti di storia medievale*, edited by A. I. Pini, F. Bocchi, and A. Carile, 445–72. Bologna, 1974.

Favaretto, I. *Quaderni della Procuratoria: Arte, storia, restauri della basilica di San Marco a Venezia*. Vol. 3, *La cappella di Sant'Isidoro*. Venice, 2008.

Fenlon, I. *The Ceremonial City: History, Memory and Myth in Renaissance Venice*. New Haven, CT, 2007.

Ferguson, E. "The Beginning of Infant Baptism." In *Early Christians Speak: Faith and Life in the First Three Centuries*, 53–64. 3rd ed. Abilene, TX, 1999.

———. "Inscriptions and the Origin of Infant Baptism." *JTS* 30.1 (1979): 37–46.

Fillitz, H., and G. Morello, eds. *Omaggio a San Marco: Tesori dall'Europa*. Milan, 1994.

Fiori, L. "Il codice autografo di Piero Giustinian: Un esempio di genesi ed evoluzione della cronachistica medievale." PhD diss., Alma Mater Studiorum, Università di Bologna, 2014.

Flanigan, C. C. "The Apocalypse and the Medieval Liturgy." In *The Apocalypse in the Middle Ages*, edited by R. K. Emmerson and B. McGinn, 333–51. Ithaca, NY, 1992.

Flores d'Arcais, F. "Paolo Veneziano e la pittura del Trecento in Adriatico." In Flores d'Arcais and Gentili, *Il Trecento adriatico*, 19–31.

———. "Il Trecento in San Marco: La recente letteratura critica e gli ultimi restauri." In Vio, *San Marco: La basilica*, 1:297–307.

———, and G. Gentili, eds. *Il Trecento adriatico: Paolo Veneziano e la pittura tra Oriente e Occidente*. Cinisello Balsamo, 2002.

Fortini Brown, P. "Committenza e arte di Stato." In Arnaldi et al., *Storia di Venezia*, 3:783–824.

———. *Private Lives in Renaissance Venice: Art, Architecture, and the Family*. New Haven, CT, 2004.

———. *Venetian Narrative Painting in the Age of Carpaccio*. New Haven, CT, 1988.

———. *Venice and Antiquity: The Venetian Sense of the Past*. New Haven, CT, 1996.

Franco, T. "Scultura e pittura del Trecento e del primo Quattrocento." In *La basilica dei Santi Giovanni e Paolo: Pantheon della Serenissima*, edited by G. Pavanello, 67–75. Venice, 2013.

Frolow, A. "Notes sur les reliques et les reliquaires byzantins de Saint-Marc de Venise," *Δελτ. Χριστ. Ἀρχ. Ἑτ.* 4.4 (1964–1965): 205–26.

Fumo, A. "Notizie dall'archivio: La sepoltura del vescovo di Bamberga in San Marco." In *Quaderni della Procuratoria: Arte, storia, restauri della basilica di San Marco a Venezia*. Vol. 4, *Il coronamento gotico*, ed. I. Favaretto, 91–92. Venice, 2009.

———. "La ricognizione del corpo di San Marco: Cronache e documenti." In *Quaderni della Procuratoria: Arte, storia, restauri della basilica di San Marco a Venezia*. Vol. 15, *Sedici anni di studi sulla basilica: Il punto della situazione*, edited by I. Favaretto, 48–56. Venice, 2021.

Furlan, I., ed. *Venezia e Bisanzio: Venezia, Palazzo Ducale, 8 giugno–30 settembre 1974*. Milan, 1974.

Gaeta, F. "Alcune considerazioni sul mito di Venezia." *Bibliothèque d'Humanisme et Renaissance* 23.1 (1961): 58–75.

Galante, A. "Per la storia giuridica della basilica di S. Marco." *JbKw* 2 (1912): 283–98.

Gallo, R. *Il tesoro di S. Marco e la sua storia*. Venice, 1967.

Gasparri, S. "The First Dukes and the Origins of Venice." In *Venice and Its Neighbors from the 8th to 11th Century: Through Renovation and Continuity*, edited by S. Gelichi and S. Gasparri, 5–26. Leiden, 2018.

Geary, P. J. *Furta Sacra: Thefts of Relics in the Central Middle Ages*. Princeton, NJ, 1990.

———. "Sacred Commodities: The Circulation of Medieval Relics." In *The Social Life of Things: Commodities in Cultural Perspective*, edited by A. Appadurai, 169–92. Cambridge, 1986.

Genuardi, L. "La 'Summula statutorum floridorum Veneciarum' di Andrea Dandolo." *NAVen* 21.2 (1911): 436–67.

Georgopoulou, M. "Late Medieval Crete and Venice: An Appropriation of Byzantine Heritage." *ArtB* 77.3 (1995): 479–96.

———. *Venice's Mediterranean Colonies: Architecture and Urbanism*. Cambridge, 2001.

Gerevini, S. "Art as Politics in the Baptistery and Chapel of Sant'Isidoro at San Marco, Venice." *DOP* 74 (2020): 243–68.

———. "Dynamic Splendor: The Metalwork Altarpieces of Medieval Venetia." *Convivium* 9.2 (2022): 102–23.

———. "The Grotto of the Virgin in San Marco: Artistic Reuse and Cultural Identity in Medieval Venice." *Gesta* 53.2 (2014): 197–220.

———. "Inscribing History, (Over)Writing Politics: Word and Image in the Chapel of Sant'Isidoro at San Marco, Venice." In *Sacred Scripture/Sacred Space: The Interlacing of Real Places and Conceptual Spaces*, edited by T. Frese, W. E. Keil, and K. Krüger, 323–49. Berlin, 2019.

———. "Topografia sacra e geografie del potere a Venezia nel Trecento." In *Strategie urbane e rappresentazione del potere: Milano e le città d'Europa*, edited by S. Romano and M. Rossi, 202–25. Milan, 2022.

Gerstel, S. E. J. *Beholding the Sacred Mysteries: Programs of the Byzantine Sanctuary*. Seattle, 1999.

———. *Thresholds of the Sacred: Architectural, Art Historical, Liturgical, and Theological Perspectives on Religious Screens, East and West*. Washington, DC, 2006.

Geymonat, L. V. "The Parma Baptistery and Its Pictorial Program." PhD diss., Princeton University, 2006.

———, and L. Lazzarini. "A Nativity Cycle for the Choir Screen of San Marco, Venice." *Convivium* 7.1 (2020): 80–113.

Ghilardi, M. "*Quae signa erant illa, quibus putabant esse significativa martyrii?* Note sul riconoscimento ed autenticazione delle reliquie delle catacombe romane nella prima età moderna." *Mélanges de l'École française de Rome: Italie et Méditerranée modernes et contemporaines* 122.1 (2010): 81–106.

Gilbert, F. "The Venetian Constitution in Florentine Political Thought." In *Florentine Studies: Politics and Society in Renaissance Florence*, edited by N. Rubenstein, 463–500. London, 1968.

Gill, J. *The Council of Florence*. Cambridge, 1959.

———. *Personalities of the Council of Florence: And Other Essays*. New York, 1965.

Gilli, P. "Comment cesser d'être étranger: Citoyens et non-citoyens dans la pensée juridique italienne de la fin du Moyen Âge." In *L'étranger au Moyen Âge*, edited by C. Gauvard, 59–77. Paris, 2000.

Gleeson, J. J., and A. Vukovich. "Orientalism and the Postcolonial Turn." TORCH: The Oxford Research Centre in the Humanities. Video talks. 17 May 2019, https://www.torch.ox.ac.uk/orientalism-2020.

Goffen, R. "Icon and Vision: Giovanni Bellini's Half-Length Madonnas." *ArtB* 57.4 (1975): 487–518.

———. "Il paliotto della pala d'oro di Paolo Veneziano e la committenza del doge Andrea Dandolo." In Niero, *San Marco: Aspetti storici*, 313–33.

———. "Paolo Veneziano e Andrea Dandolo: Una nuova lettura della pala feriale." In Hahnloser and Polacco, *La pala d'oro*, 173–84.

Goodich, M. E. *Violence and Miracle in the Fourteenth Century: Private Grief and Public Salvation*. Chicago, 1995.

Gorse, G. "Architecture and Urban Topography." In Benes, *Companion to Medieval Genoa*, 218–42.

Gossman, L. "Cultural History and Crisis: Burckhardt's Civilization of the Renaissance in Italy." In *Rediscovering History: Culture, Politics, and the Psyche*, edited by M. S. Roth, 404–27. Stanford, 1994.

Goullet, M. *Ecriture et réécriture hagiographiques: Essai sur les réécritures de vies de saints dans l'occident latin médiéval (VIII^e–XIII^e s.).* Turnhout, 2005.

Gratziou, O. "Μεταβυζαντινή Τέχνη: Χρονολογικός Προσδιορισμός ή Εννοιολογική Κατηγορία." In *1453: Η Άλωση Της Κωνσταντινούπολης Και η Μετάβαση Από Τους Μεσαιωνικούς Στους Νεώτερους Χρόνους*, edited by T. Kiousopoulou, 183–96. Heraklion, 2005.

Graziato, G., ed. *Le promissioni del doge di Venezia: Dalle origini alla fine del Duecento*. Fonti per la storiadi Venezia, Archivi pubblici. Venice, 1986.

Gregory of Tours. *Glory of the Martyrs*. Translated by R. Van Dam. Liverpool, 1988.

———. "Liber vitae patrum." Edited by B. Krusch. In MGH ScriptRerMerov, 1.2:661–744. Hannover, 1885.

Griffo, Rizzardi, ed. *Volumen statutorum legum, ac iurium dd. Venetorum*. Venice, 1619.

Grubb, J. S. "Elite Citizens." In Martin and Romano, *Venice Reconsidered*, 339–64.

———. "Memory and Identity: Why Venetians Didn't Keep Ricordanze." Renaissance Studies 8.4 (1994): 375–87.

Guarnieri, C. "Il monumento funebre di Francesco Dandolo nella sala del capitolo ai Frari." In *Santa Maria Gloriosa dei Frari: Immagini di devozione, spazi della fede*, edited by C. Corsato and D. Howard, 151–62. Padua, 2015.

———. "Una pala ribaltabile per l'esposizione delle reliquie: Le 'Storie di Santa Lucia' di Jacobello del Fiore a Fermo." *ArtV* 73 (2016): 9–35.

———. "Lo svelamento rituale delle reliquie e le pale ribaltabili di Paolo Veneziano sulla costa istriano-dalmata." In *La Serenissima via mare: Arte e cultura tra Venezia e il Quarnaro*, edited by V. Baradel and C. Guarnieri, 39–53. Padua, 2019.

Gwyn, W. B. "Cruel Nero: The Concept of the Tyrant and the Image of Nero in Western Political Thought." In *History of Political Thought* 12.3 (1991): 421–55.

Hackel, S., ed. *The Byzantine Saint*. Crestwood, NY, 2001.

Hahn, C. J. "Interpictoriality in the Limoges Chasses of Stephen, Martial, and Valerie." In *Image and Belief: Studies in Celebration of the Eightieth Anniversary of the Index of Christian Art*, edited by C. Hourihane, 109–24. Princeton, NJ, 1999.

———. *Portrayed on the Heart: Narrative Effect in Pictorial Lives of Saints from the Tenth through the Thirteenth Century*. Berkeley, 2001.

———. *Strange Beauty: Issues in the Making and Meaning of Reliquaries, 400–circa 1204*. University Park, PA, 2012.

———. "Understanding Pictorial Hagiography (with Comments on the Illustrated Life of Wandrille)." In *Hagiography and the History of Latin Christendom, 500–1500*, edited by S. K. Herrick, 52–77. Leiden, 2020.

———, and H. A. Klein, eds. *Saints and Sacred Matter: The Cult of Relics in Byzantium and Beyond*. Washington, DC, 2015.

Hahnloser, H. R. "Le oreficerie della pala d'oro." In Hahnloser and Polacco, *La pala d'oro*, 79–111.

———, ed. *Il tesoro di San Marco*. Vol. 2, *Il tesoro e il museo*. Florence, 1971.

Hahnloser, H. R., and R. Polacco, eds. *La pala d'oro*. Venice, 1994. Originally published as *Il tesoro di San Marco*, vol. 1, *La pala d'oro*, edited by H. R. Hahnloser. Florence, 1965.

Hakkarainen, M. "Regimen mixtum—μικτὴ πολιτεία." In *Roma, magistra mundi: Itineraria culturae medievalis; Mélanges offerts au Père L. E. Boyle à l'occasion de son 75e anniversaire*. Vol. 1, edited by J. Hamesse, 111–21. Turnhout, 1998.

Haldon, J. F. *The Empire That Would Not Die: The Paradox of Eastern Roman Survival, 640–740*. Cambridge, MA, 2016.

Hammerl, C. "The Earthquake of January 25th, 1348: Discussion of Sources." EC Project RHISE (1989–1993), https://emidius.mi.ingv.it/RHISE/ii_20ham/ii_20ham.html.

Harding, A. *Medieval Law and the Foundations of the State*. Oxford, 2002.

Harris, J. P. "'A Blow Sent by God': Changing Byzantine Memories of the Crusades." In *Remembering the Crusades and Crusading*, edited by M. Cassidy-Welch, 189–201. London, 2017.

Harvey, S. A. *Asceticism and Society in Crisis: John of Ephesus and the Lives of the Eastern Saints*. Berkeley, 1990.

Henry of Rimini, *Tractatus de quattuor virtutibus cardinalibus*. Speyer, 1472.

Herrmann-Mascard, N. *Les reliques des saints: Formation coutumière d'un droit*. Paris, 1975.

Hiley, D. *Western Plainchant: A Handbook*. Oxford, 1993.

Hills, P. *Veiled Presence: Body and Drapery from Giotto to Titian*. New Haven, CT, 2018.

———. "Vesting the Body of Christ." In *Examining Giovanni Bellini: An Art "More Human and More Divine,"* edited by C. C. Wilson, 61–76. Turnhout, 2015.

Hilsdale, C. J. *Byzantine Art and Diplomacy in an Age of Decline*. Cambridge, 2014.

———. "The Timeliness of Timelessness: Reconsidering Decline in the Palaiologan Period." In Mattiello and Rossi, *Late Byzantium Reconsidered*, 53–70.

Hinde, J. R. *Jacob Burckhardt and the Crisis of Modernity*. Montreal, 2000.

Historia de translationis sanctorum magni Nicolai, terra marique miraculi gloriosi, ejusdem avunculi, alterius Nicolai, Theodorique martyris pretiosi. RHC HOcc, 5:253–92.

Hobsbawm, E. J. "The General Crisis of the European Economy in the 17th Century." *Past & Present* 5.1 (1954): 33–53.

Hoch, A. S. "Pictures of Penitence from a Trecento Neapolitan Nunnery." *ZKunstg* 61.2 (1998): 206–26.

Horn, G. *Das Baptisterium der Markuskirche in Venedig: Baugeschichte und Ausstattung.* Bern, 1991.

Howard, D. *The Architectural History of Venice.* Rev. ed. New Haven, CT, 2002.

Howard-Johnston, J. D. *Witnesses to a World Crisis: Historians and Histories of the Middle East in the Seventh Century.* Oxford, 2010.

Hubach, H. "Pontifices, clerus—populus, dux: Osservazioni sul significato e sullo sfondo storico della più antica raffigurazione della società veneziana." In Niero, *San Marco: Aspetti storici*, 370–97.

Hueck, I. "La corte carrarese e i rapporti con Carlo IV di Boemia." In Banzato, Flores d'Arcais, and Spiazzi, *Guariento*, 81–86.

———. "Proposte per l'assetto originario delle tavole del Guariento nell'ex cappella carrarese di Padova." In *Attorno a Giusto de' Menabuoi: Aggiornamenti e studi sulla pittura a Padova nel Trecento; Atti della giornata di studio 18 dicembre 1990*, edited by A. M. Spiazzi, 83–96. Treviso, 1994.

Humfrey, P. *The Altarpiece in Renaissance Venice.* New Haven, CT, 1993.

Humphrey, C., and W. M. Ormrod, eds. *Time in the Medieval World.* Woodbridge, 2001.

Hurlburt, H. S. *The Dogaressa of Venice, 1200–1500: Wife and Icon.* New York, 2006.

Israel, U., and O. J. Schmitt, eds. *Venezia e Dalmazia.* Rome, 2013.

Jacobus de Voragine. *The Golden Legend: Readings on the Saints.* Translated by W. G. Ryan. Princeton, NJ, 2012.

Jacoby, D. "La consolidation de la domination de Venise dans la ville de Négrepont (1205–1390): Un aspect de sa politique coloniale." In *Bisanzio, Venezia e il mondo franco-greco (XIII–XV secolo): Atti del colloquio internazionale organizzato nel centenario della nascita di Raymond-Joseph Loenertz O.P., Venezia, 1–2 dicembre 2000*, edited by C. A. Maltézou and P. Schreiner, 151–87. Venice, 2002.

———. "The Demographic Evolution of Euboea under Latin Rule." In *The Greek Islands and the Sea: Proceedings of the First International Colloquium Held at the Hellenic Institute, Royal Holloway, University of London, 21–22 September 2001*, edited by J. Chrystomides, C. Dendrinos, and J. Harris, 131–80. Camberley, 2004.

———. "The Eastern Mediterranean in the Later Middle Ages: An Island World?" In *Byzantines, Latins, and Turks in the Eastern Mediterranean World after 1150*, edited by J. Harris, C. Holmes, and E. Russell, 93–118. Oxford, 2012.

———. "Venetian Citizenship and Venetian Identity in the Eastern Mediterranean." In *Cultures of Empire: Rethinking Venetian Rule, 1400–1700; Essays in Honour of Benjamin Arbel*, edited by G. Christ and F.-J. Morche, 125–52. Leiden, 2020.

Jacoff, M. *The Horses of San Marco and the Quadriga of the Lord.* Princeton, NJ, 1993.

Jakšić, N. "Srbrna oltarna pala u Kotoru." *Ars Adriatica* 3 (2013): 53–66.

Janes, D. *God and Gold in Late Antiquity.* Cambridge, 1998.

Jeffreys, E., J. F. Haldon, and R. Cormack. "Byzantine Studies as an Academic Discipline." In *OHBS*, 3–20. Oxford, 2008.

Jensen, R. M. *Baptismal Imagery in Early Christianity: Ritual, Visual, and Theological Dimensions.* Grand Rapids, MI, 2012.

Jessop, L. "Art and the Gregorian Reform: Saints Peter and Clement in the Church of San Marco at Venice." *RACAR* 32.1/2 (2007): 24–34.

Johnson, M. E. *The Rites of Christian Initiation: Their Evolution and Interpretation.* Rev. ed. Collegeville, MN, 2007.

Jordan, W. C. "Salome in the Middle Ages." *Jewish History* 26.1/2 (2012): 5–15.

Kantorowicz, E. H. "*Pro patria mori* in Medieval Political Thought." *AHR* 56.3 (1951): 472–92.

Kaplan, P. H. D. "Black Africans in Hohenstaufen Iconography." *Gesta* 26.1 (1987): 29–36.

———. "Introduction to the New Edition." In *The Image of the Black in Western Art.* Vol. 2, pt. 1, *From the Demonic Threat to the Incarnation of Sainthood*, edited by D. Bindman and H. L. Gates (Jr.), 1–30. Cambridge, MA, 2010.

Katzenstein, R. "Three Liturgical Manuscripts from San Marco: Art and Patronage in Mid-Trecento Venice." PhD diss., Harvard University, 1987.

Kazhdan, A. P., "Holy and Unholy Miracle Workers." In *Byzantine Magic*, edited by H. Maguire, 73–82. Washington, DC, 1995.

Keck, D. *Angels and Angelology in the Middle Ages.* Oxford, 1998.

Kemperdick, S. "Altar Panels in Northern Germany, 1180–1350." In Kroesen and Schmidt, *The Altar and Its Environment*, 125–46.

Kessler, H. L. "Conclusion: La Genèse Cotton est morte." In *Les stratégies de la narration dans la peinture médiévale: La représentation de l'Ancien Testament aux IVᵉ–XIIᵉ siècles*, edited by M. Angheben, 373–402. Turnhout, 2020.

———. "The Meeting of Peter and Paul in Rome: An Emblematic Narrative of Spiritual Brotherhood." *DOP* 41 (1987): 265–75.

———, and S. Romano. "A Hub of Art: In, Out, and Around Venice, 1177–1499." *Convivium* 7.1 (2020): 17–51.

Klein, H. A. "Eastern Objects and Western Desires: Relics and Reliquaries between Byzantium and the West." *DOP* 58 (2004): 283–314.

———. "Die Heiltümer von Venedig—die 'byzantinischen' Reliquien der Stadt." In *Quarta crociata: Venezia, Bisanzio, Impero Latino*, edited by G. Ortalli, G. Ravegnani, and P. Schreiner, 2:699–736. Venice, 2006.

———. "Refashioning Byzantium in Venice, ca. 1200–1400." In Maguire and Nelson, *San Marco, Byzantium, and the Myths of Venice*, 193–225.

———, V. Poletto, and P. Schreiner, eds. *La stauroteca di Bessarione fra Costantinopoli e Venezia*. Venice, 2017.

Klein, N. *The Shock Doctrine: The Rise of Disaster Capitalism*. New York, 2007.

Klípa, J., and E. Poláčková. "*Tabulae cum portis, vela, cortinae* and *sudaria*: Remarks on the Liminal Zones in the Liturgical and Para-liturgical Contexts in the Late Middle Ages." In Doležalová and Foletti, *Liminality and Sacred Space*, 112–33.

Kohl, B. G., and R. C. Mueller. "The Serrata of the Greater Council of Venice, 1282–1323: The Documents." In *Venice and the Veneto during the Renaissance: The Legacy of Benjamin Kohl*, edited by M. Knapton, J. E. Law, and A. A. Smith, 3–34. Florence, 2015.

Kondyli, F., V. Andriopoulou, E. Panou, and M. B. Cunningham, eds. *Sylvester Syropoulos on Politics and Culture in the Fifteenth-Century Mediterranean: Themes and Problems in the Memoirs, Section 4*. Farnham, 2014.

Kontogiannis, N. D., and S. S. Skartsis. *Venetian and Ottoman Heritage in the Aegean: The Bailo House in Chalcis, Greece*. Turnhout, 2020.

Kosegarten, A. M. "Zur liturgischen Ausstattung von San Marco in Venedig im 13. Jahrhundert: Kanzeln und Altarziborien." *MarbJb* 29 (2002): 7–77.

Koselleck, R. *Critique and Crisis: Enlightenment and the Pathogenesis of Modern Society*. Cambridge, MA, 1988.

Koster, G. *Kunstler und ihre Bruder: Maler, Bildhauer und Architekten in den venezianischen Scuole Grandi (bis ca. 1600)*. Berlin, 2008.

Köstler, A. "Paradigmenwechsel auf dem Reißbrett: Der Hochaltar der Marburger Elisabethkirche." In *Entstehung und Frühgeschichte des Flügelaltarschreins*, edited by H. Krohm, K. Krüger, and M. Weniger, 51–59. Wiesbaden, 2001.

Krause, K. "Feuerprobe, Portraits in Stein: Mittelalterliche Propaganda für Venedigs Reliquien aus Konstantinopel und die Frage nach ihrem Erfolg." In *Lateinisch-griechisch-arabische Begegnungen: Kulturelle Diversität im Mittelmeerraum des Spätmittelalters*, edited by M. Mersch and U. Ritzerfeld, 111–62. Berlin, 2009.

———. "The 'Staurotheke of the Empress Maria' in Venice: A Renaissance Replica of a Lost Byzantine Cross Reliquary in the Treasury of St Mark's." In *Die kulturhistorische Bedeutung byzantinischer Epigramme: Akten des internationalen Workshop (Wien, 1–2. Dezember 2006)*, edited by W. Hörander and A. Rhoby, 37–53. Vienna, 2008.

Krekic, B. "Venezia e l'Adriatico." In Arnaldi et al., *Storia di Venezia*, 3:51–85.

Kroesen, J. E. A., and V. M. Schmidt, eds. *The Altar and Its Environment, 1150–1400*. Turnhout, 2009.

Kuhn, T. S. *The Structure of Scientific Revolutions*. 3rd ed. Chicago, 1996.

Laiou, A. E. "Marino Sanudo Torsello, Byzantium and the Turks: The Background of the Anti-Turkish League of 1332–1334." *Speculum* 45.3 (1970): 374–92.

Lallou, W. J. "The Prophecies on Holy Saturday." *The Catholic Biblical Quarterly* 6.3 (1944): 299–305.

Landes, R. "Lest the Millennium Be Fulfilled: Apocalyptic Expectations and the Pattern of Western Chronography 100–800 CE." In *The Use and Abuse of Eschatology in the Middle Ages*, edited by W. Verbeke, D. Verhelst, and A. Welkenhuysen, 137–211. Leuven, 1988.

Lane, F. C. "The Enlargement of the Great Council of Venice." In *Florilegium Historiale: Essays Presented to W. K. Ferguson*, edited by J. G. Rowe, 237–74. Toronto, 1971.

Lanfranchi, L., ed. *S. Giorgio Maggiore*. Vol. 2, *Documenti 982–1159*. Venice, 1968.

Larivière, C. J. de, and R. M. Salzberg. "The People Are the City." *Annales: Histoire, Sciences Sociales* 68.4 (2013): 1113–40.

Lawton, D. "1453 and the Stream of Time." *Journal of Medieval and Early Modern Studies* 37.3 (2007): 469–91.

Lazzarini, L. "'Dux ille danduleus': Andrea Dandolo e la cultura veneziana a metà del Trecento." In *Petrarca, Venezia e il Veneto*, edited by G. Padoan, 123–56. Florence, 1976.

———. "Indagini di laboratorio sui materiali delle colonne del ciborio." In *Quaderni della Procuratoria: Arte, storia, restauri della basilica di San Marco a Venezia*. Vol. 10, *Le colonne del ciborio*, edited by I. Favaretto (Venice, 2015), 57–63.

Lazzarini, V. "La battaglia di Porto Longo nell'isola di Sapienza." *NAVen* 8.1 (1894): 5–45.

———. *Marino Faliero: Avanti il dogado, la congiura, appendici*. Florence, 1963.

———. "Marino Faliero: La congiura." *NAVen* 13 (1897): 5–108, 277–374.

———. "Il testamento del doge Andrea Dandolo." *NAVen*, n.s. 7 (1904): 139–48.

Lee, H.-Y. *Political Representation in the Later Middle Ages: Marsilius in Context*. New York, 2008.

Lerner, A. *Der gotische "Dogenpalast" in Venedig: Baugeschichte und Skulpturenprogramm des Palatium communis Venetiarum*. Berlin, 2005.

Lerner, R. E. *The Age of Adversity: The Fourteenth Century*. Ithaca, NY, 1968.

———. *The Powers of Prophecy: The Cedar of Lebanon Vision from the Mongol Onslaught to the Dawn of the Enlightenment*. Berkeley, 1983.

Levy, I. C., G. Macy, and K. Van Ausdall, eds. *A Companion to the Eucharist in the Middle Ages*. Brill's Companions to the Christian Tradition 26. Leiden, 2012.

Lieberman, R. "Venetian Church Architecture around 1500." *Bollettino del Centro Internazionale di Studi di Architettura "Andrea Palladio"* 19 (1977): 35–48.

Lock, P. *The Franks in the Aegean, 1204–1500*. London, 1995.

Lorenzi, G. *Monumenti per servire alla storia del palazzo ducale di Venezia: Ovvero, Serie di atti pubblici dal 1253 al 1797, che variamente lo riguardano tratti dai Veneti archivii e coordinati da Giambattista Lorenzi*. Vol. 1, *Dal 1253 al 1600*. Venice, 1868.

Mack, M. "Genoa and the Crusades." In Benes, *Companion to Medieval Genoa*, 471–95.

———. "The Italian Quarters of Frankish Tyre: Mapping a Medieval City." *JMedHist* 33.2 (2007): 147–65.

Mackenney, R. *Venice as the Polity of Mercy: Guilds, Confraternities, and the Social Order, c. 1250–c. 1650*. Toronto, 2019.

Macrides, R. "Saints and Sainthood in the Early Palaeologan Period." In *The Byzantine Saint*, edited by S. Hackel, 67–87. Crestwood, NY, 2001.

Macy, G. "Theology of the Eucharist in the High Middle Ages." In Benes, *Companion to Medieval Genoa*, 365–98.

Maguire, E. D. "Curtains at the Threshold: How They Hung and How They Performed." *DOP* 73 (2019): 217–44.

Maguire, H. *The Icons of Their Bodies: Saints and Their Images in Byzantium*. Princeton, NJ, 1996.

———. "The Political Content of the Atrium Mosaics." In *The Atrium of San Marco in Venice: The Genesis and Medieval Reality of the Genesis Mosaics*, edited by M. Büchsel, H. L Kessler, and R. Müller, 271–79. Berlin, 2014.

———. "The South Façade of the Treasury of San Marco." In Vio, *San Marco: La basilica*, 1:123–29.

———, and R. S. Nelson, eds. *San Marco, Byzantium, and the Myths of Venice*. Dumbarton Oaks Byzantine Symposia and Colloquia. Washington, DC, 2010.

Mallett, M. E., and J. R. Hale. *The Military Organisation of a Renaissance State: Venice c. 1400 to 1617*. Cambridge, 1984.

Manno, A., ed. *San Marco Evangelista: Opere d'arte dalle chiese di Venezia*. Venice, 1995.

Marangon, D. "Il fascino delle forme greche a Venezia: Andrea Dandolo, l'arte e l'epigrafia." *Hortus Artium Medievalium* 22 (2016): 157–64.

Maranini, G. *La costituzione di Venezia*. Vol. 2. Venice, 1931.

Marcon, S. "Oreficeria bizantina per i volumi preziosi di San Marco." In *Oreficeria sacra a Venezia e nel Veneto: Un dialogo tra le arti figurative*, edited by L. Caselli and E. Merkel, 57–70. Treviso, 2007.

———. "Il tesoro di San Marco: Le legature preziose, e gli studi di Iacopo Morelli su numerosi oggetti." In *Oreficeria sacra a Venezia e nel Veneto: Un dialogo tra le arti figurative*, edited by L. Caselli and E. Merkel, 131–65. Treviso, 2007.

Mariacher, G. "Postilla al 'San Teodoro, statua composita.'" *ArtV* 1.3 (1947): 230–32.

Marinković, A. "Hostage Relics and Venetian Maritime Control in the Eastern Adriatic," in *Ein Meer und seine Heiligen: Hagiographie im mittelalterlichen Mediterraneum*, edited by N. Jaspert, C. A. Neumann, and M. Di Branco, 275–96. Leiden, 2018.

Marjanović-Dušanić, S., and D. Vojvodić. "The Model of Empire: The Idea and Image of Authority in Serbia (1299–1371)." In *Sacral Art of the Serbian Lands in the Middle Ages*, edited by D. Vojvodić and D. Popović, 299–315. Belgrade, 2016.

Marshall, L. "God's Executioners: Angels, Devils and the Plague in Giovanni Sercambi's Illustrated *Chronicle* (1400)." In *Disaster, Death and the Emotions in the Shadow of the Apocalypse, 1400–1700*, edited by J. Spinks and C. Zika, 177–99. London, 2016.

Martimort, A. G. *L'Église en prière: Introduction à la liturgie*. Paris, 1961.

Martin, J. J., and D. Romano. "Reconsidering Venice." In Martin and Romano, *Venice Reconsidered*, 1–35.

———, eds. *Venice Reconsidered: The History and Civilization of an Italian City-State, 1297–1797*. Baltimore, 2000.

Martin, J. R. "The Theory of Storms: Jacob Burckhardt and the Concept of 'Historical Crisis.'" *Journal of European Studies* 40.4 (2010): 307–27.

Martin, L. R. *The Art and Archaeology of Venetian Ships and Boats*. College Station, TX, 2001.

Martindale, A. "The Venetian Sala del Gran Consiglio and Its Fourteenth-Century Decoration." In *Painting the Palace: Studies in the History of Medieval Secular Painting*, 144–92. London, 1995.

Mason, M. "I primi mosaici della basilica e l'elaborazione della leggenda marciana: Considerazioni sullo stile e l'iconografia." In Vio, *San Marco: La basilica*, 1:226–47.

Mathews, K. R. "Reanimating the Power of Holy Protectors: Merchants and Their Saints in the Visual Culture of Medieval and Early Modern Venice." In *Saints as Intercessors between the Wealthy and the Divine: Art and Hagiography among the Medieval Merchant Classes*, edited by E. Kelley and C. Turner Camp, 238–70. London, 2019.

Matino, G. "Il ciclo dell'albergo della Scuola Grande di San Marco: Una nuova prospettiva." In *La Scuola Grande di San Marco a Venezia*, edited by A. Vincenzi, 1:117–33. Modena, 2017.

Mattiello, A., and M. A. Rossi, eds. *Late Byzantium Reconsidered: The Arts of the Palaiologan Era in the Mediterranean*. London, 2019.

McCluskey, K. "Miraculous Visions: *Apparitio* in the *Vitae* of Mediaeval Venetian Saints and *Beati*." *IKON* 6 (2013): 167–81.

———. *New Saints in Late-Mediaeval Venice, 1200–1500: A Typological Study*. London, 2020.

———. "Official Sanctity alla Veneziana: Gerardo, Pietro Orseolo and Giacomo Salomani." *Conserveries Mémorielles* 14 (2013). http://journals.openedition.org/cm/1718.

McGinn, B. "Apocalypticism and Church Reform: 1100–1500." In *The Encyclopedia of Apocalypticism*. Vol. 2, edited by B. McGinn, J. J. Collins, and S. J. Stein. 74–109. New York, 1999.

———. "John's Apocalypse and the Apocalyptic Mentality." In *The Apocalypse in the Middle Ages*, edited by R. K. Emmerson and B. McGinn, 3–19. Ithaca, NY, 1992.

———. *Visions of the End: Apocalyptic Traditions in the Middle Ages*. New York, 1998.

McKay, G. K. "The Eastern Christian Exegetical Tradition of Daniel's Vision of the Ancient of Days." *JEChrSt* 7.1 (1999): 139–61.

———. "Illustrating the Gospel of John: The Exegesis of John Chrysostom and Images of the Ancient of Days in Eleventh-Century Byzantine Manuscripts." *Studies in Iconography* 31 (2010): 51–68.

Mckee, S. "The Revolt of St. Tito in Fourteenth-Century Venetian Crete: A Reassessment." *Mediterranean Historical Review* 9.2 (1994): 173–204.

Meiss, M. *Painting in Florence and Siena after the Black Death*. Princeton, NJ, 1951.

Melchiorre, M. "Sanudo, Marino il Giovane." *DBI* 90 (2017). https://www.treccani.it/enciclopedia/marino-marin-il-giovane-sanudo_(Dizionario-Biografico)/.

Merkel, E. "Affreschi poco noti a San Marco." In *Storia dell'arte Marciana: I mosaici; Atti del convegno internazionale di studi (Venezia, 11–14 ottobre 1994)*, edited by R. Polacco, 135–45. Venice, 1997.

Merores, M. "Der Große Rat von Venedig und die sogenannte Serrata vom Jahre 1297." *Vierteljahrschrift für Sozial- und Wirtschaftsgeschichte* 21.1/2 (1928): 33–113.

Mitchell, J., and N. Pickwoad. "'Blessed Are the Eyes Which See Divine Spirit Through the Letter's Veil': The Book as Object and Idea." In Doležalová and Foletti, *Liminality and Sacred Space*, 134–59.

Molmenti, P. "Il giuspatronato del doge." In Ongania, *La basilica di San Marco*, 6:19–25.

———. "I procuratori di San Marco." In Ongania, *La basilica di San Marco*, 6:29–37.

Monticolo, G. "L'*Apparitio Sancti Marci* ed i suoi manoscritti." *NAVen* 9 (1895): 111–78.

Morini, E. "Note di lipsanografia veneziana." *Bizantinistica* 1 (1999): 145–272.

Morosini, R., and M. Ciccuto, eds. *Paolino Veneto: Storico, narratore e geografo*. Rome, 2020.

Moutafov, E., and I. Toth. "Byzantine and Post-Byzantine Art: Crossing Borders, Exploring Boundaries." In "Byzantine and Post-Byzantine Art: Crossing Borders, Exploring Boundaries," edited by E. Moutafov and I. Toth. Special issue, *Art Studies Readings* 1 (2017): 11–36.

Mueller, R. C. *Immigrazione e cittadinanza nella Venezia medievale*. Rome, 2010.

———. "The Procuratori di San Marco and the Venetian Credit Market: A Study of the Development of Credit and Banking in the Trecento." PhD diss., Johns Hopkins University, 1969.

———. "The Procurators of San Marco in Thirteenth and Fourteenth Centuries: A Study of the Office as a Financial and Trust Institution." *StVen* 13 (1971): 105–220.

Muir, E. *Civic Ritual in Renaissance Venice*. Princeton, NJ, 1981.

Mulvaney, B. A., and W. R. Cook. "The Beholder as Witness: The Crib at Greccio from the Upper Church of San Francesco, Assisi and Franciscan Influence on Late Medieval Art in Italy." In *The Art of the Franciscan Order in Italy*, edited by W. R. Cook, 169–88. Leiden, 2005.

Munk, A. "The Art of Relic Cults in Trecento Venice: 'Corpi Sancti' as a Pictorial Motif and Artistic Motivation." *Radovi Instituta za Povijest Umjetnosti* 30 (2006): 81–92.

———. "Somatic Treasures: Function and Reception of Effigies on Holy Tombs in Fourteenth Century Venice." *IKON* 4 (2011): 193–210.

Muraro, M. *Paolo da Venezia*. Milan, 1969.

Murat, Z. *Guariento: Pittore di corte, maestro del naturale*. Cinisello Balsamo, 2016.

Musatti, E. *Storia della promissione ducale*. Padua, 1888.

Musto, R. G. *Apocalypse in Rome: Cola di Rienzo and the Politics of the New Age*. Berkeley, 2003.

Neff, A. "Byzantium Westernized, Byzantium Marginalized: Two Icons in the *Supplicationes variae*." *Gesta* 38.1 (1999): 81–102.

———. *A Soul's Journey: Franciscan Art, Theology, and Devotion in the* Supplicationes variae. Toronto, 2019.

Nelson, R. S. "Byzantium and the Rebirth of Art and Learning in Italy and France." In Evans, *Byzantium: Faith and Power (1261–1557)*, 515–23.

———. "High Justice: Venice, San Marco, and the Spoils of 1204." In *Η Βυζαντινή τέχνη μετά την τέταρτη Σταυροφορία: Η τέταρτη σταυροφορία και οι επιπτώσεις της*, edited by P. L. Vokotopoulos, 143–58. Athens, 2007.

———. "The History of Legends and the Legends of History: The Pilastri Acritani in Venice." In Maguire and Nelson, *San Marco, Byzantium, and the Myths of Venice*, 63–90.

Neville, L. A. *Authority in Byzantine Provincial Society, 950–1100*. Cambridge, 2004.

Nicol, D. M. *Byzantium and Venice: A Study in Diplomatic and Cultural Relations*. Cambridge, 1988.

———. *The Last Centuries of Byzantium: 1261–1453*. 2nd ed. Cambridge, 1993.

———. *The Reluctant Emperor: A Biography of John Cantacuzene, Byzantine Emperor and Monk, c. 1295–1383*. Cambridge, 1996.

Niero, A. "Censimento delle pale nell'area lagunare." In Hahnloser and Polacco, *La pala d'oro*, 187–89. Venice, 1994.

———. "Notizie di archivio sulle pale di argento delle lagune venete." *StVen* 2 (1978): 257–91.

———, ed. *San Marco: Aspetti storici ed agiografici; Atti del convegno internazionale di studi, Venezia, 26–29 aprile 1994*. Venice, 1996.

Norberg, J. "Arendt in Crisis: Political Thought in between Past and Future." *College Literature* 38.1 (2011): 131–49.

O'Connell, M. "The Venetian Patriciate in the Mediterranean: Legal Identity and Lineage in Fifteenth-Century Venetian Crete." *Renaissance Quarterly* 57.2 (2004): 466–93.

Olds, K. "The Ambiguities of the Holy: Authenticating Relics in Seventeenth-Century Spain." *Renaissance Quarterly* 65.1 (2012): 135–84.

Olympios, M. "Treacherous Taxonomy: Art in Venetian Crete around 1500 and the 'Cretan Renaissance.'" *ArtB* 98.4 (2016): 417–37.

Ongania, F., ed. *La basilica di San Marco in Venezia illustrata nella storia e nell'arte da scrittori veneziani.* Vol. 6. Venice, 1888.

Ormrod, L. "The Wenceslas Chapel in St. Vitus' Cathedral, Prague: The Marriage of Imperial Iconography and Bohemian Kingship." PhD diss., Courtauld Institute of Art, 1997.

Ortalli, G. "*...pingatur in Palatio...*": *La pittura infamante nei secoli XIII–XVI.* Rome, 1979.

Ortalli, G., and O. Pittarello, eds. *Cronica Jadretina: Venezia-Zara, 1345–1346.* Venice, 2014.

Ortalli, G., G. Ravegnani, and P. Schreiner, eds. *Quarta crociata: Venezia, Bisanzio, Impero Latino.* 2 vols. Venice, 2006.

Os, H. W. van. "The Black Death and Sienese Painting: A Problem of Interpretation." *AH* 4 (1981): 237–49.

Ousterhout, R. "Temporal Structuring in the Chora Parekklesion." *Gesta* 34.1 (1995): 63–76.

Pace, V. "Il ruolo di Bisanzio nella Venezia del XIV secolo: Nota introduttiva a uno studio sui mosaici del battistero marciano." *Ateneo Veneto*, ser. 3, 12.1 (2013): 243–53.

Pallottini, E. "Monumentalisation et mise en scène des saints dans le lieu de culte: Les listes épigraphiques de reliques dans l'Occident médiéval (VIIIᵉ–XIIᵉ siècle)." In *Le pouvoir des listes au Moyen Âge.* Vol. 1, edited by C. Angotti, P. Chastang, V. Debiais, and L. Kendrick, 31–60. Paris, 2020.

Palma, M. "Cerbani, Cerbano." *DBI* 23 (1979). http://www.treccani.it/enciclopedia/cerbano-cerbani_(Dizionario-Biografico)/.

Papamastorakis, T. "Βυζαντιναὶ Παρενδύσεις Ἐνετίας: Luxurious Book-Covers in the Biblioteca Marciana." *Δελτ. Χριστ. Ἀρχ. Ἑτ.* 27 (2006): 391–409.

Parani, M. G. "Mediating Presence: Curtains in Middle and Late Byzantine Imperial Ceremonial and Portraiture." *BMGS* 42.1 (2018): 1–25.

Parker, G. *Global Crisis: War, Climate Change and Catastrophe in the Seventeenth Century.* New Haven, CT, 2013.

Pasini, A. *Il tesoro di San Marco in Venezia.* Venice, 1886.

Pecchioli, R. "Il 'mito' di Venezia e la crisi fiorentina intorno al 1500." *Studi Storici* 3.3 (1962): 451–92.

Pedrocco, F. *Paolo Veneziano.* Milan, 2003.

Pentcheva, B. V. *The Sensual Icon: Space, Ritual, and the Senses in Byzantium.* University Park, PA, 2010.

Perry, D. M. *Sacred Plunder: Venice and the Aftermath of the Fourth Crusade.* University Park, PA, 2015.

———. "St. George and Venice: The Rise of Imperial Culture." In *Matter of Faith: An Interdisciplinary Study of Relics and Relic Veneration in the Medieval Period*, edited by J. Robinson, L. De Beer, and A. Harnden, 15–22. London, 2014.

Perry, M. "Saint Mark's Trophies: Legend, Superstition, and Archaeology in Renaissance Venice." *JWarb* 40.1 (1977): 27–49.

Pertusi, A. "Ai confini tra religione e politica: La contesa per le reliquie di S. Nicola tra Bari, Venezia e Genova." *Quaderni medievali* 5 (1978): 6–56.

———. "Quaedam regalia insignia: Ricerche sulle insegne del potere ducale a Venezia durante il Medioevo." *StVen* 7 (1965): 3–124.

Petkov, K. *The Anxieties of a Citizen Class: The Miracles of the True Cross of San Giovanni Evangelista, Venice 1370–1480.* Leiden, 2014.

Petrarch, Francesco. *Lettere di Francesco Petrarca delle cose familiari libri ventiquattro, lettere varie libro unico: Ora la prima volta raccolte, volgarizzate e dichiarate con note da Giuseppe Fracassetti.* Vol. 4, edited by G. Fracassetti. Florence, 1866.

Pfaff, R. W. *Medieval Latin Liturgy: A Select Bibliography.* Toronto, 1982.

Piazza, S. "Mosaici d'oro nelle chiese di Venezia (IX–XIV secolo): Luci sull'ingente patrimonio perduto." *Convivium* 7.1 (2020): 54–79.

Pincus, D. "The Beginning of Gothic Lettering at the Basilica of San Marco: The Contribution of Doge Andrea Dandolo." In Vio, *San Marco: La basilica*, 1:319–29.

———. "Christian Relics and the Body Politic: A Thirteenth-Century Relief Plaque in the Church of San Marco." In *Interpretazioni veneziane: Studi di storia dell'arte in onore di Michelangelo Muraro*, edited by D. Rosand, 39–57. Venice, 1984.

———. "Geografia e politica nel battistero di San Marco: La cupola degli apostoli." In Niero, *San Marco: Aspetti storici*, 459–73.

———. "Hard Times and Ducal Radiance: Andrea Dandolo and the Construction of the Ruler in Fourteenth-Century Venice." In Martin and Romano, *Venice Reconsidered*, 89–136.

———. "Mark Gets the Message: Mantegna and the 'Praedestinatio' in Fifteenth-Century Venice." *Artibus et Historiae* 18.35 (1997): 135–46.

———. *The Tombs of the Doges of Venice.* Cambridge, 2000.

———. "The Turn Westward: New Stylistic Directions in Fourteenth-Century Venetian Sculpture." In *Medieval Renaissance Baroque: A Cat's Cradle for Marilyn Aronberg Lavin*, edited by D. A. Levine and J. Freiberg, 25–44. New York, 2010.

———. "Venetian Ducal Tomb Epitaphs: The Stones of History." In *The Tombs of the Doges of Venice: From the Beginning of the Serenissima to 1907*, edited by B. Paul, 243–66. Rome, 2016.

———. "Venice and Its Doge in the Grand Design: Andrea Dandolo and the Fourteenth-Century Mosaics of the Baptistery." In Maguire and Nelson, *San Marco, Byzantium, and the Myths of Venice*, 245–71.

Piqué, F., and D. C. Stulik. *Conservation of the Last Judgment Mosaic, St. Vitus Cathedral, Prague*. Los Angeles, 2004.

Poggibonsi, Niccolò da. *Libro d'oltramare*. Edited by Alberto Bacchi della Lega. Bologna, 1881.

Polacco, R. "Una nuova lettura della pala d'oro." In Hahnloser and Polacco, *La pala d'oro*, 113–48.

Popović, D. "Predstava Vladara nad 'Carskim Vratima' Crkve Svetih Arhandela kod Prizrena." *Saopštenja* 26 (1994): 25–36.

Post, G. *Studies in Medieval Legal Thought: Public Law and the State 1100–1322*. Princeton Legacy Library 1880. Princeton, NJ, 2015.

Pozza, M. "La cancelleria." In Cracco and Ortalli, *Storia di Venezia*, 2:349–69.

———. "La cancelleria." In Arnaldi et al., *Storia di Venezia*, vol. 3:51–85.

———. "Pietro Orseolo, santo." *DBI* 83 (2015). https://www.treccani.it/enciclopedia/santo-pietro-orseolo_(Dizionario-Biografico)/.

Pratsch, T. *Der hagiographische Topos: Griechische Heiligenviten in mittelbyzantinischer Zeit*. Berlin, 2012.

Ptolemy of Lucca and Thomas Aquinas. *On the Government of Rulers: De regimine principum*. Translated by J. M. Blythe. Philadelphia, 1997.

Puglisi, C. R., and W. L. Barcham. *Art and Faith in the Venetian World: Venerating Christ as the Man of Sorrows*. Turnhout, 2019.

———. "Gli esordi del 'Cristo passo' nell'arte veneziana e la pala feriale di Paolo Veneziano." In *"Cose nuove e cose antiche": Scritti per monsignor Antonio Niero e Don Bruno Bertoli*, edited by F. Cavazzana Romanelli, M. Leonardi, and S. Rossi Minutelli, 403–29. Venice, 2006.

———. "'The Man of Sorrows' and Royal Imaging: The Body Politic and Sovereign Authority in Mid-Fourteenth-Century Prague and Paris." *Artibus et Historiae* 35.70 (2014): 31–59.

Rabb, T. K. *The Struggle for Stability in Early Modern Europe*. Oxford, 1975.

Rando, D. "Aspetti dell'organizzazione della cura d'anime a Venezia nei secoli XI–XIII." In *La chiesa di Venezia nei secoli XI–XIII*, edited by F. Tonon, 53–72. Venice, 1988.

———. "Le strutture della chiesa locale." In Cracco Ruggini et al., *Storia di Venezia*, 1:645–75.

Rankin, S. "From Liturgical Ceremony to Public Ritual: 'Quem Queritis' at St. Mark's, Venice." In *Da Bisanzio a San Marco: Musica e liturgia*, edited by G. Cattin, 137–91. Bologna, 1997.

Ravegnani, G. "Falier, Marino." *DBI* 44 (1994). https://www.treccani.it/enciclopedia/marino-falier_(Dizionario-Biografico)/.

———. *Il traditore di Venezia: Vita di Marino Falier doge*. Bari, 2017.

Reeves, M. "The Development of Apocalyptic Thought: Medieval Attitudes." In *The Apocalypse in English Renaissance Thought and Literature: Patterns, Antecedents, and Repercussions*, edited by C. A. Patrides and J. Wittreich, 40–72. Ithaca, NY, 1984.

Renier Michiel, G. *Origine delle feste veneziane*. 6 vols. in 3 tomes. Milan, 1829.

Reuland, J. "Voicing the Doge's Sacred Image." *The Journal of Musicology* 32.2 (2015): 198–245.

Reynolds, S. *Kingdoms and Communities in Western Europe, 900–1300*. Oxford, 1984.

Riccobono, F. "Paradiso." In Banzato, Flores d'Arcais, and Spiazzi, *Guariento*, 212–15.

Riesenberg, P. *Citizenship in the Western Tradition: Plato to Rousseau*. Chapel Hill, NC, 1992.

Riley-Smith, J. S. C. "The Venetian Crusade of 1122–1124." In *I comuni italiani nel regno crociato di Gerusalemme: Atti del colloquio "The Italian Communes in the Crusading Kingdom of Jerusalem" (Jerusalem, May 24–May 28, 1984)*, edited by G. Airaldi and B. Z. Kedar, 337–50. Genoa, 1986.

Roberts, A. M. "Donor Portraits in Late Medieval Venice c. 1280–1413." PhD diss., Queen's University, 2007.

Robey, D., and J. E. Law. "The Venetian Myth and the 'De Republica Veneta' of Pier Paolo Vergerio." *Rinascimento* 15 (1975): 3–59.

Rodini, E. "Mapping Narrative at the Church of San Marco: A Study in Visual Storying." *Word & Image* 14.4 (1998): 387–96.

Roitman, J. *Anti-Crisis*. Durham, NC, 2013.

———. "Crisis." *Political Concepts: A Critical Lexicon* 1 (2012), http://www.politicalconcepts.org/issue1/crisis/.

Romano, S. "Il male del mondo: Giotto, Dante, e la Navicella." In *Dante und die bildenden Künste: Dialoge—Spiegelungen—Transformationen*, edited by M. A. Terzoli and S. Schütze, 185–204. Berlin, 2016.

Rosand, D. *Myths of Venice: The Figuration of a State*. Chapel Hill, NC, 2001.

Rösch, G. "The Serrata of the Great Council and Venetian Society, 1286–1323." In Martin and Romano, *Venice Reconsidered*, 67–88.

———. *Der venezianische Adel bis zur Schließung des Großen Rats: Zur Genese einer Führungsschicht*. Stuttgart, 1989.

Rosen, M. "The Republic at Work: S. Marco's Reliefs of the Venetian Trades." *ArtB* 90.1 (2008): 54–75.

Rösener, W. "Die Krise des Spätmittelalters in Neuer Perspektive." *Vierteljahrschrift Für Sozial- Und Wirtschaftsgeschichte* 99.2 (2012): 189–208.

Rossi, M. A. "Christ's Miracles in Monumental Art in Byzantium and Serbia (1280–1330)." PhD diss., Courtauld Institute of Art, 2016.

———. "Reconsidering the Early Palaiologan Period: Anti-Latin Propaganda, Miracle Accounts, and Monumental Art." In Mattiello and Rossi, *Late Byzantium Reconsidered*, 71–84.

Rothman, E. N. *Brokering Empire: Trans-Imperial Subjects between Venice and Istanbul*. Ithaca, NY, 2012.

Rousseau, J.-J. *Emile: Or On Education*. Edited by A. Bloom. New York, 1979.

Rubinstein, N. "Le origini medievali del pensiero repubblicano del secolo XV." In *Studies in Italian History in the Middle Ages and the Renaissance*. Vol. 1, *Political Thought and the Language of Politics: Art and Politics*, edited by G. Ciappelli, 1:365–81. Rome, 2004.

——. "Political Theories in the Renaissance." In *The Renaissance: Essays in Interpretation*, edited by A. Chastel, 153–200. London, 1982.

Ruggiero, G. "Modernization and the Mythic State in Early Renaissance Venice: The Serrata Revisited." *Viator* 10 (1979): 245–56.

Ryan, M. A. "Introduction: A Companion to the Premodern Apocalypse." In *A Companion to the Premodern Apocalypse*, edited by M. A. Ryan, 1–17. Brill's Companions to the Christian Tradition 64. Leiden, 2016.

Saalman, H. "Carrara Burials in the Baptistery of Padua." *ArtB* 69.3 (1987): 376–94.

Sabellico, Marcantonio Coccio. Marcantonio. *Istorie veneziane*. Venice, 1487.

Saccardo, P. *Les mosaïques de Saint-Marc à Venise*. Venice, 1896.

——. *Saggio d'uno studio storico-artistico sopra i musaici della chiesa di S. Marco in Venezia*. Venice, 1864.

Safran, L. "'Byzantine' Art in Post-Byzantine South Italy? Notes on a Fuzzy Concept." *Common Knowledge* 18.3 (2012): 487–504.

Said, E. W. *Orientalism*. New York, 1978.

Salimbene of Parma. *Cronica fratris Salimbene de Adam ordinis Minorum*. Edited by O. H. Egger and B. Schmeidler. MGH SS 32. Hannover, 1905.

Salzberg, R. M., and C. J. de Larivière. "Comment être Vénitien? Identification des immigrants et 'droit d'habiter' à Venise au XVIe siècle." *Revue d'histoire moderne et contemporaine* 64.2 (2017): 69–92.

Sansovino, Francesco. *Venetia, citta nobilissima et singolare*. Venice, 1581.

——. *Venetia, citta nobilissima et singolare*. Venice, 1663.

Sanudo, Marino. *Vitae ducorum Venetorum italice scriptae ab origine urbis, sive ab anno CCCCXXI usque ad annum MCCCXCIII. RIS* 22, 599–1252. Milan, 1733.

Sanudo il Giovane, Marin. *Le vite dei dogi (1423–1474)*. Vol. 1, *1423–1457*, edited by A. Caracciolo Aricò. Venice, 1999.

Sanudo Torsello, Marino. *The Book of Secrets of the Faithful of the Cross: Liber secretorum fidelium crucis*. Translated by P. Lock. Farnham, 2011.

Sartorio, L. "San Teodoro, statua composita." *ArtV* 1.2 (1947): 132–34.

Schäfer, S. "Δέξαι εὐλογίαν—der Bronzestempel mit der Darstellung des heiligen Isidor von Chios und sein möglicher Verwendungszweck." In *Für Seelenheil und Lebensglück: Das byzantinische Pilgerwesen und seine Wurzeln*, edited by D. Ariantzi and I. Eichner, 327–42. Mainz, 2018.

Schilb, H. "Byzantine Identity and Its Patrons: Embroidered Aeres and Epitaphioi of the Palaiologan and Post-Byzantine Periods." PhD diss., Indiana University, 2009.

Schmidt, V. M. "Curtains, 'Revelatio,' and Pictorial Reality in Late Medieval and Renaissance Italy." In *Weaving, Veiling and Dressing: Textiles and Their Metaphors in the Late Middle Ages*, edited by K. M. Rudy and B. Baert, 191–214. Turnhout, 2007.

Schmitt, A. *Modernity and Plato: Two Paradigms of Rationality*. Rochester, 2012.

Schmugge, L. "Fiadoni, Bartolomeo." *DBI* 47 (1997). https://www.treccani.it/enciclopedia/bartolomeofiadoni_(Dizionario-Biografico)/.

Schulz, J. "Urbanism in Medieval Venice." In *City States in Classical Antiquity and Medieval Italy: Athens and Rome, Florence and Venice*, edited by A. Molho, K. Raaflaub, and J. Emlen, 419–45. Stuttgart, 1991.

Schuster, P. "Die Krise des Spätmittelalters: Zur Evidenz eines sozial- und wirtschaftsgeschichtlichen Paradigmas in der Geschichtsschreibung des 20. Jahrhunderts." *HZ* 269.1 (1999): 19–56.

Schütrumpf, E. *The Earliest Translations of Aristotle's Politics and the Creation of Political Terminology*. Paderborn, 2014.

Schwarz, A. "Images and Illusions of Power in Trecento Art: Cola di Rienzo and the Ancient Roman Republic." PhD diss., State University of New York at Binghamton, 1994.

Sedinova, H. "The Precious Stones of Heavenly Jerusalem in the Medieval Book Illustration and Their Comparison with the Wall Incrustation in St. Wenceslas Chapel." *Artibus et Historiae* 21.41 (2000): 31–47.

——. "The Symbolism of the Precious Stones in St. Wenceslas Chapel." *Artibus et Historiae* 20.39 (1999): 75–94.

Settia, A. A. "L'apparato militare." In Cracco and Ortalli, *Storia di Venezia*, 2:461–505.

Setton, K. M. *The Papacy and the Levant (1204–1571)*. Vol. 1, *The Thirteenth and Fourteenth Centuries*. Philadelphia, 1976.

Shank, J. B. "Crisis: A Useful Category of Post–Social Scientific Historical Analysis?" *AHR* 113.4 (2008): 1090–99.

Shoemaker, K. "The Devil at Law in the Middle Ages." *RHR* 228.4 (2011): 567–86.

Shukurov, R. *The Byzantine Turks, 1204–1461*. Leiden, 2016.

Siddons, H. A. "Virtues, Vices, and Venice: Studies on Henry of Rimini O. P." PhD diss., University College London, 2000.

Silver, N. "'Magna ars de talibus tabulis et figuris': Reframing Panel Painting as Venetian Commodity (14th–15th Centuries)." In *Typical Venice? The Art of Commodities, 13th–16th Centuries*, edited by E. Beaucamp and P. Cordez, 69–86. Turnhout, 2020.

Sinding-Larsen, S., ed. *Christ in the Council Hall: Studies in the Religious Iconography of the Venetian Republic*. *ActaIRNorv* 5. Rome, 1974.

Skey, M. A. "Herod the Great in Medieval Art and Literature." PhD diss., University of York, 1976.

———. "Herod the Great in Medieval European Drama." *Comparative Drama* 13.4 (1979): 330–64.

Skinner, Q. "Classical Rhetoric and the Personation of the State." In *From Humanism to Hobbes: Studies in Rhetoric and Politics*, 12–44. Cambridge, 2018.

———. *The Foundations of Modern Political Thought: The Renaissance.* Cambridge, 1978.

———. "Hobbes and the Purely Artificial Person of the State." *The Journal of Political Philosophy* 7.1 (1999): 1–29.

———. *Visions of Politics.* Vol. 1, *Regarding Method.* Cambridge, 2002.

———. *Visions of Politics.* Vol. 2, *Renaissance Virtues.* Cambridge, 2002.

Smith, J. M. H. "Les étiquettes d'authentification des reliques." *Archéothéma* 36 (2014): 70–75.

———. "Oral and Written: Saints, Miracles, and Relics in Brittany, c. 850–1250." *Speculum* 65.2 (1990): 309–43.

———. "The Remains of the Saints: The Evidence of Early Medieval Relic Collections." *EME* 28.3 (2020): 388–424.

Smoller, L. A. "Of Earthquakes, Hail, Frogs and Geography: Plague and the Investigation of the Apocalypse in the Later Middle Ages." In *Last Things: Death and the Apocalypse in the Middle Ages*, edited by C. W. Bynum and P. H. Freedman, 156–87. Philadelphia, 2000.

Sperti, L. "La testa del Todaro: Un palinsesto in marmo tra età costantiniana e tardo Medioevo." In *Pietre di Venezia: Spolia in se, spolia in re; Atti del convegno internazionale (Venezia, 17–18 ottobre 2013)*, edited by M. Centanni and L. Sperti, 173–93. Rome, 2015.

Spratt, E. L. "Toward a Definition of 'Post-Byzantine' Art: The Angleton Collection at the Princeton University Art Museum." *Record of the Art Museum, Princeton University* 71/72 (2012): 2–19.

Starn, R. "Crisis." In *New Dictionary of the History of Ideas.* Vol. 2, edited by M. C. Horowitz, 500–501. New York, 2005.

———. "Historians and 'Crisis.'" *Past & Present* 52.1 (1971): 3–22.

Stavru, A. "'Aisthesis' e 'Krisis': Rappresentazione e differenza in Platone e Aristotele." *Quaderni urbinati di cultura classica* 81.3 (2005): 151–54.

Steinhoff, J. B. *Sienese Painting after the Black Death: Artistic Pluralism, Politics, and the New Art Market.* Cambridge, 2007.

Stoyanova-Cucco, M. "La preistoria ed i mosaici del battistero di San Marco." *AttiVen* 147 (1989): 17–28.

Stringa, Giovanni. *Vita di S. Marco Evangelista, protettore invittissimo della Sereniss. Republica di Venetia.* Venice, 1610.

Stussi, A. "La Lingua." In Arnaldi et al., *Storia di Venezia*, vol. 3:911–32.

Summit, J., and D. Wallace. "Rethinking Periodization." *Journal of Medieval and Early Modern Studies* 37.3 (2007): 447–51.

Syropoulos, Sylvester. *Les "Mémoires" du Grand Ecclésiarique de l'Eglise de Constantinople Sylvestre Syropoulos sur le concile de Florence: 1438–1439.* Edited by V. Laurent. Paris, 1971.

Szépe, H. K. "Distinguished among Equals: Repetition and Innovation in Venetian Commissioni." In *Manuscripts in Transition: Recycling Manuscripts, Texts and Images*, edited by B. Dekeyzer and J. Van der Stock, 441–47. Leuven, 2005.

———. "Doge Andrea Dandolo and Manuscript Illumination." In *Miniatura: Lo sguardo e la parola; Studi in onore di Giordana Mariani Canova*, edited by F. Toniolo and G. Toscano, 158–62. Cinisello Balsamo, 2012.

———. *Venice Illuminated: Power and Painting in Renaissance Manuscripts.* New Haven, CT, 2018.

Taburet-Delahaye, E. "I gioielli della pala d'oro." In Hahnloser and Polacco, *La pala d'oro*, 149–59.

Tafel, G. L. F., and G. M. Thomas. *Der Doge Andreas Dandolo und die von demselben angelegten Urkundensammlungen zur Staats- und Handelsgeschichte Venedigs: Mit den Original-Registern des Liber Albus, des Liber Blancus und der Libri Pactorum aus dem Wiener Archiv.* Munich, 1855.

Talbot, A.-M. "Old Wine in New Bottles: The Rewriting of Saints' Lives in the Palaeologan Period." In *The Twilight of Byzantium: Aspects of Cultural and Religious History in the Late Byzantine Empire*, edited by S. Curcic and D. Mouriki, 15–26. Princeton, NJ, 2019.

———. "Pilgrimage to Healing Shrines: The Evidence of Miracle Accounts." *DOP* 56 (2002): 153–73.

———, and S. F. Johnson. *Miracle Tales from Byzantium.* Cambridge, MA, 2012.

Tassini, G. *Curiosità veneziane, ovvero Origini delle denominazioni stradali di Venezia.* 2nd ed. Venice, 1872.

Tenenti, A. "Le 'temporali calamità.'" In Arnaldi et al., *Storia di Venezia*, 3:27–49.

Tenenti, A., and U. Tucci, *Storia di Venezia: Dalle origini alla caduta della Serenissima*, vol. 5, *Il Rinascimento: Politica e cultura.* Rome, 1996. https://www.treccani.it/enciclopedia/gli-stranieri-e-la-citta_(Storia-di-Venezia)/.

Theocharis, M. "Ricami bizantini." In Hahnloser, *Il tesoro di San Marco*, 91–93.

Thiriet, F. *La Romanie vénitienne au Moyen Age: Le développement et l'exploitation du domaine colonial vénitien, XIIᵉ–XVᵉ siècles.* Paris, 1959.

———. "Sui dissidi sorti tra il comune di Venezia e i suoi feudatari di Creta nel Trecento." *AStIt* 114.4 (1956): 699–712.

Thompson, A. *Cities of God: The Religion of the Italian Communes, 1125–1325.* University Park, PA, 2005.

Tigler, G. "Intorno alle colonne di Piazza San Marco." *AttiVen* 158.1 (2000): 1–46.

———. *Il portale maggiore di San Marco a Venezia: Aspetti iconografici e stilistici dei rilievi duecenteschi.* Venice, 1995.

Toffolo, S. *Describing the City, Describing the State: Representations of Venice and the Venetian Terraferma in the Renaissance.* Leiden, 2020.

Tomasi, M. *Le arche dei santi: Scultura, religione e politica nel Trecento Veneto.* Rome, 2012.

———. "Prima, dopo, attorno alla cappella: Il culto di Sant'Isidoro a Venezia." *Quaderni della Procuratoria: Arte, storia, restauri della basilica di San Marco a Venezia.* Vol. 3, *La cappella di Sant'Isidoro,* edited by I. Favaretto, 15–23. Venice, 2008.

Trebbi, G. "Il segretario veneziano." *AStIt* 144 (1986): 35–73.

Vaccari, M. G., and S. Conti. "I 'veli' bizantini del Museo Marciano di Venezia: La pulitura; Problemi, sperimentazioni, risultati." *OPD Restauro* 8 (1996): 48–65, 88–91.

Valenzano, G. "'Celavit Marcus opus hoc insigne Romanus. Laudibus non parvis est sua digna manus': L'attività di Marco Romano a Venezia." In *Marco Romano e il contesto artistico senese fra la fine del Duecento e gli inizi del Trecento,* edited by A. Bagnoli, 132–39. Cinisello Balsamo, 2010.

Valerio, Agostino. *Dell'utilità che si può ritrarre dalle cose operate dai Veneziani.* Edited by N. A. Giustiniani. Padua, 1787.

Van Ausdall, K. "Art and Eucharist in the Late Middle Ages." In *A Companion to the Eucharist in the Middle Ages,* edited by I. C. Levy, G. Macy, and K. Van Ausdall, 541–617. Leiden, 2012.

Varanini, G. M. "Venezia e l'entroterra (1300 circa–1420)." In Arnaldi et al., *Storia di Venezia,* 3:159–236.

Varisco, D. M. *Reading Orientalism: Said and the Unsaid.* Seattle, 2007.

Vassilaki, M. *The Hand of Angelos: An Icon Painter in Venetian Crete.* Farnham, 2010.

———. "Looking at Icons and Contracts for Their Commission in Fifteenth-Century Venetian Crete." In *Paths to Europe: From Byzantium to the Low Countries,* edited by B. Coulie and P. Dujardin, 101–15. Cinisello Balsamo, 2017.

———. "Painting Icons in Venetian Crete at the Time of the Council of Ferrara/Florence (1438/1439)." *IKON* 9 (2016): 41–52.

Vauchez, A. *Sainthood in the Later Middle Ages.* Cambridge, 1997.

Veneskey, L. "Truth and Mimesis in Byzantium: A Speaking Reliquary of Saint Demetrios of Thessaloniki." *AH* 42.1 (2019): 16–39.

Vespignani, G. *La cronachistica veneziana: Fonte per lo studio delle relazioni tra Bisanzio e Venezia.* Quaderni della Rivista di Bizantinistica 19. Spoleto, 2018.

Vio, E. "Dai restauri del battistero della basilica di San Marco alcune indicazioni per la facciata sud." In *Scienza e tecnica del restauro della basilica di San Marco: Atti del convegno internazionale di studi, Venezia, 16–19 maggio 1995.* Vol. 2, edited by E. Vio and A. Lepschy, 515–49. Venice, 1999.

———, ed. *San Marco: La basilica di Venezia; Arte, storia, conservazione.* 2 vols. Venice, 2019.

———. "La tomba e l'altare di San Marco: Le colonne in cripta a sostegno di quelle istoriate del ciborio." In *Quaderni della Procuratoria: Arte, storia, restauri della basilica di San Marco a Venezia.* Vol. 10, *Le colonne del ciborio,* edited by I. Favaretto, 39–47. Venice, 2015.

Vivo, F. de. "Heart of the State, Site of Tension: The Archival Turn Viewed from Venice, c. 1400–1700." *Annales: Histoire, Sciences Sociales* 68.3 (2013): 699–728.

Volbach, W. F. "Gli smalti della pala d'oro." In Hahnloser and Polacco, *La pala d'oro,* 1–72.

Vuillemin, P. *Parochiæ Venetiarum: Les paroisses de Venise au Moyen Âge.* Paris, 2017.

Walter, C. *The Warrior Saints in Byzantine Art and Tradition.* Farnham, 2003.

Wamsler, C. A. "Merging Heavenly Court and Earthly Council in Trecento Venice." In *Negotiating Secular and Sacred in Medieval Art: Christian, Islamic, and Buddhist,* edited by A. Walker and A. Luyster, 55–73. Farnham, 2009.

———. "Picturing Heaven: The Trecento Pictorial Program of the Sala del Maggior Consiglio in Venice." PhD diss., Columbia University, 2006.

Ward-Perkins, B. *The Fall of Rome: And the End of Civilization.* Oxford, 2005.

Webb, D. *Patrons and Defenders: The Saints in the Italian City-States.* London, 1996.

Weigel, T. "Le colonne istoriate del ciborio dell'altare maggiore." In *Quaderni della Procuratoria: Arte, storia, restauri della basilica di San Marco a Venezia.* Vol. 10, *Le colonne del ciborio,* edited by I. Favaretto, 11–19. Venice, 2015.

———. *Die Reliefsäulen des Hauptaltarciboriums von San Marco in Venedig: Studien zu einer spätantiken Werkgruppe.* Münster, 1997.

Weiger, K. "The Portraits of Robert of Anjou: Self-Presentation as Political Instrument?" *Journal of Art Historiography* 17 (2017). https://arthistoriography.files.wordpress.com/2017/11/weiger.pdf.

Weiler, B. "The 'rex renitens' and the Medieval Idea of Kingship, ca. 900–ca. 1250." *Viator* 31 (2000): 1–42.

Whitaker, E. C. *The Baptismal Liturgy.* 2nd ed. London, 1981.

———. *Documents of the Baptismal Liturgy.* Edited by M. E. Johnson. 3rd. rev. ed. Collegeville, MN, 2003.

Wickham, C. *Medieval Rome: Stability and Crisis of a City, 900–1150.* Oxford, 2015.

Widener, M., and C. W. Platts. *Representing the Law in the Most Serene Republic: Images of Authority from Renaissance Venice.* New Haven, CT, 2016.

Wieser, V., V. Eltschinger, and J. Heiss. "Introduction: Approaches to Medieval Cultures of Eschatology." In *Cultures of Eschatology.* Vol. 1, *Empires and Scriptural Authorities in Medieval Christian, Islamic and Buddhist Communities,* edited by V. Wieser, V. Eltschinger, and J. Heiss, 1–22. Berlin, 2020.

Williamson, B. *Reliquary Tabernacles in Fourteenth-Century Italy: Image, Relic and Material Culture.* Woodbridge, 2020.

Wilson, H. A., ed. *The Gelasian Sacramentary: Liber sacramentorum Romanae Ecclesiae*. Oxford, 1894.

Wolters, W. *La scultura veneziana gotica (1300–1460)*. Vol. 1, *Testo e catalogo*. Venice, 1976.

Woodfin, W. "Wall, Veil, and Body: Textiles and Architecture in the Late Byzantine Church." In *The Kariye Camii Reconsidered/Kariye Camii, Yeniden*, edited by H. A. Klein, R. G. Ousterhout, and B. Pitarakis, 371–85. Istanbul, 2011.

Wray, S. K. *Communities and Crisis: Bologna during the Black Death*. Leiden, 2009.

Wunder, A. *Baroque Seville: Sacred Art in a Century of Crisis*. University Park, PA, 2017.

Zorzanello, G. "La cronaca veneziana trascritta da Gasparo Zancaruolo (Codice Marciano It. VII, 2570, Già Phillipps 5215)." *AVen* 114 (1980): 37–66.

Zorzi, A. *Osservazioni intorno ai restauri interni ed esterni della Basilica di San Marco con tavole illustrative di alcune iscrizioni armene esistenti nella medesima*. Venice, 1877.

Book of Secrets of the Faithful of the Cross (Marino Sanudo Torsello), 123
Burckhardt, Jacob, 32, 33n93
Butrint, 16
Byzantine art, 3, 6–7, 17, 35–39, 43, 48, 51–57, 66–74, 81, 84n73, 85–92, 107–8, 144, 148, 174–76, 196, 201, 204, 206, 208–10. *See also pala d'oro*
 architecture, 95n2, 175
 book bindings (San Marco), 66–70
 crown jewels, 13
 depicting rulers, 56–57, 90, 183–86, 190, 196, 201, 204
 manuscripts, 171
 style, 36–37, 38
 visual language, 43
Byzantium, 6–7, 33–37, 43, 84n73, 102, 106n21, 107–8, 174, 198, 201
 civil war in, 13n5, 198n125
 "decline" of, 13, 32–39
 relics from, 11, 83, 104n15, 105, 120
 and Venice, 6–7, 13–18, 34–39, 120, 144, 200n139, 209–11

Calò, Pietro, 104, 104n10, 110
Canale, Martino da, 22, 24, 72n41, 103, 136
Candiano, Pietro IV, 195–96
capitalism, 32
Capitolari, 129, 130
Cappella dei Carraresi, 176–78
Cappella dei Mascoli, 119
Cappella Zen. *See* Zen chapel
Caresini, Rafaino, 99n4
Castello, 127. *See also* San Pietro in Castello
catechumens, 143, 156–57, 159, 161–62, 163, 170, 173
celestial hierarchy. *See* hierarchy, celestial
Ceneda, 178n90
central dome (San Marco), 171–81
central doorway (San Marco), 46
Cerbanus Cerbani, 103n7, 119, 137–38
chancellor, 24, 30, 99n4, 190
chancery, 20, 30, 42, 66, 99n4, 138, 139, 190, 205
chaplains (San Marco), 127
Charles IV of Bohemia, 46, 190
Charles the Bald, 186n102
Cherubim, 178
cherubs, 175
Chios, 5, 15, 25, 41, 98, 99, 100, 102, 118, 119–23, 135, 136, 138, 206–7. *See also* Isidore of Chios (martyr)
Christ in Glory, 47, 85
Christian League, 14, 82, 168
Christmas Day, 61
Christological cycle, 55
Christ's Apparition to St. Mark in Prison (*pala feriale*), 76
Chronica brevis (Andrea Dandolo), 30
Chronica per extensum descripta (Andrea Dandolo), 30, 75, 89, 91, 103, 138, 195–96, 205
ciborium, 61–62, 77, 90, 91
Cicero, 29, 201
Circumcision of Christ, 61
citizens, 25, 35, 40, 42, 93, 122, 159, 169–70, 173, 195, 199, 205, 208, 211
 by right of birth (*cittadini originari*), 20, 35
 contrasted to elites, 17, 19, 20, 25, 135, 169, 191n108
 contrasted to *popolo*, 169–70
 naturalized (*cittadini per privilegio*), 20
 private, 15, 119, 181

citizenship, 5–6, 11, 19, 20n32, 25, 41, 42, 144, 157, 167–71
civic community, 15, 39, 40, 84, 85, 120
civic induction, 156–59
civic religion, 9
civil law, 27
civil servant, 19, 21, 25, 133, 137, 138, 181, 185, 191
civil service, 186, 199. *See also* civil servant; public service
civitas, 11, 91, 144, 158, 173, 202–3
clothing, 112, 148, 172–73, 211
coat of arms, 133–135, 141, 211
colonies (of Venice), 6, 11, 13, 16–18, 25, 27–28, 37–38, 41, 84, 92, 94, 104, 121, 132, 138–168–171, 204, 208–209. *See also* ambitions, imperial (of Venice)
 rebellions of, 16–17, 28, 125, 139
common law, 27
common sense, 40–42, 208
communes, Italian, 198, 202, 211
 the Commune (Venice), 22, 127, 129–30, 135
community, 21, 144
 for baptistery, 166–81
 civic, 15, 39, 40, 84, 85, 120
 crisis and, 5, 29, 39, 49
 Greek, 7, 116
 Latin, 168
 normalcy and, 41
 Orthodox, 168
 urban, 105
confraternities, 77n64, 140, 168
Consecration by St. Peter (*pala feriale*), 76
conservatism, 39
conspiracy (1355), 12, 25, 95, 139–41
Constantinople, 17, 35–37, 55, 72, 120, 175, 211
 fall of, 13, 33, 34, 35
 Latin takeover of, 3
constitution, 4, 27–28, 30, 43, 136, 197, 199–200, 205–6, 211, 212
consuetudines (legal customs derived from court precedents), 26
consuetudines (ritual customs followed in the Basilica di San Marco), 61, 77n65
Contarini, Jacopo, 22, 24
conversion, 106, 161, 173
corno, 194. *See also berretta*
Coronation, 178
Coronation of the Virgin in Paradise, 178
correttori (reviewers), 21
cosmos, 6, 49, 144, 157, 181, 204. *See also kosmos*
Council of Florence, 55n6
Council of the Ten, 30, 140–41
Council of Trent, 170
coup d'état, 25
the Creed, 157
Cretan-Venetian icons, 37
Crete, 17, 37
crisis
 ancient roots of, 41–44
 as boundary-situation, 5, 206
 as chasm, 41
 and community, 5, 29, 39, 49
 as discernment, 42, 44, 205, 206
 as disruption, 44
 historiographies of, 31–32
 as judgment, 40, 42, 206
 and the Middle Ages, 32, 45
 and reality, 30

procurators, 129–31, 191
 de citra, 130
 de supra, 130
 de ultra, 130
Proles nobelium Venetorum, 132, 132n94, 133, 134
pro magnificentia civitatis ("the magnificence of the city"),
 51
promissio (ducal oath), 21, 21n48, 22, 24, 25, 127, 130, 136
prophets, 46, 179
 (for baptistery), 148, 151, 174
 (for *pala d'oro*), 85
proskynesis, 183, 185, 201
prostitution, 116
pseudo-Dionysios, 175
Ptolemy of Lucca, 199, 200
public assistance, 168, 170
public *damnatio*, 140, 141n126
public finances, of Venice, 19
public office, 20, 169, 191, 194. *See also* civil servant; civil
 service; public service
public service, 90, 144, 169, 178, 185, 186, 196, 197, 201–3
purity, of martyrs, 110

Quarantia, 20, 132
Quem queritis, 73
Querini, Francesco, 51, 133

Ravegnani, Benintendi, 30, 138
rebellion of Venetian colonies. *See* colonies (of Venice),
 rebellions of
Redeemer, 90
redemption, 45, 55, 89, 143, 156, 159, 163, 168, 204
Regimina, 132
relics, 11, 30, 43, 70 86–88, 93, 104–5, 118, 126n65, 139, 208
 authentication of, 118
 Byzantine, 36, 104–5
 holy blood, 72, 163
 related to the Passion, 72–73, 105, 163
 ring of St. Mark, 1, 12n3
 of St. George, 11, 83
 of St. Isidore, 118–19, 124
 of St. Mark, 72n40, 75
 stone of Tyre, 123–24
 translation, 2, 25, 73, 75, 82, 83, 93, 98n3, 99, 102, 104n9,
 105, 110, 112, 116, 118, 119, 120, 121, 137, 138
religion, civic, 6, 9, 14, 18, 24, 29, 39, 42n130, 76, 81–84,
 127, 137, 138, 143–45, 156–59, 166–68, 171–74, 181,
 203–4, 208
religious initiation, 156–59
Renaissance, 32–34, 36n111, 197
repraesentatio, 202
representation, 201–3
republic (Venice), 13, 14, 16, 42–43, 85
republican regimes, 43, 199, 200, 202
Resurrection, of Christ, 163, 165
reviewers. *See correttori* (reviewers)
rhetoric
 apocalyptic, 46
 classical, 28–29, 201–2
 of Dandolo, 28–30
 hagiographic, 106, 107
 medieval, 3, 15, 29–30, 141
 triumphal, 35–36, 49
Rienzo, Cola di, 46

ring, of St. Mark, 1, 12, 12n3
rites and rituals, 66, 74, 85, 88, 135, 141, 156, 157, 165, 180,
 181. *See also* specific rites and rituals
 public nature of, 144, 156, 173, 181
Robert of Anjou, 187, 190
rogation, 61

Saba (saint), 123
Sabellico, Marcantonio Coccio, 111
Said, Edward, 34n103
saints' lives. *See* hagiography
Salome, 148, 194
salt trade, 15
salvation, 5, 12, 40, 45–49, 53, 55, 59, 71, 72, 84, 89, 90, 143,
 144, 153, 156, 159, 163, 168, 174, 181, 185, 196, 203–7, 208
Sancha of Mallorca, 190
San Clemente, 75, 76, 94, 131, 190
San Giorgio Maggiore, 1, 82, 127n69
San Leonardo Fossamala, 18
San Marco. *See specific topics*
San Marco Boccalama, 18
San Marco Project, 36n112
San Martino di Strada, 18
San Niccolò al Lido, 1, 11, 83, 112
San Pietro in Castello, 83, 158. *See also* Castello
Sansovino, Francesco, 82
Sansovino, Jacopo, 61, 146n10
Sant'Alipio, portal of, 112, 119, 131, 190
Santa Maria Gloriosa dei Frari, 181
Sant'Erasmo, 18
Santi Giovanni e Paolo, 182n96, 200
Sant'Isidoro, chapel of. *See specific topics*
San Todaro, 82
santo novello, 194
Sanudo Torsello, Marino, 12, 123–24, 140, 181n94
Sardinia, 15
scientific innovation, 31
screens (in churches), 81, 88–90
Scuola degli Orbi, 78n64
Scuola dei Mascoli, 78n64
Scuola Grande della Carità, 18
Scuola Grande di San Giovanni Evangelista, 111
Scuola Grande di San Marco, 111
Second Coming, of Christ, 47, 48
self-image, of Venice, 93
Senate, 128
sepulchrum, 73
Seraphim, 178
seraphs, 175
Serbia, 48, 164, 185, 211
Serrata of the Great Council (1297), 4, 12, 19–21, 24, 25,
 27, 126, 132, 144, 169, 200, 206
Skinner, Quentin, 198–n126, 201, 202
signoria (Venetian), 138, 180, 202
Smyrna, 14, 17
social bases, of Venetian state, 43
social formation. *See popolo*
solidarity, 14, 40, 81, 157
Solomon (king), 196
Soranzo, Giovanni, 151, 153
south transept, mosaics in, 76
sovereignty, 91, 144, 191, 198, 201–3
spolia, 3, 35–36, 93
state attorneys. *See Avogadori del Comun* (state attorneys)

state building, 11, 42
state reforming, 19–21
Stato da Mar, 144, 169
statutes, 5, 26–27, 30, 42, 138, 205
storm legend (1340), 9–12, 82, 83, 105, 117, 136, 138
St. Titus's revolt, 17
Summula statutorum floridorum Veneciarum, 26–27
supernatural intervention, 5
supplicants, 181
sword, 121, 125, 137, 202
Syria, 17
Syropoulos, Sylvester, 55n6

taverns, 18
temperate rule, 197–201
Tenedos (island), 13
terraferma, 11, 16
Theodore (saint), 59, 82, 83, 151
Thessalonike, 81
Thomas (saint), 75, 199
Thomas Aquinas, 198–99
threshold, Venice as, 32–39
Thrones (angels), 178
Tiepolo, Bajamonte, 30, 138
Tiepolo, Lorenzo, 22, 24
Tintoretto, Domenico, 141
title, ducal, 22
torture, 106, 110
Tractates on the Gospel of John (Augustine), 163
Tradonico, Pietro, 129
translation, of relics. *See* relics, translation
translation, of texts, 42, 198, 201
Treatise on the Four Cardinal Virtues (Henry of Rimini), 199
"trecento crisis," 32–35
Treviso, 15
trial by fire, 110
Trinity, 157
triumphalism, 39
Turkey, 17
tyranny, 194, 199
Tyre, 122–24, *124*, 124n59, 133, 146, 169, 209

Uffizi, 112
unity in difference, 14, 144. *See also* ecumenism
universal cohesion, 168
universitates personarum, 202

Venetian aesthetics, 38
Veneto-Genoese Wars. *See* Genoa, war with
Venezia, Paolino da, 30, 103, 123–24
Veneziano, Paolo, 11, 52n3, 103n7, 112, 116, 123–24, 181, 182
 pala feriale, 2, 5, 48, 51, 59, 71, 72, 76, 84, 88, 94, 206,
 209, 210
Venice. *See specific topics*
Verona, 15
vexillum sancti Marci, 21, 71, 133, 134
Virgin Mary, 59, 64, 98, 153, 186
visual culture, Byzantine, 3
visual diversity, 6, 18, 38–39n121, 208
visual dualism, 6, 39, 210
visual landscape, 17–18
visual narrative, 94, 143
visual verification, 118–19
Voragine, Jacobus de, 76, 178

Walters Art Museum, 102n6
warships. *See dromons* (long, oared warships)
Westcentrism, 33
will, divine, 177
William of Moerbeke, 198, 199

Zaccaria, 120
Zadar, 16, 17
Zen, Ranieri, 72n40, 133n97
Zen chapel, 75, 110, 111, 143, 145
Ziani, Pietro, 51, 55, 131, 133
Žiča Monastery, 185n101

κρίσις (Day of Judgment), 5, 40, 41–42, 44. *See also* krisis

μετανοείτε (change of mind), 161